Merce Cunningham

Merce Cunningham
After the Arbitrary

Carrie Noland

The University of Chicago Press
Chicago and London

Publication of this book has been aided by a grant from the Neil Harris
Endowment Fund, which honors the innovative scholarship of Neil Harris,
the Preston and Sterling Morton Professor Emeritus of History at the
University of Chicago. The fund is supported by contributions from the
students, colleagues, and friends of Neil Harris.

The University of Chicago Press, Chicago 60637
The University of Chicago Press, Ltd., London
© 2019 by The University of Chicago
Published 2019
Printed in the United States of America

28 27 26 25 24 23 22 21 20 19 1 2 3 4 5

ISBN-13: 978-0-226-54110-5 (cloth)
ISBN-13: 978-0-226-54124-2 (paper)
ISBN-13: 978-0-226-54138-9 (e-book)
DOI: https://doi.org/10.7208/chicago/9780226541389.001.0001

Library of Congress Cataloging-in-Publication Data

Names: Noland, Carrie, 1958– author.
Title: Merce Cunningham: after the arbitrary / Carrie Noland.
Description: Chicago; London: The University of Chicago Press, 2019. |
 Includes bibliographical references and index.
Identifiers: LCCN 2019013824 | ISBN 9780226541105 (cloth) | ISBN
 9780226541242 (pbk) | ISBN 9780226541389 (e-book)
Subjects: LCSH: Cunningham, Merce—Criticism and interpretation. |
 Cunningham, Merce—Sources. | Modern dance—United States. |
 Choreography.
Classification: LCC GV1785.C85 N65 2019 | DDC 792.8092 [B]—dc23
LC record available at https://lccn.loc.gov/2019013824

♾ This paper meets the requirements of ANSI/NISO Z39.48-1992
(Permanence of Paper).

Contents

Introduction

You are standing on a street corner waiting for a friend, he is late or you think he is late, your impatience grows because he does not come, you see everyone and everything in a not-relation, it is not the person you await. Finally, he arrives, and you find he's not late at all, your anxiety has been for more nervousness.

Stand on the same street corner waiting again, but without anxiety about when the errand will be accomplished. This is theatre! Visually aware, you see differently, that the store fronts are different as different people stand looking into the windows, that, without any intention of being self-expressive, each person is extraordinarily so. Each action as it happens and you are aware of it, is absorbing. It doesn't make much difference whether your friend arrives on time or late. You have been a spectator in the audience using your faculties watching the players in action.

 Merce Cunningham, 1957[1]

In this brief anecdote, set in the second-person *you,* Merce Cunningham exposes what I believe to be the heart of the project he pursued throughout his career. Immediately establishing an intimacy with his audience—"*You* are standing on a street corner"—he evokes the elements of a developing aesthetic that would lead him from coin tosses and numerical calculations to the combinatorial complexities of his animated computer program DanceForms. Nowhere in this passage (or in the Lecture-Demonstration from which it is drawn) does Cunningham mention chance operations, although he had already been employing coin tosses to produce random sequences of dance movement for six years. Nor does he discuss the independence of dance from music or the decentering of the stage, although he was developing these aspects of his practice at the time. Instead, he points us directly to what is arguably one of his greatest preoccupations, one that has seldom been examined in the critical literature on Cunningham, and one that might even seem to run against the grain of that literature—namely, his pre-

occupation with connections, bonds, and human relationships. Against a background of scholarship decrying his posthumanism, his aesthetics of indifference, his abstraction of the corporeal, and his refusal of meaning,[2] I maintain, on the contrary, that his dances contain a plethora of moments in which archetypal human dramas are staged, desire and interest are multiplied, the human body is highly particularized, and gestures are saturated with meaning and affect.

In a sense, though, it would be false to oppose these two sets of propositions, for they are both equally valid in Cunningham's case. Cunningham wanted to create a world in which detachment is tributary to—*and perpetuated in*—relations. "Not-relation"—as evoked in the passage above—is not exactly detachment but rather the state of mind in which one privileged attachment cancels out all the rest ("it is *not* the person you await"). The goal, Cunningham implies, is to be able to establish a relation with anyone and anything. Therefore, apprehending the "self-expressive[ness]" of the "players" is not exactly getting attached again but rather entering a state in which "not-relation" gives way to a kind of generalized relationality—by which I mean a seemingly limitless potential for relation to occur.[3] When anyone (and anything) can become the center of interest, that interest might develop into a stronger attachment and perhaps, eventually, a constraining bond. Yet at the same time, when anyone can become a center of interest, *that* anyone is also eminently replaceable by anyone else. As Cunningham shows in the anecdote above, what "you" thought you wanted you didn't want that much after all. It is not that you don't have desires, or that bonds don't inevitably form, but rather that the interval between looking and desiring can be extended, that bonds can be loosened when attention is diffused. Cunningham works at the edge between relation and nonrelation. That is, his methods (chance and otherwise) aim to rupture the habitual relations we forge between movements (and between movements and meanings), not to reveal movement in some idealized essence (movement "in itself"), but to exhibit the ambiguity of movement, to expose the multiple directions it might take. In this unstable space of the stage, Cunningham's choreography suggests that desire is always haunted by its disappearance, a specific body is always haunted by its abstraction, and the affirmation of meaning is always threatened by its loss.

One of my primary arguments in this book is that despite what has been said and written about Cunningham, chance operations were not his only or even his primary compositional technique, and the randomization of relations was not his only or primary goal. Among the hundreds of pages of choreographic notes Cunningham left to the New York Public Library of Performing Arts, there are in fact very few mentions of "chance operations." Instead, the word *procedure* appears repeatedly near the top of the page, under which we almost invariably find a formula—"throw for . . . a) together" or "b) separately"—intended to generate encounters (or not) between two or more dancers on the stage or in the perfor-

mance space.[4] For instance, the "Procedure" page from the choreographic notes for *Summerspace* (1958; plate 1) reveals that the possibility of an encounter between dancers was integrated into the chance procedure itself. In this instance at least, the duets between dancers were inspired not by some intention on Cunningham's part to have *particular* dancers express a *particular* relation to each other, but rather by the fact that his coin tosses ended up directing two dancers to arrive at the same spot at the same time.[5] *Summerspace* is composed of a set of chance-derived trajectories, a series of paths that the dancers follow to cross the stage as if they were individuals passing each other in the street on their way to a predetermined destination. It is entirely by accident, then, that two or more trajectories cross, that a spatial encounter takes place. Yet this spatial encounter, a kind of *objet trouvé*, offers the choreographer the opportunity to compose a duet; and that duet, once performed by dancers, suggests an encounter of more than a spatial kind.

Far from avoiding such moments of encounter and contact, Cunningham devised all sorts of ways of inciting them. Moreover, his objective was not always to suppress the theatrical or expressive tension generated by the encounter; at various times in his career, he placed theatricality and expressivity at the heart of his choreographic project. Cunningham was known to have built dances on the relations between individuals he observed, relations that preexisted the choreographic process. For *Neighbors*, a dance choreographed in 1991, he focused on tensions among his lead dancers, playing them out across a series of duets.[6] Thirty years earlier, in a dance called *Crises* (the subject of chapter 5), he had already mobilized the tension he observed among company members as a thematic and motivating element. The testimony of his dancers—as well as careful study of the dances themselves—provides persuasive evidence that throughout his career, Cunningham explored the vicissitudes of human relationships for dramatic ends. Yet with very few exceptions, his critics have followed point by point what he repeatedly stated in his recorded declarations: that he was not interested in relationships, not interested in expression, not interested in drama, not interested in plot.[7]

Since his death in 2009, however, a plethora of materials have become more readily available to the public. His archive—containing the Choreographic Records (notes taken during the creation, filming, or reconstruction of a dance), videos of performances and rehearsals, reviews, and photographs—has been transferred to the Jerome Robbins Collection, where it can be consulted with permission from the Merce Cunningham Trust. In addition, dance companies licensed to reconstruct individual works may have access to the Dance Capsules, digitized packages containing information on select dances, through the Trust's website. As a result, dances that have been out of the active repertory for years are now being performed all over the world, thus providing audiences with a broader view of his choreographic range. Films of performances believed lost are

being unearthed.[8] And finally, the passage of time itself has afforded scholars a healthy degree of critical distance. My book is the first to integrate into a fuller account of Cunningham's choreographic practice the wealth of these new resources as well as information gained from interviews conducted with former Merce Cunningham Dance Company members and attendance at rehearsals of two recent dance reconstructions (*Crises* [1960] and *Winterbranch* [1964]). I scrutinize in particular the process Cunningham developed to make his dances, the "procedures" he invented to treat movement material that was rarely as neutral as he purported it to be.

The procedures Cunningham devised did indeed produce unexpected sequences (what he called "continuities"),[9] but these were often placed in the service of creating not simply "unconnectedness" but also, and somewhat paradoxically, "togetherness."[10] As he suggests in the Lecture-Demonstration of 1957, anything and anyone can meet—and "this," he exclaims, "is theatre!" His version of theatre is one that establishes relationality as a kind of "milieu," to evoke Giorgio Agamben's term. For Agamben, the "milieu" proper to the human condition is "communicability." "The communicative essence of human beings," he writes, is based on "the fact of being together."[11] A human being is characterized by a susceptibility to being-in-relation, entering-into-connection. Keeping in mind that a stage is specifically a framed space in which persons relate, it could be said that any choreographer inevitably creates a milieu in which moving bodies experience and perform "the fact of being together." Cunningham is no exception. In fact, if we look closely at both his procedures and the dances that result from them, it becomes clear that discovering new configurations, new spatial—and by extension affective—relations, is part of his project. That is, he aims not only to rid himself of his tastes, habits, and desires—the already fixed and codified relations between gestures and meanings, people and people, and people and things—to arrive at that "which is not the product of *my* will";[12] he also works to *multiply* opportunities for contact, encounter, and "continuity," and in that way to invest all aspects of whatever scene with an affective charge. The world in its entirety, Cunningham seems to be saying, is filled with multiples of Charles Baudelaire's "Passante," a figure who offers the possibility of a liaison to establish, a story to unravel, a duet to dance, or a work to sign.

In sum, Cunningham does not always attempt to eliminate the germs of a plot, nor does he suppress the affective and erotic overtones of the physical contacts that occur between his dancers. On the contrary, he sometimes seems to welcome these contacts, these hints of a plot—especially if they are the result of encounters governed by chance. To return to the Lecture-Demonstration of 1957, we might read the allusion to a mode of attention that accords interest to anything and anybody as Cunningham's way of evoking the philosophy of Zen Buddhism as it was received and celebrated by his partner, John Cage, during the 1950s. Yet we might also associate this mode of dispersed and nonhierarchical attention

with the ideas in vogue during the postwar period—the "all-over painting" of Jackson Pollock and Robert Rauschenberg as well as the "open field poetry" of Charles Olson. But in the anecdote cited above, the state of mind that transforms everything into a possible relation, that saturates with interest all elements of the scene, and that allows for emergence or becoming is linked instead to "theatre." During this same period, Cage was also thinking about theatre in similar terms: "Theater takes place all the time wherever one is," he wrote in "45′ for a Speaker"; "and art simply facilitates persuading one this is the case."[13] But if Cage's notion of theatre was informed by the Zen teachings of D. T. Suzuki, Cunningham indicated in another Lecture-Demonstration of the same year that his model of theatre had an explicitly *theatrical* precedent—not an epic theatre of archetypes such as that favored by Martha Graham but another theatre of a very specific kind:

> [People are] waiting on the corner for the light to change. But this is not stillness, since we are usually agitated about waiting. But occasionally we see someone who appears to be just waiting, like an acorn waiting that may some day be an oak. It is the heroic position to wait—to acquiesce to the moment you are in (because it is the most difficult thing in life it is granted this high reward).
>
> *The plays of Checkov* [sic] *are full of this*, and I suspect that's one of the things that make it difficult for Americans to present them well. There are many scenes where the characters just sit, with little or no conversation.[14]

To be sure, the discourse that Cunningham and Cage promulgated during their lifetime would discourage a spectator or critic from seeking a traditional theatrical plot—romantic, realist, or otherwise—in their works. Yet Cunningham's allusion to Chekhov in 1957 suggests that two decades after performing in *The Cherry Orchard* while a student at the Cornish School in Seattle, the choreographer was still finding in Chekhov—or more precisely, in Chekhov's approach to waiting—a theatrical model *for choreography*. Waiting on stage creates a pause in the action, an interval separating one monologue from the next, one phrase from the next. "Theatre," at least as Cunningham defines it here, consists in a series of such pauses, a choreography in which the momentum of desire is paused, or stilled. During this interval in which nothing happens, the narrative expectations of the audience are frustrated. Cunningham remarks that it is specifically this type of interval that American audiences have a hard time observing on the stage. But without it, he suggests, there is no opportunity for something to emerge, no opportunity for the observer to "acquiesce" to, or become conscious of, the possibilities (in the "acorn") not seen before.

One of the paradoxes of Cage and Cunningham's adoption of Suzuki's teachings is that instead of de-dramatizing the world's hustle and bustle, Zen Buddhism—as they put it to work practically—tends to charge with dramatic emphasis *everything* they see or hear. It would not be far-fetched to claim that all the

philosophers and artists dear to Cage and Cunningham—Suzuki, Mallarmé, and Duchamp, but also Chekhov, Thoreau, Stein, Joyce, and Rauschenberg—exert an appeal precisely because they allow for each and every thing to be a source of interest. The detachment Cunningham proposes in the street anecdote— "standing on the same street corner waiting again"—or in the passage on Chekhov—"acquiesce to the moment you are in"—is realized by the creation of a state of *generalized cathexis*, not a blanket indifference. However, let us note that the theatrical vocabulary Cunningham employs in the Lecture-Demonstration ("spectator"; "players"; "audience") presupposes the presence of some sort of framing device. The "actors," he tells us, are framed by store windows and doors, which also change ("the store fronts are different as different people stand looking into the windows"). These instances of fenestration serve to spotlight or bring into relief. That is, Cunningham's theatrical mode of vision inevitably reestablishes a hierarchy of investments, a multiplication but also a selection of centers. Art may convince the viewer that "theater takes place all the time," as Cage maintains, but that convincing takes specific forms. Cunningham's conceit in the Lecture-Demonstration of 1957 is that all the world is a stage, an endless flow of equally valid "readymades" or centers of attention. But, just as Marcel Duchamp had to "inscribe" his objects to make them readymades, so, too, Cunningham must leave his mark on the aleatory encounter by placing it in relief.[15]

As if to convince us how easily the street can turn into a mise-en-scène, Cunningham actually staged the anecdote that opens this introduction in a section of *Antic Meet*, a dance of ten sections choreographed in 1958. "Social," the sixth section, is an ensemble piece in which five dancers proceed slowly across and around the stage, encountering one another in seemingly arbitrary patterns, sometimes locking elbows but without exchanging glances. Each dancer wears a pair of dark sunglasses, indicating either the sophistication of cocktail party-goers (David Vaughan's interpretation) or the isolation of people on the street (mine).[16] (In his original outline of *Antic Meet*, contained in a letter to Rauschenberg, Cunningham explicitly calls "Social" "a street scene.")[17] However, beyond the incessant circulating, there is nothing in the dancers' movement style to suggest the quotidian act of locomotion. Legs are turned out; feet are pointed; backs are straight; *arabesques* are extended. This is recognizably *dance*, a "street *scene*," not the street itself. The monotony of walking down a street, however, is captured by the repetitive nature of the arm movements executed by all the dancers throughout the entire sequence: first one curved arm lifts and opens to the side, then the other curved arm lifts and opens to the side, as though each member of the scene were creating—framing and protecting—his or her own personal space. Of course, the stage itself serves as a frame, a rectangular volume with a frontal orientation. When two dancers meet, our eye is attracted to them, especially if they advance toward downstage or, as at the end, remain alone near the wings. At this climactic point in the dance, Cunningham even adds a sudden clasp just

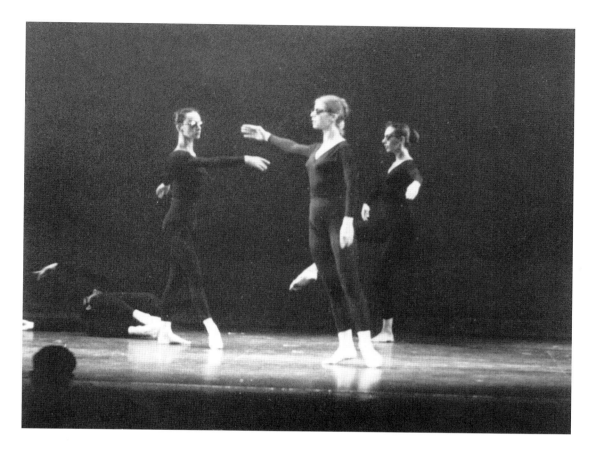

before the exit, confirming the bond between the two dancers, a woman and a man, and thus evoking the intimations of a plot. (See figure 0.1.)

Accordingly, "Social" captures less the quotidian movement of the street—the precise vocabulary of walking or stopping at a street corner—than the mode of quotidian *circulation*—the blocking of life on the street, the choreography of spatial relationships. The isolation and inwardness characterizing the dancers of "Social" seem to extend to all of Cunningham's dancers; it is as though for Cunningham, choreography were simply a variation on the act of passing by punctuated by moments of contact and interaction. Ultimately, the spatial relationships of the street (and *not* the movement vocabulary of the street) are what interest him. However, to become "art," to become "expression," these spatial relationships must be seized within the frame of a window, door, proscenium, lens, or screen. That is, the potential relations *he* sees emerging before his eyes must arise before the spectator's eyes as well. Otherwise, these relations, generative of "theatre," exist for Cunningham alone. Thus, from one angle, all action is already "theatre," and all passersby are already "actors"; but from another, actions and passersby are simply life itself. To make theatre out of life requires more than simply changing our mode of attention, adopting a stance of passive acquiescence to what is. To make theatre out of life, the choreographer must make *his*

0.1
"Social" from *Antic Meet* (1958). Remy Charlip, Carolyn Brown, Viola Farber, and Marilyn Wood. Photograph by Keith McGrary (1958). Reprinted with permission from the Merce Cunningham Trust. © Merce Cunningham Trust. All rights reserved.

theatre *our* theatre. Something must happen *after* the arbitrary to make "action" into "dance."

Capturing (or curating) the moment when "not-relation" resolves into a general and radical relationality might seem to be a counterintuitive project. Yet Cunningham was not alone in attempting to work within this relational space. As earlier scholars have argued, his project was influenced by many other artists, writers, and thinkers interested in disturbing and ramifying connections through methods of fragmentation, collage, permutation, and seriality.[18] In this book, I do not ignore these influences—from Mallarmé to Cage—but I cast them in a new light. My main objective is to reveal how each one nourished Cunningham's *theatrical* imagination.[19] Duchamp's influence was far-reaching and touched many elements of Cunningham's aesthetic; but most crucially, it was the artist's recasting of chance encounters as "rendez-vous" that encouraged Cunningham to imagine affect—and even eroticism—in the aleatory encounter, or *trouvaille*. Robert Rauschenberg, to give another example, was highly valued as a collaborator because his collage and multimedia practices indicate how the juxtaposition of seemingly arbitrary items can create not only unforeseen connections but also an internally coherent set of symbols.[20] And finally, James Joyce's aesthetic of atomization as displayed in *Finnegans Wake* was central to Cunningham's development; Joyce's disarticulation and permutation of culturally constructed "continuities"—from words into syllables, identities into words—offered a model for how *gestural* meanings could also circulate. In each case, Cunningham approached his modernist influences through the lens of a performer, someone who had spent his life onstage.

In a manuscript note of 1961, Cunningham wrote that Rauschenberg possessed three instincts "that the theater can absorb like water." These three instincts are of course also his own:

> One, the quality of the mysterious, or a *poetic ambiguity* set up as to what the object was. Two, a practicality—*the gift to change something,* by reduction or addition, or completely, depending on the immediate circumstances that the theater keeps providing. And three, a humaneness in respect to *the individual dancer* as to what he feels the dancer looks like, what makes that person and body interesting to his eye and how to treat it visually.[21]

In the chapters that follow, I return to each of these elements of the theatrical, linking them to Cunningham's gestural semiotics (a semiotics of ambiguity); his relational ontology (an ontology of the combinatorial); and his aesthetic humanism (an aesthetic attentive to how "each person" is "self-expressive"—and "extraordinarily so"). Despite his disavowal of intention, he in fact demonstrated a high degree of sensitivity to the kind of sequencing that could make a chain of movements into a dance *spectacle*, modifying the order of phrases or entire sec-

tions to maximize their dramatic potential. Cunningham was far removed from an Yvonne Rainer, for instance, who declared in her 1965 "No Manifesto" an implacable resistance to every theatrical artifice: "No to spectacle. . . . No to moving or being moved."[22] My goal is to reorient the critical discourse on Cunningham by privileging those aspects of his practice indebted to specific forms of theater as well as to the notion of theatricality itself. To think of his work as a theatre of relations, rather than a choreography of discontinuities, is to redirect the critical emphasis toward a different hermeneutics, one based on the assumption that in the process of making his dances, crucial decisions were made both before and after the throw of the die. As opposed to John Cage, who claimed to refrain from reworking the "solutions" he was given by the *Book of Changes*, or the *I Ching*, Cunningham developed many ways of selecting, framing, and highlighting what he found most interesting visually and kinetically ("what makes that person and body interesting to his eye and how to treat it visually"). Even the factors he chose to submit to chance speak volumes about his interest in spatial relationships and their tendency to solicit affect and drama.

One of the larger implications of my argument—that Cunningham's dances contain and represent relations (even if built on arbitrary encounters)—is that we can now begin to interpret his dances as meaningful, that is, as productive of meanings that are not simply "our own business" but instead anchored in the dance "text," so to speak.[23] We no longer must be afraid of imposing meanings on them because the filaments of an interpretation can be discerned in the ways in which Cunningham transforms his chance-derived sequences to produce a coherent choreography. Most of us recognize that a Cunningham dance is all-of-a-piece; it is organized by an eye in search of resonant patterns. His notes (and my attempts to decipher them) merely reveal to what a great extent the elements of each dance are indeed organized—both before and after the use of chance. Cunningham was a man of the theatre. He did not simply stand on a street corner and wait.

Yet virtually all scholars have neglected the importance of theatre to Cunningham's work—which is surprising given that his first formation, his earliest professional training, was *in* the theater. During his adolescence, he took dance classes with Maude Barrett, who taught him tap, ballroom, and folk dances of many varieties.[24] (He never lost his taste for these more popular forms.) It is odd, and perhaps a sign of the tight control discourses on the avant-garde have exerted on the study of dance, that the impact of Cunningham's early training has not yet garnered greater attention. Outside a few loose allusions in early reviews, there has been very little reflection on how the techniques and the specific routines he learned early on might have remained within his body in the form of kinesthetic memories, a resource from which to draw movement ideas. Indeed, the bulk of current research conducted on kinesthetic memory, the persistence of rhythmic patterns and stylistic mannerisms in later ways of moving,

has focused on dancers considered "ethnic" in origin.[25] Yet there is no reason to suppose that the memory of certain rhythmic patterns and steps did not also remain in Cunningham's body throughout his lifetime, inflecting his movement choices even in the later years when he selected movements to be entered into the menu (the "movement gamut") of the DanceForms software program.

Received ideas concerning Cunningham's aesthetics—his neutrality, his impersonality, his lack of theatricality—continue to play an inordinate role in his critical reception. Ever since Jill Johnston famously wrote in her review for the *Village Voice* that his "dances are all about movement," and that he embodies "the shift from representation to the concentration on materials. . . . Each movement means only itself," there has been a strong tendency to disregard the roles he played, the ethnic traditions from which he drew, and the more complex hermeneutics his dances require.[26] Clive Barnes lamented in 1970 that "Cunningham not only spurns any literary quality, but is also beginning to spurn even any dramatic quality."[27] And in 2011, Susan Leigh Foster summed up the general consensus: in Cunningham, "dance movement, now seen as entirely separate from music, present[s] physical effects that [a]re determinedly separated from connotations of the spiritual or the emotional."[28] The French response to Cunningham has also retained a stubborn emphasis on antitheatricality: in *Danse contemporaine et théâtralité*, for instance, Michèle Febvre suggests that Cunningham "deplored" the fact that "movement is expressive beyond any intention"; he sought "a new order of the body, a transparent body . . . relieved of the pathos of modern dance."[29] For Laurence Louppe, "Cunningham's dance doesn't communicate"; his project consisted in "eliminating affects," and he brought to the stage only gestures "the theatrical intensity of which *had been evacuated*."[30]

If we look more closely, however, we see that what Cunningham set aside was not theatre but rather linear narration, the plotline based on the classic dramatic arc: development, crisis, dénouement. His stripping-down of the theatrical left many resources in place: mime, gesture, music, lighting, costume, props, décor. For him, the presence of human beings on the stage guaranteed—without recourse to anything else—the framing of these human beings, and thus to some extent their spectacularization. As Martin Puchner states succinctly, "live" performance is "innately theatrical."[31] Or in Cunningham's words, "I do not understand how a human can do something that is abstract. Everything a human does is expressive in some way of that human."[32]

The choreographic inflection to Cunningham's appropriation of Zen Buddhism places him in an interesting position vis-à-vis Cage, for whom a *lack* of relation and an *absence* of expression are primary. Cunningham seems to have believed that the reprisal of "relationships and continuities" is inevitable, not something added to human nature but *nature itself*: as he wrote in 1952, "We don't, it seems to me, have to worry ourselves about providing relations and continuities, [for] they cannot be avoided. *They are the nature of things*."[33] I want to

stress this fundamental difference between Cage and Cunningham, one I will explore repeatedly in the chapters to follow. As opposed to Cunningham, Cage—at least for most of his life—did not claim that relationships are our "nature," that they "cannot be avoided." His aversion to relation as a compositional and ontological principle is based on his suspicion with respect to Western theories of harmony; he wished to "liberate" musical notes from intervallic relationships so that they could be heard afresh, in and of themselves.[34] It was in order to hear sounds outside their relations to other sounds that he turned toward the larger and less ordered world of noise. In an interview with the composer Daniel Charles, Cage presents relations as something we invent, then, forgetting we invented them, take for granted as inevitable. "The relationship," he insists, "*comes afterward.*"[35]

Arguably, the belatedness of relation is what Cunningham, too, aims to show: the coin or die is thrown, the "continuity" is forged, and the relation emerges afterward. Yet at the same time Cunningham maintains, as we have seen, that "relations and continuities . . . cannot be avoided. They are the nature of things." Clearly, he works to suspend the conventional, seemingly inevitable connections, the "chains that too often follow dancers' feet around."[36] However, his goal is not to deny relationality but to extend it; he does so by interrupting the momentum of our habitual trajectory so that other, less prescribed encounters might occur.[37] "Some people seem to think that it is inhuman and mechanistic to toss pennies in creating a dance," Cunningham wrote in 1952. "But the feeling I have when I compose in this way is that I am in touch with a natural resource far greater than my own personal inventiveness could ever be, much more universally human than the particular habits of my own practice, and organically rising out of common pools of motor impulses."[38]

Finally, Cunningham's insistence on "common pools of motor impulses" leads us to the second crucial difference between him and Cage. Cage developed his Zen Buddhist aesthetic in the context of musical composition, or, more broadly, in the context of the *aural* universe. But Cunningham was not working with sounds. His medium was the human body. Therefore, his palette was drawn from a set of physical movements capable of being performed by a trained dancer whose muscular and skeletal limitations are those of an acculturated human body (and "universal" only in that way). On the one hand, the human body is like any other artistic medium: it can be articulated into discrete units, and these units can be formed into new and unexpected combinations. On the other, the human body is utterly different from any other medium employed in the arts. A human body is one with a human person who feels, who is affected, who emotes.[39] As opposed to sounds, the movements of a human person cannot be sequenced in any order whatsoever, nor can they be entirely divorced from the socially constructed projects in which they gain meaning. Moreover, in contrast to sounds, the movements of the human body are controlled by reflexes and implicated in

a host of acquired gestural routines. They drag along with them complex histories—cultural, technical, and personal—that Cunningham sought not only to short-circuit but also to exploit. The expressiveness of the human body, its ability to convey meaning, was never something he wanted to suppress or avoid; on the contrary, it was something he hoped to *surprise*. His major and long-lasting concerns were the following, as he listed them for his students in a "Workshop in Flexibility" of 1974: (1) to discover by chance means the "multiple possibilities in movement as to what follows what," and (2) to learn how these possibilities, arrived at by accident, might generate drama among human beings on the stage. Or as he put it: "How does this"—a new possibility of sequencing—"relate to 'relationships' or seem inherent in a 'plot'?"[40] Here, Cunningham explicitly asks his students to make the leap from movement to meaning. In the pages that follow, I argue that he asked his public—albeit somewhat less explicitly—to make that leap as well.[41] He consistently associated his experiments in random sequencing (the creation of new continuities) with the production of alternative relations—among art forms, among human beings in real life, and among dancers on stage. To his mind, these relations could emerge only after the arbitrary, that is, after the coin was tossed or the die was thrown. But once these relations emerged, and once they were performed, he was confident that they would be "self-expressive"—and "extraordinarily so."

My first chapter focuses on the paradoxical relation between the arbitrary and the motivated, the unexpected and its repetition, as it plays out in Cunningham's *Walkaround Time* of 1968. Like Marcel Duchamp, Cunningham knew that contingency is solicited rather than suppressed by repetition, because repetition always has a performative dimension. When Duchamp sought to counteract his own congealed habits (his training and "taste"[42]) by employing chance procedures, then congealing their aleatory results in "works" that he not only preserved but also multiplied, he inaugurated what is arguably the most productive line of questioning to animate the twentieth-century avant-garde, including the generation to which Cage and Cunningham belonged.

I end chapter 1 by asking how a script could be said to generate the unanticipated, and, conversely, how something accidental (the rendez-vous) could produce more script (the signature, or "inscription," that the artist adds to what is now his "work"). In chapter 2, I trace Cunningham's creative investment in inscriptive practices of many kinds, from listing, writing, and drawing (the use of symbolic systems in the composition of *Summerspace* of 1958) to DanceForms, the software program with which he created *Biped* in 1999. If for Cage composition is one thing, performance is another, and listening yet another,[43] in Cunningham's work, composition and performance "iner(in)animate," to use Fred Moten's generative term.[44] The moving body suggests systems of notation, which then become inscriptions of more movement, which then must be captured by a

more advanced notational technology, which is then productive of more move-
ment, and so on and so forth in a recursive process of technological and embod-
ied experiment.

Chapter 3 (along with chapter 7) centers on theatricality in Cunningham's
corpus. Whereas in the first two chapters I am concerned with the ways in which
Cunningham seeks to circumvent literary and dramatic associations, in this chap-
ter I focus on the dramatic genres he adapts for his own use. My claim is that even
in his least explicitly narrative or dramatic dances, representational and/or
expressive modes are intermittently present in small but potent doses. The two
dances I study here are *Sixteen Dances for Soloist and Company of Three* (1951) and
Antic Meet (1958). But my observations are pertinent to many other less obviously
theatrical dances in Cunningham's repertory.

In chapter 4, I turn to the means Cunningham used to interrupt the flow of
narrative, to suspend the dramatic moment. Through an analysis of "Extended
Moment," a duet in *Suite for Five* (1953–58), I show how he used photographs—to
be precise, studio stills—to arrest and intensify the charged relation between him
and his partner, Carolyn Brown. By producing another version of Chekhov's
"waiting," the choreographer installs a pause in the action, underscoring the
montage-like quality of his dance, while simultaneously drawing out the theat-
ricality of the photograph, its latent kinetic qualities. In the case of "Extended
Moment," affect and interruption, movement and stillness, are not diametrically
opposed; instead, as in photography and dance, they nourish and amplify each
other's effects.

Chapter 5 focuses more narrowly on relationships among members of the
Merce Cunningham Dance Company as they were played out on the stage. Based
on my attendance of rehearsals for the 2014 reconstruction of *Crises* (premiered
in 1960), the chapter analyzes Cunningham's use of the elastic band as a prop to
bind two dancers together at various chance-determined points in the dance.
Such binding produces dramatic effects: the dance styles of Cunningham's two
female leads, Viola Farber and Carolyn Brown, end up affecting the movement
style of their male partner, Cunningham, through a kind of contagion. *Crises*
could be said to allegorize choreography as a practice in which dancing bodies
(including the choreographer's) become saturated and transformed by move-
ment qualities attributed to someone else. Paradoxically, *Crises* stages relation—
even intensifies it—through the application of chance procedures. Insofar as it
contains suggestively erotic moments, it is at the furthest remove from the aes-
thetics of indifference usually associated with Cunningham's work. I conclude
the chapter by suggesting that because the dance relies so heavily for its impact
on the presence of—and relationships between—particular dancers, it presents
those reconstructing the dance with a peculiar challenge. Reconstruction can be
considered another type of relationship, one that Cunningham's dances seem to
both invite and repel.

In chapter 6, I seek to complicate the critical consensus that Cunningham produced only neutral movement, movement stripped of all (personal, cultural, and historical) connotations. I also argue against the idea that he was entirely indifferent to the provenance and associations of the "steps" he selected for his movement gamut. Cunningham worked through the problem of cultural, even ethnic difference—his own and that of his steps—by exploring difference as it is manifested in rhythmic forms. I look at occasions when a specific rhythm was part of the *thematic* material of the work, an element that evokes particular associations he wanted to highlight. In that regard, I examine two works that self-consciously index popular dances resonant with troubled histories—racial and ethnic—that should not be ignored. I conclude the chapter by turning to Bill T. Jones's *Story/Time*, a work of 2012 that, by employing Cagean chance methods as tropes, draws out the less-than-neutral valences of Cunningham's experimental practice.

Chapter 7 returns to the question of relationality in the context of Cunningham's relationship to Cage. If previous chapters focus on how Cunningham either interrupted relations or theatricalized them, in this chapter I look at how he lived and taught them. Beginning with an analysis of Cage's *Water Walk* (1959) and the Zen Buddhist principles that inspired it, I then offer a fresh account of the difference between Cage's and Cunningham's appropriations of Zen Buddhism through a close reading of Cunningham's unpublished lectures and workshop notes. If for Cage the Hwa Yen principles of non-obstruction and interpenetration provided a blueprint for how human beings could relate (by not relating), for Cunningham these same principles suggested new possibilities for generating multiple relations (and dramas) on stage. In his choreography workshops of the 1970s, he taught his students how to create encounters via the chance sequencing of movements, then asked them to explore how such encounters "affected" and "altered" the movements involved.[45] This meditation on the encounter as a form of interpenetration leads me to examine the Dialogue, a genre that Cunningham and Cage performed together repeatedly throughout their careers. Although the Dialogue has been neglected by Cunningham's scholars, it offers an important example of how the two artists managed to theatricalize their intimate relation. Here, in the mode of staged performance (rather than joint recital), Cage and Cunningham interact by not interacting, finding a harmony governed only by the gestures they are, in Cage's words, "willing" to make.[46] Against the accusation that Cunningham never choreographed a same-sex duet or, more precisely, a duet for men, I claim on the contrary that the Dialogue *is* that duet. It is a *queer duet*, one that implicitly struggles with the constraints of relation as an inescapably human form.

Recycling the Readymade
Marcel Duchamp and the Rendez-Vous
in *Walkaround Time*

Preservation has always been central to Merce Cunningham's work. Figuring out how to capture and repeat the steps and phrases he executed in the studio was a preoccupation that generated innovations—not in dance notation, since he never learned or developed a notational system, but rather in compositional technique. Arguably, Cunningham was as interested in processes of recycling as he was in processes of invention.[1] He developed a modular approach, which made short-hand notation less cumbersome and allowed for permutation, self-citation, and preservation of the already done. While other variables of the dance production, such as music, lighting, costumes, and décor, might have been out of his hands, in most cases the dancing on stage was fully anticipated, planned down to the last shift of the gaze.

In the face of repeated queries from interviewers and audience members concerning the role of unplanned actions in his dances, Cunningham would respond unequivocally that improvisation was not part of his chance aesthetic. With very few exceptions, dancers were forbidden to improvise. Although at times encouraged to develop their own independent interpretation of the phrasing, they followed a carefully scripted sequence of movements and poses from which they were expected never to deviate. Yet from the beginning, the public confused "chance operations" with "improvisation," perhaps because both were seen to undermine the authorial function. The term *indeterminacy*, which John Cage began using in the mid-1950s, increased the confusion of spectators, who assumed that an "indeterminate" work was one in which performers were at liberty to do whatever they chose. But *indeterminacy* as Cage defined it was never equivalent to *improvisation* as he defined it.[2] A work that is "indeterminate with respect to its performance" gave performers a range of possible actions to execute, but it did not allow unfettered invention.[3]

It is true that during the 1960s Cunningham experimented with indeterminacy in works such as *Field Dances* (1963), where he gave each dancer a collection of actions to be performed whenever the dancer was inspired to do so. Intrigued by Judson Dance Theater choreographers, he tested out the effects of incorporating pedestrian movement and performing actual tasks on stage (such as watering a plant in *Variations V* of 1965).[4] But these innovations were quickly abandoned, for it was crucial to Cunningham's process that a movement, phrase, or entire dance, once set on dancers, be preserved in such a way that it could be repeated. The repeatability of the random was, in fact, a top priority; it might even be said that repeatability, as a quality of the dance itself, was almost as significant as the originality of the sequence achieved by chance means. That is, as opposed to an aesthetics of improvisation, which values procedures that might engender the unrepeatable, Cunningham's chance aesthetic privileges procedures designed to yield that which can be memorized and retained (even if with difficulty). A phrase that a Cunningham dancer improvised during the performance would most likely not enter the repertory; more important still, it would not have that quality of necessity Cunningham's movements receive as a result of having been repeatedly rehearsed until mastered. It is not incidental to Cunningham's aesthetic that spectators have frequently remarked on the "necessary"—rather than spontaneous—quality of the movement sequences, which I associate here with his handling of the arbitrary as an object to be preserved.[5] The repetition of a phrase during the rehearsal period creates in performance an aura of necessity because the dancer knows precisely what she needs to do. But of course the performance situation, as a form of repetition, submits the learned phrase to contingency yet again.

This chapter takes as its primary focus the paradoxical relation between the arbitrary and the necessary, the unexpected and its repetition, as it plays out in Cunningham's *Walkaround Time* of 1968. (See figure 1.1.) Like Marcel Duchamp, he knew that contingency is solicited rather than suppressed by repetition because repetition always has a performative dimension. When Duchamp sought to counteract his own congealed habits (his training and "taste"[6]) by employing elements of chance, then congealing the aleatory results in "works" that he not only preserved but also multiplied—and thus altered—he inaugurated what is arguably the most productive line of questioning to animate the twentieth-century avant-garde, including the entire generation to which Cage and Cunningham belonged. As a performing artist, Cunningham was able to realize one of Duchamp's cherished goals: to destabilize the category of the *work* through the category of the *Event*.[7] Yet while some attention has been paid to the impact of Duchamp on Cunningham's (and Cage's) aleatory methods, few scholars have explored how Duchamp's interest in the allied strategies of replication and recycling inform the performance genres that Cunningham developed.[8]

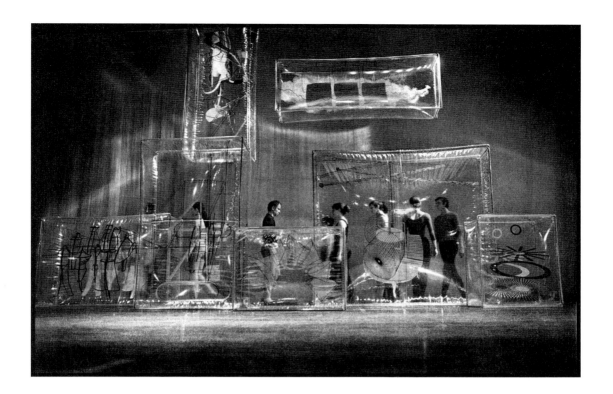

"Canning Chance"

According to his own testimony, Cunningham began using coin tossing as a compositional method in 1950–51 in order to short-circuit his own movement habits, which he believed would limit his power to invent. The procedure he used—often based on one that Cage had recently developed—involved generating dance sequences from a predetermined "gamut" of movements. He then preserved—recorded on paper—the results as a choreography so that they could be repeated over and over. The penultimate step (even after he became infirm in the 1980s) was to teach the sequence to the dancers, working with several or one at a time, depending on the effect he hoped to achieve.[9]

But the preserved phrase did not remain entirely unmodified, either during the step-by-step process of notation and acquisition or once the dancers had brought it to the stage. After generating, notating, and physically assimilating (through a brutal process of repetition) the chance-derived sequence—that is, after "canning chance," to evoke Duchamp's concise phrase—Cunningham added variables to the actual performance situation that would challenge the dancers' ability to repeat with precision what they had learned—variables, in other words, meant to revive through repetition what was in the "can."[10] The noncollaborative collaborative process that Cunningham, Cage, and Robert Rauschenberg perfected in the 1960s expanded the scope of this performance

1.1
Merce Cunningham,
Walkaround Time
(1968). Photograph
by James Klosty
(1968). Reprinted
with permission
from James Klosty.

practice, weaving together chance and archival preservation, the emergence of the new and the repetition of the habitual, the creation of the singular and the manufacture of the multiple. In repeatedly performing works that could not be replaced, Cunningham juxtaposed a set of "paradoxical principles," revealing the insufficiency of a logic that opposes the work and the performance, anticipation and delay.[11]

Duchamp first employed a method for conserving the products of a chance operation (or "canning chance") in 1913 when he "composed" the score for his *Erratum musical* by drawing musical notes from a bag. For the second version of the piece, titled proleptically *La mariée mise à nu par ses célibataires, même: Erratum musical*, he conceived of holding a funnel containing numbered balls—each number corresponding to a musical note—and letting the balls fall through the funnel into the open wagonettes of a toy train that ran at variable speeds.[12] In both cases he transferred the sequence produced by chance onto a musical staff, thereby recording the results. He followed roughly the same procedure in *Élévage de poussière* of 1920, only with a photographic instead of a paper support. A shot by Man Ray captured for posterity the chance arrangement of dust particles as they had accumulated on the reverse side of Duchamp's unfinished *La mariée mise à nu par ses célibataires, même* of 1915–23 (otherwise known as *Le grand verre*, or *The Large Glass*). (See figures 1.2 and 1.3.) The practice of using photography to

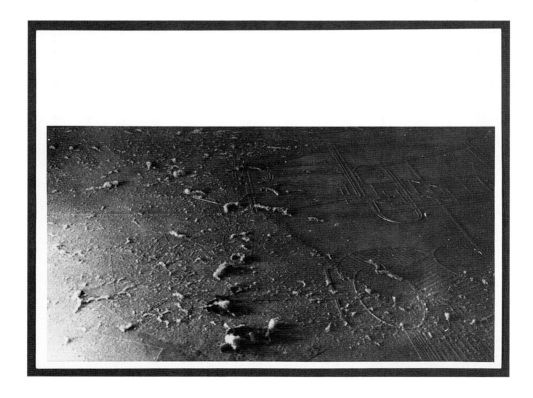

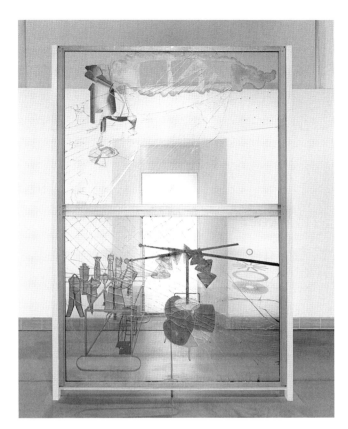

freeze or "can" a phenomenon that exists and evolves in time would become important to Cunningham as well.

The evocative expression *le hasard en conserve*, "canned chance," emerged from Duchamp's pen in 1914 to describe a work he had been laboring on since 1913 titled *3 Stoppages étalon (3 Standard Stoppages)*.[13] According to his account, to make *3 Standard Stoppages* Duchamp dropped three lengths of string, each approximately a meter long, from the height of one meter from the floor. Using varnish, he then glued the dropped strings onto pieces of canvas and cut wooden shapes based on their curves, thereby preserving their aleatory plastic form for posterity. (See figure 1.4.) In *The Green Box* (1934)—a set of notes with which Cage and Cunningham were familiar—Duchamp underscored that his objective had been to allow each string to fall "as it pleases."[14] Thus, *3 Standard Stoppages* perfected a procedure Duchamp would use many times—in *Unhappy Readymade* (1919),[15] *Élévage de poussière*, and elsewhere—which consisted in preserving a "condition prevailing at a given moment" as a sculptural memento.[16] Just as *3 Standard Stoppages* froze the results of gravity first on canvas, then on wooden slats placed in a coffin-like box, so, too, works like *Élévage de poussière* turn accident into monument in a way that anticipates Cage's and Cunningham's chance-

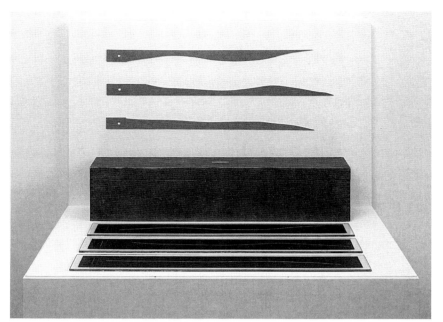

1.4
Marcel Duchamp,
3 Stoppages étalon
(*Three Standard
Stoppages*) (1913;
replica 1964).
Mixed media, 400 ×
1300 × 900 mm.
Art © Succession
Marcel Duchamp/
ADAGP, Paris/Art-
ists Rights Society
(ARS), New York
2019. Photo © Tate,
London/Art
Resource, NY.

generated works. The procedures they developed during the 1950s—using *I Ching* hexagrams or imperfections on a sheet of paper to determine sequences (or continuities)—hark back to Duchamp's early Dadaist gestures. In particular, the Duchampian archival logic of producing the aleatory, then freezing it or placing it inside a box (*boîte*) governs what we might call the archival logic of Cunningham's choreographic practice.

Cage first met Duchamp in 1942 at the home of Peggy Guggenheim, but the entire Cage milieu—Cunningham as well as Rauschenberg and Jasper Johns—developed a closer acquaintance with him during the 1960s. Critics have long recognized that Duchamp's influence on the postwar American neo-avant-garde was profound and long lasting. However, whereas Cage tended to emphasize Duchamp's probing of authorial control through the invention of non-intentional methods, Johns became intrigued with Duchampian seriality. And while the generation of artists around Daniel Buren and Michael Asher focused on Duchamp's institutional critique, Cunningham, as might be expected, took up Duchamp's challenge to explore the relationship between movement and stasis, advancing and congealing, which the artist had investigated earlier in works such as *Nude Descending a Staircase, No. 2* (fig. 1.5). Cunningham's homage to Duchamp, *Walk-around Time* of 1968, confirms that he was well aware of the legacy he was inheriting. From start to finish, this dance is a meditation on movement and immobility; it is also a rehearsal of Duchampian motifs: the nude, the machine (the simple motor), the transparency, and the "readymade." Finally, Cunningham explored Duchamp's procedures of reprisal and permutation, which rely on a modular approach to artistic production.

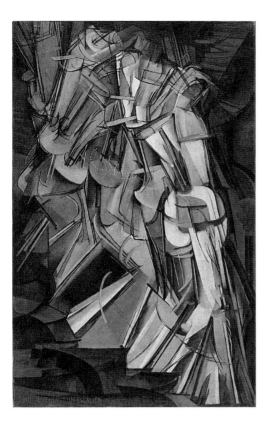

1.5
Marcel Duchamp, *Nude Descending a Staircase, No. 2* (1912). Oil on canvas, 57⅞ × 35⅛ inches (147 × 89.2 cm). Framed: 59¾ × 36¾ × 2 inches (151.8 × 93.3 × 5.1 cm). Philadelphia Museum of Art, The Louise and Walter Arensberg Collection, 1950-134-59. © Succession Marcel Duchamp/ADAGP, Paris/Artists Rights Society (ARS), New York 2019.

The term *walkaround time* comes from early computer language and refers to the interval, a technologically determined period of time in which the user waits for the computer to complete its task. During this period, the user is free to leave the area and thus to "walk around." The interval is like an aleatory measure of duration, a "time bracket," in Cage's terms, into which anything might be placed, at any pace. And pace is clearly the theme of *Walkaround Time*, as well as its fundamental material. The dance explores how quickly someone can move, how slowly someone can move, and how the same movement can look quite different when performed at various speeds. Critics have focused largely on the iconography of *Walkaround Time*, which makes sense given that *The Large Glass* and *Nude Descending a Staircase, No. 2* provide much of the visual material for its choreography.[17] For instance, when Cunningham performs a fast run while stripping off his clothes, he is recalling the full title of *The Large Glass* (*The Bride Stripped Bare by Her Bachelors, Even*).[18] Further, the trios, in which dancers turn around one another like gears or balls in a socket, evoke the many small machines populating Duchamp's paintings and installations. Finally, the exquisite adagio solos by Carolyn Brown and Sandra Neels, comprising slow-motion steps forward in space (albeit with toes pointed and legs extended), remind the viewer of the most canonical of Duchamp's works: *Nude Descending a Staircase, No. 2*. Yet there is a further source that neither critics nor scholars have observed, one that also

determines entire movement phrases of the dance: René Clair and Francis Pica-
bia's *Entr'acte*, a film made in 1924 in which Duchamp appears in a cameo role.
It is important to look more closely at *Entr'acte* for several reasons. First of all,
Cunningham appears to have drawn heavily from Clair's visual meditation on
human locomotion and seriality, recycling the film's imagery as though it were a
kind of readymade while simultaneously exploring how an image can become
significant in a new context. Further, Cunningham's appropriation of movement
images from *Entr'acte* reflects his abiding interest in the photographic still, or
freeze-frame, which I study more closely in chapter 4.

The origin story of *Walkaround Time* has achieved almost mythic status, per-
haps because it illustrates the spontaneous and informal quality of the collabora-
tions that Cunningham engaged in throughout the 1960s. In an interview with
David Vaughan, he described the genesis of *Walkaround Time* as a kind of spon-
taneous, fortuitous idea.[19] Apparently, Cunningham, Cage, and Johns were eating
dinner at the New York apartment of Duchamp and his wife, Alexis (Teeny), when
Johns suggested that the choreographer "do something" with *The Large Glass*.[20]
When Cunningham responded enthusiastically, Duchamp replied that he would
give his permission; however, he did not want to have to replicate the images
himself. Johns, therefore, took on the task of transferring seven discrete sections
of *The Large Glass* onto transparent plastic cubes of varying dimensions that could
be moved about the stage during the dance. The set for *Walkaround Time* con-
sisted of seven such cubes, with each one featuring a motif from Duchamp's
mechanical allegory of mating, what the artist referred to in his notes as "a sort
of apotheosis of virginity."[21] Johns employed a combination of silk-screening and
photographic techniques to re-create each discrete image on an individual cube
such that they could be manipulated and rearranged during the course of the
performance. The cubes' mobility added an element of movement to Duchamp's
static work that had not been present before. It also allowed the audience to expe-
rience the transparency of the cubes more dramatically, since the dancers fre-
quently dance behind them. Duchamp set only one condition on the use of his
imagery as a theatrical décor: at some point in the dance—and Cunningham
chose the end—the seven cubes had to be brought together to form the arrange-
ments of forms as they appear in *The Large Glass*.

It is important to note that Jasper Johns's idea to use the iconography of *The
Large Glass*—and to divide it into seven sections—initially came from viewing
those parts separately, as modules. As he recalls in a 2013 interview, "I think the
trigger for the Duchamp set was seeing a small booklet showing each of the ele-
ments of 'The Large Glass' in very clear line drawings. It occurred to me that
these could be enlarged and incorporated into some sort of décor."[22] From the
start, then, Johns was thinking in terms of modular units that could be put
together and disassembled. Even before speaking to Duchamp, he was already
attuned to the modular aesthetic that characterizes Duchamp's approach to fig-

uration in general, his practice of recycling elements such that they accrue symbolic weight—like items in a set—while remaining curiously independent of context and thus semiotically opaque.[23] It is this modular approach that defines the composition of *Walkaround Time* as well, an approach resonating with principles of choreographic construction that Cunningham had been developing over the course of the decade. It could be said that neither Duchamp nor Cunningham ever left a former work entirely behind; instead, they kept recycling past motifs (or, in Cunningham's case, dance phrases), thereby creating something resembling a single, lifelong artwork in which the same motifs continue to reappear in different contexts. Similar in this respect to Duchamp, Cunningham tended to approach a dance as a set of modules that could be separated and recombined—both within the same piece and across different works. His famous Event format, for instance—one in which excerpts of different dances are recycled, juxtaposed, or resequenced in new arrangements—is only the most obvious of the many ways in which he attacked the nineteenth-century notion of a dance as a narrative whole. A modular dance can be disassembled and reassembled in new ways, regardless of plot or dramatic arc.

Following a period of research and reflection, Cunningham developed a multilayered, forty-eight-minute-long piece, which premiered at the University of Buffalo on March 20, 1968; it was danced by Merce Cunningham, Carolyn Brown, Barbara Lloyd, Sandra Neels, Valda Setterfield, Albert Reid, Meg Harper, Gus Solomons Jr., and Jeff Slayton. The music, composed by David Behrman (in residence at Buffalo at the time), was titled ". . . for nearly an hour . . . ," after a piece Duchamp made on glass in 1918, *To Be Looked At (From the Other Side of the Glass) with One Eye, Close to, for Almost an Hour. Walkaround Time* would end up playing the role of summation and homage, for Duchamp died on October 2, less than seven months after its premiere. Thus, the work also became a kind of archive in retrospect—a compendium or *boîte* of famous Duchampian iconographies and conceptual gestures.

Paradoxically, given that *Walkaround Time* is an homage to Duchamp, compositionally it is one of Cunningham's least chance-generated works.[24] Instead of relying on chance procedures to produce and order the dance modules, Cunningham worked to make the partnerings or groupings of the dancers reflect mimetically the various machines and personages inhabiting Duchamp's *Large Glass*. He re-created such two-dimensional iconographic elements as the "Chocolate Grinder" and the "Glider" in three-dimensional space and durational (performance) time. In his notes for *Walkaround Time*, Cunningham refers to particular groupings by means of Duchampian titles, listing the order of dance events as (1) "Bride"; (2) "Choc. G." (or "Chocolate Grinder"); (3) "O's W." (for "optical witnesses"); (4) "Sieves"; (5) "Malic Molds"; (6) "Glider"; and (7) "Inscription." In this representational mode, the "togetherness" of individual dancers is based not on a chance-determined meeting of separate trajectories (as in *Summerspace*,

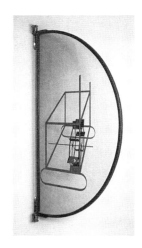

which I turn to in chapter 2) but rather on predetermined images drawn from Duchamp's works. The actions of dancers, often clustered into rotating arrangements, are dynamic mirror images of *The Large Glass*'s subject matter reproduced on the plastic cubes. Cunningham thus realizes one of Duchamp's major aspirations: to bring three-dimensionality—or four-dimensionality, if we count durational time—to two-dimensional mechanical drawings.[25] (See figures 1.6, 1.7, 1.8, and 1.9.)

1.6 (left)
Screenshot from Merce Cunningham, *Walk-around Time*; directed by Charles Atlas (1973). "Glider": Sandra Neels rolls across Douglas Dunn, who makes a plank over Susana Hayman-Chaffey, lying flat on the floor.

1.7 (right)
Marcel Duchamp, *Glider Containing a Water Mill in Neighboring Metals* (1913-15). Oil and lead wire on glass, 59⅜ × 32¹⁵⁄₁₆ inches (150.8 × 83.7 cm). Philadelphia Museum of Art, The Louise and Walter Arensberg Collection, 1950-134-68. © Succession Marcel Duchamp/ADAGP, Paris/Artists Rights Society (ARS), New York 2019.

I will base the following analysis on Charles Atlas's 1973 film of *Walkaround Time* and my own attendance at the April 2017 reconstruction of the dance at the Palais Garnier in Paris. Both the live and the filmed performance confirm that the dance phrases possessing Duchampian titles recur throughout the work. In fact, almost everything in the dance repeats at least twice, either in fragmentary form or in its totality. For instance, the Bride's solo, danced by Carolyn Brown in the original production, appears three-quarters of the way through act 1, then again soon after the intermission (which occurs twenty-three minutes into the forty-nine-minute dance).[26] Watching the performance, I experienced the solo differently the second time because of its new place in the sequence. In the first apparition in the film, Brown dances against a background of other moving dancers; in the second apparition she is regally alone for most of the augmented solo, lit by a beam that highlights her against the darkness. In general, each time a danced module is repeated, it takes on more of the quality of a fragment. Like bits of glass in a kaleidoscope, falling into and out of place, the phrases, performed by dancers in their jewel-colored costumes, illustrate the action of the inframince, Duchamp's invented word for the slight difference a repetition makes. Sometimes, the dancers are even hoisted up and moved from place to place, like pieces of human furni-

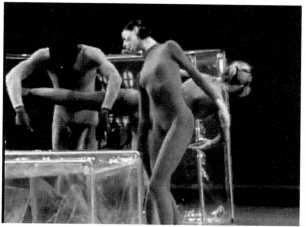

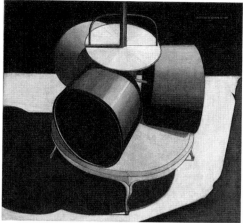

ture—or plastic cubes—to be rearranged on the stage. Their object-ness is underscored even as their physicality remains.

Cunningham thus stages for us that unsettling oscillation between the body as agent of movement and the body as thing, an oscillation that characterizes Duchamp's approach in *The Large Glass* as well. In that inexhaustible work, one which has challenged art historians for decades (and certainly cannot be fully explicated here), Duchamp maintains a tension between the "indifferent," or the asemantic object (an object to which symbolic meanings are not conventionally attached), and the symbolic role of that object once inserted into an erotic narrative. A secondary effect of this tension is the oscillation that consistently recurs during a viewing of either *The Large Glass* or *Walkaround Time* between the perception of the modules as interconnected (the Bride, the Bachelors, etc.) and the perception of the modules as discrete.[27] It is this oscillation between the semiotic power and the obdurate materiality of things, between relation and nonrelation, that the works seek to maintain.

"Specifications"

In addition to borrowing from Duchamp's stock of privileged figures (Glider, Bride, Chocolate Grinder, and so on), Cunningham also adapted for his own use one of the artist's compositional innovations: the readymade. During an interview with David Vaughan concerning the making of *Walkaround Time*, he states that the opening phrases were in fact drawn directly from his classroom exercises, thus making them, in his sense, "ready-mades," combinations of steps "tout faits."[28] Much has been made of these readymades, and Vaughan, for instance, believes them to be the choreographer's most obvious wink in Duchamp's direc-

tion, and thus the most Duchampian aspect of the work. But I would argue that Cunningham's understanding of the readymade ignores the temporal dimension of its coming-into-being, at least as that dimension is underscored in Duchamp's own definition: a "rendez-vous" occurring at "such and such an hour" (see below). To say that the dance phrases in *Walkaround Time* are readymades is to treat the readymade as any other sort of appropriated material rather than an entity of a very precise character. It is clear from Cunningham's statements that he consciously selected elements of the Duchampian pictorial imaginary and deliberately inserted them into his choreography, just as Duchamp had intentionally selected elements from his own repertory of what would become, through a process of repetition and permutation, semiotically rich iconographic motifs. However, the definition of the readymade that Duchamp advanced in 1915 goes against the notion of intentional choice. Cunningham may have made some of the dance phrases for his technique classes, and in that sense they were certainly "tout fait"; but the "tout fait" is not quite the same thing as its later incarnation, the readymade, for which Duchamp gave the following "Specifications":

> **Specifications [*Précisions*] for "Readymades."**
> by planning for a moment to come (on such a day, such a date such a minute), "to inscribe the readymade"—The readymade can later be looked for.—(with all kinds of delays)
>
> The important thing then is just this matter of timing, this snapshot effect [*instantané*], like a speech delivered on no matter what occasion [*à l'occasion de n'importe quoi*] but at such and such an hour. It is a kind of rendezvous.
>
> —Naturally inscribe that date, hour, minute, on the readymade as information. also the serial character of the readymade.[29]

Elsewhere, Duchamp indicated that there was a degree of discrimination exercised in the production of readymades insofar as the objects "found" by the artist had to elicit "a reaction of visual indifference."[30] Other than that, a negative criterion, the type of object that would become classified as a readymade was determined only by the constraint imposed—like a musical note "chosen" by an *I Ching* hexagram or a dance phrase "chosen" by the face of a die. What Duchamp emphasizes in his definition is the notion of a "snapshot effect," a sudden capture of an object as though encountered for the first time. Making a readymade, in other words, requires that the author see like a camera, possess the indifference of the camera's eye. Crucial in his list of "Specifications" (*Précisions*) is the notion of *horlogisme*, or "timing": the author chooses a particular day, date, and minute, and it is in making these "Précisions" that the author's choice is exercised. The "Précisions" provide a mechanical constraint, one that has nothing to do with the object itself. It is this constraint that, like a camera lens, focuses the eye on

something not elected by taste. The *horlogisme* serves to isolate the object within a frame, creating a "snapshot effect," a sense of something in movement suddenly frozen, lifted out of one temporality—that of becoming in time—and inserted into another—the temporality of an implacable *horlogisme*, indifferent to the body's desires.

Keeping this aspect of Duchamp's definition in mind, I propose to analyze a different kind of iconographic detail, one that Cunningham located not in the *Nude* or *The Large Glass* but rather in *Entr'acte*, the film in which Duchamp played a cameo role. Cunningham knew of the film's existence. When describing the relation of *Walkaround Time* to Duchamp in his interviews, he repeatedly stresses that "there is an entr'acte"—not an "intermission," but an "entr'acte."[31] The peculiarity of the movement phrases I will be discussing—the fact that they resemble movement captured by René Clair, and nothing else in Cunningham's repertory, either before 1968 or after—offers strong evidence that the appropriation of movement material from *Entr'acte* was another one of Cunningham's "references" to Duchamp.

Entr'acte was first shown in 1924 during the intermission of *Relâche*, a ballet by Rolf de Maré performed by the Ballet Suédois. Like many films of the presound era, *Entr'acte* explores how movement can be captured on film. It offers an almost exhaustive inventory of turn-of-the-century cinematic *trucs*, such as those pioneered by Georges Mélies: slow motion and accelerated motion, the rewind, or action in reverse, and a montage technique that makes it appear as though something seen (such as a body) can suddenly vanish without a trace. It seems appropriate that Cunningham would be attracted to *Entr'acte* as a source of movement material, given that it experiments so freely and encyclopedically with what were then the capacities of celluloid to capture the moving body within the space and time of the filmic medium. Scholars of film suspect that while making *Entr'acte*, Clair was in fact influenced by Marcel Duchamp's *Large Glass*, which was constructed during the years immediately preceding the production of the film (1915–23). As the choreographer of *Relâche*, de Maré may have also drawn inspiration from Duchamp's work. George Baker's reconstruction of the dance suggests that it contained scenes in which a single female dancer is surrounded by nine male dancers (the nine bachelors, or nine malic molds of the *Large Glass*).[32] Thus, Duchamp's interest in movement and stasis, and in depicting one in terms of the other, was echoed in both the ballet and the film: *Relâche* contains a scene in which male dancers strip down to tights while encircling a static female statue, and *Entr'acte* contains a scene in which stilled figures return to kinesis. Critics have argued that *Entr'acte* implicates the "resonant body" of the viewer by juxtaposing passages of acceleration and motionlessness.[33] *Walkaround Time* exploits such juxtapositions as well.

The scene that I believe captured Cunningham's eye occurs in the latter half of *Entr'acte*, the more narrative section of the film. A hunter—the erstwhile protagonist of the film—has been shot and his funeral has concluded. Now inside a coffin conveyed by a hearse, the hunter traverses the city, followed by a crowd of mourners. After being led across town by a camel, the driverless hearse then begins to speed up; the mourners are obliged to run at a breakneck pace to keep up with it. Their gait is captured by René Clair in slow motion—creating a kind of slow version of fast motion—and thus the entire sequence resembles the serial chronophotographs of Étienne-Jules Marey, which, as is well known, inspired Duchamp's own experiments in recording movement. (See figure 1.10.)[34] Although Duchamp may have had little to do with the choreography of the funeral sequence, we can easily discern a continuity linking Clair's sequences of running to Duchamp's own concern with chronophotographic, snapshot seriality, evidenced in his attempt to capture the various stages of locomotion in *Nude Descending a Staircase, No. 2*.[35] In the scene of the funeral procession, each stage of the mourners' gait appears clearly, almost discretely, because of the distorting speed of the film in the camera. For instance, in figures 1.11 and 1.12 we see members of the procession caught at various moments of a lunge, their knees held high with one leg stretched out behind them and the opposite foot cocked upward.

My claim here is that Cunningham reproduces the poses of this episode of slow fast-motion cinema in his own medium, that of live dance. He is ghosting Clair, who is himself ghosting Marey.[36] In order to support my claim, however, I must compare screenshots from *Entr'acte* not to the dance itself but to screenshots of the dance recorded in yet another film, Charles Atlas's version of *Walkaround Time* from 1973.[37] In this incarnation of the dance, the cast is slightly different from the 1968 production: the dancers include several from the original cast—Carolyn Brown, Valda Setterfield, Sandra Neels, Meg Harper, and Cunningham—but they are joined by Ulysses Dove, Douglas Dunn, Susana Hayman-Chaffey, Chris Komar, and Chase Robinson. Although Atlas does experiment with framing (e.g., zooming in to Valda Setterfield's torso in what I take to be an intentionally awkward but also telling close-up, a wink in the direction of the Bride), he mostly retains a frontal view of the action, imitating the viewpoint of a spectator seated in the orchestra section. The sequences with which I am concerned—where we see the slow-motion run in *Entr'acte* ghosted by dancers onstage—are shot in a straightforward, head-on manner, allowing us to distinguish clearly the dancers' movement along a horizontal plane from downstage left to downstage right.

Movement sequences that recall in slow motion the accelerated pace of running punctuate the entirety of *Walkaround Time*. But there is one section that occurs near the end of the first half of the dance in which Douglas Dunn and Meg Harper execute a particularly curious staccato duet, obviously cinematically

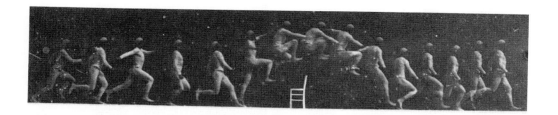

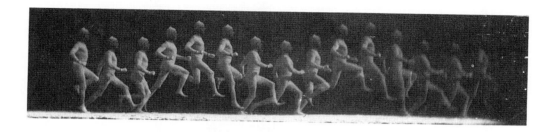

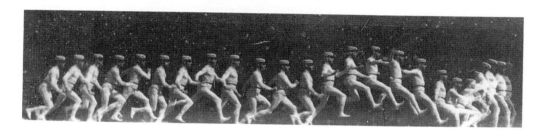

inspired.[38] In this sequence (figs. 1.13, 1.14, and 1.15), Dunn lunges forward at a drawn-out pace while Harper makes sudden little hops at his side. Their combined movements re-create the jerky effect of early filmed movement while at the same time evoking the overlapping leg positions we see in the screenshots from *Entr'acte* (figs. 1.11 and 1.12). Cunningham has excerpted and isolated positions from the running sequence found in *Entr'acte*, which appear like snapshots capturing positions that belong to the continuum of movement linking one stride to the next, one point of balance to another.[39] That is, he has tried to imitate what only decelerated film (or chronophotography) can show us: that part of the stride that cannot be held in real time because it takes place in the air. In effect, Cunningham has incorporated into his dance vocabulary a posture that he could not have seen with his naked eye. Without the camera's optical unconscious, he would be blind to this in-between movement. The lunge is a mechanically seized element copied by a human being, and thus the dance (like the camera) becomes a register of the gestural unconscious, a preserver of postures unintentionally produced. (Cunningham foreshadows here his use of the LifeForms software avatar to generate sequences of movement for dances from *Trackers* [1991] onward.) What Cunningham copies intentionally is something that can only be

1.10
Chronophotograph
by Jules-Étienne
Marey (1883):
top, gymnast jump-
ing over a chair;
middle, Georges
Demeny, gallop;
bottom, soldier
running and
jumping.

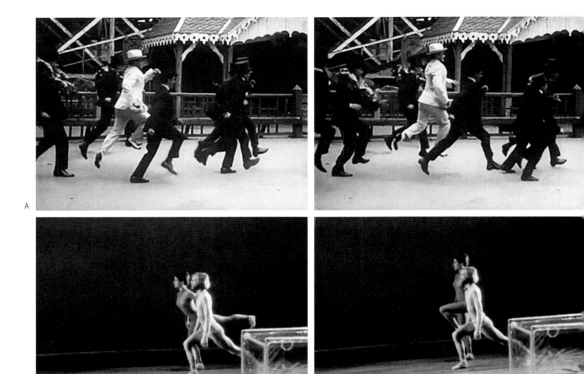

A

C

performed unintentionally (as part of a step) and then captured by technological means. In other words, Harper's posture approximates a posture that no human being could hold, an in-between linking movement registered by slow-motion cinematography and then isolated by the choreographer's eye. In *Walk-around Time*, Cunningham is not tossing a coin or throwing a die or copying the imperfections on a piece of paper. Instead, he is employing a technology responsible for proposing new movement possibilities that he could not have envisioned without that technology's intervention. He is also playing with the opposition between movement and stasis evoked by Duchamp's work, an opposition that will occupy him throughout his career.

The movement elements derived from the slow-motion episode in *Entr'acte* point to yet another important aspect of the readymade. When producing a readymade, Duchamp insisted, the artist should by no means seek an encounter with an object already deemed aesthetically interesting. Ideally, the object encountered should contain no symbolic significance; it should be semantically neutral.[40] The object could be functional—such as a bottle rack, a bicycle wheel, or a shovel (*In Advance*

1.11 (A)
Screenshot from René Clair and Francis Picabia, *Entr'acte* (1924); mourners running, caught in the middle of a lunge. The center man is about to take next stride.

1.12 (B)
Screenshot from René Clair and Francis Picabia, *Entr'acte* (1924); mourners running, caught in the middle of a lunge. Here, the center man's leg is extended forward.

1.13 (C)
Screenshot from Charles Atlas, *Walkaround Time* (1973); choreography by Merce Cunningham (1968). Meg Harper stands, with leg extended, to Douglas Dunn's right.

1.14 (D)
Screenshot from Charles Atlas, *Walkaround Time* (1973); choreography by Merce Cunningham (1968). With her left leg raised and bent at the knee, Meg Harper stands parallel to Douglas Dunn.

of the Broken Arm [1915])—but it should not carry symbolic or representational weight within an already existing pictorial or literary tradition. Duchamp at least pretended to encounter his objects without having calculated in advance their capacity to attract associations—erotic or otherwise.[41] The appeal of a bottle rack was precisely its "indifference" to the desiring eye.[42] Similarly, we can postulate that one of the things that attracted Cunningham to the odd lunges and hops of *Entr'acte* was the same thing that attracted him to the

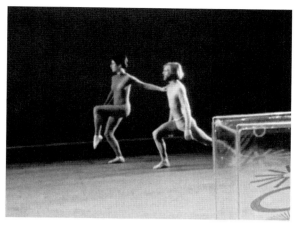

"unadorned" movements, the stripped-down ballet vocabulary he had been using since 1952 (ballet movement minus the mannerisms, the *épaulements*). In the decelerated sprints of *Entr'acte* he found material that, at least for him, lacked a precise symbolic resonance—even if eventually that material could be traced back to Clair's film, to Marey's chronophotographs, or, more simply, to the act of running.[43] In doing so, he revealed an impulse at the core of Duchamp's research: a desire to seize a semantically denuded, culturally neutral element in a kind of "snapshot," to confront the supposedly neutral object in all its nudity before recontextualizing it (and resemanticizing it) as art. Cunningham did not identify the running movements via a chance procedure; he did not select a date and time when the readymade would be presented to him. (There is no *horlogisme*, in other words.) Instead, he watched for the not-yet dance movement (the not-yet "art object," in Duchamp's terms) and transformed it into a dance movement. This process was arguably closer to the one Duchamp himself used, one that relied less on the chance encounter (as prescribed in the "Specifications") than on the artist's ability to discern the unremarked, the semantically indifferent. The *horlogisme* Duchamp had in mind is realized more fully in the procedure Cunningham applied to the making of *Summerspace*, a dance of 1958 that relies on timing and spacing to produce encounters of an initially aleatory nature. I turn to these encounters and the interaction of inscription and performance they exemplify in the next chapter.

Suspensions

If it is true, as Jill Johnston has claimed, that Cunningham's "originality" was to "appear on his own stage without cultural encumbrances," then he would have been at pains throughout his career to find movement material also lacking in such encumbrances.[44] René Clair's camera provided him with a revelatory glimpse of previously untapped corporeal possibilities that—unlike the vocabulary elements of modern dance or ballet—would not have to be ripped out of a

preestablished dance vocabulary and further desemanticized. The in-between movements of ambulation are captured in *Entr'acte* while still naked of symbolic meaning and emotional intensity—although they certainly possess a kinetic intensity that Cunningham could mobilize for his own choreographic ventures. Despite the fact that these movements belong to a project—in the case of the *Entr'acte* narrative, chasing a hearse—they do not have to mean "chasing a hearse" because they have been excerpted, disarticulated from the "intentional arc" to which they diegetically belong.[45] They are bits and pieces of locomotion, and thus can be recycled as movement elements to be placed in another continuity. Their relation to what comes after and before, their place in a syntax of movement, can be reimagined.

Thus, the "walkaround time" to which the title alludes could be seen to name, not simply the interval during which the computer programmer waits for the data entered to be processed as a code then retranslated back into an intelligible result, but also the interval separating gesture from meaning. The "walkaround time" occurs just after a gesture has been performed but before it has yielded meaning, or information in a cybernetic sense. The gesture or step is suspended in an asemantic void that nonetheless anticipates the attribution of meaning.[46] We might call the movements of *Walkaround Time*, after Mark Franko, "delays" in dance.[47] Apparently, when this work premiered in 1968, Cunningham performed a solo during the *entr'acte*. By 1973, however, he had eliminated his solo and simply allowed his dancers to "walk around," the curtain lifted, and thus thoroughly exposed them to the audience as they relaxed and chatted casually behind and among the Duchamp cubes. The second version of the *entr'acte* was a more coherent response both to the title's suggestiveness and to the project of desemanticization and suspension just described. An *entr'acte* is a kind of interval, a breathing space in which nothing in particular has to happen, nothing has to have meaning within a plot.

Cunningham's explicit goal in training his dancers in the way he did was to enable them to execute and permute vocabulary elements lifted out of their place in a conventional syntax or learned routine. In other words, the goal was to create a kind of pause in the acculturation and semanticization of movement. He sought to liberate movement from a conventional meaning so that it could appear in a brief interval, an *entr'acte*, a delay, without being weighed down by "cultural encumbrances." Not only did he insert well-known elements of ballet, modern, vaudeville, and folk vocabularies into the movement gamuts he used as the basic material of his dances; he also introduced unusual, previously unremarked (and unremarkable) kinetic behaviors into his grids and charts. He looked everywhere for these unusual kinetic elements, focusing his gaze on street life, on animals, on images found in films, television programs (sports), and museums (Greek urns). Many of his dances are based on an extensive investigation of a single type of action—the fall for *Winterbranch* (1964), the turn for *Summerspace*, the tilt and

twist of the torso for *Torse* (1976). In *Walkaround Time*, he explores the basic forms of forward locomotion—not just the run but also the walk, the stride, and the hop, in both pedestrian and stylized versions. He analyzes and breaks down the syntax of these forms, as though he were himself a chronophotographic apparatus. Then he treats the disarticulated bits and pieces as desemanticized material to be reinserted into a new combination or montage. Just as Duchamp collected images from earlier works and recombined them in new ways for *The Large Glass*, so, too, Cunningham recombines physical motions captured as "snapshots" to produce new sequences and juxtapositions. Once broken down, these bits of movement can return in the form of a snapshot, that is to say, a kind of filmic still, like an individual frame in a sequence of twenty-four frames per second. Film is the medium that presents stillness (captured in a frame) as movement (a succession of frames), whereas dance draws out the movement that is in the still. In *Walkaround Time*, Cunningham works with movement stills on two levels: he isolates them to highlight their alphabetic, building-block quality; and he recycles them, placing them in new arrangements, exposing and exploiting their potential to project movement ahead of themselves. A frame within seriality, a frame within other frames (no matter how cut up, no matter how discontinuous), contains a nascent motricity: frozen movement shoots off vectors of intention that a choreographic eye like Cunningham's can choose to follow—or not.

Fragments of the lunging and hopping phrase performed by Harper and Dunn reappear scattered throughout the dance. For instance, near the beginning, the two dancers execute a miniature version of the hop and lunge phrase they will perform later; and toward the end of act 1 Dunn reprises his odd lunge and gets lifted and carried off the stage, still frozen in the lunge position, by five other dancers. A recurrent visual motif of *Walkaround Time* is, as I have been arguing, the frozen pose as transportable object: a dancer strikes the pose (Dunn's lunge, Carolyn Brown's *relevé* in fifth position), then gets treated like an inert object to be picked up and displaced. Over the course of the dance, the dancers—or, more precisely, the dance positions they hold—appear increasingly similar to the transparent vinyl blocks on which Jasper Johns has reproduced the icons of Duchamp's *Large Glass* and which are themselves just more furniture to be moved around during the stage. Dance movement and visual image alike become letters in an alphabet—or notes in a hat—to be reshuffled to create new works.

Still, the question that Cunningham—after Duchamp—seems to pose is whether these bits and pieces of locomotion can remain suspended, or whether they are ever entirely without "cultural encumbrance," beyond semantics. What happens to the fragments of locomotion when they are reinserted into Cunningham's dance? If we look again at the odd duet between Harper and Dunn, we may be struck by its conclusion, which nothing in the René Clair film anticipates. After the series of lunges and hops, Harper and Dunn end up back to back (although not touching) instead of moving laterally across the stage, as before. Whereas

throughout the rest of the duet they have both gazed ahead in the direction toward which they are proceeding (downstage right), just as the running figures of *Entr'acte* all face forward toward their destination, here the two partners seem to enter a new space, that of the interpersonal relation established by the duet genre. Their two gazes, pivoting in unison toward the center of the stage, toward the public, and ultimately toward each other, create a semicircle within which they are linked. Although there is nothing overtly sexual about the head movements, the mutual acknowledgment of the other's presence suggests a future involvement.

In this section of the dance, Cunningham has made intentional choices to ensure that the suggestion of such an encounter will occur. Whereas in Étienne-Jules Marey's chronophotographs or the chase episode from Clair's *Entr'acte* the snapshots of locomotion include many overlapping figures, in *Walkaround Time* Cunningham has chosen to reduce these figures to two. Further, whereas Clair's figures are all men, Cunningham has re-created the scene with a man and a woman, engaging the implicit erotics evoked by any heterosexual partnering on an American (heteronormative) stage. Finally, he prepares us to view the slow fast-motion duet *as a duet* (and not just a figuration of overlapping identical figures) by adding an element not in the film: Harper rests her hand on Dunn's shoulder as she executes her hops, thereby transforming the hopping routine into something resembling a traditional folk dance. There is nothing in the mechanics of the choreography that requires her to do so; she could easily balance without his support. But by touching him on the shoulder she establishes a kind of stereotypically "feminine" dependence on him. Their roles are clear. When the two stand back to back in the conclusion, Dunn stands with his feet apart and firmly planted on the ground in a stereotypical posture of masculine solidity, whereas Harper stands with her feet together—a version in profile of the male/female icons on restroom doors. This phrase is repeated three times, with the partners switching places before turning again to look in the other's direction. With each repetition they move closer, still not touching. Finally, Harper arches back, and Dunn catches her in his outstretched arms.

Cunningham's choreographic choices suggest that whether obtained by dropping a string, determining a specific date and time for an encounter, or appropriating a movement previously unmarked, the resulting image or dance figure cannot remain neutral or indifferent for long. The *trouvaille* will be recycled in a variety of ways, and each time it will quickly take on a meaning suggested by its new context. In the work of Marcel Duchamp, especially, this context is more often than not one that evokes an erotic relation. Duchamp may have sought to differentiate his chance method and its attendant philosophy from that of the surrealists; clearly, he wished to distance himself from André Breton, for whom the *trouvaille* manifested the will of a transcendent power—or, alternatively, a hidden desire.[48] And yet from the very start, Duchamp's definition accentuates

the affective undertone of the encounter: it is "a kind of rendez-vous." As Rosa-lind Krauss, Amelia Jones, Craig Adcock, and a host of other art historians have argued, Duchamp, even given his forays into cross-dressing and role-play, tended to privilege forceful vectors of heterosexual desire and intense erotic fixations which might have appeared limited in orientation from the perspective of the next generation.[49] Cunningham exhibits his awareness of these intense erotic fixations in *Walkaround Time*, focusing undivided attention on the Bride in three riveting solos, performed by his three female muses at the time: Carolyn Brown, Valda Setterfield, and Sandra Neels. To be sure, he also references Duchamp's forays into gender-bending by impersonating the Nude of *Nude Descending a Staircase, No. 2* in a striptease performed at the pace of a brisk run. (See the start of act 2.) For a few moments, Cunningham even makes himself into the Bride, thereby complicating the heterosexual erotics exemplified by the Dunn-Harper duet. His motions replicate the whirring of bicycle wheels, the seriality of Marey's chronophotographs, and the iconography of *Nude Descending a Staircase, No. 2* in one startling image of flesh as mechanical gait.

A rendez-vous is, after all, an assignation. It is a promise to show up, to render yourself (*se rendre*), to implicate yourself in a relation with something you might not have had a relation with before. However the chance meeting occurs—by dropping a string, predetermining a time of contact, tossing a coin, or picking a musical note from a bag—it will produce a transformation. The object encoun-tered will no longer be just that object ("a thing is just that thing"), no matter how stripped of functional or symbolic meanings it might be.[50] In that moment of encounter, something in the object is ignited, some potential to be in relation is activated. And out of that rendez-vous, out of that relation with the "maker" of the readymade and, eventually, the spectator, there flow new associations. A set of industrial molds can become a group of "bachelors"; a "chocolate grinder" might suggest the churning of onomastic pleasure; juxtaposed snapshots of run-ners could evoke a country dance. From these hints of resemblance there emerge longer scenarios, elaborated on to differing degrees depending on the nature of the project and the context in which the object is placed.

Thus, the chance object, image, or dance step, once "canned," does not remain in that can. Instead, it overflows its container, provoking more encoun-ters, and thus more associations, every time it reappears. And reappear it cer-tainly does. The string shapes of Duchamp's *3 Standard Stoppages*, for instance, are recycled to produce first the painting, *Réseau de stoppages*, of 1914, then the lines connecting the malic molds of *The Large Glass*. The odd lunge in *Walkaround Time* appears first in a duet, then in a solo, then in yet another duet. The detached building block, because of its unmarked, "unadorned" appearance, turns out to be a generator, not an expunger, of scenarios. Like a letter in an alphabet, it may possess no meaning in itself; but once reproduced, once performed, it partici-pates in the creation of a seme—or a scene. With respect to Cunningham's

dances, it is not that through the process of permutation, the dancer performing the movements or holding the positions has been dehumanized; rather, the movements and positions the dancer executes have been decontextualized, abstracted from the cultural meanings they have acquired (their denotations and connotations, to speak in linguistic terms). Human significance has not been eliminated; on the contrary, the cultural meanings of the gestures have simply been placed in suspense. As a result of that suspension of conventional meanings, these gestures take on a new significance, one they can bear only in that particular moment of performance by that particular person.

Many critics have remarked on the heightened alertness of Cunningham dancers, even as they execute movements that seem to have no specific meaning. Often what is being observed is not affect per se but affect coming into being, its bare outlines or proleptic shadow. The forceful alertness or intensity of the dancers is due at least in part to the fact that the choreographer purposefully created conditions of performance, or cultivated a sensitivity in his dancers to conditions of performance, that allowed each performer to find in the repetition of the known something fresh. Their affect, then, seems attached to the movement because any emotional investment in narrative they might be ready to make is going to be interrupted before it can develop; their focus must shift from the arc to the instant: first this, then that, then that. Cunningham's choreography relies heavily on this paradoxical relation between repetition and contingency, the "canning" of chance and its (re-)release in performance. The Event format of his dances was nothing if not an attempt to discover the generative possibilities of iteration. Cédric Andrieux, one of Cunningham's finest former male dancers, has observed with respect to this paradox that the repetition required by Cunningham's difficult sequencings never eliminated the sense he had of encountering the movement as if for the first time. The fact that he was not required to match the rhythm of his dancing to the musical score (which could change from performance to performance) allowed him to phrase the movement differently each time. He felt "liberated" from having to evoke an "imposed" emotion, free to make his own rhythms, his own phrastic forms. When dancing a Cunningham dance, he states in his account of his years with the company in Jérôme Bel's *Cédric Andrieux*, "I am totally in the moment"; although repeating learned sequences as accurately as possible, Andrieux remembers feeling authorized to "dance the movement according to how I am feeling, what I am thinking, on a particular day."[51]

Cunningham kept his dancers alert and on edge through a variety of measures—by introducing them to the musical accompaniment at the premiere, for instance, or rearranging the sections of a dance immediately before its performance. For *Dime a Dance* (1953), he required audience members to toss coins to determine the work's contents; in *Rune* (1959), a chance procedure determined the sequence of the sections for each performance. He also frequently worked

with composers whose scores were not played in the same way each night, thereby denying access—as Andrieux states—to fixed cues. Finally, he cut up his dances into fragments, permuting them into different arrangements for each Event. To some extent, he was following the permutational logic of Stéphane Mallarmé's *Le Livre* (*The Book*), an unfinished work the plans for which were published by Jacques Scherer in 1957. Mallarmé envisioned his *Livre* to be a set of separate, unbound pages that could be arranged in as many forms as there were readers, or "operators."[52] He thought of the reading as a theatrical performance generated by the chance combination of predetermined (verbal) events. The various permutations would encompass, he wrote in "Le livre, instrument spirituel," "des relations entre tout"—every possible relation between every possible thing.[53]

However, whereas Mallarmé limited his variants to a mathematically calculable number, wishing to control all possible permutations and thus exhaust all potential "relations," Cunningham was always hunting for a fresh way to use preserved materials. In short, he wanted to magnify the potential of performance itself. By employing movements as semantically "unadorned" as he could make them, he aimed not only to render visible the unique quality of each individual dancer but also *to allow that individual dancer to be nonidentical to herself,* to move as she would "on a particular day"—at that hour and on that stage. By combining the predetermined (the "canned" phrase) with the indeterminate and contingent (its performance), Cunningham invented an *horlogisme* as implacable and as generative as Duchamp's. Like Duchamp, he also augmented the potential for the rendez-vous to produce a supposedly unscripted relationship—that would then need to be signed, thus producing more script ("inscribe that date, hour, minute, on the readymade," Duchamp wrote in his "Specifications"). An unscripted relation is, however, an oxymoron. An encounter between any two entities (artist and object; dancer and phrase; artwork and audience) is always caught in the drift of what any meeting implies. The singularity of an encounter between two bodies on stage is particularly subject to the momentum of an encounter's implicit erotics. Further, the particular lens through which the encounter is captured—not to mention the nature of the hand that "signs" it—adds something to the encounter it might not otherwise have had. Thus, the decontextualization of an iconographic or gestural element can place it in a nebulous in-between space, suspending it between previous meanings and future associations, either through *horlogisme*, permutation, or montage. Still, the interval, the in-between space, the *entr'acte,* has its own peculiar momentum, at once propelling us toward *and keeping us from* the inevitable next step.[54]

In 1956, Cunningham choreographed a dance called *Nocturnes,* which he described in his notes as a series of "rendez-vous" derived from the chance-determined crossings of dancers in space.[55] Throughout his career, he conceived of his dances as encounters or meetings, opportunities for couplings that rarely

unfold into plots. The rendez-vous was for him a point of departure, not just for the readymade—the neutral movement content he placed in his gamut—but also, and more frequently, for the human scenarios that the chance-chosen movement content—once framed, and in that way "signed"—could suggest. And the trick was, precisely, to suggest. The goal was to reveal within "n'importe quoi" the emergence of relation at the very point of its suspension. Whatever emerged from the encounter would have the quality of something scripted in advance—the necessary—that remained nevertheless "in advance" of the script. But precisely how did dances like *Nocturnes* emerge from chance encounters? How did Cunningham mobilize the neutral and the indifferent to produce an erotics of chance? How do script and performance interanimate in his work? These are the questions I will turn to next.

Summerspace
The Body in Writing

The concept of "inter(in)animation" is one of the most important to have emerged in recent years in the discipline of performance studies. Fred Moten coined the term (without the parentheses) in *In the Break* as a way of designating temporal and medial co-construction. Moten is interested in how the photographic and the phonographic, "vision and sound," the past and the present, could be said to enliven and ghost each other.[1] Rebecca Schneider has developed the term further in *Performing Remains*, retrieving the previousness of Moten's usage by locating the term in "The Exstasie," a poem by John Donne published in 1663. "So to'intergraft our hands, as yet / Was all the means to make us one," Donne writes, suggesting that the presence of one thing *in* the other ("intergraft") is what, paradoxically, creates a single being ("make us one").[2] The poem is not just about a couple melding hands—"When love with one another so / Interinanimates two souls"—but also about the presence of death in life and life in death. Grafting Donne onto performance studies, so to speak, Schneider adds the set of parentheses "in order to highlight the syncopation of interanimate"—to mutually enliven—"and inter*in*animate"—to mutually deaden, and thus to trouble the immediacy of the thing to itself.[3] Schneider's target is the opposition of the "live arts" to the "still arts," which is the subject of this chapter and of chapter 4 (on dance and photography) as well as a theme of the previous chapter on Marcel Duchamp (movement and stasis). Implicit in both Schneider's and Moten's use of the term is a sense of *temporal* ghosting; a temporal (not just ontological) ghosting renders the notion of pure presence an oxymoron. The ghosting I will treat in this chapter has to do with the way in which the still inhabits the live and the live inhabits the still, that is, how something considered exterior to the self is grafted onto that self, allowing it to manifest another facet of what it can be.

 Inter(in)animation is a useful term in the context of the choreographic prac-

tice I will be analyzing here, for it captures well the relationship Cunningham sets up between inscription and performance, a disembodied symbolic code and embodied movement. I ended the previous chapter by asking how script could generate the unanticipated (how an *horlogisme* underwrites the rendez-vous), and, conversely, how something accidental (the rendez-vous) could produce more script—the "inscription" (Duchamp's word) that the artist adds to what is now his "work." In this chapter, my emphasis will be on scripts understood as mnemonic devices that have been turned toward the *production* rather than the preservation of dances. I will trace Cunningham's creative investment—his real investment in terms of time, effort, and resources—in inscriptive devices of many kinds: from writing and drawing (the use of symbolic systems in the composition of his early dances) to LifeForms and DanceForms, software programs that employ diagrams and schematic avatars to propose—as did previous inscriptive systems—new sequences of embodied steps. In *Le hasard comme méthode*, Sarah Troche has offered a reading of Duchamp's first chance composition, *Erratum musical*, that opens the line of questioning I want to pursue here. "To realize *Erratum* [*musical*]," she writes, "and to sing the results of chance, one must necessarily inscribe those results on a score [*partition*] that registers them, one by one. This music cannot be imagined before it is played; it presupposes, then, a written trace, not as the end-goal of a previous reflection, but as the non-expressive origin of a music inscribed according to a game of chance [*le tirage à sort*]."[4]

Another way of putting this would be to say, as did John Cage, that composition is one thing, performance is another, and listening is quite another, and that each one is a distinct and discrete process.[5] *Pace* Cage, I will argue instead that composition and performance inter(in)animate in Cunningham's work. That is, the inscription (composition) and the movement (performance) are like shoots grafted one onto the other. With respect to Duchamp's *Erratum musical*, for instance, we might observe that he could not have come up with the musical notes he placed into the bag (in the first version) or the wagonette (in the second) if they couldn't be sung in the first place, that is, if they weren't already a possibility offered by the embodied vocal apparatus. The inscription on the score thus reflects certain qualities of the human voice. At the same time, however, we can see how an inscriptive system is grafted onto the human body: the type of pitches that a trained voice learns to produce is determined by the Western system of musical notation, which parcels out the vocal range into the intervals established by what musicologists call equal temperament tuning. What the human voice *can do* at any given time and within any given culture reflects a culturally acquired sense of pitches and intervals; in turn, these pitches and intervals are derived from a symbolic system that captures only a small portion of what the human vocal apparatus is actually capable of. Likewise, if we look at Cunningham's choreographics, we observe a similar inter(in)animation: the gamut of movements

for a particular dance includes only species of movement he can conceive of performing individually, as disarticulated units, and thus they are drawn from his own embodied experience. These movements generate—they are the template for—the many symbolic systems he will use to manipulate his body via chance procedures. Yet the symbolic systems themselves (here, numbering, drawing, and all the varieties of structuring that writing allows) inform how the body perceives itself in the first place, how it breaks up the kinetic continuum into isolatable parts. Within the body there is already, as Laurence Louppe has proposed, "an interior score," or, to quote Sabine Huschka, an "interior*ized*" score.[6] The body and its notations are "intergrafted," cogenerative, in a recursive process the limits of which remain unknown.

Numbers, Lists, and Charts

At the time of his death, Cunningham left behind a large collection of papers relevant to his choreographic practice that are now housed in the Performing Arts Division of the New York Public Library at Lincoln Center. As anyone who has glanced at them already knows, his notes, cataloged under the heading Choreographic Records, are far more than post facto notations. They are in fact an important resource for understanding Cunningham's creative process, a kind of genetic record tracing the various steps he employed in the composition of his works as well as the social conditions from which they emerged. Included in the files are of documents of many kinds: pages of quickly jotted-down ideas for future dances not yet made; "Procedure" pages enumerating the elements to be subjected to a chance operation of some kind; extensive lists and charts of body parts, steps, positions, and phrases to be entered into charts and used in a movement gamut; diagrams of the usually rectangular (but sometimes round) stage space; symbols representing phrases or positions; stick-figure drawings; records of coin tosses (heads or tails); computer printouts of *I Ching* hexagrams; continuity sheets recording the chance-derived order of phrases or sections in a dance; notations of dances made after their creation and intended as a mnemonic device; shot-by-shot directions for the filming or videotaping of a dance; casting lists; sketches for lighting, costume and set designs; and so on.

In contrast to John Cage's scores, these documents were not intended to be exhibited or shared. Cunningham did publish several sets of his notes in 1968 under the title *Changes: Notes on Choreography*, and these have served as a precious resource for scholars interested in his creative process. In 1977, the Margerete Roeder Gallery began exhibiting some of Cunningham's notes as though they were Cage's scores. Cage himself had been inspired by his friend, the composer Morton Feldman, who began in 1952 to mount his musical scores on the wall, working on them "as if they were paintings."[7] Liz Kotz has written perspicaciously that Cage privileged the graphic notational form of the work

because, unlike an audio recording, it permitted multiple versions.[8] (The score could be interpreted and performed differently, whereas an audio recording imposed more variables.) Cage's flexible, "indeterminate" scores allowed for variations in performance; he in effect "repositioned writing as a kind of *productive mechanism*."[9] This point will be important as I proceed: although Cage and Cunningham used notation in different ways, both conceived of mark-making as more than simply commemorative. As in Duchamp's *Erratum musical*, the inscriptive gesture played a seminal role in the music or movement that followed.

This is particularly clear in Cunningham's case. His choreographic notes are neither a (retentive) score, a scribal recording of a dance already performed, nor are they an anticipatory (protentive) blueprint of the dance that would come into being. Instead, they constitute a series of intermediary steps, an integral and essential part of the process, without which the dance would never be made at all. A study of his choreographic notes makes evident the singularity of his project by revealing to what a great extent—an unprecedented extent in the history of dance—his choreography was based *on the act of writing*. Whereas it has been acknowledged that Cunningham's use of computer software technologies (Life-Forms) made a clearly discernible impact on the movement combinations he employed—and thus on the "look" of the finished dance—it has not been properly recognized to what a great extent the quality of Cunningham's *pre*-digital dances was influenced by the abstract symbolic system of writing, or inscription more broadly, understood as the imprinting of marks on a durable surface. The look and feel of his dances are products not of chance procedures alone but also of the mark-making practices without which chance methods of composition could never be pursued in the first place.

In general, critics and reviewers have been reluctant to place too much emphasis on the "paperwork" involved in creating Cunningham's dances. For instance, Jill Johnston, a devoted fan, wrote in 1968: "Whatever he did exactly or does now exactly is irrelevant to the bald look of the work."[10] Her assessment reflects a standard bias in much dance criticism (especially in the review genre). As opposed to art criticism, which tends to maintain a stronger link to the academic field of art history, the dance review often confines itself to the experience of the spectator. Little commentary is generated concerning the history of the work's genesis, the process of building a dance piece by piece that goes on beyond the spectator's gaze. Until now, the conceptual implements employed by choreographers have not garnered much attention. (The recent acquisition by the Getty Art Institute of Yvonne Rainer's papers and the interest taken in her autobiographical accounts indicate that scholars are finally digging deeper into how dances are made.)[11] In contrast, the compositional process that Cage developed was discussed both by critics and by the composer himself: he gave lectures on his unconventional strategies as early as 1939. Cunningham, who began choreographing in the late 1930s, did not give public Lecture-Demonstrations until the

1950s, and he never explicitly talked about his use of chance procedures, not even in the program notes to his early chance works.[12] Perhaps that is why his reviewers also neglected to look any further. Doris Hering, in her review of the Merce Cunningham Dance Company's 1954 New York Théâtre de Lys performance, divides his works into "conventionally composed works"—such as *Septet*, *Banjo*, *Root of an Unfocus*, and *Totem Ancestor*, which she praises—and chance works, "those tireless utterances suspended in an emotionless void."[13] Although she alludes to the fact that some dances were "determined by chance," she exhibits not a grain of curiosity concerning how they were actually made. It wouldn't be until Remy Charlip (one of the earliest members of the company) published "Composing by Chance" in the January 1954 issue of *Dance Magazine* that the public gained any idea of how, practically speaking, Cunningham derived movement phrases from the materials of pen, paper, coins, and dice.[14]

Whereas historians of conceptual art and minimalism have grown accustomed to the rich cross-fertilization between writing and performing, the text and the installation, historians and reviewers of dance have been less willing to entertain the possibility that movement could emerge from marks inscribed on a page. A tradition so closely associated with invention pursued on and through the moving body has had a hard time foregrounding that part of the choreographic process *not* done on and with the moving body.[15] Cunningham's own quip—"I call it paperwork, but John Cage calls it composition"—shows that even he did not identify the creative core of his choreography with the drawing up of lists, movement gamuts, charts, and continuities.[16] Writing is a stationary practice, and thus incompatible with the dynamism we associate with dance. Yet one of the appeals of the *I Ching*—at least for Cage when he first began forming hexagrams in 1950—is that it kept him writing at a desk for hours. He seems to have craved the actions of writing, both physical and mental, whereas Cunningham craved larger movement, hours alone in the studio. Even after Cage began employing a computer program to "toss" the *I Ching*, he still spent entire days poring over texts in order to make new texts. The titles of his works from the 1970s and 1980s tell it all: *Writing through "Finnegans Wake"*; *Writing through "The Cantos"*; *Writing through "Howl."* (And Cage really did write, continuing to use his hand even after Andrew Culver made him computerized versions of his operations, marking up his paperback copy of *Finnegans Wake*, for instance, with multicolored pens.)[17] In contrast, Cunningham always insisted that he began not with an idea but with a "step."[18] Nevertheless, the voluminous notes contained in the Choreographic Records at the New York Public Library are proof that Cunningham, too, spent hours seated before a desk—and, later, a screen. For both artists, the involvement of the hand still mattered in a way that Duchamp would have considered nostalgic; to that extent, their "conceptualism" was unorthodox, as wrapped up in the handiwork as it was in the idea.[19]

Whether Cage and Cunningham employed the *I Ching* correctly or not

remains a matter of some debate.[20] But what is clear is that they both followed the two major principles of the *I Ching*, a divinatory system that prefigures inscription as both a gestural practice and a mode of thought. First, with respect to the physicality of writing, the *I Ching* demands a series of repetitive gestures: to make one hexagram, three coins must be tossed six times each. Second, with respect to the conceptual nature of writing (alphabetic writing especially), the *I Ching* demands multiple translations from one symbolic system to the next. The results of each toss need to be written down as a number, which can then be translated into a type of line (broken or not); then each hexagram must be keyed to a number between 1 and 64 (the concordance is found in the *I Ching*). Once the results of the repeated coin tosses (each group of six) are transformed into numbers (between 1 and 64), these numbers must be written down to produce a random number series. Finally, the numbers must be keyed, each one individually, to a note or a sound—or, in the case of Cunningham, a movement or position—that bears the same number. These sounds and notes, or movements and positions, have been chosen in advance by the coin tosser; he has prepared a gamut of material that also has to be written down—either in the form of an abstract symbol (a crochet on a staff or a letter) or, as in the case of Cunningham, by means of a verbal rendering, a symbolic cipher, or a stick figure. The amount of writing involved in such a procedure is absolutely enormous. We have of course grown accustomed to thinking of Cage as sedentary; who hasn't seen a photograph of a bespectacled Cage poring over papers on a desk? But among the two-hundred-plus photographs of Cunningham contained in David Vaughan's catalogue raisonné of his dances, *Merce Cunningham: Fifty Years*, we find not a single one of the choreographer in the same position, although he certainly must have spent a good portion of his day at a desk with pen in hand.

With some important exceptions, almost all of Cunningham's dances from 1951 onward required an enormous amount of "paperwork." Preparatory lists, grids, charts, numbering systems, and pictograms were all essential elements of his toolbox. Just as poets sometimes list rhyming words or collect adjectives for future use, so Cunningham sought inspiration through the systematic inventorying of options—and this as early as 1944, years before chance operations were even on the horizon. My point is not that the kinesthetic experience of the dance was of less importance to him; once Cunningham had generated the salient variables through the creation of "paperwork" phrases, he then tried out and actualized them in the studio or on his dancers, often modifying them as he progressed. I only want to stress here that his imagination was nourished by the options and differentiations that his marking systems brought to the fore. That is, even when he was young and fully capable of dancing all his invented continuities, his way of thinking about dancing was influenced by operations that can only emerge from the *techne* of mark-making.

Numbering, to take the simplest instance of inscription, was essential to Cun-

ningham's choreographic practice. Many paleographers believe numbering to be the operation at the very origin of writing in its pictographic, ideographic, and alphabetic forms.[21] But numbering is a very particular kind of mark-making: not only does the logic behind numbering permit the generation of a list; it also allows for permutation in sequencing. If movements, positions, and entire phrases can be symbolically represented as *numbers*, then they can be rearranged, either randomly or systematically. The order of the phrases may be permuted as a result of their placement into an *array*. As Jack Goody, an anthropologist concerned with the cultural effects of literacy, has pointed out, the salient feature of a list is that "it relies on *discontinuity* rather than continuity."[22] Goody stresses further that listing is an agent of discontinuity because it follows no grammar or syntax other than seriality—one thing after another. Listing therefore encourages segmentation, atomization, or a pixelated state of what otherwise might be apprehended as a totality. A list allows for the "formal manipulation" of elements that have been decontextualized. With the advent of listing, Goody continues, elements "removed from the body of the sentence . . . and set aside as isolated units" are capable of being ordered in a limitless variety of ways.[23] Obviously, Cunningham appreciated what Goody identifies as "*the generative possibilities of graphic reductionism*."[24] The advantage of a numerical system is that by applying a principle of abstraction, reduction, and blunt differentiation, it creates more options for recombination and permutation. Trusting the "generative possibilities" that "paperwork" could yield, Cunningham began most of his dances by inventorying and numbering options (or representing them by reduced symbolic means). This produced the gamut.[25] He then placed them in an array, produced a random number series (by tossing either coins or dice), rearranged the order of the items in the array according to the random number series he had just produced, and recorded that *new* order under the heading Continuity.[26] *Continuity* is a word that comes from Cage's musical vocabulary. According to the principle of a random array, it is possible, wrote Cage, "to make a musical composition"—or, in Cunningham's case, a dance—"the continuity of which is free of individual taste and memory (psychology) and also of the literature and 'traditions' of the art."[27]

One of the most curious features of Cunningham's choreographic practice is that he did not remain content with numerals, either Roman or Arabic, but instead invented a plethora of symbolic systems for differentiating and manipulating the elements of a list of movements contained in his gamut. For *Suite by Chance* of 1953, for instance, he created charts with cells, each numbered one of which contains a short verbal description and a stick-figure drawing representing another option in a family of options (e.g., types of kneeling, sitting, or lying on the back). The charts therefore combine three different systems of symbolic inscription (numbers, verbal descriptions, stick figures) in what might be considered an overabundance of information (cybernetic, taxonomic, iconic). For *Canfield* of 1969, he developed an entirely new device, relying this time on a

numbering system based on the icons found on a deck of cards (heart, diamond, club, and spade), plus the numbers 1 to 13, to identify fifty-two different movement options. Likewise, for *Winterbranch* of 1964 he devised a code of eighteen geometrical shapes, each one keyed to a verbalizable movement phrase. (See figure 2.1.)

The abstract diagrams (fig. 2.1) may have been drawn on notecards and selected one by one in the manner of the notes for *Erratum musical*, thereby forming a dance phrase. Each geometric shape corresponds to a specific movement, posture, or phrase. The key indicates, for instance, that "square" equals "girl in attitude over boy's back." In performance, the square translated into the image we see in figure 2.2.

The variety of symbolic systems Cunningham invented throughout his career is mind-boggling. My study of the archive has revealed that he wrote a Procedure page based on one of these symbolic systems for almost all the dances he made, dances that would have been impossible without recourse to writing or, more broadly, the practice of making marks. By this, I mean not only that he habitually wrote down ideas, movements, and sequences in the form of abstract ciphers and schematic reductions; I mean, more crucially, that he simply could not have generated the kind of phrases he did without a *mind of writing*. It may well be that Cunningham's initial motivation in listing options was a desire to enlarge his

kinetic imagination (as he always insisted).[28] Since he wished to introduce into dancing something he had not done before, he had to find modes of exploration that would take him beyond his idiosyncratic movement habits, beyond his dance training, beyond his tastes. Charts and symbols such as those made for *Suite by Chance* replied to this self-imposed charge; they expanded what could be imagined, preserved (noted), and tried out (experienced) in the studio. The variety of options generated by the inventorying of shapes and gestures would simply not have been available to a creator who did not systematically write them down.

A principle of exhaustive enumeration thus subtends Cunningham's practice and makes it strikingly different from that of other choreographers.[29] Inscription was, in his case, a generator of movement; to this extent, his choreography could be seen to be a product—at least in part—of *writing's* imagination. That is, what Cunningham could physically produce was in some cases limited by what a given mark-making system—or, in the case of LifeForms, a digitized list of preprogrammed articulations—could discriminate and instantiate in the form of marks on a page or ciphers on a screen. This is a point that the philosopher Michel Bernard makes well: "The way in which a dancing body is decomposed into units . . . corresponds to a particular perceptual mode"; "The materiality of the dancing body, submitted to aleatory compositional methods, is a priori reduced to the

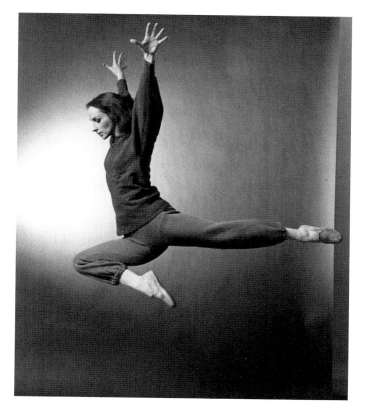

2.1 (facing)
Merce Cunningham, from the Choreographic Records for *Winterbranch* (1964). © Merce Cunningham Trust. All rights reserved.

2.2
Carolyn Brown in Merce Cunningham, *Winterbranch* (1964); costumes, makeup, and lighting by Robert Rauschenberg. Photograph by Jack Mitchell. Reprinted with permission from Craig Highberger for Jack Mitchell.

categories of an abstract, conventional system."[30] Bernard is emphasizing here that the system by means of which a body is divided into units for the purposes of the chance procedure is overdetermined by a historically specific way of viewing the body, coded graphically by means of conventional signs. Cunningham clearly knew how deeply his own manner of perceiving the dancing body was limited by his training, and thus by his historical situation. (Otherwise, he would not have sought so many different ways to overcome that training and that situation.) The factors he chose to submit to chance—for example, in *Summerspace* (1958), *par terre*; *en planche*; *en l'air*—are those he was most familiar with as a dancer trained, at a certain moment in time, in the Martha Graham method and at the American School of Ballet. Bernard is right to underscore that Cunningham could not escape from his habitus, his acculturated body and the (historically specific) conventional modes of viewing, isolating, and graphically symbolizing that body's various parts. But it was precisely Cunningham's understanding of these limitations that made the randomized permutational and combinatorial procedures necessary. Inserting conventionally determined units into a counterintuitive, unconventional continuity is at the very heart of his adventure, one that required both the conventional symbols that inscriptive systems provide and their fixation on a durable surface that the paper support invites.

Summerspace

One of the richest sites for investigating Cunningham's use of writing and symbolic systems is the collection of preparatory notes he made for *Summerspace*, composed over the course of the summer months while in residence at Connecticut College, New London, in 1958. (See plate 2.) With décor and costumes by Robert Rauschenberg, the dance was originally a meditation on space inspired by the large hall the company dancers rehearsed in at the college. (Ergo the title, *Summer*space). The studio shot in plate 2 shows the dancers together in combined positions that they never actually assume in the course of the work.[31] What the photo does reveal about the dance, however, is an ambition on the part of Cunningham and Rauschenberg that could not be realized during their lifetimes: to create an "all-over" effect by covering every surface of the stage with a variegated but homogeneous drop cloth. Here, in the confined space of the studio, Rauschenberg wraps the dancers in the pointillist backdrop he created with Jasper Johns by spraying Day-Glo paints through a stencil, thereby responding more fully to Cunningham's ideas as they were conveyed to the artist in a letter of 1958: "I have a feeling it's like looking at part of an enormous landscape and you can only see the actions in this particular part of it . . . like a landscape seen in the distance."[32]

What Cunningham's comments suggest is that he wanted his choreography to give the impression that the angle of the spectator's gaze was not a privileged one, that in fact that gaze could not be totalizing or panoptic. It isn't just that Cun-

ningham wanted to evoke actions continuing in
the erstwhile "beyond" of the wings, or that the
space of the stage had no center, no fixed coor-
dinates. He also sought to overlap actions in such
a way that they would establish multiple coordi-
nates for the dancers' trajectories, all activated
and meaningful at the same time. After a rather
tepid reception of the first performance, Cun-

2.3
Doris Humphrey,
from *The Art
of Making Dances*
(1959), page 82.

ningham remarked on the blindness of the audience: "It all passed in front of
them, but they couldn't see it."[33] *Summerspace* enforced a radical change in hab-
its of viewing dance. Vis-à-vis contemporaneous uses of the stage, Cunningham's
was, quite simply, illegible—in the strong sense of the term. *Audiences could not
read the stage.* They didn't know where to look or how to interpret what they saw.
The conventions in place at the time did not allow them to register trajectories
so intermingled, asymmetrical, and decentered.

Ever since court ballet was formalized in the mid-seventeenth century during
the reign (and with the participation) of Louis XIV, the stage space has been semi-
oticized, each quadrant given a specific meaning and invested with relative
power. The king could always be found at the center, with courtiers placed at
precise distances keyed to their rank. Until Cunningham appeared on the dance
scene in the mid-twentieth century, modern dance had not substantially dis-
placed this hierarchical reading of the stage. Doris Humphrey, in her famous
manual on choreography, *The Art of Making Dances*, reiterated what had already
been established by generations of ballet choreographers: that stage space is hier-
archical and that each area "naturally" has its own meaning. The graph from her
book (fig. 2.3) reflects this conventional view, one inherited largely from court
ballet.

According to Humphrey, position 1, at stage center, is the most commanding
point of the stage. Other "strong areas" include positions 2 at the back corners
(upstage right and left, away from the audience); positions 3 at the front corners
(downstage right and left, closest to the audience); position 5, directly in front
of 1; and position 4, directly behind 1. The blank circles in the diagram mark are,
for Humphrey, the "weak areas" of the stage.[34] These "natural meanings of stage
space" tell the spectator not just where to look but also what to think of the danc-
ers inhabiting these "weak" or "strong" spaces. From a traditional choreographic
point of view, even the directions taken by the dancers—their trajectories across
the stage—contain meanings. In another diagram from *The Art of Making Dances*,
Humphrey indicates that a figure moving forward toward the audience (from
upstage to downstage) attracts the attention of the spectator to the "potent cen-
ter"; however, once the dancer has crossed that center and moved further down-
stage toward the audience, the dancer loses the enchantment that greater dis-
tance had earlier ensured.[35] (See figure 2.4.)

2.4
Doris Humphrey,
from *The Art
of Making Dances*
(1959), page 81.

If we compare Humphrey's diagrams to those of Cunningham, we get a sense of how different his approach truly was. In *Summerspace*, he was also concerned with trajectories across the stage, but as opposed to Humphrey, he did not code them in advance as bearing a particular meaning, nor did he designate certain areas of the stage as "strong" and others as "weak." He was, however, intrigued with the trajectory as a choreographic element, and it was with the idea of multiple and intersecting trajectories that he began making *Summerspace* in July of 1958. In the account he gave in *Dance Magazine* of 1966, he observed that "the principal momentum" behind the dance was "a concern for steps that carry one through a space, and not only into it."[36] He especially sought movements for his gamut that are locomotive rather than decorative, although as he proceeded he added plenty of visibly striking postures and details to the raw chance results.

Would Cunningham have been able to imagine decentering the stage in the way he did if he had not had the tools of inscription at hand? I believe that he was largely successful at dissociating trajectories from their conventional narrative and psychic weight because he could *first* imagine them as lines on a page. He began his "procedure" for the composition of *Summerspace* by tracing out a chart that divided the dance stage into six points—downstage right, middle stage right, and upstage right; downstage left, middle stage left, and upstage left—before he drew in the trajectories connecting the points. (See figure 2.5.)[37]

Based on the opening two phrases of the dance, I would speculate that the diagram reproduced as figure 2.5 represents the stage from the perspective of the dancers; that is, point 6 is upstage right with the dancers' backs to the backdrop, and point 1 is closest to the audience to the dancers' left. The diagram, like a map, clearly helped Cunningham figure out exactly how many paths could be created between the six points; it served as an aid in imagining and enumerating ambulatory possibilities that he might not otherwise have seen. Cunningham writes in his account of the dance's evolution that the "movement gamut for the piece was quite simple. From each number in the piece to each other number went a line (i.e. 1 to 1, 1 to 2, 1 to 3, etc., to 6 to 6). 1 to 2 presumed the reverse of 2 to 1, so there were only 21 in all."[38]

In effect, though, the movement gamut was far from "simple." What Cunningham probably meant was that the gamut of possible trajectories across the stage was limited by the number and location of the points he had chosen. The actual movement executed during the trajectory turned out to contain far more than "simple" walks, runs, and leaps. A page found in the notes for *Summerspace* marked "Procedure" reveals the number of complexities he introduced into the movement palette. Each element—how fast; how to "go through space"; how

low or high ("par terre," "en planche," "relevé"); how many dancers; whether together or separate; and length in seconds—would have to be determined by a "throw" of a coin (Cunningham refers in the Procedure page to "coins" and "heads" and "tails"). (See plate 1.) Cunningham reproduced a version of his Procedure page in the 1966 article for *Dance Magazine*, "*Summerspace* Story: How a Dance Came to Be." Here, he drops the variable "if [they] move/if not what?" (see plate 1) and replaces it with another: "Did they end the action on or off the stage?" Both address the issue of the stilled dancer. Cunningham appears to have been entertaining the idea of trajectories that end near but not exactly at the numbered point indicated in the diagram. He was already thinking in terms of poses rather than trajectories, for if a dancer does not exit, she can either start a new phrase or hold a position while another phrase is begun by someone else. Although *Summerspace* is a dance about continual movement, there are a surprising number of moments when dancers remain onstage held in place. Of course Cunningham's overall intention was to explore crossings, to revel (after a career of cramped studios) in the luxury of extensive rehearsal and performance spaces that Connecticut College offered. But during the process the various crossings, traced first on the paper, began to suggest sculptural groupings in a three-dimensional space. That is, Cunningham began to see the paper as a field evolving *in time*.

Working for the most part with each dancer individually, teaching each trajectory one by one, Cunningham created, as he put it, a "sense of beings in isolation in their motion, along with the sense of continuous appearing and vanishing."[39] At times, the toss of the coin would produce crossings, encounters, and groupings ("how many dancers"; "whether together or separate"). At least theoretically, it was entirely arbitrary if and when these encounters would occur, encounters that would add an element of drama to the choreography by drawing the spectator's attention to one action (and one part of the stage) in particular. Finally, the other effect that resulted directly from Cunningham's use of diagrams and lists was that dancers would at times have to shift without warning or transition from one tempo to another, switching the pace of the dance for no apparent narrative or kinesthetic reason. Pace was also a variable Cunningham wanted to explore in the dance ("how fast"). Originally, before he came up with *Summerspace*, he had been planning to call the dance *Velocities*. The word *pace* remains as an echo in the final title: *Summer*space.[40]

The Procedure page is the closest Cunningham came to making a "score" for a dance. It is a score, however, only insofar as it resembles a set of instructions, as in Yoko Ono's *Instruction Pieces* or George Brecht's *Event Scores* (all produced in the early 1960s).[41] In contrast to these two types of works, Cunningham's instructions are only the first step in a long process of instruction-based composition. They are guides to further procedures, a kind of master list of operations that must be completed before the dance can come to life. Once he had drafted

the Procedure page, the next step would be to determine each variable listed on the that page, one by one. Indeed, the folders for *Summerspace* include many such lists, pages filled with calculations, each set of which works out another element that had to be determined in order to fill in the contours of the trajectory concerned. First, the trajectory itself: Cunningham associated a certain kind of movement—hop, turn, triad steps, slide, runs, and so on—with each trajectory. (See figure 2.6.)

Next, Cunningham worked out a phrase based on the fundamental step selected for each trajectory and listed them in order. To clarify: it was the choice of the generic content of the phrase—that is, it had to contain a "run"—and not the precise steps within the phrase that he left to chance. We should recall that he is assuming the perspective of the dancer, keeping what would be the back of the stage closest to him as he draws. The paper and the marks it contains obey a spatial imagination nourished by a corporeal experience of the stage. At the same time, though, Cunningham decides to number the spaces on the rectangular stage counterintuitively, making spots "1" and "2" furthest from him (and closest to the audience), as though the pull of the top of the page (not the stage) made him start in the upper left-hand corner (the way you would begin to write a letter, for instance). Darby English has referred to this oscillation between seeing the page as a piece of paper and seeing it as a stage as "a call and response with writing."[42] This is an illuminating way to think about how the tools of mark-making work for Cunningham, how they serve his purpose: he enters into a kind of dia-

triad phrase markings (handwritten choreographic notes):

SS

1	2
3	4
5	6

• = physical
□ (around no's) = mental (i.e. 1 to 2)

- 1 to 1 – triads in circle ✓
- 1 to 2 – triad phrase #1
- 1 to 3 – triad phrase #2
- 1 to 4 – brush hop phrase #3
- 1 to 5 – tours
- 1 to 6 – triad-turn & side-leap phrase #6
- 2 to 2 –
- 2 to 3 – arc. hopping on one foot
- 2 to 4 – leg-lift phrase #4
- 2 to 5 – slide phrase
- 2 to 6 –
- 3 to 3 – walks, runs, leaps or skips ✓
- 3 to 4 – turn & leg swing phrase #7
- 3 to 5 – tours in single, double, triple
- 3 to 6 – triad + attitude phrase #5
- 4 to 4 – step-close & split jump ✓
- 4 to 5 – triad-turn & arabesque tour
- 4 to 6 – plunge & attitude
- 5 to 5 –
- 5 to 6 – lean phrase
- 6 to 6 – triad & jump phrase

2.5 (facing)
Merce Cunningham, from the Choreographic Records for *Summerspace* (1958): map of stage with six points.

2.6
Merce Cunningham, from the Choreographic Records for *Summerspace* (1958): steps for trajectories.

logue with the perceptual mode conditioned by writing on a flat surface, allowing its "call" to incite his kinetic "response." We can see how this mode of perception—mobilizing visual and kinetic faculties—is brought to bear on another of the variables he had to contend with: the shape of the itinerary that would transport the dancer from one spot to another. By tossing a coin (or coins), he could determine how the two end points of a trajectory would be connected, as in the second phrase of *Summerspace* in which a solo male dancer travels from point 6 to point 1 in a turning phrase that Cunningham describes as "triad-turn and side-leap-phrase" in figure 2.6. Figure 2.7 shows his effort to imagine the kind of formations (turning, running, etc.) that could be danced between points by working them out first on paper in the form of lines and squiggles. He gave himself a variety of choices: the distance between the two points could be traversed directly, in a straight line; in a set of repeating circles (which translates as turns); in a kind of meander with sharp angles; or in an undefined angle. Note that due to the two-dimensional format of the paper's surface, he had to shift his perspective to the bird's-eye view.

In addition, Cunningham had to determine whether the movement would be executed *en l'air*—which meant a leap or in *relevé—en planche*—at the level of the

walk—or *par terre*—on the floor. Further variables included how many dancers would be involved and how many seconds the action would take to complete. In figures 2.8 and 2.9, we see how he collected all the elements together, each one presumably arrived at by chance means.

The order of phrases that he obtained by using chance—listed in figure 2.8—is roughly the order he used for the opening of the dance. It is interesting to observe, however, that Cunningham felt it necessary to add "free" phrases in between some of chance-determined phrase sequences. These free phrases were necessary in order to get a dancer from the point on the stage where one trajectory ended to the point where the next one began. For instance, the free phrase inserted between phrases 3 and 4 takes the dancers from point 4, where they finish phrase 3, to point 5, where according to the chance-determined result they are supposed to start phrase 4.[43] Throughout the dance, Cunningham had to insert these transitional phrases, which were "free" insofar as he could put in them whatever he liked. What was pre-scripted about these transitional or free

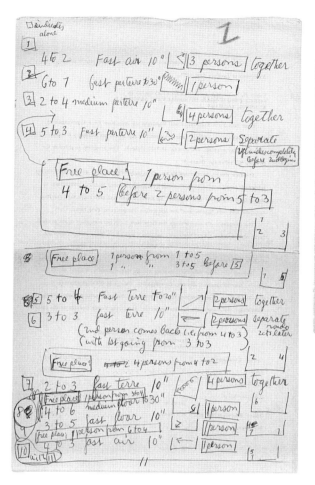

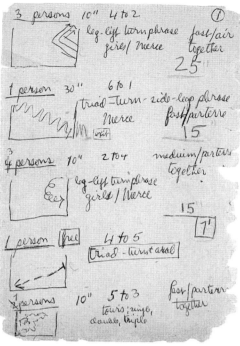

phrases is where they would begin and end. Again, it was the dancer's trajectory across the stage that was most severely restricted by the throw of the coin.

The notes for *Summerspace* tell a story all by themselves, one in which a hero—the choreographer—must obey commands and overcome obstacles to create a work he can sign. Cunningham emphasized in an interview with Jacqueline Lesschaeve around 1979 that for him, it was never just a matter of blindly following instructions, of leaving everything to chance. On the contrary, he remarks,

> I never thought and still don't, that dancing is intellectual. I think that dancing is something that is *instinctual*. No matter how complex something I make or do may be, *if it doesn't come out as dancing* it's of no use. I don't care about the diagrams—those are things that one does, that I need to do often with my pieces because of the complexity. But that's only paper work—you have to get up and do it. [You have to] get out there and work on it, otherwise it never materializes: it doesn't come alive. And what then is the point?[44]

Here, Cunningham is defending himself against the accusation that his work is inorganic and mechanical, as opposed to organic and "instinctual." But wasn't the instinctual, the reflex-driven, precisely what he was trying to avoid? Wasn't the entire point of Cunningham's adventure to go beyond what had been considered "dancing" up until then? Didn't he want to disturb the spectator's perspective (as well as his own) to offer not only a new way to see but also *something new to see*?

In 1958—and, I would wager, at whatever point in his career—Cunningham could not abandon all control over the ultimate shape and look of his dances. This was not simply for practical reasons. To be sure, it was harder, as Cage once remarked, to give chance free reign if it meant that dancers would end up crashing into each other as they cross the stage.[45] And as we see in Cunningham's preparatory notes, he did have to make practical decisions concerning how to adapt the "continuity," or order of phrases/trajectories, to what it is possible for human beings to do in space. Yet a plethora of small choices along the way transformed *Summerspace* from a bunch of lists into "dancing" as Cunningham understood it in 1958 ("if it doesn't come out as dancing it's of no use"). If we watch the film version of *Summerspace* made by Charles Atlas in 2001, we find that the choreographer followed closely the order of trajectories as they appear in the notes; however, he also introduced a number of steps and poses that no written document contains.[46] (Even Margaret Jenkins's 1965 notation of the dance [in the *Summerspace* folders] fails to capture much of what goes on in the film.) For one thing, as in *Walkaround Time* (1968), Cunningham exploits the moments when two dancers find themselves at the same place at the same time. As he suggests on the dance's Procedure page, "if togetherness happens," a duet could ensue. But he does far more than just follow the prescriptions of the Procedure page. The dance includes multiple duets in which men and women touch each other; they cultivate a physical contact that none of the variables alone—or combined—could produce.[47] Further, he adds small hand movements to ornament and add visual interest to a streamlined or "simple" leap; and he situates a dancer (or dancers) in a sculptural pose that can best be appreciated when viewed from a frontal perspective.

Finally, it is not insignificant that Cunningham also felt it necessary to add an entrance, the phrase that occurs at the very beginning of the dance. In this entrance, predetermined by no toss of the coin, a female dancer emerges from upstage to run swiftly in a large circle, tracing the full circumference of the stage. Like a magician defining her space of divination, a surface on which signs will soon be read, the dancer enters from point 1 and returns, after the longest trajectory possible, to point 1.[48] Although not included in his final *written* continuity, the circular run circumscribing the symbolic space of the stage echoes the first trajectory Cunningham worked out on paper: point 1 to point 1. (See fig. 2.5.) This

circular run seems to emanate *from* the paper, from the logic of the surface it provides. And yet there is one aspect of the run that cannot be transduced or anticipated by writing, and that is its *pace*, one of the "velocities" that inspired the title when he first began the project. Indeed, all the variables Cunningham could write down and determine by chance were subordinated in his mind to the play of velocities, the superimposition of tempi, that he wanted the dance to be about. He could determine by chance whether a phrase would be "fast" or "slow"—a very schematic measure—but he could not determine the exact rhythms of the phrases, the relative speeds of the trajectories. These were all a matter of a timing that Cunningham had to add later, after the layered calculations had been worked out. Once the dancers began to *perform* the inscriptions, the timings had to be modified. They were then fixed for those performers, but perhaps changed again when performed by others, as Cunningham's notes for later reconstructions suggest. (See figure 2.10.)

It appears that when Cunningham started to plan his procedure, he anticipated a period of ten to thirty seconds for each trajectory. But as we see in figure 2.10, the velocity of the movement as it was performed introduced small varia-

tions. These variations were, in turn, noted down and kept. Thus, the dancers, inter(in)animated by the initial inscriptions grafted onto them, in turn animated the script, responding to signs by signing their own time.

Biped

As a result of his experiments with mark-making, Cunningham's own notion of what constitutes "dancing" evolved. By making extensive use of inscriptive techniques, he managed to produce something that only now, with the passing of more than half a century, looks (and feels) like dance. Procedures like those used in *Summerspace* permitted him to train generations of dancers to move in ways that seemed unnatural back in 1958, and thus to forge bodies physically and kinesthetically different from those of other trained dancers of that era, bodies attuned in new ways with respect to the space of the stage and what could be done on it.[49] In addition, he managed to train new generations of *viewers*, whose ability to see dancing was in many respects amplified. Throughout his career, Cunningham first challenged himself, then his audiences, to accept dances built on something conventionally thought to be outside the art form known as dance. He began with mark-making, grafting it onto bodies so that they could grow in new ways. These new ways eventually became habitual to him (and his audiences). His wager was that something more could be teased out of the body, some other way of moving that the given *techne* hadn't yet divulged. So eventually he turned to video, which, he noted, "gives opportunities of working with dance that are not available on the stage."[50] From *Westbeth* (1974–75) onward, he began choreographing for and with the video camera, finding that it changed how he approached space, movement, and time. Like television, video montage exaggerates the sense of discontinuity he had always sought, providing inspiration for conceiving the dance as a series of abrupt changes resembling those produced either by cutting (as in film and video) or channel surfing (as in TV). *Roadrunners* (1979), for instance, was composed of "short things that happen and disappear and other things that come in"; it was "closer to TV than anything I had made before."[51]

By 1989, Cunningham was gaining interest in yet another system for registering and generating movement: the software program known as LifeForms, developed in 1986 by Tom Calvert, Catherine Lee, and Thecla Schiphorst at Simon Fraser University.[52] *Trackers*, premiered in 1991, was his first experiment in computer-assisted choreography. Clearly intrigued, Cunningham continued to use LifeForms as an interface for testing movement sequences before mounting them on his dancers. The program worked by dividing the human body into fourteen segments that could be combined and sequenced in many ways. At least at the beginning, all the movements stored in the software menu of LifeForms (like all those he had preserved as written lists for *Summerspace*) were derived from movements Cunningham himself had—or could have—performed, although the

sequences made of them were not.[53] He chose the movements for each part of the dancer's body from his favored dance vocabulary (starting with leg positions, then adding arm positions), storing them in the menu. The first version of Life-Forms permitted him to enter only individual poses, like a set of photographs, so at first he was obliged to continue tossing coins to build the entire phrase.[54] Later, he would compile phrases by means of a sequence editor, trying them out on animated figures that could be manipulated onscreen. But again, to transform them into what Cunningham considered "dancing," he had to graft the inscriptions onto living bodies, potentially modifying them in the process. Schiphorst recounts that "when these movement sequences appeared physically impossible, Merce would work with his dancers at discovering how they could be made to work."[55] The modified sequences ("made to work") might then provide the material for later ventures with more refined versions of LifeForms, platforms that rely on motion-capture technology (and thus a closer approximation of real-time movement—itself informed by the earlier technology) in a recursive pattern with which we have now grown familiar.

In 1997, Paul Kaiser and Shelley Eshkar of Riverbed Media invited Cunningham to test their new motion-capture computer animation software program titled Biped, named for the two-footed avatar the programmers had invented. When projected on the computer screen, the Biped avatar appears more "life-like" than the earlier hoop or concentric-circle figures of LifeForms that divide the human figure into fourteen discrete and disconnected parts. Biped is based on a sophisticated apparatus of motion capture capable of accounting for "detailed 'kinematic' effects, including skin and tendon behavior."[56] Apparently, even a "foot landing on the ground" and the reverberating transformations effected throughout the rest of the body (inverse kinematics) can be registered, entered into the program, and reproduced onscreen. The programmer's segmentations of the animated figure, its "shapes," and the connections between them are still, of course, approximations, extrapolations from articulations of the human body. But Biped can take as its primary building blocks entire phrases (and not just still poses) danced by living human beings who transmit their positions in space by means of multiple sensors attached to their bodies. These sensors then compose a moving screen image that, over the years, has become incrementally—if asymptotically—closer to what we see with the naked eye when we watch a human being performing the same movement. Intervening in identical reduplication of the human is the interface itself, which must make its digital cuts according to differentiations it can recognize. These differentiations may be subtler, but they still cut up the body according to culturally, historically, and technologically specific modes of perception. To cite Michel Bernard again: "The way in which a dancing body is decomposed into units . . . corresponds to a particular perceptual mode."[57] Whether human movement is approximated by means of stick-figure drawings, geometric symbols, verbal descriptions, fourteen-

sectioned avatars, or sensors that can register reverse kinematics, there is always a mode of perceiving the body peculiar to the technology involved, one that calls for and is altered by a performative supplement. It is the performance of the pre-scripted movement that forces the various inscriptive systems to evolve, to extend themselves by inter(in)animating with the human body. As a result of interfacing with a technology, the human body itself changes; but because those changes cannot be predicted, the next generation of the technology must gain further discriminations in order to encompass what that body has and might become.

Kaiser and Eshkar's Biped equips the user to make a kind of blueprint of sequences performed by an animated avatar, but it also allows that individual to make an actual animated film, what Steve Dixon has called "a discrete 'movie'" that can be projected on a scrim during the live performance.[58] Cunningham decided to produce precisely this kind of multimedia event in 1999. In his own *Biped*, the dances of the avatar—which look like mobile charcoal sketches in different colors—were projected on a scrim, behind which the live dancers performed Cunningham's choreography. The avatar dances were generated by capturing the motions of three Cunningham dancers by means of reflective markers adhered to their joints and body parts. Once again, Cunningham allowed an unknown factor to enter his experience of watching the dance: he did not see the dances of the avatar until they were projected on the scrim at the time of the premiere, performed in Berkeley in April 1999. The projection intervals were determined by a chance operation so that no two performances would be identical. Thus, during *Biped*, live dancers dance to an unpredictable visual accompaniment, just as earlier they had danced to an unpredictable score.

The effect of the software interface on Cunningham's choreography is a subject that has been well treated by Roger Copeland, Thecla Schiphorst, Stamatia Portanova, and others. According to Copeland, for instance, "By the time of *CRWDSPCR*, we begin to see movements on stage that look as if they've been directly influenced by the shapes and rhythms of the Life Forms wire-frame figures. . . . As early as *Trackers*, the unusual walking rhythms resulted from experimenting with the spacings between walking step patterns that already existed in the Life Forms 'menu.'"[59] Likewise, Portanova claims that after 1991, "footwork becomes the main component of the performance, and the position and movement of the arms appears as an added element."[60] Schiphorst, too, observes changes in Cunningham's emphases immediately after his adoption of LifeForms software. In a 1992 interview concerning the development of motion-capture systems, she explains that the program tended to make the choreographer think primarily in terms of space and sequencing rather than rhythm and dynamics.[61] Interestingly, during this same interview she tells Cunningham that software could be developed to record what Rudolf von Laban called "effort qualities."[62] Apparently, however, the choreographer showed no interest in that functionality,

not simply, I believe, because he did not think in terms of effort qualities but also because *such qualities were specifically what he could count on his dancers to produce.* As always, he refrained from telling the dancer *how* to perform the movement—with what Laban called bound flow or lightly weighted, for instance—and instead concentrated on *what* the dancer should perform. He was concerned with clarity, not emphasis. Ironically, the reduction of each movement to a number, sketch, or algorithm did not preclude the dancer's addition of effort qualities. On the contrary, "graphic reductionism" *solicited* such qualities, called them forth, in that call-and-response pattern I referred to earlier. This is an important point, one that reveals a good deal about Cunningham's choreographic ethos. In 1956, while working on *Suite for Five*, he made an important discovery, namely, that the order of movements, or the continuity itself, could suggest to the dancer how it should be performed: "*Dynamics in movement come from the continuity*," he scribbled down, all in italics.[63] Effort qualities were thus never calculated by the software program developed for Cunningham *because Cunningham did not want them to be.* Ultimately, effort qualities, linked to rhythm and dynamics, remained largely the purview of the individual dancer. The dancers were not, therefore, "*softwareized*," as Portanova puts it, even if they were copying the movements of an avatar or the directives of a script.[64]

In fact, Cunningham made this point in an interview of 2005 when he stated that he did not want the "metrics" of the computer version to influence the rhythms and tempi of the actual dancing.[65] He still considered LifeForms (and its offspring, DanceForms) to be essentially forms of "notation," which he continued to "double" with his own written notations.[66] What the computer allowed him to do was something he had already sought to do with other inscriptive systems: divide up the full range of movement into units that could then be permuted via the discriminations the notational system was able to provide. The computer gave him the extra advantage of being able to view—before trying out—the continuity on a screen avatar. "It's a continual balance of making and looking," he stated in 2004. Just as he had looked at his dancers as they executed the phrases he had earlier made by means of chance procedures, so too with Life-Forms he devised a phrase on the computer, then watched the dancers perform it, then remade it when he liked the changes they had introduced. "Oh, keep it!" he would say when he saw the result of the modifications two dancers brought to their overlapping sequences, invented on two different screens but now, sharing the same space, becoming "sequences in relation to each other."[67]

On balance, then, I think that it would be incorrect to say that the computerization of the choreographic process obliged Cunningham's dancers to acquire what Copeland has characterized as "the emotional reticence and the palpable physicality of objects" (no more so, in any case, than in *Walkaround Time*).[68] "Emotional reticence" and a cold "physicality" may have been performance qualities that sneaked in during a short period of his choreographic output when

he was arguably more invested in testing out his new toy than in encouraging his dancers to respond creatively to its capabilities. Ultimately, though, Cunningham still allowed his dancers to adapt the computer-generated sequences to their own bodies. How could he not? It was inevitable that individual dancers—the "person" dancing—would inflect sequences invented by a program.[69] Equally inevitable, however, is that sequences initially tested on an avatar would retain something "genderless," as Copeland has put it, something otherworldly.[70] *Biped* is perhaps one of Cunningham's most intriguing dances because it superimposes the "effort qualities" of a genderless, centerless, joint-generated, virtual avatar on the living, breathing, emoting, racialized, ethnicized, and gendered body of an individual dancer. Some of the phrases of *Biped* do seem utterly divorced from those found in the habitus of any culture we know. As Portanova notes, the abstraction offered by any inscriptive system allows "a certain distance from social or cultural norms"—but for Cunningham, *this was always the point*.[71] For a "certain distance from social or cultural norms" is not the same thing as a "certain distance" from the human. Cunningham, in fact, felt that the inscriptive interface allowed him to move *closer* to the human, to reach beyond gestural regimes ("the particular habits of my own practice") toward a human motility not yet defined.[72]

In 1968, Cunningham described his exhilaration as he watched Joan Skinner during a rehearsal take on a notoriously difficult sequence of movements, seamlessly threading one movement to the next by means of her own crafted response. According to him, Skinner introduced a type of "coordination, going from one thing to another, that I had not encountered before, physically."[73] This type of coordination—necessitated by the arbitrary order of the things coordinated—struck him as aesthetically interesting precisely because it reflected neither a cultural nor a professional norm. That is, moving as Skinner did was alien to both the bodily *hexis* of a twentieth-century American woman and the bodily *hexis* of a twentieth-century modern dancer.

Cunningham must have felt a similar emotion as he watched *Biped* from the wings in 1999. He would have been exhilarated by the otherworldly coordination of his company members as they danced against the backdrop of their cybernetically created partners. The sequence near the beginning of the dance provides a telling example of technological intergrafting as it affected the coordination of the dancers almost fifty years after Cunningham first observed Skinner, "going from one thing to another," in what was probably a section of *Sixteen Dances for Soloist and Company of Three* (1951). At approximately five minutes into the dance, we see three women and two men emerge from the black backdrop to perform a phrase in a unison that is anything but strict.[74] (See plate 3.) Whereas the two avatars ("dancing" on a larger scale, on a higher plane) sketch out identical mirror images, totally in sync with each other, the five dancers struggle to remain in unison. Through their deviations from the cybernetic ideal, they suggest not only their individual humanity, their distinctive personhood,

but also—and thus—their potential to enter into relation. Although at this point in the dance, the dancers do not touch or initiate anything that looks like intimacy, nonetheless their very disunion is an invitation to encounter. This encounter occurs a minute later in a male-female duet (danced by Thomas Caley and Banu Ogan in Charles Atlas's 2005 film). Indeed, ensemble numbers frequently resolve into duets, creating a kind of systolic/diastolic rhythm in which separateness alternates with imbrication. There is nothing genderless about the dancers in these duets, even if the dancers are sometimes the same gender, and even if their movements are (roughly) identical, drawn from the same movement resources of the sequence editor.

A few minutes later, we witness another set of phrases that, while recalling no "social or cultural norms," also differ substantially from what the avatars are doing simultaneously, or in syncopation, on the scrim. These phrases include some of the most elegant and ethereal sections of the dance. The combination in rigorous succession of an arch paired with a *relevé*, then with a *passé*, then with an *arabesque* is so physically demanding as to seem impossibly virtuosic, even unreal, given the serenity of the dancers' countenances during this explosion of energy and grace. Banu Ogan's extensions of the spine remain fully executed despite the changes in leg position suggested by the sequence editor. In executing these repeated arches of the torso (above a changing lower body), Ogan seems to evoke an android litheness. What is exhibited here is quintessentially bipedal: pure vestibular virtuosity in the form of a spine suspended and balanced precariously on an extended toe. Yet it is not that Cunningham's dancers have achieved—or descended to—the order of the inhuman; they have not become imitations of an essentially cyborg motility. Rather, Cunningham's dancers have captured an exquisite potential of human bipedalism itself: its ability to continue evolving, to continue intergrafting, while remaining truly "one." The dancers' gestures appear "as if jabbed by an electric current," as Cunningham puts it, because they *have* been jabbed by an electric current. Here, we witness the inter(in)animation of the human body, or, put differently, *an augmentation of its power to be affected*. The goal is not to make the dancer look as though she were riding an energetic wave (as in the work of William Forsythe); rather, the goal is to make it seem as though she were executing an operating chain, following the course of what might look unfamiliar but is actually lived on the order of the body as habitual because it has been repeated a brutal number of times. The work on the body that occurs during the arduous months of rehearsal mirrors the process whereby a young body assumes a culture-specific bodily *hexis*. Cunningham's practice has a critical edge, then, for it implies that any bodily *hexis* is to some extent inorganic, grafted onto something conventional and arbitrary—in short, a matter of chance.[75]

Nine Permanent Emotions and *Sixteen Dances*
Drama in Cunningham

In 1968, the dance critic Edwin Denby remarked that Cunningham, while no longer interested in making narrative or symbolic works, nonetheless continued to manifest his "very large dramatic imagination" in different and unexpected ways. "From the start Merce was an extraordinarily dramatic dancer," Denby recalls in his appraisal for *Dance Perspectives*. According to him, Cunningham possessed a remarkable dramatic presence:

> Even though he later give it up, it still is quite strong when he wants to use it, as he did, for instance, in *Sixteen Dances* in an abstract way, and as he does from time to time in the current repertory—in the soft-shoe dance, for instance, that everybody remembers. But also he can suddenly turn a strictly neutral lyric abstract sequence of movements into a dramatic situation by the force of his dramatic imagination. You see this appear and you see it disappear again in the piece, and the shift is very light and wonderful.[1]

Here, Denby singles out *Sixteen Dances for Soloist and Company of Three* of 1951 as a dance in which Cunningham deploys his "dramatic imagination" in an "abstract" way. By "abstract," I think he means that the dramatic moments he discerns cannot be tied down to a literary referent or a familiar scenario. As a member of the generation that sought to create what critics have termed a "non-representational" theatre, Cunningham clearly attempted through a variety of methods to confound elements of plot.[2] Yet Denby still finds in his work moments of dramatic intensity supposedly divorced from representation or narrative. Denby is on to something important here, something that has been noted by other critics but never pursued in a rigorous way.[3] Building on Denby's observations, I will argue in this chapter that in almost every dance Cunningham choreographed, there can be found the kinds of shifts (from "neutral" to "dramatic") he associates here with both *Sixteen Dances* and *Antic Meet* (the dance of 1958

containing the memorable soft-shoe routine). I speculate that in any given choreography there is a dominant mode—say, chance-derived continuities, or the random sequencing of steps—and a subordinate mode—such as pantomime or lyric expressivity. That is, even in the least explicitly dramatic dances, representational and/or expressive modes are intermittently present in small but potent doses.

Choreographed during the 1950s, *Sixteen Dances* and *Antic Meet*, the two dances I will study more closely, can be said to trouble the boundaries of modern dance at a time when Cunningham's reputation in the modern dance world was hardly secure. Both were ground-breaking in their own way: in *Sixteen Dances*, Cunningham used chance procedures for the very first time; in *Antic Meet*, he and John Cage inaugurated the method of collaborative noncollaboration that would characterize their joint works from that point on. And yet, as provocative as they were, both works draw heavily from a highly conventional dramatic form—not just vaudeville in the case of *Antic Meet* but also, and more profoundly, classical Hindu dramaturgy. Cunningham's Choreographic Records (his working notes as well as photographs and letters) indicate that the *rasas*, or "permanent emotions," of classical Hindu drama served as inspiration for *Sixteen Dances*, *Antic Meet*, and, as I will demonstrate, a host of other dances he choreographed throughout his long career. Why might he have turned to classical Hindu drama in the early 1950s? Was there something in his earlier training as an actor that might have predisposed him to take an interest in the *rasas*? Did classical Hindu drama provide him with the necessary cover to indulge his "dramatic imagination"—as well as his strong interest in theatre—at a time when modernist antitheatricality was at its height?

This chapter is one of two that will examine the dramatic in Cunningham's oeuvre. Whereas earlier I was concerned with the ways in which he mobilized the arbitrary results of chance procedures to circumvent literary and dramatic associations, in this chapter my focus will be on those moments when drama nonetheless returns. I will attempt to understand his turn to classical Hindu drama in the 1950s as well as the lasting influence it had on his movement choices. In chapter 7, I turn to the decades of the 1960s and 1970s, when Cunningham's approach to the theatre was shaped by different pressures. In both chapters I am concerned with how dramatic modes function not to narrow his choices but rather to open spaces in which to explore alternative plots.

"There *Is* More to See (Perceive) Than Steps" (Carolyn Brown)

At the Cornish School in Seattle, Merce Cunningham received what was, outside New York, the purest training in the Stanislavsky method available in the United States during that period. From 1937 to 1938, Alexander Koiransky, the former Moscow Art Theater member, taught courses there in an acting method that

Cunningham described later as "very straight Stanislavsky."[4] Koiransky had worked primarily as an artistic designer for Konstantin Stanislavsky's productions in Moscow, but after emigrating in 1922 he went on to stage and direct many plays in the United States. He was the ghostwriter of Stanislavsky's *My Life in Theater* and worked closely with Richard Boleslavsky, another Stanislavsky-trained teacher who would leave his mark on the American stage and screen of the prewar period.[5] In an interview with David Vaughan, Cunningham recalls that while at the Cornish School he performed in two of Koiransky's productions, Molière's *Le Bourgeois Gentilhomme* and Chekhov's *The Cherry Orchard*. Although his apprenticeship with Koiransky was brief, we can be fairly sure that he learned at least the rudiments of an acting style associated today with the interrogation of a personal affective interiority.

Koiransky was one of several Russian emigrés from the Moscow Art Theater who worked to spread Stanislavsky's method throughout the United States during the 1920s and 1930s. Like Boleslavsky and Maria Ouspenskaya, also actors in the Moscow Art Theater who emigrated to the United States in the 1920s, Koiransky was a member of the first generation to initiate American actors in the method that Boleslavsky called, after Stanislavsky, the "Outward Means of Expression."[6] Koiransky's close association with Boleslavsky—in 1923 the two mounted together the first American Stanislavsky workshop in Pleasantville, New York—provides a clue to the kind of preparation in acting Cunningham received during his first year at the Cornish School. Establishing what this preparation might have entailed is important for understanding his relationship to drama and, more pointedly, his later receptivity to the classical Hindu *rasa* theory found in the ancient text *Natya Sastra*, which would serve in the 1950s as an alternative to Martha Graham's potent brew of psychic self-exposure and mythic characterization. Cunningham's formation in the theater—from his early days in provincial vaudeville to his more advanced studies in acting technique—provided experiences that had a lasting impact on his approach to acting in dance or, more broadly, to dance as a discipline drawing from skills associated with theatrical training and the building of an inner motivation for behavior onstage.[7]

During his formative years, Cunningham was exposed to a wide variety of theatrical practices. By 1951, when he turned to choreograph what was at that time his most ambitious work to date—*Sixteen Dances* is fifty-three minutes long—he had acquired a formidable collection of methods for constructing live performances before an audience. An adolescence spent performing in music halls left him with skills related to popular entertainment forms; two years of dance and theatrical training at the Cornish School provided contact with the Stanislavsky method as filtered through Koiransky as well as training in the Graham technique as filtered through Bonnie Bird; summers in Oakland, California, at Mills College exposed him to composition as taught by Louis Horst; readings in classical Hindu aesthetics introduced him to the notion of an "imper-

sonal" emotion conveyed by a conventional gestural vocabulary; and a summer spent in Asheville, North Carolina, at Black Mountain College in 1948 introduced him to the Bauhaus methods of Oscar Schlemmer and Antonin Artaud's Theatre of Cruelty. During the latter period, Cage's growing interest in the *I Ching*, Zen Buddhism, and experimental modes of composition placed pressure on Cunningham's acquired notions of choreography's responsibility to intention, communication, and meaning, all categories related to theatrical performance.

Little has been written on Cunningham's interest in classical Hindu theatre and dance, even though his appropriations were more than superficial and fleeting. Similar in this respect to Cage, he tended to accumulate and superimpose elements of different aesthetics rather than replace one with another in succession. However, Cage passed relatively quickly through his Hindu phase, borrowing (and, it could be argued, distorting) a few ideas from Ananda K. Coomaraswamy, then moving on to privilege new preoccupations.[8] In contrast, the theory of the *rasas*, or eight "permanent emotions" (plus the ninth, a state of tranquility), as presented in Coomaraswamy's texts remained an active and generative source for the choreographer.[9] Coomaraswamy's *The Transformation of Nature in Art* and *The Dance of Shiva* are the two major sources of Indian *rasa* theory that nourished Cage and Cunningham during the mid-1940s.[10] In his essay "The East in the West," Cage indicates that he, too, was indebted to South Asian themes and Hindu philosophy while composing the scores to both *The Seasons* (1947) and *Sixteen Dances* (1950-51). As time went on, both artists would turn increasingly toward "Eastern" models for inspiration. However, Cunningham was more taken than was Cage with the *dramatic* resources provided by classical Hindu drama.[11] He incorporated aspects of (Coomaraswamy's version of) *rasa* theory, not only into his "transitional work," *Sixteen Dances for Soloist and Company of Three* (1951),[12] but also, as we shall see, into the choreography of *Antic Meet* (1958), *Exchange* (1978), and *Fabrications* (1987).[13] It would be a mistake, then, to assume that when Cunningham began in 1951 to use chance procedures, he simultaneously abandoned all other compositional means and their related theoretical supports. Coin tossing was only one of a plethora of methods he developed, and Cage's critique of expression only one factor among many responsible for generating Cunningham's approach to the performance of danced movement.

It could be said of Cunningham, as it has been of Cage, that at one point or another he "subverted" all the aesthetic and philosophical systems he appropriated for his own use.[14] But this would not capture his evolving relation to his sources and inspirations. Textual sources in particular seem to have remained important to him over long periods of time.[15] Although in interviews he often insisted that his work was inspired by "steps" and not texts,[16] the fact is that iconic gestures and entire pantomimed episodes motivated by textual sources never disappear entirely from his movement vocabulary—despite the introduction

of LifeForms computer software as a compositional tool. Evidence from the archive indicates that Cunningham returned to a small number of source texts throughout his career. James Joyce's *Finnegans Wake* was one such source; Coomaraswamy's writings on the *Natya Sastra* was another. Further, his engagement with François Delsarte and other gestural codes and theatrical forms (Commedia dell'arte, vaudeville, Hollywood tap dance) provided him with a rich set of choreographic ideas that have hardly received attention.

Cunningham certainly had many opportunities to develop what Edwin Denby calls his "dramatic imagination" and establish himself as a man of the theater. In 1944, he even wrote a "dance-play," *Four Walls*, which was performed at the Perry-Mansfield Summer Theater in Steamboat Springs, Colorado, by Julie Harris and Cunningham himself, among others.[17] *Four Walls* is reminiscent of Ibsen in its focus on dysfunctional, ensnaring, and even sinister family relations, but its language is inflected by the portmanteau words and paronomastic wordplays of James Joyce. (Cunningham's version: "these straggling-made / idiot casualties that we call blood-bonds.")[18] *Four Walls* demonstrates Cunningham's early identification with dramatic situations and personae. His stage directions instruct the actors to use their bodily movements to evoke a certain mood ("A definite formalized movement feeling is established at the outset by the movement of the FATHER and MOTHER down the stairs") as well as the characters' internal conflicts ("The BOY is completely away from it inwardly, only observes it when convenient outwardly. The GIRL fights it inwardly and outwardly").[19] In *Four Walls*, Cunningham is working in the genre known during the period as the dance-drama, which places dance at the service of exhibiting a character and his or her *état d'âme*.

It was at the Cornish School that Cunningham first encountered the method of character development that systematically probes the relation between inner and outer worlds. Unfortunately, there are few extant records pertaining to his first classes in acting method there. What we do know is that he did not get along well with his acting teacher and soon showed as much interest in dance—which was an important part of the theatre curriculum—as in drama. A letter he wrote to his father during that period reveals that his relationship with Koiransky was anything but smooth.[20] The letter suggests, in fact, that it may have been Koiransky who sent him from the Theater to the Dance Department (although in other contexts he tends to represent this switch as his own decision): he was "kicked out of the drama-class play, & hence all the drama work," because he told "the jerky Russian who teaches drama" that he had to leave rehearsals to attend a dance concert.[21] Yet seventy years later, Cunningham would praise Koiransky as "a marvelous, extraordinary teacher" who gave him lessons in "very straight Stanislavsky."[22]

While it is hard to pin down precisely what phase of the Stanislavsky method Koiransky would have taught at the Cornish School, clues can be found. For

instance, Cunningham recalls that Koiransky had the acting students build their own sets; he thus continued the tradition he had been schooled in at the Moscow Art Theater (MAT). This seemingly incidental detail suggests that Koiransky was committed to transmitting the spirit of the MAT's early years. Its instructors from that period—from 1897 (the founding of MAT) to 1923 (when Stanislavsky came to the United States)—were devoted to developing a method known as "affective memory" (or sometimes "emotional memory," depending on the translation), based on Théodule Ribot's assertion that emotions generated by past experiences remain in the psyche and can, with the help of the five senses, be recalled.[23] Later, Stanislavsky would focus more intently on motivation, although from the start the identification of a goal in the formation of character was an essential element of his method. If we believe the approach to acting in dance that Cunningham developed for *Sixteen Dances* is indicative of what he learned at Cornish, then it seems clear that his "straight Stanislavsky" education included, and may have even privileged, Stanislavsky's concept of affective memory. What is affective memory, and how might it contribute to dance?

Stanislavsky's *An Actor Prepares* reached an English-speaking audience in 1936, just a year before Koiransky taught at the Cornish School. In his first effort to construct an acting theory, Stanislavsky explains that a well-developed "emotion memory" allows actors to "preserve what they have acquired through their intellectual, affective or muscle memory" and then to use these feelings toward the creation of a scene.[24] Stanislavsky invents a dialogue between a teacher and his student in which the teacher differentiates between "emotion memory" and "sensation memory," leading the astute student to inquire, "To what extent does an actor us[e] his sensation memories?" The teacher then launches into an explanation, indicating that the senses of sight and hearing are particularly important to the process of awakening the emotion memory ("to reconstruct" an impression).[25] Similarly, in the autobiography he wrote (assisted by Koiransky), *My Life in Art*, Stanislavsky emphasizes the necessity he felt during the prewar period to develop "an inner technique of experiencing" emotions by cultivating in actors the ability to recall and revive what they had assimilated thanks to their intellectual, affective, or muscle memory.[26] Only by studying their emotions on the "psycho-physical" level could actors come to "live" their characters onstage.[27]

Granted, Stanislavsky's method took various forms in the United States, but the affective memory exercises his disciples developed appear to have been among the constants of the approach as it made its way from coast to coast. The version of the Stanislavsky method that encourages actors to study their own affective responses and sensory impressions was handed down to the next generation of Stanislavsky instructors, notably those of the Group Theatre in New York City. Throughout the 1930s and 1940s, teachers such as Lee Strasberg and Elia Kazan assigned exercises requiring their students to recall "the entire sensory history" of an event—the state of the body, its sensations and external

behaviors—when undergoing a particular type of experience.[28] Cunningham may have rejected the aspect of Stanislavsky's method that centered on character and motivation, but I believe he retained Stanislavsky's emphasis on embodiment, the significance (and significant resources) of the actor's bodily memories, his full sensory and affective presence on stage. At the tail end of the 1930s, Cunningham's training in "very straight Stanislavsky" probably entailed close monitoring of his own affective states and their relation not only to felt emotions but also to outward forms, along with tracking the physical, gestural manifestations that these affective states produce. One of the most important consequences of such an approach to characterization is that it emphasizes the internal life of the actor—or, as the case will be, the dancer—and assumes that this internal life can inform the production of visually compelling gestures and actions.[29]

What, we might ask, is the relation between the "straight Stanislavsky" training Cunningham encountered at the Cornish School in 1937–38 and *Sixteen Dances for Soloist and Company of Three*, the first major choreographic project using both chance procedures and *rasa* theory, undertaken in 1951? Is there any relation at all?

To determine the relation between the "straight Stanislavsky" method (the creation of an interiority), the portrayal of permanent emotions (*rasa* theory), and the development of chance procedures (the interruption of plot by permutation), we need to look more closely at Cunningham's notes for *Sixteen Dances*. These notes reflect his familiarity with Coomaraswamy's texts in that they consistently refer to figures belonging to *rasa* theory—the Odious Warrior, the Heroic, Sorrow—and include a meditation on "the colors attributed to Rasas."[30] In addition, there are allusions to figures from Greek myth (Medea) and Northwest Indian religions (Medicine Man), which resonate with Cunningham's preoccupations of the same period. For instance, *The Seasons*, originally titled *Northwestern Rite*, also uses imagery from Native American rituals and dress; apparently, Cunningham based some of his costumes on photographs he found in a catalog on painting by Indians of the Northwest Coast.[31] Meanwhile, the reference to Medea in the notes indicates that in 1948, two years after leaving Martha Graham's company, Cunningham was still tempted by the archetypes of Greek tragedy: in that same year, he choreographed a narrative dance titled *Orestes*. Nonetheless, though drawing from many sources, *Sixteen Dances* was clearly choreographed under the sign of Coomaraswamy and his interpretation of the *Natya Sastra*: "The choreography," Cunningham states in an interview,

> was concerned with expressive behavior, in this case the nine permanent emotions of Indian classical aesthetic, four light and four dark with tranquillity the ninth and pervading one. The structure for the piece was to have each of the dances involved with a specific emotion followed by an interlude. Although the order was to alternate light and dark, it didn't seem to

matter whether Sorrow or Fear came first, so I tossed a coin. And also in the interlude after Fear, number 14, I used charts of separate movements for material for each of the four dancers, and let chance operations decide the continuity.[32]

The program notes to the early performances of *Sixteen Dances* did not offer this kind of explanation to audiences of the time. For example, the program for a performance on January 21, 1951, merely lists the configuration of dancers in each part: "Solo/Trio/Solo/Duet," and so on.[33] The audience, then, was not expected to be cognizant of the emotion represented by each dance. And yet the gestures Cunningham chose to represent those emotions are arguably conventional ones. As he explains in the same interview, "For anger, there was some kind of large, strident gesture; the warrior [ended up] shooting himself or hitting himself and crawling off the stage, making these terrible sounds."[34] Anger is, of course, one of the eight permanent emotions (*raudra*, sometimes called the Furious), the others being the Erotic (*sringara*, desire or love); the Heroic (*vira*, energy or vigor); the Odious (*bibhasta*, disgust); the Terrible (*bhayanaka*, fear or shame); the Pathetic (*karuna*, pity or grief, sometimes called Sorrow); the Wondrous (*adbhuta*, surprise or wonder); and the Mirthful (*hasya*, humor or laughter), plus the Peaceful (*santa*, bliss or tranquility).[35] Coomaraswamy argues in *The Transformation of Nature in Art* that only the permanent—*not* the contingent, individual, passing—emotions should be the subject of a work of art. Citing *The Dasarupa: A Treatise on Hindu Dramaturgy*, he writes that "'the extended development of a transient emotion becomes an inhibition of rasa,' or, as we should now express it, the work becomes sentimental, embarrassing rather than moving."[36]

It is easy to see why Cunningham would have been attracted to *rasa* theory as presented by Coomaraswamy: it offers a first level of abstraction from self-expression at a time when both he and Cage were moving incrementally away from the author as source (his tastes and habits but also his psychological motivations).[37] In 1951, inspired by his readings in Hindu dramaturgy, Cunningham began seeking dance equivalents to permanent rather than personal emotions. There is evidence in his Choreographic Records that he spent time focusing in particular on Anger: "dance of large + violent movement (like preparation for vast canvas to come!) Movement should mount in spasmodic jerks in manner of anger (at inanimate objects) [Note in margin: uses 'shiva position'] Should be heavy, accented, + stiff in feeling. (It seems to me that anger produces a kind of dizziness which could be off-center in motion)."[38]

Anger as "large" and "violent," as "spasmodic," "heavy," "accented," and "stiff in feeling," producing a kind of "dizziness" that can be manifested as moving "off-center"—where is Cunningham getting these adjectives and movement ideas from? Not from the *Natya Sastra* or Coomaraswamy but rather from his experience of the emotion of anger as lived in his own body. And why anger?

Accompanying the notes in the records folder is a four-page typed letter that Cunningham appears to have written to himself during the period of composition. The letter lacks a date, but the reference to *Sixteen Dances*, which he fears will be too long, makes it clear that it must have been written when he was in the midst of working out his ideas for the choreography. "Why not forget it?" Cunningham asks himself, perhaps in reference to the length of the piece. He then responds:

> I think I'll go on with this a little bit, maybe it will clear my head, and could it clear my heart? The first dance is as the present title suggests, concerning Anger, but not in any specific way, as yet. The second dance, without volition, a dance for three girls is imagined now done in tights and a kind of train that lags on the floor. This dance is presumed to have a slightly intoxicating effect, as though the dancers were propelled by some outside force. Number 3, Brief Tragedy, is done in a suit of ordinary clothes, and with an ordinary garden chair, and is a moment of madness on the part of human behavior.[39]

It could be that Cunningham was relating the work of composition directly to a personal dilemma: "Could it clear my heart?" The scenes he sketches might—or might not—have been associated in his mind with the feelings he was experiencing at the time, such as loss of control ("without volition," "propelled by some outside force"), "Anger," and "madness." In truth, though, there is little interest in determining a biographical motivation for Cunningham's thematic choices; I suspect that were we to discover one, it would not be particularly revelatory. The relationship between biography and dance is a highly mediated one, and speculating about it tells us little about *how*, according to what principles, the dance transforms the materials drawn from the artist's life. What the letter draws our attention to is an entirely different kind of relationship between the choreographer and the movement he invents, one that involves exploring Anger with a capital *A* as a visceral and corporeal rather than a personal and emotional experience. The Anger Cunningham wishes to represent will eventually become "specific," *not* by becoming a manifestation of his own anger, but rather by taking on a form in keeping with anger's specific effect on his body. There is more evidence in the Choreographic Records to justify such a conclusion. Just a year before beginning *Sixteen Dances*, Cunningham choreographed a dance called *Pool of Darkness*, a dramatic work that critics found more reassuringly modernist in tone. In the notes that he took while composing *Pool of Darkness*, he refers to "The Furies" as archetypes of Anger, then asks himself, "What is the outward character of anger? What is the physical manifestation of anger? enlargement of strength?"[40] Here again, the process Cunningham is following is reminiscent of the early Stanislavsky method involving the search for external ("outward") behaviors for internal states. He merely exchanges one set of archetypes (Greek)

for another (Hindu), and plumbs his sensory history ("It seems to me that anger produces a kind of dizziness") for corresponding movements ("off-center in motion").

Coomaraswamy's description of classical Hindu dramaturgy in *The Transformation of Nature in Art* provided a tool that would have resonated with Cunningham's preoccupations as an actor. In the first chapter, after introducing the notion of *rasa*, Coomaraswamy explains that the "specific way" in which a *rasa*, or permanent emotion, achieves representation on stage is through a four-pronged process. First, the actor (or director) needs to identify the "Determinant," the overarching "physical stimulant" to action; it might be the theme of the scene or the plot.[41] The Determinant is the first order on which drama is generated and by which the permanent emotion is established. Second is the "Consequent," which follows automatically from the establishment of the Determinant: "the specific and *conventional* means of 'registering' emotional states, in particular gestures [*abhinaya*]."[42] Consequents are "conventional means" in that they usually involve the codified gestures, or *abhinaya*, which every well-trained actor is expected to know. In Hindu dramaturgy, gestures are not spontaneously chosen but rather externally imposed; they are the direct *consequence*, so to speak, of the Determinant, the plot element and the emotion it entails. Third are the subordinate "Moods" (*vyabhicari*), the "conscious emotional states as represented in art."[43] These are refinements on the general, overarching permanent emotions, and according to convention there are precisely thirty-three of them. "In any work," Coomaraswamy writes, there are "emotional colorings," "Fugitive or Transient" moods such as agitation and impatience that contribute to the effect of the scene but must not be allowed to dominate it. Last are the "involuntary [as opposed to "conscious"] physical reactions [*sattva-bhava*], for example fainting."[44] The four orders work together to produce a performance that is at once legible and believable, codified and embodied. Actors need not rely on their "sensory history" or "affective memory" to create the role. For example, Hindu actors are not instructed to turn to their lived experience of Fear to identify and then portray fainting as appropriate to its representation. Even with respect to an "*involuntary* physical reaction," the actors can rely on convention. Coomaraswamy makes this clear in a passage from his introduction to *The Mirror of Gesture*, another text on Hindu dramaturgy, in which he speaks of the episode known as "Showing Fear of the Bee." The episode "is to be acted as follows: 'Move the head quickly to and fro [*Vidhutam*], *the lips quivering*.'"[45]

Whether or not the actor has experienced Fear as an uncontrollable quivering of the lips, he is expected to adopt this conventional and codified outward sign in his performance. Every detail of the interpretation, in other words, is guided by convention—one familiar to the audience—rather than by the self-identification of the actor with his role. In *The Mirror of Gesture*, Coomaraswamy emphasizes that the Indian actor's exhibited state "is altogether independent of

his own emotional condition": "Precisely as the text of the play remains the same whoever the actor may be, . . . so there is no reason why an accepted gesture-language [*angikabhinaya*] should be varied with a view to set off advantageously the actor's personality."[46]

The tool Coomaraswamy provides Cunningham's own dramaturgy is the notion that the actor's personality has little bearing on just how he will represent an emotion in performance. Indeed, the actor's own emotions should most emphatically *not* serve as the material that will generate the gestural content (the Consequents) of the performance. Since both the Consequents and the involuntary physical reactions are drawn from a conventional, codified repertory, it is assumed in Hindu dramaturgy that they will be easily interpreted by the audience. For an initiated—or even, arguably, an uninitiated—viewer, the "quivering lips" are fully legible as the outward index of the emotion of Fear. What Cunningham takes from Coomaraswamy, however, is not a repertory of timeless and unchanging gestures, the *Natya Sastra*'s *abhinaya* keyed to specific emotional states. Rather, he adopts the categories of the permanent emotions as tools for depersonalizing his emotional behaviors on stage. Further, he adopts the implicit premise that involuntary, visceral physical reactions can be divorced from personality. Actor-dancers can bring to their performance the visceral accompaniments to a strong emotion—whether drawn from memory or imposed by a code—without playing a role in the Western sense, that is, without portraying a psychologically delineated character with a backstory and a set of motivations. Actors can separate embodiment from the psychologizing tendency of subject-centered theatrical traditions and still preserve the auto-affective, internal dialogue of actor-dancers with their own sensory states.

Cunningham used *rasa* theory in a first instance to depersonalize the anecdotal and autobiographical quality of modern dance by organizing movement under the category of permanent emotions. He then added two twists that further detach the movement from a readily accessible meaning: (1) he separated the movement inspired by a permanent emotion from a dramatic narrative (or Determinant) by eliminating narrative structure entirely ("It didn't seem to matter whether Sorrow or Fear came first, so I tossed a coin"); and (2) he chose not to share with the audience the permanent emotion each dance is supposed to depict. This is an important decision, highly indicative of the changes in modern dance spectatorship Cunningham was seeking to effect. He could very well have titled *Sixteen Dances for Soloist and Company of Three* something like *Eight Permanent Emotions plus Tranquility*. He could have replaced the generic subtitles listed in the program—*Solo, Trio, Solo, Duet*—with the names of the emotions with which each one is associated in his notes. (For instance, in the notes Cunningham calls one of the dances "Sorrow," another "Jig for Joy," and yet another "Odious Warrior.")[47] But instead, he keeps the key to the code secret—from both the audi-

ence and his own dancers.[48] The relation between gesture and meaning exists, at least in his own mind—but that relation is intentionally obscured.

Cunningham rarely refers to the role acting techniques played in his choreographic and performance practice. The word *interpretation*, for example, never emerges from his pen, and expression is treated as something that occurs automatically, in an unintended manner.[49] In his multiple interviews, post-performance talks, and writings, he stresses his two-pronged effort to focus on the movement itself, to execute it "with the clearest precision,"[50] and by doing so to liberate the spectator from an imposed and predetermined movement script (e.g., a system in which each movement could be interpreted as having a specific meaning, as in a language). The critical dogma on Cunningham has established for decades that "his dances are all about movement, and what you see in them that relates to your common experience is your own business and not his."[51] But here we must proceed with caution, for it is by no means clear that this is all he sought to do. As Carolyn Brown, one of his lead dancers, has insisted, "No matter what Merce himself says publicly . . . , there *is* more to see (perceive) than steps."[52] It may very well be that in some cases "a jump is just a jump," but in others a jump is motivated by what performance theorist Gretchen Schiller has called "an internal dramaturgy," a layer of kinetic reasoning that draws from multiple aspects of a person's being.[53] An internal dramaturgy is a process allowing the dancer to transform a string of movements into a performance utterance, something that draws attention because the dancer/actor is herself *attending*, is present as more than a practitioner of technique. Throughout her autobiography, Brown comments on the peculiar and marvelous capacity of Cunningham's dances to render the dancer fully present to her own activity—and similar observations have been made concerning Cunningham's own dancing. But the dancer's attention to what she is doing is itself iterable, even narratable. When through the process of rehearsal that form of attention becomes something she can rely on, something that can ground a performance, then it constitutes a form of internal dramaturgy, a story she is telling herself as she moves that is less verbal, or verbalizable, than kinesthetic. In this context, Schiller has argued that the dancer's internal dramaturgy does not necessarily consist of words; it can instead occur as sounds (humming or grunting with emphases), as rhythmic beating or counting, or as a melody sung to the self. Brown has called her own internal dramaturgy "the 'song'": "There *is* a meaning in every Cunningham dance, but the meaning cannot be translated into words; it must be experienced kinesthetically through the language of movement."[54] Whether the internal dramaturgy the dancer develops involves the invention of a story, a melody, a dynamic, or a texture, in each case the dancer is invited to become a creative, choreographic element.

For certain dances, Cunningham might have had a specific "narrative" in mind. That this is so is indicated by the frequency with which his notes refer to

preoccupations and themes that seem in retrospect almost obsessive—the satyr or Bacchus figure; the Everyman or "H.C.E." figure from *Finnegans Wake*; the Odious Warrior; the Hero; and Socrates.[55] Yet it is clear that just as often, he and his dancers found themselves without a dramatic plot or suggestive figure to hang their movement on. This does not mean, however, that dancers moved thoughtlessly through their paces, that they were "nature puppet[s]," as Cunningham once said, "dancing on a string . . . without thought."[56] The "nature" that a Cunningham dancer might be said to obey is his or her *own* nature, that is, the deep wealth of accumulated affective and sensory memories, the possibilities for kinetic sense-making, that reside within each human being and that can be mobilized to give at least personal meaning to either an invented character drawn from a text (as in the case of the Odious Warrior) or a continuity of movements that *serves* as a text. For it is in many cases the continuity itself, the chance-derived sequence, that is like a text to be read, interpreted, and given life. As Cunningham exclaims in a "Eureka!" moment in his notes for *Sixteen Dances*, "*Dynamics in movement come from the continuity*."[57] What could he mean by this? He means that the "dynamics," the modulations in effort quality, pace, and rhythm that constitute the dramatic arc of a movement phrase, do not disappear when there is no narrative (or musical) context to propel them; instead, the dancer's *singular* "nature," corporeal substrate of the narratable self, takes over the task.[58] That is, the "entire sensory"—and kinetic—"history" comes to the dancer's aid, suggesting a logic that might lead from one movement to the next. That is why even a computer-generated sequence of movements can be embodied, lent a sensory profile and even an affective tone. While learning the phrase, its odd articulations awakening new sensations, the dancer is directed toward and gains access to a conversation occurring among kinetic, sensorial, and affective orders, a conversation that does not require the framework of a psychological drama to do its compelling work.

"Gesture *Is* Evocative" (Cunningham)

The late 1940s to early 1950s was a crucial period for Cunningham. Since roughly 1942, Cage had been encouraging him to leave the Martha Graham Dance Company, possibly because Cage was thinking through a new counterintuitive relation to expressivity, and he associated Graham with an overly text-based expressive mode. As he wrote in a 1944 letter to Cunningham, "Expressivity often comes about through no attempt to make it or to express anything."[59] Cunningham mirrored this sentiment in his comments on *Untitled Solo* (1953): "I choreographed the piece with the use of 'chance' methods. However, the dance as performed seems to have an unmistakable dramatic intensity in its bones, so to speak. It seems to me that it was simply a question of 'allowing' this quality to happen rather than 'forcing' it."[60]

Anchored deeply in the practice of both artists was the belief that expressivity could be considered a type of epiphenomenon, something to be discovered indirectly ("simply a question of 'allowing' [it] to happen") while focusing on something else.[61] This belief might very well have motivated their search for unintentional compositional means, but several critics have recently suggested that another impetus was at work. Situating Cage in his historical moment, Jonathan Katz has argued that Cage's (and implicitly Cunningham's) turn away from overtly expressive modes was in fact motivated by a need to mask strong emotions in a homophobic environment. A solution was offered by the discovery of classical Hindu drama and Zen Buddhism, both of which downplay the significance of the personal. "This is not to say," Katz adds, "that the [homosexual] closet alone motivated Cage's deepening involvement with Zen"; but a "turn towards an anti-expressive art" was clearly facilitated by creative practices that emphasized—and provided tools for—depersonalization.[62] Thomas Folland has also argued that Cage and the coterie of friends gathered about him in the 1940s were reacting against the aesthetics of their contemporaries, the abstract expressionists, in part because of their strong heterosexist bias. Artists like Cage, Rauschenberg, and Cunningham chose to work against the figure of the tortured artist, rejecting the interpretation of artistic gestures as revelatory of a self defined primarily in psychic terms.[63] In that context, for Cage to treat a note as just *that note*, for Cunningham to treat a movement as just *that movement*—and not the index of a psychic state—appeared fresh and radical. Such, then, would become the project of a burgeoning post-expressionist avant-garde. The question remains, though: Why, if Cunningham belonged to this avant-garde, would he continue to have recourse to more traditional expressive modes? If all he wanted to express was something "beyond intention,"[64] why would he embed *rasa*-related minidramas in his works? More broadly, why would he continue to seek inspiration from literature and myth if his central interest was in movement itself?

In reference to dance of the 1940s and 1950s, Cunningham has written that "it was almost impossible to see a movement in the modern dance during that period not stiffened by literary or personal connection."[65] At first, we might assume that he is referring to the work of Graham, who in the postmodern period came to represent the most tortured (and abstract expressionist) version of modern dance. However, a glimpse at the postwar modern dance scene indicates that many of Cunningham's contemporaries were invested in forging literal links between movements and texts (often more literal than Graham's own).[66] These links would be secured by extensive program notes. For instance, when Cunningham presented *The Seasons* in 1947, on the program with him was John Taras's *The Minotaur*, which recounts episode by episode the narrative of the Greek myth. The program tells us that the dance contains seven sections, each bearing a title referencing an element of the story—"The Palace of Minos"; "Pasiphae and the Bulls," "The Labyrinth," and so on.[67] José Limón, whose dra-

matization of literary sources has been well documented, stated in the 1950 program of an August performance at the Connecticut College American Dance Festival (in which Cunningham also participated) that *The Moor's Pavane* consists of "variations on the theme of *Othello*."[68] Similarly, the program notes for Doris Humphrey's *Lament for Ignacio Sanchez Mejias* (performed that same evening) cite a specific literary source: "The poem [by Lorca] concerns the life and death of an Andalusian bull-fighter, and is in four parts."[69] Meanwhile in New York, several talented young choreographers of the post-Humphrey generation were beginning to foreground their Jewish heritage, creating dances inspired by biblical figures, such as Anna Sokolow's *Songs of a Semite* of 1943, which focuses on Ruth, Naomi, and Rebecca.[70] Katherine Litz, who spent some time with Cunningham at Black Mountain College, advanced a program that allied dance with a kind of dramatic language; in 1948, she argued that dancers should study acting because "every movement, no matter how arbitrary, can be given dramatic quality through an understanding of emotional values."[71]

Graham, too, was interested in acting technique, and taught for several decades at the Stanislavsky-inspired Neighborhood Playhouse in New York City.[72] Like her peers, she furnished an interpretive frame for her spectators, writing in the program notes for *Cave of the Heart* in 1946, for instance, that the dance was about "possessive and destroying love" and was based on the myth of Medea. Yet Graham tended to treat myth in a less literal way than other choreographers at the time. Mark Franko has argued that for her, "myth allowed for a reliving of a psychological moment through which the artist's self could be expressed as mythological persona. Graham theatricalized these literary concepts to the point where they no longer seemed literary, but fundamentally choreographic."[73] Surprisingly, these words seem appropriate to Cunningham's project as well—at least as that project was carried out in *Sixteen Dances*, when he was examining his own involuntary physical reactions in order to devise movement equivalents of Anger. Franko goes on to clarify that Graham's filtering of a "psychological moment" through a "mythological persona" was less a form of storytelling—she does not recount the myth in a pantomimic dance—than what he calls an "embodiment": "The images produced *by feeling* emerge from behind, beneath, and through story or character—when these are present—in a way that disrupts, undermines, or renders ambivalent the information narrative imparts while still relying upon it."[74]

Rendering ambivalent while still *relying on*—this is Cunningham's tactic too. But of course he takes the "render[ing] ambivalent" impetus much further. It is not only that the spectators can't be sure of what they see because the mythic persona has been realized through a disruptively embodied presence; in addition, Cunningham jettisons the identifying title, the program notes, and all clues that might allow audiences at least some access to the myth on which he is nevertheless relying. Further, from *Sixteen Dances* onward, he introduces random

ordering and, increasingly, the disaggregation, permutation, and recurrence of individual phrases, further disrupting and undermining the link between an original source of inspiration and our experience of the performance as spectators. In short, Cunningham forges a relation, a *dramaturgical* relation, which he then proceeds to attenuate and dismantle as much as he can.

No wonder, then, that in the late 1940s, when modern dance was struggling with its relation to drama, Cunningham felt compelled to underscore in the program to *The Seasons* that his goal was "to use the materials of myth, that is, the wending of a span of nature's time, *in my own terms*."[75] These terms involved intentionally obfuscating the allusions to the mythic, literary, or personal subtext that still continued to shape his movement choices. Cunningham's working notes for *The Seasons* indicate clearly that the dance was based not only on the seasons of the year but, like *Sixteen Dances*, composed at least partially under the sign of classical Hindu sources. Listing the dance's characters in his notes, Cunningham cites the god Vishnu, whom he intended to personify.[76] Unfortunately, we do not have recordings of either *The Seasons* or *Sixteen Dances* and so cannot determine which gestures might have portrayed which gods or which permanent emotions of classical Hindu drama. But we can study the Choreographic Records, especially Cunningham's notes, as well as the photographic documentation, all of which suggest that the choreographer was in fact making use of fairly conventional associations. With respect to Anger, as we have seen, he proposes "large + violent movement"; "movement should mount in spasmodic jerks." And a photograph he identifies as the Odious Warrior—reproduced in David Vaughan's book *Merce Cunningham: Fifty Years* with a legend—shows him in a lunge, mouth wide open, as though making a large sound such as a roar or shout (fig. 3.1).

The connection Cunningham makes here between the permanent emotion—the Odious—and the outward gesture—a lunge with mouth wide open—is not particularly subtle, but neither is it easy to identify without an orienting frame. Consider, for instance, the return of this Odious Warrior figure in "Room for Two," the duet of *Antic Meet* (fig. 3.2). It is likely that had we not already seen the photograph—accompanied by the legend "MC as 'Odious Warrior'" in Vaughan's book[77]—we would not recognize the Odious Warrior gesture in "Room for Two." I have found not a single scholarly or critical account of *Antic Meet* that mentions either this figure or the dance's genetic connection to classical Hindu drama. Yet Cunningham's notes indicate to what a great extent *rasa* theory was crucial to his thinking as he developed this dance. At least at the start, he seriously considered basing the entire dance on the *rasas*. There is ample reason to believe that in 1958 he was reprising some of the preoccupations he had first addressed seven years earlier in *Sixteen Dances*, and even recycling, in odd ways, the gestures he had devised.

In the years that intervened between *Sixteen Dances* and *Antic Meet*, Cunningham choreographed several dances—all lost—that recall the preoccupations of

the 1951 work. The program notes for *Springweather and People* (premiered in 1955) explain that by "not relying on psychology the 'modern' dance is freed from the concerns of most such dancing."[78] It should be noted, though, that at least Cunningham's version of "the 'modern' dance" is not free from other concerns. As the program notes go on to say, such dancing is intentionally "illuminated from time to time by feelings which are in turn heroic, mirthful, wondrous, erotic, fearful, disgusting, sorrowful and angry." Here, of course, we are back in the presence of the permanent emotions, the "disgusting" being another name for the Odious, which seems to have been of particular significance to the choreographer. Again, in *Lavish Escapade* of 1956 the influence of classical Hindu dramaturgy is made manifest; Cunningham's notes tell us that he was experimenting with facial gestures, taking his cue from both classical Japanese Noh theatre and what he calls "Indian books."[79]

Whereas only a handful of photographs of these two earlier dances survive, in the case of *Antic Meet* we have sufficient video documentation as well as a cornucopia of working notes to help us piece together the relation between the dances of the early to mid-1950s and *Antic Meet* of 1958. These sources provide evidence that some of the episodes of *Antic Meet* reprise those planned for *Sixteen Dances* seven years earlier. For instance, we learn that in the section of *Sixteen Dances* titled "Brief Tragedy," Cunningham intended to dance with a chair; he does so in the duet titled "Room for Two" in *Antic Meet*. Further, the two dances resemble each other with respect to their overall structure:

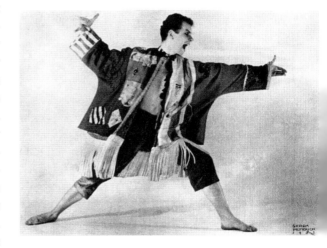

episodic and pantomimic while remaining nonnarrative. In a letter to Robert Rauschenberg, his dance company's artistic director at the time, Cunningham compares the episodic structure of *Antic Meet* to "a series of vaudeville scenes which overlap."[80] But seven years earlier, he had already begun entertaining the possibility of using vaudeville as a model: in the 1951 notes to *Sixteen Dances*, he asks himself, "Can such short pieces work one after the other [as] in vaudeville, or will they only unnerve a spectator?"[81]

Cunningham's shift from a dance explicitly based on the *rasas* to one imitating the style of vaudeville can be traced in the notes to *Antic Meet*. Early on in that notebook, he lists the eight permanent emotions in this order—"Anger/Sorrow/Fear/Odious," then "Erotic/Wondrous/Mirthful/Heroic." He even devotes some time to investigating what he calls the Consequents of the "Comic" (or "Mirthful"): "throbbing of lips, nose + cheeks/opening of eyes wide or contracting them/perspiration/colour of face/taking hold of sides." Here, Cunningham transforms

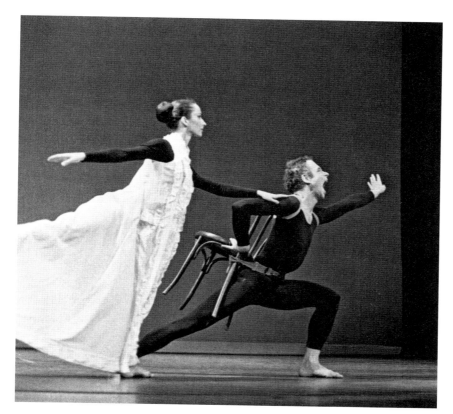

Consequents into what Coomaraswamy identifies as "voluntary physical reactions." (Coomaraswamy's Consequents are, in contrast, the *abhinaya*, the codified gestures.) This indicates that by 1958, Cunningham had taken some distance from Coomaraswamy's texts (and thus may have been creatively misreading them). Nevertheless, he demonstrates continuing interest in determining which visceral reactions are associated with which permanent emotion, and he is still linking these visceral reactions (e.g., "throbbing of lips") to specific types of movement, such as the "strange movement of limbs." Some of these movement suggestions seem to have found their way into the dance (see Cunningham's dance with a multilimbed sweater). But the *rasas* are not Cunningham's only inspiration. As is often the case in his notes, he juxtaposes different mythic and literary intertexts as he sifts through choreographic ideas. In the notes to *Antic Meet*, we find references to Fyodor Dostoevsky's *The Brothers Karamazov*, from which he took the epigraph used in the program: "Let me tell you that the absurd is only too necessary on earth."[82] He also entertains an alternative literary model, James Joyce's *Finnegans Wake*: the first episode of the dance covers the "Death or Sacrifice of hero-god (Finnegan's Fall) (old year)"; the second, "Rebirth of hero-god H.C.E. (wakes) (new year)"; the third, "purging of evil by driving out a scapegoat (god or devil, hero or villain) (H.C.E. troubles in park + subsequent police troubles)"; and so on.[83]

We can surmise, then, that Cunningham subordinated the *rasas* to other systems of symbolism as he moved toward the model of vaudeville, focusing increasingly on the Comic, then on mockery ("Laughter is caused by mimicry of others' actions," he writes in the notes while meditating on the *rasa* of the Comic).[84] Yet despite this shift, he retains a few stock forms from classical Hindu drama: the quartet titled "Bacchus and His Cohorts" recalls a scene he called earlier, in *Septet* of 1953, "Krishna and His Gupis"; the figure of the Odious Warrior reappears, as we have seen, in the duet "Room for Two"; and the gestures of the Heroic seem to have been reprised and mocked in the male duet, the competitive and acrobatic "Sports + Diversions, 1."[85] There is little non-intentionality in evidence here.

Antic Meet's reprisal of figures and scenes suggested by classical Hindu drama is not incidental to Cunningham's aesthetic. Indeed, throughout his corpus we find instances of what appear to be minidramas corresponding to *rasas*, sometimes presented at first remove as isolated citations, as in the case of *Antic Meet*, where the Odious Warrior gesture appears twice but entirely decontextualized. That gesture erupts amid a mockingly courteous *pas de deux* between Cunningham and Carolyn Brown. Why, we might ask, would the gallant Cunningham suddenly strike the pose of the warrior, his mouth stretched open as though emitting a ferocious cry, while Brown calmly maintains her *arabesque* beside him? Does the Odious Warrior serve a dramatic function here, suggesting a hidden violence in the playful scene? Or is the gesture repurposed and given a new signification in the duet? How are we supposed to interpret Cunningham's wide-open mouth and the suggestion of a war cry that it conveys? Do we register it subliminally? Does the tension in his stance—his outstretched arms and bent knee, the forward thrust of his torso, and his snarling jaw—communicate aggression (or aggressive virility) on a visceral level? Is the stance animated by an internal dramaturgy productive of a particular dynamics to which we, perhaps unknowingly, are receptive?

At times, Cunningham's gestural equivalents for the permanent emotions are highly legible, even frankly pantomimic.[86] Yet although he seems to have established *for himself* a fairly conventional relation between a gesture and its correlative meaning, he chooses not to share that relation with either his dancers or his audience; he does not provide a discursive frame or hand us a key to the code. This is an important element in the aesthetic Cunningham was developing during the 1950s. If the title of *Orestes* in 1948 alerts us to the theme and thus sets up an interpretive frame, by 1951 Cunningham is encrypting his "literary and personal" associations. It is not that such associations no longer interest him, but rather that he does not want them to limit the movement's connotative force; in his words, he does not want a one-to-one referential relation to "stiffen" the movement, to anchor it to a text or an autobiographical given. "I don't think that what I do is non-expressive," he stated in 1979. "It's just that I don't try to inflict it on anybody, so each person may think in whatever way his feelings and experi-

ence take him."[87] Already in the case of *Sixteen Dances*, spectators were invited to interpret the gestures as they saw fit. Speaking of the Odious Warrior, Cunningham remarked, "Some see this dance as a hunter frightened by his hunt, others as an exuberant drunk on a binge."[88]

Over the course of the 1950s, Cunningham would increasingly favor a disconnect between his own experience of performing the gesture—which might engage his "dramatic imagination" (as well as sensory memories)—and the potential experience of the spectator. He takes this disconnect further in *Antic Meet*, recycling and citing an earlier performance in a later one and thus potentially attenuating the relation between the gesture and the permanent emotion it had been chosen to depict. The citation of a gesture such as that of the Odious Warrior takes it to a second degree, submits it to a decontextualization that can easily lead to mockery. Jill Johnston remarked after a 1960 performance of *Antic Meet* that it seemed to be a set of "take-offs" on other varieties of dance, including ballet and Martha Graham.[89] One might wonder whether Cunningham, by citing the Odious Warrior, was also doing a "take-off" on his own work. His recycling of phrases has been noted by critics and discussed at some length;[90] less often studied is what happens when a gesture or an entire phrase associated with one particular meaning in one dance is recycled in another dance. What can we say about the status of the Odious Warrior when it appears semantically unsupported by a program note and performed as a citation? Is the Odious Warrior's thrusting gesture, the movement itself, "expressive, regardless of intentions of expressivity, beyond intention"?[91]

These are semiotic and dramaturgical questions that cannot be answered in any consistent or definitive way. We cannot know, for instance, what Cunningham was feeling when assuming the Odious Warrior in any given context, nor can we ascertain what every spectator might have thought or felt while watching it. The expressive potential of a gesture is not something that can be defined. That said, I would argue that many of Cunningham's gestural choices do evoke a particular emotional state. They strike the audience as meaningful, not because we are given a key to the code and not because "movement itself is expressive, beyond intention," as he stated, but rather because in many cases his gestural choices draw from a large body of movements that have already been accorded a specific signification in Western culture. It is not possible to determine whether such gestures are legible to all audience members. What can be said, however, is that by planting these moments in his corpus, by encrypting these representational passages, Cunningham invites the possibility of a dramatic reading. That is, the conventional nature of the gestures—Anger as "large"; the Odious as roaring; Sorrow (as we shall see) as collapsing the chest—solicits a particular variety of attention from the spectator, who may now more readily assume an interpretive stance. To what extent this interpretive stance persists or, alternatively, is obstructed depends on the nature of the individual dance. In many cases, Cun-

ningham seeks to frustrate the interpretive attitude, making abrupt switches in pacing and movement quality so that movements do not stiffen into plot. Still, during these singular moments when, as Edwin Denby puts it, a "neutral lyric abstract sequence of movements" becomes "a dramatic situation," the gestures can awaken within us cultural associations as well as visceral memories. For these gestures are based on a set of cultural associations and visceral memories we share. It is hard *not* to interpret a strident, "bound-flow" gesture such as the Warrior's lunge as anything but a sign of strength, vigor, and aggressivity. Cunningham seeds his works with such gestural hints. "Gesture *is* evocative," he stresses in his interview with Jacqueline Lesschaeve.[92] A collapsed chest evokes melancholy; a leap is the signature of joy.

Permanent Emotions Redux

In conclusion, I want to turn to a work Cunningham choreographed in 1978, *Exchange*, which reprises the eight permanent emotions of classical Hindu drama—and even includes some of their earlier gestural Consequents—in a decontextualized manner. *Exchange* allows us a glimpse into Cunningham's mature way of working with both intention and non-intention in the creation of "dramatic situations." Again, as in *Antic Meet*, the *rasas*, so present in his working notes, have been disguised or eclipsed by other scenic choices in the finished product. Yet what is striking when we watch the 1978 Charles Atlas film of *Exchange* with both *Antic Meet* and *Sixteen Dances* in mind is the consistency of Cunningham's gestural choices. Developed over the spring of 1978, *Exchange* has been characterized by critics as an "intellectual puzzle," requiring spectators to determine "what switches with whom" (as the name implies).[93] Reviews of the work generally focus exclusively on these "switches"; for instance, in an account of a 1978 performance, John Mueller notes that the company is "divided into two groups which occupy the stage at different times, meshing only in the passages of transition and at the end."[94] What reviews do not say is that the dance was initially conceived as a ritual involving the eight permanent emotions. Cunningham was only slightly more specific in his interview with Lesshaeve, indicating that the work has to do with "the idea of recurrence, ideas, movements, inflections coming back in different guises, never the same."[95] This, of course, could characterize any of his dances; almost all contain phrases that are repeated "in different guises" (his example of a "recurrence" in *Exchange* being that "a phrase done in parallel position in Section I, would be redone in turned-out position in Section II").[96] Recurrence was not merely a structural device within the dance but a principle governing the relation of *Exchange* to other works in the repertory.

Cunningham's notes, begun in April of 1978, reveal that the dance's working title was *Odyssey*. It is interesting to speculate on why he chose this title, as well

as why he subsequently changed it. He wrote that he liked to choose titles that are ambiguous, "with open, multiple meanings."[97] Naming the work *Odyssey* would have encouraged spectators to identify Cunningham as Ulysses and the separate episodes as representations of Ulysses's escapades. But there is nothing in the notes to support such a representational project other than the title. Instead, we find a list of eight episodes, each one based on a different permanent emotion, with particular attention given in the first section to what he calls "warrior fighting: heroic/fear/sorrow." At first, as was often the case, Cunningham determined what role chance would play. On April 13, he produced a Procedure page with instructions for the creation of sixty-four discrete phrases for each section (their number representing the number of hexagrams in the *I Ching*). Apparently, he intended to organize these sixty-four phrases according to chance procedures involving the toss of a coin: a toss would determine whether "metric or not"; how many times phrases repeated; whether there would be "carry-over" from one section to the next; and whether the section would contain a "real-life" event.[98] He opted for a tripartite structure: "part I—circle is 'group ceremony' Odyssey"; "part II—diagonals"; "part III—field/area/disco." He then made the following list:

love erotic
peace tranquil
war fear/anger
labor heroic
games humor
mystery wonder
eating odious
death sorrow

Once again, we find one subtext superimposed on another: the episodic nature of *The Odyssey*, in both Homeric and Joycean versions, lends itself to the episodic display of the permanent emotions—here eight, with tranquility treated as a separate emotion equivalent to "peace," and "fear/anger" treated as the two sides of "war." That the *rasas* were never far from Cunningham's mind is evidenced by the fact that as the dance evolved over the course of the month, he continued to allude to various possible orderings of the permanent emotions, ultimately intertwining them at points when tosses of the coin—as well as his well-developed choreographic eye—told him what to repeat and where.[99]

Exchange contains one of Cunningham's most beautiful duets, performed in the second section by Ellen Cornfield and Chris Komar in the Charles Atlas film at about twenty minutes into the almost forty-minute-long dance. The duet involves a fast-paced reprise of some of the earlier exchanges between Cunningham and Catherine Kerr, adding fluttering hand and arm movements to embraces and lifts. Since Cunningham specifies in his notes that the duets in *Exchange* could

be associated with the "erotic," the "humorous," or "anger," we might be tempted to speculate on the emotional tenor of this particular duet. The movement is athletic and playful, resembling most closely the humorous duet in "Sports + Diversions, 1" of *Antic Meet*. (See plate 4.)

It is also tempting to continue seeking recurrences of permanent emotions as well as other recurring vignettes—in fact, this is one of the favorite pastimes of Cunningham devotees. In *Exchange*, however, the recycling of individual phrases contradicts the notion of discrete episodes and their clear ordering. Phrases that might have initially been related to a permanent emotion have been broken up and relocated at other sites in the dance. In the beginning, for instance, Cunningham briefly sketches out a collapsing inward movement of the shoulders; this movement belongs to the "Sorrow" solo, which he performs in part 3. Yet the permanent emotion episodes, such as "The Heroic" and "Sorrow," have an integrity suggesting that Cunningham choreographed them as distinct wholes. Of course, this does not stop him from repeating their elements elsewhere "in different guises." (See plates 5 and 6.)

In this dance, it is possible to find gestural echoes of other *rasa*-related Consequents, Coomaraswamy's "specific and conventional means of 'registering' emotional states, in particular gestures," worked out earlier. These are treated not ironically, as in *Antic Meet*, but rather as possibilities to be explored yet again. To be sure, Cunningham may have recycled certain gestures from earlier works, treating them as just another set of building blocks to place in his gamut alongside *pliés* and *tendus*. Yet it is important to note that despite this more distanced approach, he never stopped earnestly searching for the "outward character" of the permanent emotions. *Rasa* theory was for him a resource, a choreographic tool, not only for creating movement but also for exposing what might have been personal concerns in archetypal form. A last example from *Fabrications* suggests that even as late as 1987, Cunningham was still fascinated with the power of the permanent emotions to provide new movement ideas. We find in his notes to *Fabrications* from January 1987 allusions to four different permanent emotions and their potential gestural equivalents:

SORROW: woman on knees arching repeatedly, hand held by man. She has 1
 hand over her eyes + brow repeat 3 or 4 times; stop; then repeat again + exit
ANGER: couple exiting. Man rushes in + takes girl in arms + they do a short
 waltz; Her escort pulls her off + hurries her off stage
FEAR: woman faints + is caught by man and carried off
ODIOUS: Distorted variation of phrase done by one, while others are doing it[100]

While watching the 1987 performance series, I was able to identify only one of the four phrases listed in the notes, "Sorrow," which occurs about halfway into the dance (v).

We might fruitfully compare a gesture such as "Sorrow" to a *pathosformel*,

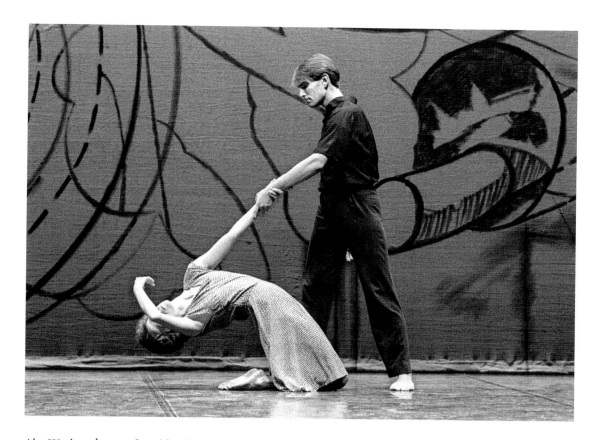

3.3
Merce Cunningham,
Fabrications
(1987): "Sorrow"
phrase, "with 1
hand over her eyes
+ brow."
Photograph © 1987
Dee Conway.

Aby Warburg's term for a kinetic-visual form that seems to invite evolving interpretations. The meaning of a *pathosformel* is never firmly fixed, yet neither is it entirely aleatory, easily replaceable with anything else. And here we arrive at the limit point of Cunningham's poetics—or, more precisely, his poetics as they have been reiterated by critics. We also find ourselves in a position to speculate why Cunningham might have continued to insert minidramas into his works. First of all, with respect to his doctrinaire poetics, it is indeed clear that Cunningham believed in the dramatic and expressive potential of the arbitrary. Yes, a choreographer could just allow expression to happen as a result of chance. And the expressive gestures that simply happen might indeed inspire in a spectator a certain feeling or interpretation that the choreographer had not intended. But would this feeling or interpretation be entirely unpredictable and unmotivated? Can any gesture mean anything to anyone? Is there nothing in the gesture itself that evokes a particular emotion (and not another)?

It is helpful here to distinguish between a movement and a gesture in dance. Let us define *gesture* as Cunningham does, as "evocative" movement.[101] From this perspective, gesture would be a category of movement that has accrued cultural associations over time, such as an open chest for the Heroic, a snarl for the Odious, a contraction or collapse for Sorrow. In contrast, "movements" would be actions of the body less systematically associated with communicative acts,

such as a balletic *plié* or *passé*, or transition steps such as *enchaînements* or the modernist triplet. As we have seen, Cunningham subjected both movements and gestures to decontextualization through chance procedures, permuting them so as to unhinge them from the prior meanings they might have evoked. A gesture "stiffened" with allusions could regain its plasticity as a result of randomization. Yet Cunningham was aware that gestures and movements strung together in arbitrary sequences present singular challenges to dancers. He often expressed a keen interest in what a dancer would make of either a chance-derived continuity or, as in *Exchange*, an intentionally choreographed phrase that had been freed from an interpretive gloss. "It is like a juggling act," he explains,

> because on the one hand there is what you want the movement to look like, and at the same time there is a person who is not yourself, who is doing the movement. I don't expect that person to do it the way I do it. But I try to give the movement clearly, so that it will be done clearly, each dancer in his own way. And that's the big trick: how to get that out of dancers. Because it isn't only training, although that has a great deal to do with it. It has to do with temperament and the way they see movement, the way they are as a person and how they act in any situation; all that affects the dancing. It's all part of it.[102]

Cunningham found himself confronted with a similar challenge when he had to dance the entirely chance-derived continuity of *Untitled Solo* (1953). That is, he had to teach himself something he hadn't made, learn to embody a novel phrase by means of his "temperament" "as a person." If he couldn't "get that *out*" of himself—if he couldn't *ex*-press how he acts "in any situation"—then it wouldn't be dancing. This approach should be contrasted with Cage's approach to musical composition. Cage the experimentalist was more interested in hearing one of his compositions for the first time only *after* it was finished. For early Cage, the execution did not intervene in the making of the work; only later, when he developed what he called "indeterminacy," did execution become important to the work's identity. In contrast, for Cunningham, *execution is a step in the creation of the work*, an interpretation or embodiment crucial to the work's coming into being *as dance*. As he said to Jacqueline Lesschaeve, "No matter how complex something I make or do may be, if it doesn't come out as dancing it's of no use."[103]

But again, what does it mean to "come out as dancing"? The dance might have been presented to the dancer as arbitrary—in the sense of not motivated by a plot, not generated in response to an emotion, and not shaped in harmony with a musical score—but it still had to *look* like it was motivated. To "come out as dancing," the movements had to gain that *gestural quality*, the quality of being intended and in continuity with the dancer's other ways of doing ("the way they are as a person"), without miming or symbolizing one particular thing. But from

what could the dancer draw if not the movement itself as a trigger, as a stimulus? This has been the argument of Cunningham and his followers for generations— that movement is itself generative of meaning. But generative how? Without the dancer's interpretation, the investment of her being, the movement itself is no more than what Cunningham called "paperwork." Hence the movement never appears purely in itself except on the page, which, as Cunningham reminds us, is not dancing.

Cunningham once stated that he always felt uncomfortable when working with Martha Graham, because she would provide an "emotional explanation" for a movement, an explanation that worked for her but didn't resonate with his own experience.[104] He preferred the method of his Russian ballet teacher, who would demonstrate a wickedly difficult combination and then shout, "And now, *dance*!" "Dance," in this instance, meant "to get from this position to the next one."[105] Elsewhere, Cunningham calls this skill "coordination"; as I mentioned in the preceding chapter, coordination is something he first identified as a center of choreographic interest while watching Joan Skinner execute the chance interlude of *Sixteen Dances*: "It was as though it worked for her. It was the first time where you encountered a coordination, going from one thing to another."[106] To coordinate one movement with another, to rope movements together into a continuity to the point where, as Cunningham puts it, "you *make* it a necessity," such is dancing—dancing as making something that is unnecessary *look* necessary.[107] To make something "a necessity," the dancer compensates for what is random in the sequence by drawing from her "person."

There is no doubt that Cunningham was intrigued by this order of skill, by what he called in his interview with Lesschaeve "momentum" or "energy" (dancing comes "not from something expressive but from some momentum or energy").[108] In his essay "The Impermanent Art," written almost three decades before his interviews with Lesschaeve, he still relates this energy to emotion: "Dance is not emotion, passion for her anger against him. I think dance is more primal than that. In its essence, in the nakedness of its energy it is a source from which passion or anger may issue in a particular form, the source of energy out of which may be channeled the energy that goes into the various emotional behaviors."[109] An important theorist of the emotions, Charles Darwin, also believed that a corporeal intensity, an energy source, underlies the shapes to which cultures come to attribute particular emotions.[110] Cunningham probably felt he needed to retain contact with this naked energy source in order to prevent the stiffening of movement ("passion for her," "anger against him"). This stiffening of energy into emotion, into narrative, threatened to occur in the case of the programmatic *Sixteen Dances*. For the truth of the matter is that although he was a highly inventive choreographer, capable of coming up with a startling variety of movement ideas, he was also—by today's standards—limited, even obsessional, likely to repeat the same gestures and phrases again and again.

Thus, Cunningham had a compelling reason to develop and refine procedures for stripping movements of their gestural evocativeness, for challenging their potential to communicate particular meanings or emotional states. However, it is equally true that he remained fascinated by intentionally expressive gestures, the permanent emotions of classical Hindu drama and the Consequents that I have been studying in this chapter. As we have seen, his dominant practice was to mix the two—expressive gestures *and* sequences composed of simply "going from one thing to another." Why would he have done so? On a first reading, we might conclude that Cunningham thrived on the ambiguities created by the juxtaposition. He objected to coercive, policed associations and did not want to impose his own on either his audiences or his fellow dancers. Perhaps the juxtaposition allowed him to discover new meanings in old gestures, such as those he identifies with Sorrow or The Odious Warrior. This would explain why he rarely allows the minidramas—either *rasa*-related vignettes or "found" dramatic moments—to flower into full-blown plots. As Edwin Denby notes, these dramatic episodes flicker into view then fade away: "You see this appear and you see it disappear again."[111] Yet it bears repeating that the vignettes corresponding to *rasas* are different in nature from the found dramatic moments I addressed in previous chapters, moments when a coin toss produces an encounter between two dancers that evokes for Cunningham a relation, amorous or otherwise. Not only are such vignettes intentionally choreographed, *they are also intentionally acted*. They are hints of a more conventional mode of theatricality that comes to puncture the surface of an otherwise *anti*theatrical avant-garde mode.

Ultimately, there is something daring about Cunningham's periodic reliance on conventional choreographic modes and allusions. I believe that when he inserts a permanent emotion, he is not just testing out whether intentional gestures, his own variety of *pathosformel*, will lose their predetermined meanings when robbed of titles and sutured from context. He is not merely interested in how audiences will respond. Something else is at work. Let us look one last time at the moment in *Exchange* when Cunningham dances his "Sorrow" solo. This is a solo that is not a solo—by which I mean that it is more like a cabaret number, with the star backed by a chorus of young dancers in a semicircle behind him. (In the "Heroic" solo, a chorus of young men kneel at his feet.)[112] Cunningham is center stage, commanding the full attention of the audience for what seems like an embarrassingly long time. What "Sorrow" and other such minidramas permit Cunningham to do is, precisely, *act*. That is, in episodes such as that portrayed in plate 6, Cunningham allows himself to act in that peculiarly Stanislavskian way that involves exposing himself (drawing from the nakedness of his person) *and* playing a role. These episodes allow him moments of heightened, even mannered expressivity, however mediated, that are highly theatrical and often recognized as such. To put it differently—and perhaps against the grain—the permanent emotions in these episodes permit him *to come out of the closet Cage made*

for him, to indulge in precisely that variety of theatrical expressivity denied by their shared avant-garde austerity. In a context in which "theatricality" came to stand for something "endlessly personalizing,"[113] when, during the 1950s, theatre possessed "a specifically queer timbre,"[114] Cunningham's own dramatic tendencies had to go underground. Playing the Odious Warrior, the Heroic, and Sorrow enabled him to act out his *anti*-antitheatricality. The permanent emotions of classical Hindu drama offered a form of resistance against a subtle but nonetheless coercive program of resistance, freeing him to flirt provocatively with the edges of camp.

"Passion in Slow Motion"
Suite for Five and the Photographic Impulse

Sharon Lockhart's *Goshogaoka Girls Basketball Team* (1997), a series of twelve staged chromogenic prints, presents a curious intermingling of the photographic and the theatrical arts. (See plate 7.) Taking stop-action sports photography as her iconographic model, Lockhart places and then photographs the members of a Japanese basketball team in a set of fixed sculptural groupings based on activities associated with the sport. Whereas stop-action sports photography presumably captures the athlete in medias res—think of Michael Jordan reaching up to make his famous hook shot, his feet off the ground in midflight—Lockhart arranges the girls in postures that only appear to be those of moving bodies. After a moment, the viewer observes something preternaturally weighted in their stance. The girls—not the snapshots—have stopped their own action. What Lockhart has captured in stillness are personifications of human wax figures approximating gestures of movement that, in fact, are not moving. The fascination we might experience when contemplating Lockhart's work derives from this curious mixture of photography mimed and miming photographed.

The contemporary choreographer Boris Charmatz has attempted a similar coupling of the photographic and the theatrical in *Flip Book*, a danced collage of photographs of Merce Cunningham and other dancers presented in three different versions: *Flip Book*, performed by professional dancers (2008); *50 ans de danse*, performed by former dancers from the Merce Cunningham Dance Company (2009); and *Roman-Photo*, performed by nonprofessional dancers and students (2009). Described by the poet and playwright Gilles Amalvi as "Dance in a kit," *Flip Book*—as the three versions are colloquially referred to—is constructed from the readymade order suggested by David Vaughan's catalogue raisonné of Cunningham's dances up to 1997, *Merce Cunningham: Fifty Years*.[1] Instead of taking arrested movement as the subject matter of the photograph, Charmatz takes the photograph as subject matter for arrested movement. He uses Cunningham's

famous quip, "anything can follow anything," as a trope, basing the continuity (order of phrases/trajectories) of his dance on a sequence that is not random but rather chronological, and thus out of the hands of the author/choreographer. To give an example of a typical sequence: at one point in *Flip Book*, we see the re-creation of a photograph found on page 233 of Vaughan's book, an action shot from *Fabrications* of 1987 by Johan Elbers; this is followed by the re-creation of a candid shot of Cunningham relaxing in a chair during the Grand Central Event of 1987, photographed by Tom Brazil; next we see the re-creation of a photograph of a performance of *Carousel* (1987) by Jonathan Atkin; then one of *Eleven* (1988) by Michael O'Neill; then another by O'Neill, a leap from *Five Stone Wind* (1988); and so on and so forth. The re-created poses in *Flip Book* follow the sequence of the photographs in Vaughan's book. In between the poses, the dancers have to rush from one spot on the stage to another, underscoring the disconnect between the poses, the lack of kinetic, narrative, or emotional motivation underlying their sequencing. However, it is important to note that Charmatz leaves out of his continuity the intervening photographs of costumes and props that appear in Vaughan's book, thereby indicating that he defined the content ("gamut") of the piece not as the photograph per se but more specifically as the photograph of human beings.

The response to Charmatz's *Flip Book* from the Merce Cunningham community has been unequivocally hostile. Alastair Macaulay, a longtime supporter of Cunningham's work, published a review in the *New York Times* accusing Charmatz of being "unserious . . . about dancing itself."[2] He laments the fact that Charmatz uses photographs of any kind of movement, whether it is derived from Cunningham's choreography or not. And Charmatz does not even respect chronological order: "No matter if the photos are of curtain calls, or if, without chronological point, they occur in the appendix." To Macaulay, *Flip Book* is a false view of Cunningham's aesthetic; viewers, he writes, "could see basic angles of spines and legs misrepresented"; there was "a striking lack of the linear tension that made Cunningham's choreography register powerfully in large theaters," and "nowhere" in *Flip Book* was there any sign that Charmatz had grasped "such basic features of Cunningham choreography as taut rhythm, stylistic rigor or careful positioning within stage space." In short, *Flip Book* was "an act of desecration," unfaithful to the aesthetic Cunningham left behind.

To be sure, Charmatz's process in *Flip Book* is distinct from the one Cunningham frequently used to compose his own dances. For one thing, Charmatz did not choose his own gamut of movement based on the movement qualities of his dancers or on a specific movement possibility he wanted to explore. The comparison with the *Goshogaoka Girls Basketball Team* series by Lockhart highlights another difference between Charmatz and Cunningham. For her series, Lockhart made all the poses look as though they were based on the same genre of photograph; they were all created as staged performances, like studio shots of dancing.

In contrast, Charmatz borrowed photographic material derived from many genres: the snapshot of the live performance; the publicity photo used on a poster; and candid photos of figures seated, conversing at parties, or taking bows. I will argue in this chapter that Cunningham, like Lockhart, was fascinated by a particular genre of photography: the poised action shot taken in such a way as to suggest movement stilled by the camera. Whatever one might think of Charmatz's *Flip Book*—is it a send-up or an homage?—it must be admitted that he intuited something in Cunningham that others have not remarked before, what we might call his *photographic sensibility*.[3] Critics have long acknowledged Cunningham's interest in film, video, and digital technologies, but they have not studied how he employed the photograph, particularly the studio shot, as a choreographic tool.

Between the Live and the Still

Even early on, Cunningham tended to view dance through a lens of some sort. For the choreographic tone of *The Seasons* of 1947, Cunningham turned to images he had seen the year before at an exhibition on Northwest Coast Indian painting at the Betty Parsons Gallery in New York City.[4] In *TV Rerun* of 1972, he had dancers hold cameras and photograph one another while performing. The choreography of *Locale* (1979) was first produced for Charles Atlas's camera before it was performed on a proscenium stage. Indeed, Cunningham possessed a high degree of sensitivity to the mediated nature of the live. It would not be an exaggeration to say that despite all the emphasis placed on his love of movement, he had an equal passion for the *documentation* of movement, the various media that frame, crop, and support our experience of moving bodies in space.[5] In fact, it could be argued that during his lifetime, he was already engaged in the very process of reconstruction from which some of his devotees are struggling to save him, a process that has only accelerated since his death in 2009.[6] To be sure, he expressed little interest in returning to past dances, often leaving the work to others when it was a question of reviving a dance from the repertory that hadn't been performed for years.[7] Yet Cunningham's Event format clearly constitutes a practice of reframing in that it enables excerpts of different dances to be recycled, juxtaposed, or resequenced in new arrangements. His experiments with filming dance (as in *Westbeth* of 1974–75) revealed to him how the eye naturally mediates movement in space. And his collaborations with Nam June Paik brought home dance's discursive nature, what Mark Franko has called the "delay" that prevents movement from ever entirely coinciding with itself.[8] In other words, vision doesn't register directly; there is a cultural lens, if not a technological device, that frames what we see.

Long before these forays into intermediality, Cunningham was already considering the relation between dance and the *photography* of dance. He was fasci-

nated by the way dance looks when stilled, the peculiar tonicity muscles display when they are miming a phase in a movement sequence (similar to what we see in Lockhart's photos): the stillness of a body posed. He was investigating stillness throughout the 1950s, inspired by John Cage's integration of silence into his own compositions of the period. In Cunningham's notes for dances such as *Spring-weather and People* (1955), *Suite for Five* (1953–58), *Nocturnes* (1956), and *Crises* (1960), he uses the words *stillness*, *silence*, and *quiet* interchangeably, pointing to a modality of the body that is not that of frozen repose. A "quiet" moment is not a cessation of dancing but part of the dance itself, just as Cage considered silence an active element of the musical composition. However, in *Suite for Five* Cunningham takes his investigations a good deal further, integrating *as movement material*—that is, as an ingredient in his movement gamut—poses borrowed from studio shots of other dances. *Suite for Five* is, not coincidentally, one of the most frequently photographed and reconstructed works in the Cunningham repertory. I want to suggest that it is also one of Cunningham's most internally remediated dances, a dance about the relation between danced movement and photographed movement, a dance that resides ambiguously between the live and the still.

Suite for Five is self-consciously self-citational, containing both previously performed movement material and previously performed *photographed* movement material. Like so many of Cunningham's dances, it recycles postures and phrases from earlier dances; but his notes reveal that he went beyond his normal practice and actually found inspiration in photographs of postures and phrases from earlier dances. If, as Rebecca Schneider has suggested, "a performance may contain a pose, but is not a record of a pose," in *Suite for Five* the performance of the dance is, quite literally, the record of a pose.[9] We might thus want to ask, with Philip Auslander, if it is "worth considering whether performance recreations based on documentation actually recreate the underlying performances *or perform the documentation*."[10] The program notes to *Suite for Five* do not announce that the dance includes photographic documentation, or that its dancers are "performing" the documentation of past works—this is something I have had to glean from Cunningham's notes. But the bizarrely static quality of the poses, especially in the duet titled "Extended Moment," is impossible to ignore.

Suite for Five began as a sequence of solos for Cunningham, originally titled *Solo Suite in Space and Time*, that were composed in 1953. The dance evolved over time: in 1956 he added a trio, a duet, and a quintet; then, according to David Vaughan, in 1958 he added a solo for Carolyn Brown and reduced the number of his own solos from five to three.[11] The seven sections were composed according to a distinctive chance method inspired by Cage's *Music for Piano* (1953), which serves as the dance's musical accompaniment. For that piece, Cage traced the imperfections he found on a piece of paper onto a page of musical staves; the placement of the marks then dictated the notes to be played and the order in which to play them.[12] Following Cage, Cunningham placed a transparency on top

4.1

Merce Cunningham,
from the Choreo-
graphic Records
for *Suite for Five*
(1952): imperfec-
tions on paper;
time. © Merce Cun-
ningham Trust. All
rights reserved.
Reproduction cour-
tesy Jerome Robbins
Dance Division,
The New York Public
Library for the
Performing Arts.

of a page of imperfections and copied the pattern. The copied pattern represented the stage from a bird's-eye view; where the spots appeared was where the dancers would find themselves in a sequence determined by numbering the spots from left to right and using a chance process to produce a dancer's trajectory, timing, and pace. (See figure 4.1.)

Cunningham divided the page into five-second intervals and gave each spot a number. The distance between the numbered spots on the paper could then be measured as a temporal duration, indicating how much time the dancer had to get from one point to the next. According to his notes, Cunningham made "a page for each dancer in each of the seven dances that comprise the suite. In the Duet, the Trio and the Quintet [he] superimposed the pages for each dancer to find if there were points they came together which would allow for some sort of partnering or *stopped position*, some form of liaison between them."[13] By 1958, the titles of the seven sections were as follows: "At Random" (a solo for Cunningham); "Transition" (a trio); "Stillness" (another solo for Cunningham); "Extended Moment" (a duet for Cunningham and Carolyn Brown); "Repetition" (a third solo for Cunningham); "Excursion" (a solo for Brown); "Meetings" (a quintet); and "For the Air" (a final solo for Cunningham).

The "stopped position" to which Cunningham refers is particularly prevalent in the duet between Brown and Cunningham titled "Extended Moment," which is four minutes and thirty seconds long. It is in the notes for this duet that we find evidence indicating that he was thinking of *photographed poses* for his movement gamut. (See figure 4.2.)

Apparently, Cunningham originally intended "Extended Moment" to constitute the second movement of another dance he had been working on, provisionally titled *Socrate* after the French composer and pianist Erik Satie's 1918 composition of the same name for orchestra and voice. He had already choreographed "Idyllic Song," a solo, to the first movement of Satie's *Socrate*, in 1944. This dance, one of Cunningham's few efforts to present a clear theme (the death of Socrates), was not completed until 1970, when it was performed under the title *Second Hand*. His note for the *Socrate* "Duet" (fig. 4.2) alludes to "Louis' photos"—a reference we will examine in a moment—and illustrates with stick-figure drawings a set of poses numbered 1 through 6. Several of these poses are assumed by the two dancers in the *Suite for Five* duet, "Extended Moment"; but they are *not* poses found in what would later become the duet ("IInd Mvt") of *Second Hand*.[14] What this suggests is that Cunningham decided to integrate choreographic ideas initially generated for the second movement of *Socrate* into the choreography of "Extended Moment." Interestingly, while the second movement of *Socrate* (or *Second Hand*) uses a movement gamut similar to that employed in "Extended Moment," it contains far fewer lifts and, following the theme of platonic friendships, is much less physically intimate. The only element from the earlier note that Cunningham preserved for the duet in *Second Hand* is item 1—"walk-into-run around stage." This element, however, appears at the very end rather than the beginning of the duet in *Second Hand* and involves gestures of comradery rather than an embrace.

So who was "Louis," and why were his photos significant? What did these photos have to do with the "10 shapes" the choreographer charged himself to "make" for the ten-minute duet? Here, it is important to register Cunningham's choice of words: according to his note (fig. 4.2), he plans to make ten "shapes"—not movements but *shapes*. Under the section marked "II," he lists six such shapes, all of which (except one, item 5) could be held for an indefinite period of time. (In item 5, one partner is being swung off the ground. This swing-and-lift shape does appear in "Extended Moment.") The implication is that the choreographer is listing the shapes he has already seen represented in "Louis' photos." As opposed to the opening "walk-into-run" and the "slow figure" under section "III," the positions sketched out in section "II" of the note are identified with the nature of the photograph—that is, as a recuperation of something already performed in the past.

According to Carolyn Brown, the "Louis" to whom Cunningham refers is Louis A. Stevenson, a friend and amateur photographer who had been taking studio shots of Cunningham and his dancers at rehearsals throughout the mid-1950s.[15] Some of these studio shots have been preserved in the Jerome Robbins Collection at the Lincoln Center Library for the Performing Arts in New York City; others can be found on the Merce Cunningham Trust website in the Dance Capsule for *Suite for Five* and *Nocturnes* (1956). It is possible that figure 4.2 refers

Duet - [IInd Mvt. Socrate] [10 minutes]

I - walk - into - run around stage [Make 10 shapes]
 (1) into air

II - from Louis' photos
 (1) Carol on Floor ; M. arabesque over her
 (2) à la plage : leaning from each other
 (3) leaning on shoulder g.w.
 (4) holding outright on shoulder
 (5)

 (6) holding out from waist

III - Slow Figure !

C's U.S. leg goes behind

to photographs that were taken by Stevenson of *Suite for Five* itself, and that Cunningham intended to reuse the same poses Stevenson had captured for *Socrate*. Figure 4.3, Stevenson's 1956 photograph of "Extended Moment" in *Suite for Five*, corresponds to item 1 as listed under the rubric "Louis' photos": "Carol on floor; M arabesque over her." Figure 4.4, another of Stevenson's 1956 photographs of the dance, corresponds to item 3, "leaning on shoulder of M." ("M." = Merce).

However, other poses that Cunningham represents with his stick-figure drawings point to photographs Stevenson took of dances Cunningham had choreographed *before* "Extended Moment," notably *Springweather and People* of 1955. In figure 4.5. we see Stevenson's photograph of that earlier dance, taken in either 1955 or 1956. The shape listed as number 6, "holding out from waist," might have referred to this photograph of Brown held at the waist, with one leg lifted in the air.[16] Figure 4.6 reproduces a photograph Stevenson took in 1955 of *Springweather and People* in which we see a pose similar to that listed as shape number 2: "à la plage ['at the beach' in French]: leaning from each other."

Of course, Cunningham's notes are rarely an exact blow-by-blow (or step-by-step) account of the finished piece; rather, they are clues to his evolving compositional ideas, some of which are abandoned along the way. Not all the "shapes," or "stopped positions," in Stevenson's photos are identical to those that appear in "Extended Moment"—although several are. Ultimately, what Cunningham seems to be imitating is less the pose than the quality of the *posed*, the frozen quality of the studio shot. In the duet between Cunningham and Brown, each leaning pose, each lift, and each embrace are held for a brief period (two to three seconds), as though the partners were intentionally posing for the camera. And this, I would wager, is the effect Cunningham hoped to achieve.

For the sake of analysis, "Extended Moment" can be divided into four distinct sections. There are two interludes, which we might call the "shape interludes": each one contains nine shifts in position, some of which are repetitions of the same shape. In the middle and at the end of the duet, we find sequences of what Cunningham would have called transition steps: somewhat mincing, Nijinsky-style angular *coups de pieds*, *petits battements*, *pas de bourrée*, and low *rond-de-jambes*. The shape interludes do not appear to follow the rule Cunningham ostensibly set for himself: to determine the length of time of each movement phrase according to the imperfections on the paper and the distances in between them. During the two shape interludes, the pace is slow and surprisingly even. The allusion to "Louis' photos" in the choreographic note suggests that Cunningham wanted the sequence to have the quality of a series of discrete stills placed side by side. Indeed, the regularity of the pauses lends to the sequence an uncanny resemblance to a series of frames on a contact sheet. Content from the earlier dances is being recycled for use in a new one. At the same time—and just as

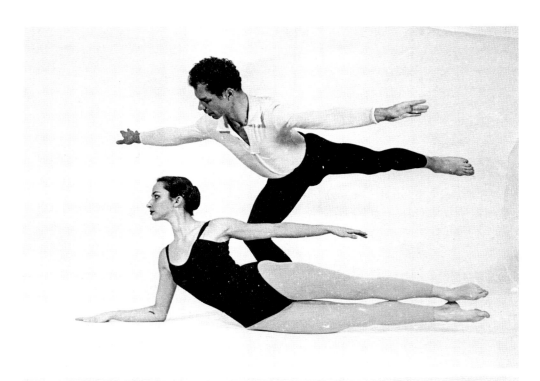

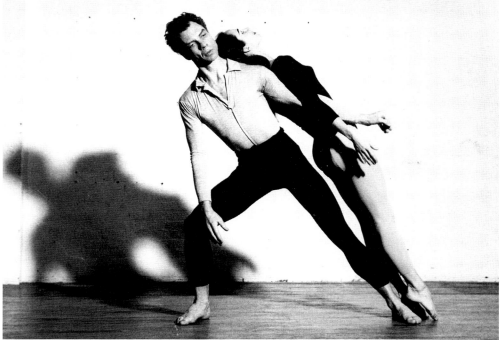

4.3 (top)
Merce Cunningham, *Suite for Five*: Merce Cunningham and Carolyn Brown, "Carol on
floor; M arabesque over her." Photograph by Louis A. Stevenson (1956).
© Merce Cunningham Trust. All rights reserved.

4.4 (bottom)
Merce Cunningham, *Suite for Five*: Merce Cunningham and Carolyn Brown, "leaning on
shoulder of M." Photograph by Louis A. Stevenson (1956). © Merce Cunningham Trust.
All rights reserved.

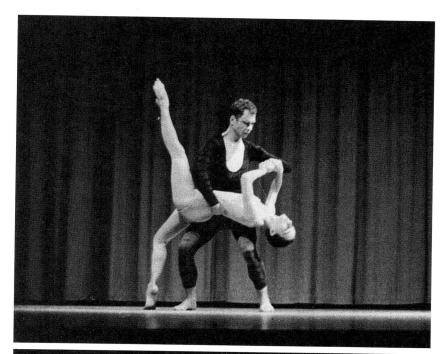

4.5 (top)
Merce Cunningham, *Springweather and People* (ca. 1956): Merce Cunningham and Carolyn
Brown, "holding out from waist." Photograph by Louis A. Stevenson.

4.6 (bottom)
Merce Cunningham, *Springweather and People* (1955): Merce Cunningham and Carolyn
Brown, "à la plage: leaning from each other." Photograph by Louis A. Stevenson.

crucially—a *quality* drawn from studio shots (and the contact sheets they generate) is being used to determine the movement quality of the duet.

By integrating photographic stills that are literally shots of positions (visual shapes, not movements), Cunningham here underscores a feature of his compositional practice: he often placed positions into cells of a chart, thereby producing a continuity composed, paradoxically, of separate pieces of stillness. He built up many of his dances from discrete stillnesses, poses that, like studio shots on a contact sheet, could be separated from a movement continuum and rearranged, like so many tiles of a game or frames on a roll of film. Although Cunningham choreographed entire phrases as well, certain isolated poses became like elements of a vocabulary that he frequently reused. For example, a clasp, captured both by Stevenson in 1956 (fig. 4.7) and on a contact sheet by another studio photographer, George Moffett, around the same time (fig. 4.8 and plate 8), appears not only in *Suite for Five* but again in *Roaratorio* of 1983 (plate 9).

The lift in which the woman arches away from the man, leaning her torso against his waist (or, as in *Roaratorio*, his upper body), is a kind of picture, a plastic element, just as much as it is a unit of movement in a movement gamut. If we think of filmic montage as the splicing together of separate *images-mouvements*, to evoke Deleuze's terms, then it is not entirely clear that what we observe in "Extended Moment" is a case of montage. There is "movement" in these "images," but it is deliberately minimal, composed only of the uncontrollable fluctuations caused by breathing, muscle strain, and so on. The two dancers move as quickly as possible from one stopped position to the next, muting the transitions to imitate less a series of filmic frames—placed side by side to create the effect of continuous movement—than separate, isolated studio shots arrayed on a contact sheet.

In a later note to *Suite for Five* (fig. 4.9), Cunningham refers to the duet through yet another analogy to the filmic medium: "Passion in slow motion." Jotted down in the upper right-hand margin of the note, these words characterize in the manner of a subtitle the juxtaposition of the two nearly opposed qualities that we find in "Extended Moment": "passion," an emotion that is fiery, intense, and unreflective, and "slow motion," a movement quality that tugs against the tide of passion, decelerating it, revealing it bit by bit.[17] Slow-motion cinematography, as I argued in chapter 1, was a particular fascination of Cunningham's.[18] In "Extended Moment," we see him trying to marry the fragmenting, disarticulating energy of frame-by-frame projection to the sweeping momentum of the lived relation. It is as though he wanted

both to sustain—to freeze—the intense affects he shared with Brown in performance *and* to dismantle them, to break them down into viewable, assimilable frames. In "Extended Moment," he aims to stage (expose) a relation and simultaneously to delay it, to submit it to the ocular abstraction of a position "held."

Yet if slow-motion cinematography is the slowing down of a *continuous* gesture, then these "shape sequences" in "Extended Moment" are not really like cinematic slow motion after all. Although Cunningham explicitly evokes "slow motion" in the note reproduced in figure 4.9, the dancing in "Extended Moment" is, as I have been insisting, more photographic in quality. If we view Charles Atlas's filmic reconstruction of 2005 or the Universal Studio film made in 1960 with the original cast,[19] we can easily identify the photographic quality that Cunningham is seeking to incorporate into the dance, a quality we can associate with slow-motion film only if we think of each frame as separable and discrete, a kind of *photogram*. Similar to the filmic frame, which, as Roland Barthes points out, can be detached from the narrative function of the scenario, the dance—momentarily arrested—can also become a counternarrative, or, more precisely, a counter *to* narrative. As Barthes wrote, it "scorns logical time."[20] According to Rosalind Krauss, Barthes "found himself locating the specifically filmic—what he thinks of as film's genius as a medium—not in any aspect of cinematic movement but rather, paradoxically, in the photographic still." Krauss maintains that the photographic, with its focus on shapes, can deliver a counternarrative force by focusing our attention on "a seemingly aimless set of details that throws the forward drive of diegesis into reverse as it were, scattering the coherence of the narrative into a disseminatory set of permutations."[21] If we follow Krauss (following Barthes), we might say that the photographic is Cunningham's *critical mode*. The photographic is his way of suggesting that order—the way things are—is not the *necessary* order, that individual moments—and thus the narratives they sustain—might be detached one from the other, suggesting "a disseminatory set of permutations" in which relations may be revised.

Human beings on a stage, however, are never as perfectly still as the figures in a studio photograph or film still. As Cunningham once wrote, "*Sustaining* immobility is an action."[22] The movement content of "Extended Moment" is certainly kinetic, but it is the kinetic record of a still, the folding back into temporal passage *of* that still. Conversely, Cunningham often directed his dancers to find the stillness in temporal passage—the stillness in movement. He

4.7 (facing)
Merce Cunningham, *Suite for Five*: Merce Cunningham and Carolyn Brown, the "clasp." Photograph by Louis A. Stevenson (1956). © Merce Cunningham Trust. All rights reserved.

4.8
Merce Cunningham, *Suite for Five*: Merce Cunningham and Carolyn Brown. Photographs by George Moffett (ca. 1956). Reproduction courtesy Jerome Robbins Dance Division, The New York Public Library for the Performing Arts.

duet ; 4:30 " } 'not like a folk dance'

Space I II } Passion in
 slow motion

together at beginning; + at circled pt.

time:
 I II
① both start after 8" - together
② to 20" to 28"
③ to 1'49" " 1'49" ← together
④ " 2'11" " 2'21"
⑤ " 2'21" " 3'13" } moving
 +
 stillness
⑥ " 3'32" " 3'32" stillness + silence
⑦ " 3'42" " 3'17"
⑧ " 4'00" " 4'00"
⑨ " 4'30" " 4'30"

movement assumed to
move unless indicated
otherwise

la coreografía
es como
 chocar no contra

duet

wanted his dancers to bend the durational (and therefore the theatrical) toward the emotional remoteness of the temporally arrested, the posed, or the picture-like. His choreography was largely devoted to dismantling the very opposition between kinesis and stillness. He pursued a lifelong exploration of the dialectical relation between shapes and rhythms; disjunctions and continuities; positions and transitions; "stances and actions"; or what he called, in an even more transparent allusion to the visual arts, "combines" (in the choreographic notes to *Aeon* [1961]).[23] Cunningham wrote of *Suite for Five* that "the action of the dance is deliberate, that is, the movements are short or long, often surrounded by stillness. . . . I suppose I could say the dance is about silence; but it just *is* silent, or has many moments in it that are *still*."[24] What he refers to in his notes as "shapes" (fig. 4.2) are these moments of stillness. I do not believe that they are the "exhaustion" of dance, its resistance to an imposed motility, as André Lepecki has asserted in reference to the use of stillness by contemporary choreographers.[25] The shape is not the opposite of motion but rather movement aware of how it strikes the eye, movement that seeks the eye, movement that remains.

Positions and Transitions

Cunningham explored the opposed pairs movement and stasis, or transition and position, in many of his dances, not just in the early years but throughout his entire career. In 1984, he chose to emphasize the static quality of the pose yet again, explicitly referring to held content as "pictures" in the dance of the same name. In his choreographic notes to *Pictures*, he specifies that he will make sixty-four "pictures" and thirty-two "transitions." The pictures, he states, will look like "silhouettes"—or the other term he uses in his notes, "slides." (See plate 10 and figure 4.10.) The title of *Pictures* tells it all: Cunningham is interested here in the relation between the pictorial version and the dance version of the same pose. (See figs. 4.11 and 4.12.)

Cunningham choreographed "transition" sections to link one pose or "slide" to the next, clearly distinguishing between the two varieties of choreographic material. As far as I have been able to determine, in *Pictures* he was not seeking to perform the documentation of a previous dance: the stick-figure drawings of human tableaux do not appear to imitate previously danced postures or their photographic reproduction. His concern here is thus different—and certainly the flavor of the dance is different. He had perhaps aimed to reproduce what he described, referring to *Suite for Five*, as a "ballet revolv[ing] around a quiet center," but the effect of choreographing from stick figures is a loss of that "revolving" energy, that is, a loss of that energy in the photograph from which a taut stillness, like a spring, might be released.[26] The difference between the two dances results from another choreographic decision as well: *Suite for Five* was initially conceived as dance in the round (with spectators seated on all sides). In

contrast, *Pictures* requires a proscenium stage and a severe frontal orientation to make sense of its silhouettes. In the opening phrase of *Suite for Five*, for instance, Cunningham is supporting Carolyn Brown extended horizontally on his shoulder in the pose similar to that listed as item 3 in his notes to the dance (fig. 4.2). After a few seconds, still balancing Brown on his shoulder, he rotates on his knees a full 360 degrees, thereby underscoring not only the wraparound viewing context but also the three-dimensionality of the shape. If he began with the idea of making *Suite for Five* a dance in the round, then already the concept of shape had to reflect something other than an aesthetics of the slide. A shape is already a volume; it is on the road to kinesis, to a phenomenalization in time. The shape anticipates what Fred Moten has described as "a looking that cannot be sustained as unalloyed looking," a "looking" that contains movement as an element of looking's being.[27]

It would be a mistake, then, to believe that Cunningham was satisfied to classify the elements of his movement gamut as either entirely static or entirely mobile. His dances show, in fact, that he could make an action pass easily from one (the static) into the other (the mobile).[28] Although the studio stills of Louis A. Stevenson reappear as discrete poses in "Extended Moment," they could also generate more fully mobile phrases. Cunningham, that is, could repurpose a choreographic element obtained from a photograph, altering the practical function it served in one dance to produce a different quality in another dance. An instance of such a repurposing can be found in his work of 1960, *Crises*. In this dance, Cunningham recycles the pose we saw earlier among Stevenson's photographs, a pose from *Springweather and People* reproduced in figure 4.5. Here, Brown is poised in an extreme arch; she is balanced on one leg with the other leg extended high in front of her while remaining suspended from one of Cunningham's outreached hands. In *Crises*, the pose reappears not as the climax of a sequence or as the performance of the stillness of a photographic still. On the contrary, in *Crises* Brown moves *through* the back arch. In other words, the pose, used earlier in "Extended Moment" as a stopped position, returns as a *transitional* step, a way of crossing the stage. Brown extends one leg straight above her, then curls that leg under her arched body to take a backward step, extending the opposite leg vertically above her torso in turn. She completes the arch-walk no less than eleven times, moving in this upside-down manner all the way from stage left to stage right. Thus, what appears first as a photogenic pose in *Springweather and People* captured as a photograph by Stevenson in 1955 is then reprised in *Crises* as a mode of *locomotion*. Within the stillness of the pose lies the potential for bipedal action.[29]

Note that in the pose as captured in the screenshot (plate 11), the male partner, Rashaun Mitchell, is facing in the direction of downstage right, toward which he will walk (and toward which Jennifer Goggans will ambulate backward, one leg at a time). In Stevenson's studio still from *Springweather and People* (fig. 4.5),

the male partner (Cunningham) is not placed in a position from which he can move forward. Both feet are planted firmly on the ground, his legs in a slight *plié* in an abbreviated second position parallel so that he can hold the full weight of his partner. The two versions of the same pose differ not so much in their plastic identity as in their kinetic identity. The *Crises* version is light—Goggans is partially supporting herself on a single foot. In contrast, the *Springweather and People* version is weighted—not only is Cunningham planted on the earth, but Brown hangs like a weight on the string of his arms. The first version of the pose (in *Crises*) is transitional, moving the action forward. The second version of the pose (in "Extended Moment") is climactic, marking a cadence, a hold. Cunningham must have seen both possibilities in "Louis' photo." That was his gift, that is the way he saw: as though eyes could infuse the black-and-white glossy with vectors of energy, duration, and dynamics. As though seeing could make time.

The Sound of the Still

Perhaps while sketching out his ideas for "Extended Moment," Cunningham chose to derive inspiration from "Louis' photos" because they *augment* that peculiar stopped-motion quality of the studio still. Stevenson was not a professional

dance photographer, and his style is decidedly not that of the typical (or at least the coveted) dance photographers of his time. If we compare Stevenson's shots with those of professionals, such as Barbara Morgan (Martha Graham's photographer) or Walter Strate (José Limón's photographer, who also photographed "Extended Moment"), it is easy to see that Stevenson erred on the side of the stillness that so intrigued Cunningham.[30] If we look at examples of their work (figs. 4.13 and 4.14), we can see that both Morgan and Strate follow the directive issued by the modern dance pioneer Rudolf von Laban: dance photography should capture the dancer *in movement*.

Laban notoriously expressed an aversion to the photographic apparatus as a recording device, believing that it betrays that which is essential to dance: its unfolding in time. He insisted that if photographs were required—and at the dawn of the twentieth century, they were increasingly employed as a means of publicizing and preserving dance—the photographer should take care to depict "a before and after."[31] Stevenson, in contrast, was manifestly not interested in "a before and after"—and this is perhaps what drew Cunningham's eyes to his photos. Cunningham was deeply suspicious of Laban's modernist credo—that choreography must chart an uninterrupted flow, that an un-self-reflexive vitalism lies at the heart of dance. It makes sense that he would want to explore the still element of dance during a period when he was trying to differentiate himself from the Laban-Duncan-Humphrey aesthetic—and that he would use Stevenson's photographs to do so. The simultaneous sense of liveliness and arrest, the Brechtian interruption that characterizes Stevenson's photographs, would have provided the perfect foil with which to counter the vitalist (melo)drama of modern dance in the Laban tradition.

Finally, it is important to emphasize that the tensions Cunningham was investigating—between the still and the kinetic, the extended and the instantaneous, or, in trade terms, the *pose plastique* and "flow"—are the very tensions that shape the entire history of concert dance. Jean-Georges Noverre, the originator of the *ballet d'action*, argued in his *Lettres sur la danse et sur les ballets* of 1760 that ballets should take as their model not the sister art of theatre but the two-dimensional art of painting. As a young man, Noverre studied the visual arts, believing that "a composer who desires to rise above his fellows should study painters and copy them in their different methods of design and execution."[32] A "ballet is a picture," he wrote, "or rather a series of pictures connected one with the other."[33] He used the words "living tableaux" to describe this picture series. Jennifer Homans—anachronistically but with acumen—refers to Noverre's "snapshot images": "In these painterly tableaux," she writes, "the dancers often froze

in a snapshot image before moving on, and Noverre even thought to introduce pauses into his ballets to focus attention on 'all the details' of these 'pictures.'"[34]

It could be said that throughout the history of concert dance, two fundamental but contrasting impulses have shared the stage: the vitalist impulse toward uninterrupted kinesis (illustrated in Laban's aversion to photography) and the pictorial impulse toward composition, sculptural arrangement, and even two-dimensionality (which we see developed in the works of Vaslav Nijinsky, a clear model for Cunningham in many ways). In an interview published in 1980, Cunningham revealed his understanding of this history: "In ballet, about two centuries ago, the positions were very clear, and probably came first. . . . In folk, [it's not the positions,] . . . it's the dancing . . . the act of doing it."[35] Having read Cunningham's comments on the distinction between ballet and folk, we are now in a better position to understand the other marginal comment penned at the top of the page of notes reproduced in figure 4.9: when he announces that the duet "Extended Moment" is "not like a folk dance," he is underscoring that it will be a dance of "positions" and not "the act of doing it."

Clearly, the mode of kinesis Cunningham was after in "Extended Moment" was more like a tableau vivant than a folk dance. And yet the extended slow-motion stopped position he privileged in the duet—and that I have been empha-sizing until now—is countered by a curious gesture he inserts in the middle, a gesture that interrogates the quiet, the still, of the temporal arts. In "Extended Moment," after the first "shape interlude," Cunningham lowers his body to the floor, with one leg extended behind his torso. Then he bows his head and taps the floor with his extended hands. (See figure 4.15, which shows the moment in which he makes the "tap.")

4.11 (facing) Merce Cunningham, from *A Pictures Book for J. C. Xmas 1984* (Red Hook, NY: John Cage Trust, 1984): sketch of last pose.

4.12 Screenshot of Merce Cunningham, *Pictures*: last pose, featuring Merce Cunningham and Patricia Lent (performance video, 1987; director unknown).

The tapping phrase is repeated five times. It is as though the choreographer had given himself the directive to tap the floor as slowly as he possibly could *while still making a tapping sound*. That is, he holds the pose of "tapping" as long as possible but introduces into it something that no picture can capture: the aural effect. A tap, after all, is one "moment" that cannot be "extended." The tapping provides a kind of sonic accent that, by contrast, underscores the slow pace of the move-ment as a whole as well as its silent, photo-graphic quality. The temporal lapse between each tapping phrase is approximately the same length as the "stillnesses," which are two to three seconds long. These stillnesses seem to arrest time. As the partners hold their positions, we hold our breath. How-ever, Cunningham's taps not only reinstate real time (as opposed to slow-motion tem-porality); they also evoke the click of the camera shutter, the sonic resonance of the

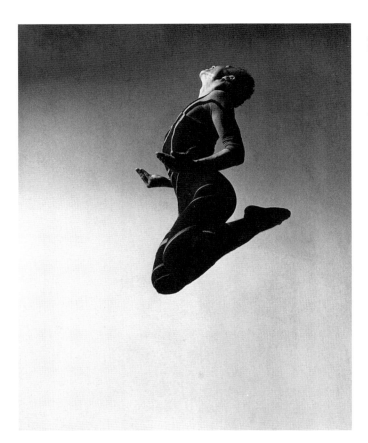

still, or what Rebecca Schneider has referred to as "the phonic materiality of photography."[36] In effect, we hear the click, the acoustic phenomenon that, at least until the digital age, accompanied the taking of the picture. We hear, that is (in Roland Barthes' more dramatic phrase), "the abrupt click breaking through the mortiferous layer of the Pose."[37] But Cunningham's poses are not "mortiferous." They index the "that has been" of the past—the past of the dance and the past of the photograph of the dance—but they are also "shapes," which Cunningham identified with "clarity," not inanimacy. "The trick," he wrote, was to "keep them both"—to inter(in)animate the "act of doing it" *and* the "positions." "They oppose each other but that's what makes them valuable, that's what will keep it lively. If you emphasize activity, steps, a lot of movement, but the *clarity* of the positions is not very great, that isn't very satisfactory. Now, if you keep that energy *in* it, clarify the positions more at the same time, that is especially interesting."[38] Clarity in time: the tug of the form against the pace of the blur.

The "Photographic Force"

We might well ask why Cunningham turned to photography at precisely that moment in 1958 when he was preparing his notes for a duet. To some extent, this

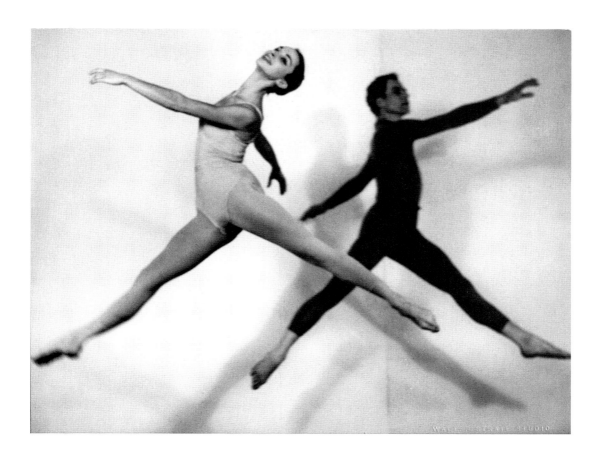

turn was predictable, not simply because of his interest in stillness, inspired by Cage, but also because photography, as Rosalind Krauss has remarked, was becoming a ubiquitous element of the cultural environment during that period.[39] Following the trend, Cunningham started employing photographers to publicize his fledgling company in the early 1950s. However, and even more important, at this time he began to enjoy the attention of one photographer in particular, Robert Rauschenberg, whose aesthetic would be increasingly identified with his own. It was during the 1950s that Rauschenberg discovered the documentary, permutational, and symbolic properties of the photograph. He produced his first "combine," *Untitled*, around 1953, which contains a postcard photograph of a painting by Edgar Degas. That same year, he began photographing Cunningham and his dancers, attending and shooting rehearsals of *Septet*, *Suite for Five*, and other dances. For instance, an attitude from one of Cunningham's solos in *Suite for Five*, "At Random," appears in the upper left-hand corner of one of the contact sheets of photos made during that period (fig. 4.16).

Rauschenberg did not incorporate photographs of Cunningham and his company into his artworks until 1959, beginning with *Trophy 1 (for Merce Cunningham)*. But then in 1963 he reproduced a shot he had taken of a rehearsal of Cunningham's *Aeon* (1961) in his remediated silkscreen photographs, *Scanning*

(plate 12) and *Express* (plate 13). Like Cunningham, Rauschenberg was treating the photograph as *content* to be manipulated. Douglas Crimp, Rosalind Krauss, Thomas Crow, and Branden Joseph have all argued that photographs allowed Rauschenberg to detach the subject matter of the image from its usual context, at once to evacuate and to ramify its connotative power. Rauschenberg possessed, according to Cunningham's assessment, an ability to create "a poetic ambiguity . . . as to what the object was"; he could take a representational element and bend it to many symbolic and compositional purposes, just as Cunningham would do in his own works.[40] By the mid-1950s, Cunningham and Rauschenberg were both elaborating what I would call a *rogue semiotics*. They were reshuffling charged content—sometimes photographic content—the obdurate stasis of which could be placed in question by means of remediation, that is, by making a dance into a photograph or the photograph into a dance.

Interestingly, Krauss has associated this rogue semiotics—a semiotics of the permutational—specifically with photography, or what she calls the "photographic force." In her essay "Perpetual Inventory," she wonders if "the photographic forces already assembling on the surfaces of the Combine paintings themselves release uncontainable networks of association."[41] In this rendering, the force of the photograph, of movement stilled, would consist in its ability to engender new relations, new sequences, that the momentum of movement arguably obscures. Could it be that something like a photographic force inhabits Cunningham's choreography as well? Would this force be derived from the specific characteristics of photography as a technology, the way in which the photograph extends a moment indefinitely in time? Is there a similarity between, on the one hand, the way ballet—or the balletic modernism of Cunningham—slices movement into frames and, on the other, the way the force of the photograph allows us to linger on a particular visual arrangement for a longer period of time? Does the "stopped position" encourage us to look, as did Cunningham, until we see other possibilities, alternative extensions, new futures for the moving body? Is the force of photography shared and even anticipated by dance? Perhaps there has always been something photo-

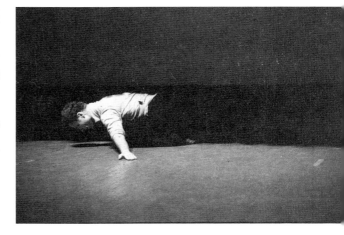

graphic *within* dance, something that predates the invention of photography, rendering dance inescapably intermedial, in contest with itself. I believe that Cunningham was especially attentive to this intermedial quality, and that he situated his inquiry at the sweet spot of semiotic and temporal irresolution where multiplying networks of association meet the arrest of narrative,

4.15
Merce Cunningham, *Suite for Five* (ca. 1958): Cunningham tapping the floor. Photograph by George Moffett. Reproduction courtesy Jerome Robbins Dance Division, The New York Public Library for the Performing Arts.

4.16
Robert Rauschen-
berg, contact
sheet showing
Merce Cunningham
and dancers
rehearsing at
Cunningham's 224
West Fourth
Street studio in
New York.
Contact sheets of
vintage nega-
tives. Photo-
graphs by Robert
Rauschenberg
(1953).

where affect meets its visual form, and where dance as movement meets the clarity of suspension.

Finally, a note on the pictorial itself. Clearly, there is a pictorial impulse in Cunningham, but by "pictorial," I do not mean that he has the impulse to make his dances look like pictures—or I don't mean that alone. The word *pictorial* has a rich history in the photographic and cinematic arts, referring to a specific movement in photography of the late nineteenth and early twentieth centuries that privileged aesthetic over documentary values, as well as a cinematographic style in which the scene is arranged as a kind of fresco according to compositional values associated with painting. My use of the word *pictorial* does not refer to the aestheticization of the image, nor am I solely interested in the performance of documentation (which would be, in one sense, the very opposite of *pictorialism* in the photographic sense). *Pictorial* as I am using it here refers instead to the

urge to discover and even expand aspects of another medium *within one's own*. As Sergei Eisenstein points out, pictorialism consists in the effort of one medium—film or photography—to act like another medium—such as theatre or landscape painting.[42] But pictorialism is also an adequate way to understand Aby Warburg's confirmation of the *survivance* of gesture in painting while he was observing the Hopi ritual dances in Arizona.[43] Warburg extended the dynamic attributes of one medium by looking at it through the properties of another. Eisenstein makes a similar point in his essay "Word and Image," namely, that a "dynamic principle lies at the base of all truly vital images, even in such an apparently immobile and static medium as, for example, painting."[44] The dynamism of the image, though, relies on a composition that draws in the spectator, that incites her to linger and thus to lend temporality to the image through her own gaze.[45] We might remark that Marcel Duchamp would certainly be pleased with this reminder of the spectator's role in the creation of the work of art; but here, I believe Eisenstein is on to something else. It is not merely that the spectator of a stilled image contributes to (or determines) its meaning. To Eisenstein's mind, the spectator responds to the *temporality* in the image, she switches on that embedded temporality simply by engaging in the phenomenal act of viewing. In the case of dance, the equation is a bit different. The performance of the stills in "Extended Moment" already takes place in time. What this performance references, then, is another type of temporality, that which is intrinsic to "Louis' photos," the very reverse of motion in stillness, or dynamism in the pose. The problem, for Cunningham, is not how to enliven the photo, the stopped position, but how to create quiet or stillness in a medium that invariably makes noise (footfalls, breathing, taps), a medium that privileges movement and thus shortens the interval, prevents vision from lengthening its own temporality, its own force. As Rebecca Schneider observes, "The pose articulates an interval, and so, in Henri Bergson's sense, is given to multiple and simultaneous time(s)."[46] How to activate those multiple and simultaneous times of the interval is a question that led Cunningham to explore the variety of still media we have been studying here. The fact that Cunningham, throughout his work, continually restaged dance's relation to the photograph—as well as the statue (e.g., *Shards*), the frieze (*Septet*), the film (*Walkaround Time*), and the picture (*Pictures*)—by no means makes his choreography subservient to these other media. Rather, the process of developing an intermedial self-consciousness allowed him to discover—and extend—the moment of dance.

Bound and Unbound
The Reconstruction of *Crises*

"We don't need to be afraid to say that *Crises* is dramatic," declares Jennifer Goggans as she begins her short speech delivered during an intermission between two Cunningham Studio workshop showings of the dance Cunningham made in 1960.[1] Standing before an audience of Cunningham students and admirers in November of 2014, she prepares us for what we will see: "John Cage once said that connection creates drama. You may have noticed something strange about this piece—that the dancers are connected by elastics. Here, they are literally connected, so there is lots of drama!"

Indeed. *Crises* is one of Cunningham's most overtly dramatic works. To engage in its reconstruction requires spectators to rethink their interest in drama from the considerable distance afforded by the passage of time. The critical literature on Cunningham, which leans heavily on what he himself stated in print, has tended to neglect the possibility that for him, the dramatic was a mode or area of experimentation. During the 1950s and 1960s, he wanted to turn the focus away from drama—so that his work might be viewed as a sequence of movements rather than as a narrative (reliant on literary sources); and so that personal meanings would not be mapped onto the actions produced on the stage. But as I argued in chapter 3, it is important to recall that Cunningham himself had a theatrical training, wrote plays, was a reader of Antonin Artaud, and cared more than we might suspect about the dramatic impact of his dances on their audience. Goggans might not have known of his background in theatre when she staged *Crises*, but she was highly aware of his interest in the dramatic tensions that could be generated between individual dancers onstage. Having observed the choreographer over the course of her twelve years in the Merce Cunningham Dance Company, she learned a good deal about how he would choose and coach the partners of his duets, and that knowledge was passed on to the dancers who reconstructed *Crises* in 2014. It has frequently been argued that dance reenactments, because

they reinterpret and recast the dance, present the opportunity to develop a new critical approach to the choreographer, whereas more traditional projects of reconstruction merely attempt to reproduce the original. But as I will argue in this chapter, in the case of the reconstruction of *Crises*, the mere act of bringing the dance back into the repertory has had the result of encouraging a new perspective on Cunningham's work.

Dancers and audiences (and certainly witnesses of the reconstruction, myself included) have been given the opportunity to discover a new Cunningham, one whose complexities could be manifested simply by taking up the work again in a context less limited by the framing discourses Cunningham and Cage sought so hard to erect. The simple fact that time has passed, that new audiences are not in the grip of the same *idées reçues*, means that a dance—even reconstructed in a spirit of fidelity—can divulge something not seen before. And fidelity itself is complicated: Goggans clearly wished to remain faithful to the precise movement content of the dance (the actual steps), but she also hoped to impart some of Cunningham's way of working with his dancers. It is this subtler knowledge that can be activated when a former company member participates in a reconstruction, especially when the dance being reconstructed has been passed along from one dancer to the next in a process requiring a variety of interpretive work rarely associated with Cunningham and his aesthetic. It is even possible that the decision to reconstruct early dances such as *Crises*—and more recently, the controversial and rarely performed *Winterbranch* (1964)—is itself subversive in nature.[2] The most overtly dramatic works in Cunningham's repertory were often made for specific dancers (whose idiosyncratic, expressive qualities the choreographer appreciated), and thus they were retired from the repertory when that dancer left the company. To reprise these works is tacitly to challenge our understanding of the choreographer and his way of creating drama—not through plot but through an exploration of choreography as a practice charged with the drama of relations between particular human beings. Insofar as any reconstruction takes place at a date later than the original, it can be said to participate in the larger project of reenactment. That is, a reconstruction holds the potential to release agencies formerly latent in the work, whether such a goal is an explicit intention of those undertaking the project or not.[3]

Merce Cunningham's death on July 26, 2009, sent tremors throughout the dance world. Artistic communities in general lost an important innovator, a choreographer whose influence had spread well beyond the shores of the United States. Yet at the same time, Cunningham's disappearance offered multiple opportunities to assess his works anew. Decisions made before his death—such as the folding of his company—led to the possibility that his works might enjoy a rich but unpredictable afterlife. A licensing program put together by the Merce Cunningham Trust has encouraged many restagings of his works while dance scholars

have found new archives readily accessible online at mercecunningham.org and Youtube.com.[4] At least two new generations of choreographers have arrived on the scene since the formation of Cunningham's company in 1953, making it possible—and even reasonable—to place in question the account he himself gave of his own work. Is it really true that Cunningham's dances are about nothing but the movement? Did he short-circuit our access to drama as pugnaciously as, say, Yvonne Rainer did in *Trio A* (1966)? Did he develop an aesthetic agenda as radically antitheatrical as the one she set out in her "No Manifesto" of 1964?[5] Could he have authored Boris Charmatz's "Manifesto for a Dancing Museum" (2009) and placed in question the nature of a dance's temporality (or the dancer-choreographer relation) in the same way?[6]

Crises in the 1960s

Not only is *Crises* a dramatic work, but, in addition, it was made to feature Viola Farber, one of Cunningham's most dramatic dancers. Even the costumes designed by Robert Rauschenberg, tonally fiery and intense, highlighted the dramatic nature of the material: four dancers wore leotards and tights dyed different shades of red, while Farber wore golden yellow, "an exaggerated extreme of red," Cunningham noted.[7] Uncharacteristically, the choreographer directed the women to wear their hair down—and there is a good deal of hair swinging in the piece. According to his account, he chose the music—*Rhythm Studies* by Conlon Nancarrow (Nos. 1–6 and part of 7)—"after the dance was choreographed," thus ensuring that the movement was at least originally conceived as independent of the score. However, the choreographic records suggest that at some point, he began to cue the transitions in the dance to the transitions in the music.[8] Drawing the movement closer to the score constituted a significant deviation from his stated practice, but it was only the first deviation of many.[9] Intention clearly played a role early on. Far from assigning movements or phrases arbitrarily, Cunningham carefully selected an individuated movement "gamut" for each dancer.[10] This was a practice he developed early on, one he followed throughout his career and explicitly linked to *Crises* in his treatise on choreography, *Changes: Notes on Choreography*.[11] As I argued in my introduction, critics have tended to overemphasize his reliance on chance operations, neglecting to note that it was only *after* selecting the gamut of movements with a certain dancer in mind that he would then toss coins to determine the movements' sequence, or "continuity." For *Crises*, Cunningham chose in advance the movements that would be placed in the gamut of each dancer; he then applied a process of random selection to determine not only the sequence of the movements but also the timing and the placement of contact between the dancers. Further, coin tosses indicated to the choreographer whether two dancers would be "attached" and, "if so, how, by holding each other, or by elastic, [and] where it might go."[12] In this way, Cunningham allowed

the elastic band to become a choreographic agent: it was involved in crafting the quality of the movement and initiating the coupling of dancers (and thus creating duets). It also served as a stage prop ripe with symbolic meanings that his choreography could exploit.

The sets of individuated movement gamuts, one for each dancer, reflected Cunningham's intimate knowledge of his dancers, their movement qualities and body types. The conceit of the elastic band ensured that at various points in the dance, two different movement qualities and body types would meet and interact. Encounters between dancers were thus treated as just another spatial variable, governed not by a narrative arc but by an aleatory result: "Where these contacts came in the continuity, or where they were broken," Cunningham explains, "was left to chance in the composition and not to personal psychology or physical pressure."[13] Despite his disclaimer, however, the title, *Crises*, evokes directly some type of psychological or physical "pressure"—perhaps the pressure of too much enforced intimacy during those summer months when *Crises* was being made during the Merce Cunningham Dance Company's residency at Connecticut College in New London. The word *crisis* is a Greek noun meaning a crucial turning point in a disease. Originally from the verb *krinein*, to separate, judge, or discriminate, *crisis* refers to a moment of decision. Over time, it took its place in a specifically theatrical lexicon, indicating the turning point in a situation or plot. It is important to note that *crisis* shares several meanings with the related noun, *climax*, which also denotes a point of extremity or a critical juncture. Few of Cunningham's titles reference psychological or theatrical states in just this way, a fact that permits us—even encourages us—to seek a dramatic meaning in the proceedings on the stage.[14]

Much about this work might strike us as atypical, a surprising departure from what audiences have been taught about Cunningham's practice. Indeed, his explicit rejection of the dramatic arc with its crisis, climax, and dénouement ("Climax is for those who are swept by New Year's Eve," he quipped[15]) might very well make it difficult for us to consider *Crises* anything other than an odd exception, perhaps one that confirms the rule. Nevertheless, I believe that *Crises*, even with its overt sexual pantomime and what one critic called its "sleaziness," is less an exception to than a revelation of Cunningham's choreographic style.[16]

But how was *Crises* regarded in the 1960s? According to multiple reviewers, audiences in the early years of the decade found the dance more comical than dramatic.[17] This audience reaction can be explained, at least in part, if we resituate the dance in its performance context. Commissioned by the American Dance Festival, *Crises* was juxtaposed on the festival's program to Pearl Lang's *Shira*, a Martha Graham–inspired dance with a religious theme. In her review, Doris Hering called *Shira* "an ecstatic utterance" accompanied by a "lush score"; it "confronted the theme of mortality" through a series of clearly symbolic gestures.[18] In contrast, Hering found the Nancarrow score for *Crises* "unbearably" jarring,

concluding that Cunningham had "turned his back on dramatically motivated dance."[19] No wonder that in this context, *Crises* struck audiences as incongruous and even slightly slapstick. The jangle of the player piano and the odd movement vocabulary would have evoked nervous titters among viewers primed to appreciate more thematically coherent and musically transparent fare.

Yet, as I have suggested, the dramatic material embedded in *Crises* was not ignored (or misunderstood) by audiences simply because it differed from that which animated the works of Graham, José Limón, and their followers. Cunningham's variety of dramatic intensity was less available to contemporary audiences because its presence was obscured by the discursive frame Cunningham himself had wrought, the rhetoric of emotional neutrality he tirelessly circulated from the early 1940s onward. The recent reconstructions of *Crises* remind us once again that a discourse always surrounds and influences the reception of a work, and therefore that movement can never be just movement, the human body exposed in all its inalienable nondiscursive essence.[20] Ever since Cunningham wrote in 1952 that movement need not have an "actual or symbolic reference to other things,"[21] scholars and reviewers alike have largely accepted the notion of a nonreferential, semantically denuded dance vocabulary. In 1986, for instance, Susan Leigh Foster summarized what had become a critical consensus, explaining that for Cunningham, "the dance could simply be about human bodies moving and nothing more"; he "emphasized the arbitrariness of any correlation between movement and meaning."[22] In short, he (and to a great extent his critics) both urged us and forbade us to associate any particular movement with any particular symbolic meaning or affective resonance.[23]

Since 2001, however, the mantra "movement means movement" has begun to unravel. Although Cunningham *overtly* discouraged symbolic and autobiographical readings, he also found ways to solicit them, leading us toward the very contexts his statements would appear to exclude. Recent work by Daniel Callahan has disclosed less than veiled references in the dances to the choreographer's partnering with Cage; for instance, Callahan asserts that *Second Hand* (1970), a lyrical homage to Erik Satie begun as early as 1944, reveals "parts of their own [shared] history."[24] In chapter 3, I suggested that Cunningham's eroticism—as well as his emotional palette—is more on view than we might have imagined. As time passes and the historical and personal contexts of his dances become clearer—due to the publication of Cage's *Selected Letters* and Carolyn Brown's memoir, *Chance and Circumstance*, the availability of Cunningham's unpublished writings and notes, and the forthcoming publication of his diaries—we can begin to discern discrepancies between the stated objectives of the two artists and their actual practice. Nowhere is this discrepancy more evident than in the duets Cunningham choreographed for *Crises*.

We are fortunate to have greater access to these duets than we previously had: a 16mm film made by Helen Priest Rogers of an August 14, 1961, performance at

Connecticut College is now available online through the Merce Cunningham Trust website; in addition, Cunningham's notes for the dance may be found at the New York Public Library, Jerome Robbins Collection. The first thing to be observed when watching the 1961 film is the degree to which the style of the dance draws attention to the idiosyncratic movement qualities of the original members of the Merce Cunningham Dance Company—especially Viola Farber, Carolyn Brown, and Cunningham himself. The choreographer has underscored the dancers' distinctive ways of moving, not merely by exaggerating them, but also by setting them into close relation during the duets. In performance, the elastic bands that periodically tie two dancers together freight their encounters with an added charge; the bands tend either to accentuate the tension between the two dancers as they move in opposed directions or exaggerate their intimacy as their bodies are pressed close. Two different (and idiosyncratic) movement styles are thus forcibly joined—not at the hip, although that is suggested at the end of the dance, but at other joints, such as wrists and ankles. Whereas other dances of the same period—*Summerspace* (1958), *Antic Meet* (1958), *Rune* (1959), and *Aeon* (1961)—all contain quirky or unusual movements and movement patterns, *Crises* is particularly replete with the sinuous extensions and eye-catching curves of Viola Farber, for whom, by all accounts, the dance was made. Watching the 1961 video, we become alert to what Cunningham himself referred to in his notes as "quivering gestures," "wiggling," and "shaking,"[25] thereby indicating his desire to capitalize on the dancing body's fleshiness, its presence on stage as a carnal rather than an abstract substance.

We have been conditioned as Cunningham viewers to experience the coolness, the clarity, and the cleanliness of a Cunningham dance. Although we might be seated very near the edge of the stage during a theatrical performance, and although we might end up near the dancers during a museum Event, we rarely remark on the trembling of their sweaty bodies as they struggle to maintain a pose. Nor do we attend consciously (or hermeneutically) to moments when two dancers make genital contact in the process of executing a move. *Crises*, however, develops in us different habits of viewing—or at least it could. Instead of distancing us from the intense affect of sensuous gestures—"reobjectifying" them through fragmentation, randomization, decontextualization, and parataxis—the dance manages to bring that affect up close, almost rubbing our noses in it.[26] Over the course of the twenty-two minutes of the piece, we are encouraged to read a relationship, an explicitly erotic relationship, into the exchanges between the dancers. In the duets especially, there is what Cunningham called in "Space, Time and Dance" a "surfeit" of climaxes, a surfeit of "crises."[27] Yet this surfeit does not produce a leveling effect; it does not dissipate the erotic tension or the affective intensity of the individual moments of the dance. Instead, that surfeit, the multiplication of "crises," tempts us to find a climactic energy in *every* contact, every encounter we see. *Crises*, in other words, encourages a different kind

of spectatorship, a kind of eroticized version of a Buddhist awakening in which each moment of life—or at least of performance—promises an encounter of heightened (carnal) intensity. Cunningham: "Now I can't see that crisis any longer means a climax, unless we are willing to grant that every breath of wind has a climax (which I am)."[28]

Cunningham is suggesting in this remark that we might find drama even in those encounters that initially strike us as indifferent and unremarkable, neutered of all sexual charge. Just as "every breath of wind has a climax," so, too, any corporeal contact might set off electric sparks. In short, we need not try to be dramatic; the sheer presence of two bodies on the stage is enough. Yet there is evidence from the staging of *Crises* that points us in a slightly different direction. We know that in this piece, the choreographer intentionally amplified all the elements that make a dance dramatic. Cunningham and Rauschenberg dressed the dancers in various shades of red and dictated that the women's hair be loose and wild. (During the reconstruction, Jennifer Goggans directed the women to "throw [their] hair around.") Meanwhile, the music, which materializes the clash between at least two (and up to thirteen) independent, rhythmically distinctive piano riffs, forces us to experience dissonance at a more visceral sonic level. Finally, the prop, the elastic band that literalizes the connection between the dancers, visually draws our eye to exact points of contact between bodies, underscoring both sensuous and conflictual modes of touch.[29] It is as though everything in *Crises*—the movement, the prop, the costumes, and the music—were conspiring to undermine the materialist conceit propagated by Cunningham and Cage ("a thing is just that thing"). Even Cage's comment on *Crises*—that the relationships rendered "explicit" by the elastic band remain "mysterious"—seems slightly off.[30] It is precisely because the relationships showcased in *Crises* are *not* so mysterious that it appears to us exceptional, a departure from the coolness and abstraction we associate with Cunningham's work.[31]

Reconstructing *Crises* in 2014

When Goggans taught the dance to the workshop dancers, she was careful to avoid explicit references to Cunningham's personal relationships with his dancers, but she did focus a good deal on Viola Farber's movement idiosyncrasies, which the student dancers could access through Rogers's film. Goggans had danced Carolyn Brown's role in the first reconstruction of *Crises*, undertaken in 2006 under the guidance of Robert Swinston and Carol Teitelbaum (Holley Farmer played Farber's role; Rashaun Mitchell played Cunningham's). The 2014 reconstruction of *Crises* that I observed was thus "three generations away" from the original production, as Brown put it when recollecting the sequence of performances and reconstructions in which she had taken part.[32]

In *Chance and Circumstance*, Brown suggests that at least three conflicts were

coming to a head during the months preceding the making of *Crises*. First, it appears that Cunningham was secretly planning to exclude Remy Charlip, the only other male dancer in the company, and *Crises* was the first dance in which he did not appear. It is no accident that this work focuses on the rather intense and competitive relationships among the remaining members of the company. Second, Brown reports that Cunningham was increasingly uneasy while choreographing the commissioned work during a residency at Connecticut College in the summer of 1960. In one of her letters, she notes, "Merce is in decline at last. . . . He seems very, very sad, despondent, lonely. . . . He is so alone—with no one to talk to. Pearl Lang has her husband José his wife. Etc. Merce has no one—no friends and although I try to be helpful, something, someone more is needed."[33]

With Cage absent, Cunningham was left on his own to navigate what was at the time an alienating environment. It is no wonder that he would have fallen back on his relationships with company members, relationships that might have been intensified by their isolation in the countryside. Another of Brown's letters reports that "Viola and I think he's making a witches' dance. It is all quite sinister, wild and strange. Once Viola said to Merce she'd like to be a witch in a dance. So who knows? Maybe he is granting a wish (witch)."[34]

By all accounts, Farber was a moody person, and this may have contributed to Cunningham's decision to make a "witches' dance" for her, one that would explicitly pit her type of energy against Brown's. Although there are no solos in *Crises* (except very brief ones by Cunningham and Judith Dunn), it is by no means an ensemble piece. The dancers, except when engaging in duets, appear isolated, in their own worlds. The duets, however, are unmistakably instances of partnering, gestural expressions of close involvement. When partnering Farber, Cunningham is at times responsive and physically intimate, and at others manipulative and bossy. In contrast, when partnering Brown, he takes on the more traditional tasks of the *pas de deux*, such as supporting her *developpés* and *pirouettes*. Finally, when partnering Dunn he is solicitous, chivalrous, almost a supplicant at her side. It is as though he were choosing not just between different women but also between different ways to move, different ways to *be*.

The competing drives Cunningham exposes (or performs) in *Crises*, his sequential interest in the three women he partners, could have been a mask for an erotic ambivalence of a different sort. Just because he carried on a long-term sexual relationship with Cage does not mean that he never felt erotic urges toward others—both male and female. Speculation aside, though, what the duets with the female dancers plainly reveal is that Cunningham as a choreographer could draw from a variety of relationship types for inspiration. In the *Crises* duets, he allowed himself to explore a broad array of movement styles and varieties of relation, shifting how he moved to accommodate his partner to the point where he ended up pushing the envelope of what might be considered appropriate male dancing behavior within the frame of the traditional couple genre. Put differently,

by accommodating and imitating his partner he could trouble the gendering of his movement vocabulary without leaving the duet structure behind. Much has been said about Cunningham's effort to evacuate narrative, and certainly, he rarely foregrounded a plot per se. But the very nature of the duet as a form is to suggest an intimate relationship, one that almost inevitably bears the seed of a larger drama. Cunningham knew this. Not only did he make the duet one of his lifelong preoccupations, but in *Crises* he focused on the potential for coupling to excite narrative expectations by figuring conflict as kinetic contrast, that is, by exaggerating the different movement qualities of each of his leading ladies and by responding to each dancer in a different way.

As many have noted, Farber possessed a highly distinctive way of moving that deeply affected the flavor of Cunningham's work during the period she worked with him (1953–65). In the choreographer's words, "One of the special characteristics of this dance [*Crises*] was due to Viola Farber. Her body often had the look of one part being in balance, and the rest extremely off. Now and again it was like two persons, one there, another just ahead or behind the first. This was coupled with an acute rhythmic sense."[35]

Farber was certainly one of the dancers for whom the movement gamut was "individualized to a great degree."[36] The other dancer similarly distinguished was Carolyn Brown. In contrast, Marilyn Wood and Judith Dunn perform phrases that seem more generic, perhaps for the simple reason that they are often given basically the same moves to perform. What is odd is that the only male dancer—Cunningham—does not always have a vocabulary (or "gamut") sharply distinguished from that of the women. Yet during the period leading up to *Crises*, he almost invariably gave himself more challenging, awkward, and idiosyncratic movements to perform in his solos than he assigned to his female dancers. For *Changeling* (1957), for instance, he invented lots of small hand and head gestures, moving like an otherworldly creature, half-animal, half-man. But in *Crises*, Farber and Brown also perform a wider range of material, much of it uncodified and difficult to describe. That is, some of the material would not fall under the categories we associate with Cunningham: ballet, modern, popular, or folk. Instead, he choreographed movements for Farber, Brown, and himself that seem to undermine the very notion of technique—although the performance of the 2014 reconstruction I watched demonstrated the difficulty of the movements despite their being technically uncodified. What I mean by "uncodified" is not "everyday" or task-oriented actions. The movement vocabulary of *Crises* includes a range of micro-motions that disturb the pose, whether balletic or modern. When describing what these dancers do, words like *jerk, wobble, slither, undulate,* and *punch* come to mind. Cunningham's own descriptives from his notes include "quiver," "wiggle," and "glide"; and "Kurati [*sic*] fists" is used to evoke the strange rhythmic punching moves he makes during two of the duets.[37]

Crises opens with a duet that clearly highlights and derives from Farber's

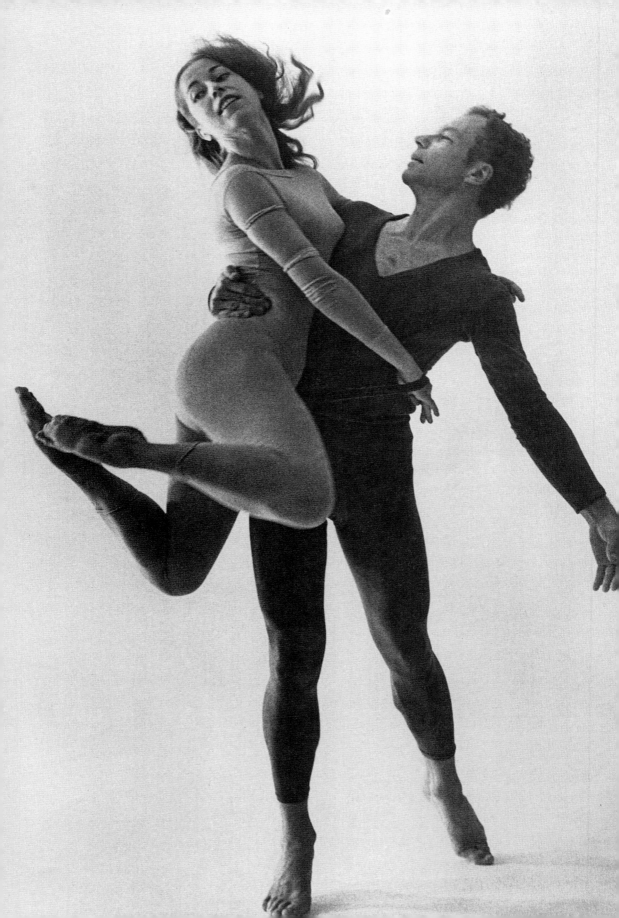

signature style. But her "sensuous" contribution to the duet begins only after a lengthy period of suspense.[38] Cunningham specifies in his notes that a tape of the first of Conlon Nancarrow's *Rhythm Studies* should start even before members of the audience are settled in their seats. Then the house lights should go down and the curtain rise to reveal Farber standing at downstage right, facing Cunningham, who is located at downstage left, facing the audience. After five seconds, Cunningham abruptly turns to face Farber. As he swivels his hips back and forth, back and forth, hands held rigidly to his brow, she kicks violently toward him from across the stage in a low contraction and then turns to face upstage and begin her next phrase: a slow extension of her leg to the side while undulating her arms, achieving a precarious balance in *relevé*. "Quivering" her torso (Cunningham's word), she repeats the extension from *passé* five times. After the fourth time, Cunningham crosses the stage in *chené* turns and comes to stand behind her, making circles around her head with small "Kurati" punches into the air. After the fifth extension, Farber lowers herself into a split, her torso "quivering"— again, Cunningham's term—while her hands reach to the back of her head in a position reminiscent of Cunningham's hand position at the beginning. As she completes the split downstage, Cunningham begins a split behind her, leading with the opposite leg, his hands folded together at the level of his navel. Slinking downward, he "shakes" his head "unevenly," Cunningham's notes tell us, "in proportion to Viola's body shaking." This is no small detail: the shaking that takes place in her body is communicated to his. It is as though her crackling energy were able to spring, like an electric spark, across the air into his body, giving the impression that the dancers are connected by an invisible cord.

Indeed, immediately after this sequence, the first elastic band appears, literally materializing the connection the couple have already established on kinetic grounds. Cunningham hauls Farber up from her split, sets her straight, and then inserts her right hand through a band that has been placed around his waist. The audience has probably not noticed the band until this moment, since it is the same color as his costume, a dark red. The gesture by which he inserts her arm into the elastic band appears undancerly; it has the slightly awkward but matter-of-fact air of theatrical blocking during a rehearsal: "Now I put your hand here, see?" But although Farber must pause ever so slightly to allow herself to be manipulated, inserted into the prop, the actual connection loses none of its dramatic character, since it has been rendered symbolic by the heat generated between the pair. Cunningham inserts her hand from the top of the elastic downward, thus drawing attention to his lower pelvic region. Facing him squarely now, Farber lifts her left leg and, in a thrusting gesture, wraps it around his torso. She arches dramatically away from him, but he lifts her and swings her around in what has become an iconic moment of the piece. (See figure 5.1.)

The photograph of this moment in the duet was most likely taken during a studio session or photo shoot and not during an actual performance. Yet it still

5.1 (facing)
Viola Farber and Merce Cunningham in Cunningham, *Crises* (1960). Photograph by John Wulp. Reprinted with permission from Hugh Martin for John Wulp.

manages to convey the duet's conflictual nature: Farber pulls away from the central axis of Cunningham's body, the point at which she is tied, literally, to his waist. The dancers' smiles belie what is the far less sanguine tone of the dance, for a struggle is clearly taking place. This is another moment when the power relation between the pair appears to switch. At the beginning of the duet, Farber calls the shots—Cunningham moves "in proportion" to her movements; his jerkiness is a direct result of her own. Next, he takes control by forcing a more literal connection, attaching her to him with the elastic band. But in the next phrase, Farber turns the tables. She uses the fact that Cunningham is connected to her by the waist to spin him around repeatedly. Then, after she makes three kicks in his direction, they try to pull apart. She releases herself from the elastic but remains attached to him, hand in hand. Exerting equal weight and pressure, they both subside to the floor. Once they are entirely prone, the second elastic band comes into play: this time, Cunningham puts his right hand through a band that has been placed on Farber's upper arm. In a kind of awkward tug-of-war *par terre*, they take turns pulling the other along the floor toward stage left. A photograph of this part of the duet taken by Bill Griffin shows how close the two dancers were when executing this movement; here (fig. 5.2), Cunningham seems to be burying his face in Farber's hair.

After six of these pulls across the floor—Farber always leading the way on her left side, and Cunningham, on his belly, sliding after her—Cunningham flips himself over and Farber climbs onto him. She curls up in a ball, her back stacked on his torso, and the pair rotate until, simultaneously, they both sit up. She abruptly executes a frontal split across his thighs, ending up facing the audience. A second later, he concludes the phrase dramatically by striking a high arch, his hand still gripping hers and his lower body pinned to the floor by her weight.[39]

The duet between Viola and Merce is arguably one of the most awkward and inventive parodies of the sexual act to be performed on a modern dance stage. Everything is there except the bump and grind: the bodies side by side or one on top of the other, the pushing and pulling away, the abrupt release at the end. But who ends up on top? As Cunningham arches ecstatically, Farber dominates majestically from above. At this point in the piece, Nancarrow's score is confined to a repeated four-note melodic line, somewhat like a jagged Joplin rag that adds to the sense of comic slapstick. In contrast to more traditional ballet choreography that approaches dance as a sublimation of the sexual act, this duet ironically displaces and channels sexual energy *without elevating it to a sublime form*. The yanking and hauling of bodies along the floor suggest none of the grace of a classically sensuous duet. Ultimately, connection between the two dancers is not exactly erotic, but it is not *not* erotic either.

The end of the duet consists of a sequence of short runs. After all the twisty, jiggly, quivery movement of the previous passage, the running sequence seems clear and crisp. Rhythmically, however, the runs are anything but regular. The

sequence bears the distinct signs of having been choreographed by chance means—and in fact, Cunningham's notes disclose that he determined by coin tosses the direction in which the dancers would run, how many steps they would take in each direction, and whether they would start the run with the right or the left foot. A separate group of pages in the notes titled "Crises Numbers" contains a list composed of three columns: the first listing two numbers, either 3 or 4 (indicating the number of steps); the second listing the initiating foot ("R" or "L"); and the third with arrows pointing up, down, sideways, or diagonally (the direction of the run). The final running pattern—which Cunningham specifies should be executed while Farber's right arm is still connected to Cunningham's right hand by an elastic band—directs the dancers in a complex, metrically uneven pattern: "3, 3, 4 (hold 4 counts)" and so on.[40]

Although the pattern of the running was arranged by chance, the running itself could not be purged of all affective resonance. Speedy running always suggests a compulsion to escape, to catch, or to lead. It thus remains relatively easy to read into the running sequence a clear meaning. For instance, during the 2014 rehearsals of the reconstruction, Jennifer Goggans told the dancers of the duet, "She's in charge." To the male dancers (there were double casts), Goggans explained, "It has a tugging feeling. She's really pulling *you*." "Stay close," she insisted, as the woman's pace challenged the man's. "She's changing her directions, and you're like whaaaa?!" Goggans entreated the two female dancers to "take bigger steps so that you're really pulling him." When the dancers were learning the complicated sequence, executing it at a slower pace, it appeared

mechanical and drill-like. However, when speeded up, the running sequence inevitably caused a relationship to emerge between the two dancers. Goggans was merely asking each pair to exaggerate what was already present in the placing and pacing of the steps: the initiating action of the woman. Since the woman runs quickly, determining which way the couple will turn, she causes the man to look as though he were being dragged behind. And of course, a woman dragging a man behind her conveys a drama. The duet's final gesture compounds the sense a spectator might have of a lovers' quarrel (or an erotic chase). As Farber exits downstage left at a run, Cunningham stands upstage left, with legs together and his back to the audience. At a fast-action pace, he raises his arms overhead and opens them wide, bringing his gaze abruptly to the ceiling as if in an exclamation of pain or shock. In Goggans's words, "Oh, no! Viola's escaped." She's gone.

If the slow motion of Cunningham's earlier duets (in *Suite for Five* [1953–58], for instance) tends to add gravitas to the paired dancers' co-seduction, the fast pace of this last running sequence shifts the choreography toward a Keystone Kops comic register. The final gesture Cunningham performs, that of a lover abandoned by his beloved, strikes us as both satiric and genuine at once. As is always the case in *Crises*, there are at least two ways to read what is happening. On the one hand, the duet is a lyrical dance, an artistic reworking of the movements typical of a lovers' quarrel. Chance is merely an extreme case of such reworking. Accordingly, we can experience the gestures as part of a recognizable vocabulary of narrative ballet. On the other, the duet is a farce, a reworking of movements that typically distances us from identifying (with) the action. The pace at which the runs are executed, the intentionally quirky, off-balance, hippy motions, and the literalization of human connection by means of the prop are all deeply estranging; they prevent us from taking the "passion" too seriously. And yet, when performed under the right conditions, the heat of passion is still there. *Crises* enables us to experience both at once—the heat of erotic conflict and the comic relief provided by the prop.

Choreography as Contagion, Not Capture

Whenever a choreographer creates for a specific dancer—as Martha Graham had for Erick Hawkins, as George Balanchine had for his many *étoiles*, as Cunningham had for Viola Farber—it is tempting to read an autobiographical narrative into what happens on the stage. *Crises* plays with that temptation on many levels. The *pas de deux*, which might be an allegory for a choreographer's relationship with his lead dancer, takes on an even greater charge in *Crises*, since the choreographer played the male lead in the original 1960 production. The precise nature of the physical relationship staged between Farber and Cunningham—she initiates, he chases after her—lends itself easily to a biographical interpretation. Could it be that there really was an erotic tension between them? Did he sense that he

needed to constrain her? Was he ambivalent about how close he wanted them to be? Did he feel both controlling and controlled? In general, Cunningham's relationships with his lead dancers, even if they were not erotic in nature, could be complex and intense, a possibility that the multihued costumes visually underscore: Farber wore golden; Carolyn Brown pink; Judith Dunn and Marilyn Wood red; and Cunningham an even darker red.[41]

It is always dangerous to speculate on the autobiographical content of a work of art; yet as Daniel Callahan and Jonathan Katz have both pointed out, there is also a danger in blinding ourselves to the ways in which an artist's sexual orientation and personal history might influence not only the work but also the way the artist chooses to present it to the public. Respecting too rigidly the artist's own claims has in some instances "obfuscated fuller understanding" of the work, as Callahan asserts, preventing us from seeing how personal biography (which is never strictly personal) shapes *formal* decisions.[42] The critical literature on Cunningham has been extraordinarily circumspect with regard to his private life; however, it is likely that the tide will soon turn. What will begin to be evident, I believe, is that despite Cunningham's disclaimers, the autobiographical was always one of the poles he was interested in exploring—if only because it could contrast so sharply with the impersonal nature of his aleatory processes. In *Crises*, the nature of the prop—an elastic band—conjures forth all sorts of questions. How can we not wonder whether it meant something specific, such as the dangers of bonding or the pleasures of intimacy? Might it have been intentionally chosen to symbolize struggles the dancers were experiencing in real life? Was it merely by chance—and chance alone—that Viola and Merce ended up side by side on the floor?

We are not likely to find answers to these questions, and, from at least one angle, they are beside the point. For the relationship staged in the duet lends itself to an allegorical reading of an entirely different kind. The connection that Cunningham and Farber establish in the initial duet may indeed serve as an allegory not simply for a choreographer's relationship with another dancer but also for the practice of choreography itself. That is, the control Farber has over Cunningham as she leads him across the stage may indicate her ability to compel him—or, in more positive terms, her ability to inspire him—to forge a dance vocabulary that suits *her* way of moving. More crucially still, the duet may point to her ability to compel (or inspire) him *to imitate her way of moving*, to absorb her unique motricity into his own way of moving as a dancer. It could be said that in *Crises*, we witness a kind of contagion, a transfer of movement qualities associated with a female partner (Farber) onto the very body of the male (Cunningham).

How, precisely, does Farber's way of moving flow into and alter Cunningham's? After the initial duet, what happens to her way of moving in the rest of the piece? A few examples are in order. Following the initial duet, and after a trio sandwiched between two quartets, Cunningham begins a duet with Judith Dunn.

He reprises the punching motions he used at the very beginning of the piece (to create a halo around Farber's head with "Kurati fists"), only this time he is hunkered down in a deep *plié* in first position from which he pivots to face Dunn. In between the crouching punch sequence (the rhythm of which is also carefully patterned, probably according to a random number sequence), he rises on one leg and extends the other into an attitude in second position. Just as Farber had (during her opening phrase), Cunningham also quivers and wobbles, thereby imitating the off-balance quality he attributes to her in his notes. It is as though he had caught Farber's body—had caught the *quality* of her body—not just by gripping her wrist but also by a kind of osmosis or contagion. Through his physical intimacy with Viola, he has contracted her way of moving, revealing that the connection between two bodies can produce an intermingling of their kinetic qualities.

We might recall an earlier instance of such contagion: the passage in the opening duet when Cunningham jerks his head "in proportion to" Farber's jerks and wobbles. *Crises* contains many such moments when Farber's sudden contractions and wobblings are mirrored by Cunningham, causing him to fall. Even though there are passages in the dance when he clearly assumes the dominating role, Farber's peculiar quality of movement seems to hover over the entire piece, imposing itself on different bodies like an insistent motif. Yet Farber's is not the only body to have an influence on Cunningham's. In his duet with Carolyn Brown, we see once again how partnering can ignite an intimacy that troubles the barrier between two dancers and their ways of moving. This duet occurs midway through the piece, immediately following a brief solo in which Cunningham executes a leaping combination typical of the male virtuosic interlude in the *pas de deux* of narrative ballets. Devouring stage space with soaring *sautés* in second position, he seems to be energetically reasserting his dominance just before Brown steps onto the scene. He joins her as she enters from downstage left and begins a virtuosic phrase of *développés* while leaning back in an extreme arch, all the while walking backward diagonally toward upstage right. (See figure 5.3.)

After these repeated arch-walks, he "pick[s] her up by waist and carr[ies] her DSR," Cunningham writes in his notes. The choreographer specifies further that while held by the waist, Carolyn should "mov[e] everything but [her] torso."[43] He captures her and holds her horizontal and thus perpendicular to his upright carriage. To the spectator, it looks as though Brown were dangling like a ganglion, gently waving her arms and legs in all directions. Cunningham firmly sets her down, then holds her left ankle to the floor as she lunges forward and continues wiggling away from his grip. Again, her motions are willowy and sensuous, her arms reaching forward and away. She is clearly trying to escape from the hold of the man who has captured her, but she does so without the aggressiveness of Farber's earlier quiverings and kicks. Again, Cunningham seems to be underscoring the differences between the way his two lead dancers move, and perhaps even

5.3
Merce Cunningham, *Crises* (1960):
Carolyn Brown and Merce Cunningham, the
"arch walk." Photograph by John Wulp
(1960). Reprinted by permission from
Hugh Martin for John Wulp.

between the two types of relationship he enjoyed with these dancers, both of whom were integral to his professional development as a choreographer. A few moments later in the duet, he seems to take on the very quality of movement that Brown has just exhibited. Both have ended up stage center: as she reprises a variation on the iconic pose from *Summerspace*, falling onto her knees repeatedly—from the left, from the right—Cunningham executes a series of falls from on high. In his notes, he writes, "I fall from arabesque position with wiggling (4 x's)."[44] Both, in other words, are falling: she from her knees, he from *relevé*, at syncopated rhythms, and both are "wiggling." The gangly movements Brown executed near the beginning of the duet (while Cunningham held her horizontally off the floor) now enter into *his* movement vocabulary. He falls out of the *arabesque* due to the instability of the balance caused by the variety of wiggles and tremors that his female dancers have introduced. These off-center movements, exaggerations of the kind of involuntary trembles that accompany any dancer's attempt to achieve or hold a pose, hence accentuations of their carnal being, have become the very theme of their duet. Whereas the off-balance character attributed to Farber's way of dancing might be seen by some as a liability, Cunningham treats it as a force, a possibility to be explored, a color to be added to the mix. Each dancer presents a different hue of that color: Farber is the forti-

fied, aggressive version—a red so hot it has become gold; Brown emphasizes the vulnerability and fluidity of an off-balance stature, producing in her version a kind of aqueous wavering; and Cunningham makes quivering and wiggling into motions that border on the obscene.

Whether They Are "Attached" and, "If So, How"

These exchanges between Farber and Cunningham, or Brown and Cunningham, transform movements—first introduced by a woman, we might note—into gender-bending choreographic units that either gender may perform. Cunningham's adoption of a particular woman's way of moving not only suggests her intermittent dominance but also counteracts the highly gendered nature of the classical *pas de deux*. Although Cunningham has been criticized by some scholars for retaining traditional gender roles, distributing tasks (such as lifting for men, being lifted for women) in a manner consistent with the most traditional ballet choreographers of his day, it is indeed possible to identify moments when he seeks to escape from such a strict segregation of movement styles.[45] To be sure, dances such as *Suite for Five* (1953–58) and *Duets* (1980) use partnering to create sharp contrasts between male and female dancers. Yet in *Crises*, Cunningham offers the duet as an exercise in commingling, an exchange in which the movement style of one dancer influences—or contaminates, to prolong our pathological metaphor—that of another. What occurs at times in *Crises* is a loss of gestural differentiation, an elimination of gender marks from specific motions, and a reduction of both dancers to (quivering) flesh. To say that Cunningham's body is feminized when he assimilates some of the movement qualities of his female partner is not quite correct, since these qualities are distinctively *hers—that* dancer's—not "feminine" in some generic sense. Viola Farber's embodiment can be seen to alter Cunningham's embodiment; her body activates in his a sympathetic (mimetic) response. He is imitating (or absorbing, miming sympathetically) her off-balance stance. The result of the duet's intimacy is to unchain a particular movement or movement quality from a particular body (and from a particular gender), allowing movements and qualities to circulate from one body identified as female to another body identified as male.[46]

Crises could be said, then, to reenvision choreography as a practice in which the choreographer's body—as a dancer's body—is saturated, overwhelmed, and transformed by movement qualities attributed to someone else. In consequence, the piece encourages us to place some pressure on the definition of choreography as presented, for instance, by André Lepecki in *Exhausting Dance*. Here, Lepecki makes a bold comparison between choreography and "tyranny."[47] There is a "strange power," he writes, "at the core of the choreographic that subjects the dancer to rigorously follow predetermined steps."[48] Lepecki's idiom is intentionally polemical, probably because he wants to make a point about what Theodor

Adorno might have called the "total administration" of daily life under capital-ism, or the movement regime of modernity. But his terms ("tyranny," "tyrannical machine") call out for some qualification, especially in light of what we find in *Crises*. The dance is less about coercion than transmission, a sharing of move-ment that flows in both directions. On the one hand, choreography is a giving-to-dance, as Mark Franko has felicitously put it.[49] In this vein, Carolyn Brown reports in her autobiography that she experienced learning the steps of a Cun-ningham dance as a liberation, not a tyrannical constraint. On the other, chore-ography itself is informed by the dancers who help realize it. In short, the gift goes both ways. *Crises* overtly stages this transfer of motile qualities. It is a dance about the process whereby movement is given from one person to another. That process is indeed fraught with peril—and it is sometimes out of balance—for that giving can turn into manipulation. But the process can also provide both chore-ographer and dancer with a chance to extend themselves, to evolve physically by discovering capacities offered by another way of moving, another dancer's as-yet unwritten choreographies, so to speak.

It would be inaccurate, however, to conclude that *Crises* projects an entirely sanguine attitude toward the choreographer-dancer relation. Whereas Cunning-ham's interest in Farber's way of moving may have played a large role in deter-mining the movement gamut he gave her, she also became an object of choreo-graphic manipulation at various moments in the work. That is, the control she exerts on Cunningham's movement gamut is only part of the story; he, too, exerts control in ways we have yet to examine. There are in fact two duets in *Crises* in which Cunningham plays the role not of sympathetic emulator, responding kin-esthetically and kinetically to the qualities of his partner, but rather of dominator, a controlling, manipulating force. Near the beginning, he partners with Judith Dunn, strapping her right foot to his left hand. During the course of the duet, he manipulates her legs into an attitude in *plié*; lifts her leg back up into a forward extension; turns her and lowers her to the floor, eventually hinging under her right leg, as if it were a bridge extended above him. Even when he lies down at her feet at the end of the duet, it is up to him to release her foot and allow her to walk away. Similarly, the second *pas de deux* with Farber near the end of the dance transforms the female partner into a kind of toy. Instead of submitting his body to her quivering, absorbing her quality as if it were a traveling electric spark, Cun-ningham takes charge in a matter-of-fact and entirely unambiguous manner. First, he grabs hold of her left foot with his left hand and clasps her two hands together with his right hand over her head; then he proceeds to flip her back and forth from an attitude front to an attitude back, finally guiding her as she awk-wardly hops off the stage. The relation between the two dancers resembles more closely that of a puppeteer to his puppet than that of a cavalier to his ballerina (although the suggestion here is that the latter is simply an exaggerated version of the former). The literalized connection between Farber and Cunningham

promptly loses its romance, its intimate, albeit conflictual quality, generating instead a mechanically repeated phrase.

Cunningham may merely have intended to point out the manipulative aspect of his relation to his dancers, the way choreography does indeed involve, as Lepecki has argued, a degree of tyrannical blocking. But the women in *Crises* are ultimately a cross between puppet and dominatrix. We would be reducing what is a complex depiction of the choreographer's project were we to characterize the contact in *Crises* as uniform, for the choreographic contact as depicted here is both a form of tyranny *and* an example of contagion. The figure of the choreographer is by turns a lover subjected to his muse and, alternatively, a puppet master subjecting his puppet to manipulation.

The transfer of movement qualities from one body to another requires a good deal of observation and contact, a togetherness portrayed in the dance as both creative *and* pathological. Commingling may in fact augur a danger for the dancer whose movement quality is being emulated as well as for the choreographer who emulates that quality. Further, the addition of a prop—an elastic band—that actively informs the morphology and dynamics of the movement raises the question of choreographic agency: Precisely who, or what, is determining the shape and feel of the dance? In the duet between Merce and Viola, who is the choreographer? Cunningham? Farber? The elastic band? Or an assemblage of all three?

"The dance is full of violence," Cunningham observed in reference to *Crises*. "How that came about through the above proceedings I don't remember, except if you have to bend and turn, attached or not to someone, and they are turning differently from you and at a greater or lesser speed, some violence might occur."[50] He is referring here to the fact that chance "proceedings" (and not plot or psychology) determined if and when two dancers would make contact, either attached by an elastic band or not. Initially, Cunningham might have meant for *Crises* to be a dance about togetherness, but the procedures he applied ended up producing a situation in which togetherness looks a lot like collision, an accidental or forced contact between bodies rather than their motivated and rational (or passional) union. What we can glean from Cunningham's notes is that he used a chance procedure (probably coin tosses) to determine where on the body of each dancer the contact would take place: "Throw to indicate parts of the body *not* to be used/or to be used," we read on a sheet of graph paper in the file.[51] But the point on the body where the contact would take place might have been the very last element to be determined, even though it would play a large role in the shape of the movement, given that a bend or turn had to begin its arc from that spot. On the same page, under the heading "Procedure," Cunningham lists five different elements of the dance to be determined by chance:

(1) toss for 1 or more predominant species

(2) toss for which one or ones [8 = 4+4 = 2+2 = 1+1]

(3) toss for which time length (or fraction of)
 (a) toss for possibility of non-use
(4) toss for part of body not to be used
(5) toss for duet or trio or[52]

Elsewhere, we find a list of eight movement types that might have constituted the "species" to which Cunningham refers in procedure 1 above: "Bend/rise/extend/turn/glide/dart/jump/fall." The finished dance does indeed include these eight species, and one or two seem to predominate in certain parts of the dance. If procedure 1 told him how many "predominant" movement species there would be in the phrase (the examples he gives always use either one or two), then procedure 2 would identify "which one or ones" would be used (e.g., bend, rise, extend, etc.).[53] Procedure 3 indicated the length of time that would be devoted to that particular phrase (or combination of species). Procedure 4 is the one that would determine what body part would not be used (or, alternatively, if all could be used). And procedure 5 determined whether the section of the dance would be a solo, duet, trio, or quartet.

Another list in the folder suggests that Cunningham determined in advance a number of ways in which two bodies could be connected, such as "body to: hips/waist/chest"; "head to: neck/chin/brow"; and so on. The finished piece contains a total of seven connections by means of an elastic band; however, body parts of two dancers make contact many other times over the course of the dance without being literally tied together. When Cunningham republished his comments on *Crises*, he added a sentence in parentheses in order to clarify his procedure. "Made in the summer of 1960 at Connecticut College," he explains,

> I decided to try a dance where, instead of being separate, the dancers could be together, one could hold another, that is, contact one another some way, but further not just by holding, or being held, but through being attached by outside means. I used elastic bands around a wrist, an arm, a waist, and a leg. (These places on the body were found by chance means *as the choreography proceeded*), and by one dancer inserting a hand under the band on another's wrist, they were attached but also, at the same instant, free.[54]

The added sentence in parentheses suggests that the body part that would be strapped was determined after the other features (numbers 1 through 5 listed above) had been chosen by random selection. This meant that drama, the conflictual moments, would result as much from *the place where the two dancers were connected* as from the nature of the movements in which they were involved. The "*outside* means," in other words, created the illusion of an *inner* motivation. Bending could become pulling away; running could become escaping; and turning could become a tug of war.

The last—and perhaps most important—instance of a binding takes place at

the very end. As the dance draws to a close, with all four women on stage, Cunningham enters from stage left and proceeds toward the center stage in a series of *chené* turns. Next, he descends into a crouch (a hunched-over *plié* in fourth) and turns to face toward Dunn, and then toward Brown in what looks like a frenzied effort to interest one of them in his movements. As he speedily switches directions, he also lowers the elastic band from his waist to his knees and extends it with his right hand in the direction of whichever woman he is facing, as if inviting her to come near, to connect, to insert her hand. Suddenly, as he extends the elastic toward Carolyn, the stage lights are extinguished, leaving us to wonder which—if any—woman accepts his offer of connection. This last use of the prop is different from all the others, for it seems to signify the refusal of a connection, the rejection of an invitation to closeness. Here, the elastic band becomes a sign of a frustrated and incomplete rather than a successful binding.

As I mentioned earlier, it is not always the case in *Crises* that connections between bodies are literalized by means of an elastic band. For instance, at one crucial point in the duet between Carolyn Brown and Cunningham, he grasps her left foot with his right hand, forcing it down to the floor *without* the restraint of a band. Brown struggles to escape, lunging away repeatedly from the point at which he directs her heel toward the floor. In the middle of the duet, he lets go and moves downstage to execute a series of falls on his own. Surprisingly, even though released from his grip, she continues to lunge away from the point where he had held her heel to the floor. That is, she continues to behave as though trapped in the position in which he first placed her until he returns to grab her foot once again. Her inability to escape from him, even when he has let go, suggests that a connection between them remains in her body even when he (or the elastic) is not there. It is as though the prop signified not only a synchronic togetherness, two people connected by physical proximity, but also a diachronic togetherness, two people connected by muscle memory, as are choreographer and dancer across time.

The status of the prop is thus a curious one in *Crises*, for its function seems both practical and allegorical at once. The elastic band literally holds two bodies together, but it also suggests emotional attachments that are conflictual in nature. On a more abstract level, the band could be read as allegorical of how meaning is so often imposed on—or attached to—dance movement. Cunningham tended to depict meaning-making as a kind of "connection" that he wished to break. Commenting on dance of the 1950s, he once stated, "It was almost impossible to see a movement in the modern dance . . . not stiffened by literary or personal *connection*."[55] And in his essay "The Impermanent Art," he stresses that movement should not be burdened by such connections: "In dance it is the simple fact of a jump being a jump. . . . This attention given the jump . . . helps *to break the chains that too often follow dancers' feet around*."[56] The grip that holds Carolyn's foot to the floor, the elastic band that straps Viola's arm to Merce's hand—these

are like the "chains" of meaning that prevent movements from being just what they are. Inasmuch as they demand interpretation, they are allegorical. The elastic band in *Crises* is a literalization of a danger that always threatens—the danger of being entrapped in relations or meanings, the danger of being tied down.

Bondage, however we may interpret it, is a recurrent theme in Cunningham's work, one often literalized through a prop that limits or entraps. He toyed with the idea of using a chair as a form of bondage as early as 1951, while making plans for *Sixteen Dances for Soloist and Company of Three*. In *Antic Meet* (1958), he actually did dance with a chair strapped to his back and described the chair in his notes as "a large mosquito that won't go away . . . like a leech."[57] *Aeon* (1961) also plays with literal bondage; Cunningham employs a rope designed by Robert Rauschenberg, tying Brown's feet together at one point, encircling her waist at another. *Winterbranch* (1964) integrates a piece of fabric that was used to drag people off the stage. Although the fabric didn't exactly bind the dancers, it directed their movements, transforming them into a kind of package (or another prop) to be brusquely displaced. The function of the prop as a form of entrapment was literalized to an even greater extent in *Place* (1966): Cunningham ends the piece by struggling to emerge from a large plastic bag. Even the stools used for *Roaratorio* (1983), which dancers transport from one side of the stage to another at various points in the dance, were envisioned as creating limits to movement. Patricia Lent, who reconstructed the 2010 version, calls the stools "baggage," like weights (or "chains") the dancers must bear.[58]

Cunningham is by no means the first choreographer to use a prop as a trap, a bind, or a prosthesis, one that significantly influences the choreographic act. Oskar Schlemmer and Loïe Fuller immediately come to mind as the foremost manipulators of props that extend and shape the dancer's movement. Ruth St. Denis's dances with veils also belong in this tradition, as do Doris Humphrey's dances of the period 1919–24, such as *Scarf Dance* (or *Valse Caprice*) and *Soaring*. Humphrey later satirized modern dance's reliance on scarves, comically binding herself up in a long fabric band in *Theater Piece* of 1936. Then, of course, there is Martha Graham's *Lamentation* (1930), described by Graham herself as a work in which a "tube of material" compels the dancer "to stretch within [her] own skin."[59] Dance has always engaged the prop as a kind of prosthetic or binding element that exerts what Alfred Gell would call "secondary agency."[60] Adrian Heathfield has remarked astutely that performance practitioners did not need to wait for theorists of "Thing Theory" or "The New Materialism" to arrive on the scene before attending to the affordances of objects and responding to their interpellations.[61] Choreographers, dancers, theater directors, and actors have always been aware of the ways in which movement and action are conditioned by things. They attend to the agentic properties of objects, exploiting their role as *actants* in the assemblages we call performance.[62]

The vital role of the prop in *Crises* was underscored several times during the

rehearsals for the 2014 reconstruction. At one point, a young dancer named Ernesto Breton asked Jennifer Goggans whether, during a particularly difficult set of arches and turns, his partner Erin Dowd (playing Brown's role) could clasp his hand instead of him clasping hers, which might have changed the placement of the elastic band. Goggans answered with a categorical no. As she explained, who is clasping whom *matters*, for the nature of the clasp determines who initiates the turn and thus affects how the turn looks. Again, in the case of the running sequence, the placement of the elastic band produces a situation in which it looks as though the man is being forcefully dragged by the woman. As Goggans noted, the placement of the prop ensures that a drama will ensue; as a form of connection determined by a chance operation, it scripts the dance.

Since the location and timing of the connection were, according to Cunningham, determined by chance, then chance must ultimately be considered an *actant* in the assemblage as well. In other words, chance should be seen as an active collaborator, although Cunningham does not tend to present it as such. To be precise, however, we are considering two sorts of collaboration here. At one extreme, Cunningham and his artistic collaborators—Cage, Rauschenberg, David Tudor, Jasper Johns, and so on—worked separately and in isolation such that their contributions would inflect one another as little as possible. At the other extreme, Cunningham, the dancers, the chance operations, and the prop all worked together in close proximity and constant exchange. They formed an assemblage in which each agent would necessarily affect all the others. If in rehearsal Cunningham found that a phrase determined by chance couldn't be executed by a dancer the first time around, he would often alter that phrase to suit the dancer's capacities.[63] If he observed and partnered a dancer for too long, *his* own movement vocabulary would be altered by *her* form of kinesis. If a prop enforced a particularly dynamic action, then that action—and its dramatic implications—would be preserved in the finished dance. Thus, the directive to move could pass from inscription to prop, from prop to body, and from body to body in a chain of intimacies that Cunningham must have at times found unbearable. As opposed to the clean, remote connections established among Cunningham and the various musicians and artists with whom he collaborated, those between Cunningham and his materials were often messier, stickier, potentially leading to more "crises," or critical points where decisions had to be made.

Reconstruction as Contagion

Ultimately, the unbearable and yet desirable nature of connection is the major structuring principle of *Crises*. It is also what makes the dance a peculiar choice for reconstruction. Any reconstruction implicitly raises questions about its own ability to connect to what that dance originally was, but *Crises* raises even more difficult issues, since its movement contents are so intimately bound up with the

physical personalities of specific dancers in the original production. We should recall that Cunningham dropped *Crises* from the repertory for many years before he finally brought it back to the stage in 2006. Apparently, he felt that the dance was associated with Viola Farber to such an extent that it shouldn't be danced by anyone else. He retired it from the repertory in 1965, only allowing it to be performed once in 1970 on the occasion of Farber's temporary return.[64]

No dance can remain the same over time. It is reauthored to some degree by every new dancer who revives a role in it. But *Crises* asks us to place even greater pressure on the concept of author by presenting the transfer of movement from one body to another as a kind of contagion. When Merce "catches" Viola's "quivering gestures" in his own, is she then the original author of his movement? The question could be asked even more broadly: Is the style Cunningham developed throughout the 1950s, the one to which he affixed his signature, entirely his? Or did Viola Farber and Carolyn Brown both play crucial roles in its inception? It may be that in a very real way the Cunningham technique, now taught throughout the world, owes a good deal to what *their* bodies were able to achieve. Further, although Farber and Brown had quite distinctive movement qualities, the fact is that they both shared a single training, having studied for years with Margaret Craske, the English ballet mistress who offered classes at the Metropolitan Opera School of Ballet from 1950 to 1968. Craske, in turn, had had "a long career as a ballerina with the Ballets Russes during the time of Diaghilev and Cecchetti."[65] The authorship of Cunningham's movements in *Crises* might belong to that balletic lineage as well as the many other lineages—tap, vaudeville, folk, ballroom, Graham—which he assembled to form a style.

So what happens when a new group of dancers attempt to bring *Crises* back to life? To whom—or to what—can we attribute the dance that emerges from their efforts? When approaching these questions, it is important to remember that not all reconstructions are alike. The one I observed—and that serves as my sole example—involved young dancers, workshop students at the Cunningham Studio, who were either apprenticing with other companies or just starting their careers. Their professional training and experience were limited (although their dancing was highly skilled), and their time in the studio was curtailed (they had only ten rehearsals). For these reasons, their treatment of Cunningham's movement material should not be considered exemplary of what can happen when professional companies with greater means attempt to reconstruct his works. At the same time, however, I believe that the challenges the student dancers faced in the workshop framework were indicative of the challenges many dancers encounter when removed from the intimate circle of Cunningham's dancing peers. We can still learn something about *Crises* by attending to its reconstruction, especially one directed by a dancer linked to Cunningham for over eleven years.

Jennifer Goggans began the first rehearsals by teaching the steps in blocks that the dancers could absorb. Frequently, she directed the dancers to watch per-

tinent phrases on the small screen of her laptop or cell phone. Technically or mnemonically more challenging sections of the piece were taught at a slower pace, then brought up to speed later. Most dancers caught on to the movement quickly; only the running and punching sequences, which follow no consistent or logical rhythm, were difficult to master. As veterans of the Cunningham Trust's workshops (and thus more experienced with respect to Cunningham's technique), the women, especially, had little trouble learning their parts. With coaching from Goggans, they could approximate the affect and dynamics of movement initially performed by Farber, Brown, Judith Dunn, and Marilyn Wood. What they had some trouble with, though, was the use of the gaze. Repeatedly, Goggans had to instruct them on how to use their eyes to intensify the drama of the passage: "Scan the room as if you were after someone," she told the women playing Dunn's part; "your focus is nasty," she told her Violas. Goggans's coaching confirmed what Mark Franko has observed, namely that "the quality of the dancer's gaze was an important element of [Cunningham's] early style. That gaze was intent, at times smolderingly intense, while avoiding explicit dramatic statement."[66] Here, though, Goggans did not *want* to avoid "explicit dramatic statement"; in fact, at one point when attempting to enliven a performer's glance, she coached, "Think evil thoughts!" Yet she was self-conscious about giving the dancers the kind of directions—what to feel, what to think—that Cunningham was known *not* to provide. At one point during Brown's duet with Cunningham, she cautioned the women playing Brown, "I don't want to tell you what to feel, but for *me*, I was thinking 'Oh my god, I want to get away!'"

On the one hand, then, Goggans was adding to the reconstruction something Cunningham would not have provided during the original rehearsals. In other words, she was interpreting the movements in a way that Farber might not have, and thus she was veering closer to the type of dramaturgy that might be called for in a reenactment (a self-conscious distancing of the dancer from the historical circumstances of the original performer). On the other, she was trying to be faithful to the piece in a larger sense, working to create human situations that recalled, as much as possible, the lived relationships among the original members of the company, relationships that the workshop students didn't have time to develop among themselves. Interestingly, the dancers of Goggans's generation *did* dance as though they had had the time to develop those relationships. Timothy Ward, a student of Cunningham's who performed in his Repertory Understudy Group in 2009, conveyed to me in an interview that he thought the choreographer often paired dancers for a duet based on the electricity he witnessed between them when they were dancing together. "He sought out dramatic pairings," Ward recalls, suggesting that even in his later years, Cunningham relied on the relationships already burgeoning among company members to enliven the movement he gave them to perform.[67]

Many observers have noted that during the 1970s especially, Cunningham's

dancers seemed to have lost some of the qualities that had enlivened the performances during the earlier decades. Some critics believe that those same qualities returned to the company's performances in the last years of its existence. Perhaps, though, what really changed over time were not the intrinsic qualities of the dancers themselves but rather the degree of permission they were granted *to relate to one another on stage.* Be that as it may, Goggans, who joined the Merce Cunningham Dance Company in 2000, certainly belongs to a generation of dancers who developed an uncanny ability to channel the energies of Cunningham's earliest dancers, skipping generations—along with Holley Farmer and Cédric Andrieux, among others—to retrieve the qualities of intimate connection that dancers had enjoyed (and suffered) during the first decade of the company's existence. Note that the training in Cunningham technique that the *Crises* reconstruction workshop dancers had received (both at Westbeth and at the new City Center Studio) was not, on its own, enough to give them a visceral understanding of what *Crises* required. As I observed while watching the rehearsals, oral coaching combined with enacted example had to be contributed by dancers who had worked closely with Cunningham and, in Goggans's case, with Carolyn Brown. Reviving *Crises* with relatively inexperienced dancers was indeed a tall order for Goggans to fill. Yet while nuances of tone were sometimes difficult for the Farbers of 2014 to master, the biggest challenge was clearly reserved for the male workshop students who had to play Cunningham himself. They simply couldn't acquire—either by studying the 1961 film or by dialoguing with Goggans—the reptilian quality of Cunningham's movements, the supple yet seamier aspects of his performance. The problem came to a head while Goggans was attempting to teach Cunningham's final entrance, one that he makes while crawling forward, one leg extended at a time, belly up. Goggans had to call in Rashaun Mitchell, the dancer who had partnered her in the 2006 reconstruction (and who had been with the company since 2004) to show the men how it should be done. (See plate 14.)

Mitchell's performance of Cunningham's entrance was spellbindingly different from that of the student dancers.[68] Although they, too, had tried to slither (as instructed by Goggans), Mitchell added a syncopated quality to his advance. He intentionally varied the pace of his steps, as if he were imagining a scenario in which he had to take advantage of moments when he was not being watched to cover as much ground as possible. That is, Mitchell managed to evoke the sneaky animality as well as the confidence, speed, fullness, and power of Cunningham's dancing, even as he slightly altered the movement to suit his own frame.

In fact, what made Mitchell's performance memorable, and thus allowed him to increase our interest in the dance, was not that he copied exactly the steps Cunningham had made. Rather, he was able to make the movement his own even while partnering each woman with an absolute, unwavering, ravenous attention.

In other words, he could be *theatrical*. Mitchell's way of supporting the female dancer was at once more efficient and more expressive; he was actually *doing* something, relating to her in a very specific way, while also making each movement a presentation of virtuosity and speed. It was as though he were sounding the full physical (and thus dramatic) consequences of each step, each hold, each clasp or bind. Luckily, one of the male dancers playing Cunningham immediately understood what he was seeing. From then on, *his* Cunningham was more determined, less hesitant, "more subtle and really creepy," as Goggans had directed him to be. The power of Mitchell's performance as mirrored by the younger dancer inhered both in how he asserted his physical relationship to his partner, responding to her as if linked by an *affective* as well as a material bond, and in how he created a movement flow, extending a long vein of energy from one position to the next without pause. The latter was simply a by-product of a more mature technique and a greater familiarity with the movement; the former, the evocation of an affective bond, can be ascribed to a grasp of the theatricality required by this particular Cunningham dance.

It is perhaps too vague to say that *Crises* is a dance about creating bonds. Yet that is precisely what Mitchell and Goggans showed it to be. They suggested that Cunningham was interested in bonds of many kinds and in both their negative and positive connotations. In kinetic terms, the bond could encourage flow between bodies, creating intimacy—a contagion of movement—and thus potentially suppressing the boundaries that police difference. An affective bond could provide support, but it could also allow one dancer to dominate another or become entrapped. On a semantic level, the bond could connect gesture to feeling, thereby allowing expression to occur but also threatening to congeal the meaning of the dance.

Carolyn Brown's remarks on reconstructing *Summerspace* seem pertinent in this regard. She speaks of the "quivering animal alertness" that she sought to impart when working with dancers at the Paris Opera Ballet, and of her attempts "to rediscover the initial spirit that informed the dance in the process of its creation."[69] But she rejects the notion that drama or affect were behind this process, or that they informed that "initial spirit": "Not narrative ideas, not emotional ideas—but movement qualities!" she insists. But I would counter that perhaps drama ("narrative ideas" and "emotional ideas") and "movement qualities" are precisely what *cannot* be unbound. Or rather, if the dance is to be dance, they can be unbound only to be bound again in a new way. And the qualification "new way" is vital. The state of a reconstruction may be similar to the state of the dancers in *Crises*: they are bound to a past version by a prosthesis, by an elastic band that makes them move; but they are also, as Cunningham puts it, "at the same instant, free." That is, a good reconstruction is one that inter(in)animates a past

work. It does not rely on exact imitation, on being bound too tightly to an original. In fact, reconstructions that base their casting on the physical attributes of the original dancers or that insist on exactitude in execution are often less successful. Rashaun Mitchell, a young African American dancer, does not resemble Merce Cunningham, nor does he move in the same ways. Yet in the *Crises* reconstruction of 2006, Mitchell was able to establish relationships, *dramatic* relationships, with his female partners that, even if they were different in nature from those Cunningham maintained with Brown and Farber—even if they were merely fantasized in a theatrical way—nonetheless produced the very image of involvement and drive. Mitchell brought, if not the exact relations, then *relationality* (that is, the possibility of connection, and thus drama) to the staging of the dance.

Crises constitutes a kind of limit case, an extreme version of what is implicit in many of the dances Cunningham made. As with these other dances, *Crises* is essentially about encounters. The piece does not deposit these encounters along a plotline, but rather allows them to multiply, to become "crises" in the plural, points in a drama at which decisions must be made. As Douglas Dunn put it, "Merce is dedicated to the image of a decision."[70] Because these critical encounters are not situated in a plot, these decisive, climactic moments remain nothing more than "images"; but they are not by that fact drained of their flavor. On the contrary, Cunningham's great accomplishment as a choreographer is to have succeeded in creating "images" of drama without plot through a combination of variables, one of which is the full investment of each dancer in exploring the "images" of affective relation that the accumulation of variables can yield.

In a revealing interview with Jacqueline Lesschaeve, Cunningham discusses how drama comes about in his work. Speaking of *Locale* (1979), he explains:

> You see a man and a woman dancing together, or being together, it doesn't
> have to be thought of this way [as dancing "together"], but you make a ges
> ture which can suddenly make it intimate, and you don't have to decide that
> this is an intimate gesture, but you do something, and it becomes so. . . .
> Gesture *is* evocative: those moments which are not intended to express
> something, but are nevertheless expressive.[71]

He goes on to offer a specific example from *Locale* in which he wanted to choreograph a passage where a man "leap[s] toward a girl who's then pulled up by another man so it's a continuous movement."[72] His first interest, he emphasizes, was in choreographing a "continuous movement," that is, in making a visual and kinetic shape. But as he worked on the sequence with Catherine Kerr and Joe Lennon, certain possibilities began to appear:

> I must get her [another dancer] back to him, so I had her come and do the
> gesture over him, and I thought, what if she is down over him? . . . She went

and, bending over him, she turned her head so that the side of her face touched his chest and I thought, that works very well, but it isn't as though I set out to make an intimate connection. It just came out that way.[73]

Cunningham's account of his procedure finds resonance in many other examples; he would start with a movement idea, and then be happily surprised by the kinds of relationships the results would evoke. "Gesture *is* evocative," as he admits. What he doesn't say here is that much more is involved in locating that gesture such that its evocative power might be tapped. That is, *where* the gesture is placed in the sequence (its "locale") matters. Cunningham saw himself as providing the circumstances in which such intimate moments could occur. According to his account here, he did not set out to create those moments of "intimate connection." However, his actions while making *Crises* and many other dances—*Suite for Five in Time and Space* (1952–68), *Nocturnes* (1956), *Summerspace* (1958), *Aeon* (1961), *Winterbranch* (1964), *Variations V* (1965),[74] and so many others—indicate otherwise. Granted, he may not have set out to create those *specific* moments of "intimate connection," but he certainly did set out to create situations in which such moments would occur. How could the positions Cunningham devised *not* produce erotically charged situations? (Asking what would happen "if she is down over him" is already to welcome eros.) Although he states in his interview with Lesschaeve that "you don't have to decide," in fact such situations of chance encounter do create crises, moments when the choreographer *must* decide. "What if she is down over him?" is posed as a question, but if the gesture turns out to be evocative of intimacy, Cunningham can choose to retain that gesture in the final "canning" of the dance.

Cunningham once said of *Nocturnes* that he intended it to be a "sequence of rendez-vous."[75] This was a telling way for him to describe not only *Nocturnes* but many other works of his as well. In the case of *Crises*, it was the movement "species" privileged in the phrase (bend, turn, etc.) as well as the chance-derived location of a prop or grip that determined to some degree the *tenor* of the rendez-vous. That is, the basic rudiments of the encounter itself were scripted into the dance. Accordingly, the encounter, as a unit of movement, could be *taught*. But what the workshop reconstruction of *Crises* illustrated is that while encounters are an intrinsic part of the choreography that future dancers inherit, how they respond to those encounters (as togetherness, violence, or bondage) is only partially governed by the choreography and the prop. Not all motivation can be generated and scripted by "outside means."

Admittedly, in *Crises* Cunningham set out to inscribe motivation into movement more overtly than in the other dances for which he is known, making decisions from the start about the casting, the nature of the movement, and the qualities of the prop that would overdetermine the affective tenor of the dance. As he himself said, it is very hard for two dancers to turn in two different directions

while tied by an elastic band *not* to emote tension, *not* to imply conflict, simply because their physical conduct is associated culturally in that way—and perhaps even experienced viscerally as tense and conflictual. *Crises* comes as close as any Cunningham dance ever could to revealing the evocative nature of gesture, the (almost) ineradicable connections we make between movement and meaning, even when that gesture has been generated by outside means. Still, even the steps of *Crises* could not, on their own, evoke the drama generated by the original dancers, the original relationships. Such drama required something more: it required a drama*turgy*, a set of interpretive decisions made by the dancers themselves. This indicates that a gap always remains between movement and meaning; that no choreography can root a reconstruction in an original; and that no choreographer can entirely control a dancer, since that dancer—whether the original dancer or the dancer of the reconstruction—may link movements to meanings in new ways.

The Ethnics of Vaudeville, the Rhythms of *Roaratorio*

Critics seldom think about Cunningham in terms of his ethnicity. Indeed, the general assumption has been that in the modernist avant-garde, experimentalism trumps social identity, and the drive toward individuation transcends collective affiliation. Susan Leigh Foster is one of the few scholars to depart from this way of thinking, for she has questioned the critical consensus that Cunningham's choreography is "all about movement" and that in his "faceless, placeless" dances, "what you see in them . . . is your own business and not his."[1] Foster observes in "Closets Full of Dances" that the only reason Cunningham could represent his dances as conveying no meaning is that he enjoyed the privilege of being white, and thus having a body unmarked by an audience's racial/ethnic associations—the presumption being that his movement would be unmarked as well. Cunningham, she insists, had the luxury of being able to assert that no particular meaning was conveyed by his sheer physical presence on the stage; implicitly, this would mean that no particular meaning was conveyed by the stage presence of African American dancers such as Gus Solomons Jr. or Rashaun Mitchell either. That the shapes made by Black dancers would be equivalent to (have the same "content" as) those made by Cunningham is of course more difficult to sustain in light of how audiences "read" dancers marked by their skin color.[2] Foster therefore taxes Cunningham with refusing to see that dancers of color inevitably project a very different image onstage from that projected by white dancers. As she puts it, "Living in the kind of world constructed by his dances," a world she construes as predicated on neutrality and the interchangeability of bodies and roles, "homosexual conduct or African American identity would carry valences no different from those of white heterosexual behavior. Both homosexual and heterosexual object choices, black and white aesthetic choices, would hypothetically take place within the same open field of possibilities." For her, then, "the very project of locating identity in a physicality that

denied racial difference could only be supported by a tradition that presumed its own universality."[3]

Cunningham did tend to treat all his dancers as though they enjoyed "the same open field of possibilities" with respect to the connections they could forge on the stage or the "valences" they might possess for an audience. To the extent that he could be accused of ignoring the racial and ethnic associations that spectators might project, Foster's comments bear weight. At the same time, though, Foster seems to assume that there would be a *correct* way to mark the white body as *not* universal, a choreographic practice that would "locat[e] identity in a physicality" that *affirms* rather than denies "racial difference." But what would it mean to affirm racial difference on the stage? How could audiences anticipate the meanings a body might solicit, the valences it might possess? What might be the hazards of presupposing particular valences—ethnic, racial, homosexual, or otherwise—as they attach to a specific dancer? Is there perhaps another kind of particularity that Cunningham hoped, choreographically, to affirm?

I will argue in this chapter that Cunningham worked through the problem of ethnic and racial difference formally instead of thematically by exploring difference as it is manifested in rhythmic phrasing. Rhythm in his choreography plays many roles, at least two of which are significant in this regard. First, when Cunningham made the seminal decision to separate the music from the dance, he loosened the grip of traditional, culturally specific rhythms on the dancing body. By allowing the choreography to establish irregular patterns of emphasis, he avoided what he called the "clichés" of the dance styles in which he had been trained—not just the patterns of modern and ballet but also those of tap and ballroom.[4] By choosing in most cases not to impose rhythms derived from a score, he left his dancers free to discover and then display their own interpretation based on a set of variables (body type, affective state, variations in training) that he could not—and did not wish to—control.

This is an important aspect of Cunningham's practice, one that speaks to his desire to bring out "the dancer in the dance." Yet it would be inaccurate to assume that he encouraged a free interpretation of rhythm at all times. Indeed, several dancers have emphasized that Cunningham often imposed a specific rhythm on the dance phrase. In a 1987 interview, Valda Setterfield, for instance, remarks that "the rhythms were always so incredibly strong," after which Carolyn Brown adds that he would snap his fingers during rehearsals, thereby ensuring that they "had a real sense of that rhythm."[5] Further, there were occasions when a specific rhythm was part of the *thematic* material of the work, an element that indexed associations he wanted to highlight. Here, I will be looking at two such occasions, two works that self-consciously quote popular dances and their well-established rhythms: *Antic Meet* of 1958 and *Roaratorio* of 1983. These works borrow rhythms that Cunningham did not invariably choose to disarticulate through chance procedures; sometimes they were incorporated *tel quel*, without distortion. My argu-

ment is that these rhythmic quotations carry reminders of a history *that is not Cunningham's alone*, reminders of a history that is collective rather than personal, ethnically marked rather than neutral. While it is true that many of his choreographic procedures were developed explicitly to obscure conventional clichés through the arbitrary resequencing of steps, there is another, less studied Cunningham who cherished such clichés and worked to foreground their implications. My interest, then, is in exploring the tension between what I see as two opposed impulses in Cunningham—on the one hand, the impulse to detach, and on the other, the impulse to rejoin—as they are manifested in his manner of mobilizing rhythm.

I will define rhythm both in relation to meter—rhythm as the way temporal values are distributed within a measure—and as a pattern independent of meter to be developed in its own right. The topic of rhythm takes us well beyond formal questions, for rhythm is often closely associated with ethnic or racial characteristics, not merely types of music or dance. In the 1960s, the archeologist André Leroi-Gourhan claimed that rhythm is at the heart of what defines human beings *as* human beings; it is also that which divides human beings into distinct ethnic groups, or *ethnies*. Each *ethnie*, he believed, could be identified by the unique rhythms of the gestural chains (*chaînes opératoires*) it had invented to build dwellings, fabricate tools, practice rituals, and so on. He wrote in *Le geste et la parole* (*Gesture and Speech*) that "rhythm is the creator of forms"; the fundamental characteristic of the human species is the "application of percussive rhythms, repeated over a duration," requiring a cognitive, muscular, auditory, and visual involvement.[6] His research convinced him that a sensitivity to rhythm is a shared human attribute, a defining gift, with no one ethnic group possessing greater mastery over it than any other. Indeed, what distinguishes human from animal groups, he argued, is humans' cognitive investment in rhythmic practices, the ways in which they build ever more sophisticated rhythmic chains of gestures to address an ever-widening variety of needs.

However, rhythm has not always been approached in such a positive and ecumenical light. Throughout the early twentieth century, social scientists and humanists argued that particular *ethnies* (or, in their terms, *races*) were more "rhythmic" than others; as a corollary, a sensitivity to rhythm was recast as a "primitive" rather than a sophisticated trait.[7] In the twentieth century, the claim was most often made with respect to African Americans and peoples of Irish descent, both of whom will be at issue here. *Roaratorio* is explicitly an investigation of the rhythmic forms associated with the Irish; *Antic Meet* explores that uniquely American—more explicitly, Irish American and African American—hybrid: tap. In general, rhythm is a constitutive rather than a supplementary feature of Cunningham's aesthetic. Rhythm is at once a cherished inheritance (from tap and folk dances, in particular) and, conversely, an unwanted ingrained habit, a set of modern dance clichés to be rooted out and replaced by rhythmic

patterns lacking an identifiable historical source and thus ethnically unmarked. In his public statements, Cunningham did not overtly associate particular rhythms with either a modern dance technique or a specific style of ethnic dance. Nonetheless, it is my contention that in at least two examples of his choreographic practice, those connections were tacitly established. True, he developed a way of working that aimed specifically to short-circuit movement patterns derived from a variety of sources; yet his claim that he sought to counter his habitual patterns and "tastes" is highly ambiguous. Where did these habits and tastes come from? What might have been their ethnic connotations? At what strategic points might Cunningham have wanted to foreground rather than obscure them?

I begin this chapter with a reflection on the role played by Cunningham's earliest training in his choreographic development, attending in particular to the reappearance in his work of tap dancing. I take a closer look first at *Antic Meet* and then at *Roaratorio*, an hour-long dance that is nothing if not a study in rhythm understood as a form of ethnic expression. If in *Antic Meet* Cunningham embraces rhythms identified with the ethnic syncreticism of vaudeville, in sections of *Roaratorio* he sets out to explore the possibilities of ethnically coded rhythmic patterns, tempering them through the application of experimental procedures. The last section compares Cunningham's evocation of the ethnic vernacular in *Antic Meet* and *Roaratorio* with Bill T. Jones's *Story/Time*, a dance based on chance procedures inspired by John Cage. By comparing a white choreographer who randomizes elements of Irish culture with a Black choreographer who randomizes elements of African American history, I bring to the fore the problems inherent in racializing rhythms *and* in randomizing them.

Vaudeville

Cunningham's earliest experiences with dance were, by his own account, experiences with rhythm.[8] An Americanized version of the sailor's hornpipe from the British Isles based on a 2/4 metrical structure is the first dance he learned, at the age of ten. A few years later, he began studying at the Barrett School of Dance in Centralia, Washington, where he learned routines based on other dances developed in Great Britain—but adapted and popularized by African American dancers—such as the clog dance and soft-shoe tap routines. Throughout his life, the rhythmic textures of these vernacular genres remained in his body, influencing his choreographic imagination. They were his "first imprint," as the former Cunningham dancer Neil Greenberg has claimed.[9] The ability to execute fast footwork was one that Cunningham prized both in himself and in the dancers he selected for his company. At least two former company members have reported in interviews that they believe they were chosen largely for their agility, their fast feet and strong rhythmic sense.[10] Beautiful line also mattered to Cunningham, but an ability to pick up quickly and perform accurately the complex rhythms of

a new choreographic unit—which involves both mental plasticity and physical dexterity—was crucial. He sought to attract and retain highly adaptable dancers, those who possess a refined rhythmic intelligence, able to shift seamlessly and suddenly from one tempo to the next.

To a large extent, Cunningham saw the dancing body as a percussive instrument. Don Daniels, an editor for *Ballet Review*, was not the only critic to notice this aspect of his technique: "Cunningham's percussive dance patterns," Daniels wrote in 1985, are essential to his attempt to counter "the clichés of conventional dance." He was echoing the dance critic Edwin Denby, who wrote earlier that Cunningham's "dances are built on the rhythm of a body in movement, and on its irregular phrase lengths."[11] These are important insights, for they suggest that playing with rhythm ("irregular phrase lengths") was one way for the choreographer to escape not simply his own habits and tastes but also his training. Whereas in Doris Humphrey's *Lament for Ignacio Sanchez Mejias* (1947) José Limón timed and accented his movements in tandem with Norman Lloyd's percussive score, in most cases Cunningham denied himself access to a rhythmic template and set out to make the body its own rhythmic source. By approaching the body as a percussive instrument, he essentially challenged the modernist notion of the body as a vehicle of gestural *signs*. In several dances, he even underscored the body's percussive possibilities by tapping the floor—for instance, in *Suite for Five* (1953–58), *Crises* (1960), and *Antic Meet* (1958)—thus shaping movement to make not meanings but sounds. In this regard, Cunningham joined a venerable tradition of dancers—not white and modernist but Black and Irish—for whom dancing is as much about hearing as it is about seeing, a visible "rhythmic exactness," as Brian Seibert puts it in *What the Eye Hears*.[12]

Springing rhythm from music was part of a larger attack on the predictable and the formulaic, signaling a resistance to aesthetic and, in some cases, political norms. In 1951, Cunningham warned that although music and dance might share the same temporal envelope, efforts to sync musical and dance rhythms could produce undesirable results: "The concentration on the minutiae of rhythm in the music-dance relationship," he wrote, "leads to the 'boom-with-boom' device, giving nothing to either and robbing both of freedom."[13] Cunningham's use of the word *freedom* in this context suggests that he believed there was something important to be gained from exploring alternatives to habitual rhythmic patterns. The independence of choreography from score was of course also championed by Cage several years earlier: "The support of the dance," he claimed in 1956, "is not to be found in the music but in the dancer himself."[14] In this quote, the dancer is conceived as a source of unique rhythms not governed by acculturation. While both artists shared a desire to escape rhythmic clichés, Cunningham also approached rhythm as an arena for intertextuality, a way to cite specific dance forms and their related historical and ethnic associations.

The dogma surrounding the Cage-Cunningham aesthetic would make us

believe that Cunningham always worked without seeking support—rhythmic, dynamic, or otherwise—from a musical score. But there is a good deal of evidence to suggest that more often than he cared to admit, he based a dance phrase's rhythms on an external, predetermined source. That is, he occasionally cued the distribution of durational values and accents to audible patterns, either with the intention of evoking an external context or simply as a mnemonic device. To give just one example: we know both anecdotally and from the Choreographic Records that one episode in *Ocean* (1994) follows the rhythm of the song "Yankee Doodle Dandy," written by George M. Cohan and danced by the Irish American Jimmy Cagney in the 1942 film of the same name. Rebecca Chaleff, a dancer who participated in a workshop reconstruction of the dance in 2014, reports that she would hum the melody of the song while she practiced the phrases, using it as a mnemonic device.[15] Here the dancer was not simply following a meter (2/4 or 3/8, for instance); she was actually timing the individual movements to accentuations *within* the measure. There is further evidence that while in the process of choreographing, Cunningham would sometimes listen to musical recordings, even recordings of jazz music, although they were rarely used as the actual score. "It was not unusual for him to work alone with all sorts of conventional music," Carolyn Brown recalls.[16] She recounts further that while he was in the process of choreographing the trio *Cross Currents* in 1964, she could hear "the sounds of some big-band forties jazz" wafting through the "locked doors of the studio."[17] The jazz music, she laments, was never made available to the dancers, although it was probably audible in the visible rhythms of the phrases they performed.

That Cunningham sometimes listened to music while choreographing is itself surprising. But jazz? Apparently, he liked jazz music and sometimes used it for rhythmic inspiration. As opposed to Cage, whose disdain for jazz is almost as famous as Theodor Adorno's, Cunningham never abandoned his love for the strong rhythms of ballroom and the intricate percussive patterns of tap. Even Cage himself, at least at the beginning of his career, thought of jazz as an inspirational source: "Sound and rhythm have too long been submissive to the restrictions of nineteenth-century music. . . . For interesting rhythms we have listened to jazz," he wrote in 1939.[18] Swing and other forms of jazz would have been familiar especially to Cunningham from his days as a student of ballroom, his frequentation of dance halls and clubs, and of course his early training in tap dancing with Maude Barrett of Centralia, Washington. His relationship to rhythm is thus complex: if on the one hand he sought to avoid rhythmic clichés, on the other he was fully capable of mobilizing them. If he posited the existence of a dancing body freed from convention (habits, tastes, but also the tics of training), he also recognized how deeply those conventions were embedded as well as the resources—in the form of allusions—they could provide.

It has perhaps not been properly acknowledged that the trajectory of Cun-

ningham's career spans the considerable distance between vaudeville (where tap was king) and the avant-garde. Over the course of seventy years, he participated actively in a number of revolutions that changed how we situate and perceive modern dance. Early in his career he was nourished, like so many other modern dancers—Loïe Fuller, Ruth St. Denis, Ted Shawn, Vaslav Nijinsky, and Martha Graham—by a realm of performance genres utterly foreign to the elegant venues where his works are now displayed.[19] Of course, Cunningham differed from his vaudeville predecessors insofar as he went on to attend college, majoring first in drama, then in dance. If in the early teens, when Ruth St. Denis was performing on the vaudeville stage, the boundary between a popular audience and a "high art" audience was blurred, by the 1920s modern dance was already dissociating itself from the equivocal realm of the popular. Isadora Duncan was especially concerned with segregating *Black* popular dances from white American dance, constructing "the genre of modern dance as whiteness," in the words of Susan Manning.[20] By the 1960s, the venues that once nurtured modern dance—and that Cunningham knew well—had become a distant memory.

Yet if we go back in time, we can see the great extent to which vaudeville contributed to the creation of modern dance—even Cunningham's. The network of regional vaudeville theaters set in place by B. F. Keith and Edward F. Albee at the end of the nineteenth century allowed small towns dotted throughout the Midwest and the Northwest—with primarily white and Christian populations, such as Centralia, Washington—to have access to cultural forms created in New York City by artists whose ethnic roots were quite diverse.[21] Vaudeville became the very model of the melting pot, and it was on New York's vaudeville stage that Italian, Jewish, and Irish American performers met and shared routines with African American artists,[22] producing what we now think of as quintessential "American" dance forms such as tap and its immediate ancestor, "jigging."[23] It was these forms that gained traction in what the poet Vachel Lindsay called "Higher Vaudeville," where the careers of St. Denis, Fuller, and Shawn were born.

Arguably, Cunningham's dance appears to have very little to do with this hybrid genealogy. His work has invariably been placed on the side of a white experimentalism in league with the high modernism of James Joyce and Gertrude Stein. Further, his close association with Cage has also influenced his reception, situating his choreographic creations at the antipodes of popular entertainment and African American genres. However, that perspective on his aesthetic, one that has dominated his reception since he began his career, requires qualification. To oppose Cunningham to vaudeville and other popular forms requires that we suppress a number of important facts about his choreographic choices, several of which maintain a completely different relationship to popular entertainment than that commonly attributed to Cage. A quick survey of his choreographic production reveals a surprising number of direct and indirect allusions to forms typically associated with "Higher Vaudeville." A short list would need to include the

Commedia dell'arte in *Deli Commedia* (1985); the "pageant" (a kind of popular parade) in *Septet* (1953) ; the tango in *Aeon* (1961); the reel in *How to Pass, Kick, Fall, and Run* (1965); the multiple folk dances in *Rebus* (1975); the pantomime in *Squaregame* (1976); an interlude in the comic style of Mack Sennett or Harold Lloyd in *Scramble* (1967); the burlesque chase and a step dance in *Travelogue* (1977); the jigs and reels at the choreographic heart of *Roaratorio* (1983); another burlesque in *Doubletoss* (1993); and yet another reel in *Nearly Ninety*, his last full work of 2009.

In consulting the voluminous Choreographic Records, we quickly find that far from excluding vernacular dances invented in popular arenas, Cunningham never ceased incorporating them into his repertoire in a highly conscious fashion. In 1986, he even titled a dance *Grange Eve* for the dance halls owned and operated by Masonic societies such as the Elk Club, where vaudevillians on tour would present their shows—precisely the type of venue where Cunningham first performed in his early teens. ("We danced in Grange Halls," he tells Meredith Monk in a 1997 interview.)[24] *Grange Eve* contains a swing dance and some contra dances with a full-out do-si-do.[25] Cunningham's appropriations are rarely parodic; on the contrary, they reveal profound aesthetic and affective investments in the vernacular—even the *ethnic* vernacular—that have never been properly explored. He might have tried to extract these movements from the movement chains to which they habitually belong, but he could not—nor did he always attempt to—efface their rhythmic resonance or historical ties.

In 1932, just when Cunningham was beginning his studies at the Barrett School of Dance, vaudeville as an institution was almost moribund, a large number of its theaters having been transformed into cinemas. During the previous decades and up to the Great Depression, however, there existed a thriving entertainment economy based on twenty-two separate vaudeville tour circuits, most of which were managed by the vast chain of Orpheum Theaters. One consequence or by-product of the tour system was the creation of regional schools of dance. These schools were established by retired vaudevillians so that they could pass on their "numbers" to the next generation.[26] Cunningham's first dance teacher, Maude Barrett, was one such vaudevillian. "When I was thirteen," he recounts, "I asked my mother if I could learn tap dancing with Mrs. Maud Barrett [*sic*] who had opened a dancing school in Centralia. . . . She gave a recital every year in a theater in town that was used as a cinema but had been originally a vaudeville house. . . . She knew tap dances and waltzes and soft shoe and lots of other dances. . . . She'd been in a circus, in vaudeville."[27]

Cunningham first met Barrett at the Catholic church in town frequented by his family. Previously, he had attended vaudeville shows at the local Liberty Theater, the same venue where he would present his first dance acts in 1934. By the early 1930s, the kind of dancing Barrett taught would have been familiar to middle-class families like the Cunninghams. With the advent of Hollywood musi-

cal comedies, dances originally developed on the vaudeville stage had been, in effect, "whitened," laundered of their supposedly less savory lower-class and ethnic associations.[28] Thus, even an upright bourgeois family could enjoy spectacles that included (and relied on) dance steps originally invented in the street. The public could experience a wide variety of tap styles on the silver screen, including the soft-shoe acts (so named because they were danced without metal-tipped shoes) of African American performers such as the Nicholas Brothers (Fayard and Harold Nicholas), who had grown up on the Black vaudeville stage, and Bill "Bojangles" Robinson, who began in Black minstrelsy. The upscale elegance of soft-shoe numbers danced by Gene Kelly and Fred Astaire owed an enormous and uncredited debt to the dancing of the Nicholas Brothers, Bill Robinson, and John W. Bubbles, and the elegant soft-shoe dancers Charles "Honi" Coles and Charles "Cholly" Atkins.[29]

Given the significance of popular dance during Cunningham's youth, it is not surprising that he would have chosen as the themes of his very first choreographic ventures the steps and stagings of popular dance routines: "Western" dances for *Banjo* (1953); music hall dances for *Dime a Dance* (1953); and traditional folk dances for *Picnic Polka* (1957).[30] Jean Erdman, who danced with Cunningham in Martha Graham's company during the early 1940s, recounts that when he first arrived in New York City, Graham sent him to study at the American Ballet Theater because, despite his two years of modern dance training at the Cornish School in Seattle, his "main style was tap dancing."[31] This is perhaps an overstatement, but Cunningham's early choreographic touchstones clearly were, to a considerable extent, vernacular dance forms and theatrical devices that he could only have picked up from his vaudeville experience.

Dime a Dance is particularly interesting in this regard. For the first few performances, Cunningham asked a spectator to pick a card from a deck of cards numbered 1 to 13, each numeral corresponding to a different dance routine. The lottery procedure would determine the choice and sequence of the seven dances included in that evening's performance. The title of the dance, of course, is a direct allusion to the prewar music halls where young women would receive ten cents for dancing with a partner. Arguably—and perhaps heretically—one could advance the claim that the chance procedure used in *Dime a Dance*, which relies on a random number series produced by the spectator's choice of cards, owes as much to the ambience of the vaudeville show as it does to Cage's Buddhist aesthetics of indeterminacy. Vaudeville was famous for cultivating a "participatory culture" in which the relation between the public and the performer is quite intimate.[32] In his case, Cunningham solicited his spectators' participation in several ways, requiring them not only to interpret the meaning of the dance but also, at times, to determine the contents and/or the sequencing of the dance, in the manner of a master of ceremonies who tries to kindle the interest of his audience by making them feel directly involved in producing the show.[33]

Gallery

procedure

throw for where begin from
" " " go, to
[" " if more]
(if not what?)

space

throw for fast, medium or slow
" " how go (how thru space)
" " en planche, par terre, en l'air
" " a) together
if togetherness } b) been separated
happens c) " much " (i.e. if 3 possibilities,
(separatoness; all 3 sep. or 1 or 2)
a) some for many rand o
b) 1 does completely separated from one another
" " length of time in seconds

	1	2
	3	4
	5	6

throw for [] = alone
or with 1 or more
succeeding nos

Example

from:

1 coin R or L stage ; heads or tails / heads R.
2 " s 1,3,5 or 2,4,6 heads, head-tail, tails head-tail 4
 tails " heads
to:

R or L stage ; heads or tails / heads R.
1,3,5 or 2,4,6 ; ", head-tail, tails / " 2

Fast, med, or slow; heads, head-tails, tails | " fast
how thru space ; heads, head-tail, tails "

(2 to 4)

en planch, terre or air ; heads, head-tail, tail / tails air
10" min. length of time ; heads for 10", tails more heads 10"

Plate 1 (facing)
Merce Cunningham, from the Choreographic Records for *Summerspace* (1958): "Procedure" page.
© Merce Cunningham Trust. All rights reserved. Reproduction courtesy Jerome Robbins
Dance Division, The New York Public Library for the Performing Arts.

Plate 2
Merce Cunningham, *Summerspace* (1958): studio shot with Merce Cunningham, Viola Farber,
Carolyn Brown, and Steve Paxton. Photograph by Richard Routledge (1963).
© Merce Cunningham Trust. All rights reserved.

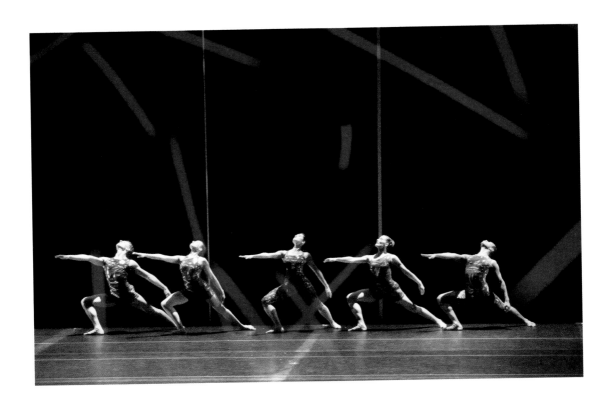

Plate 4 (facing)
Merce Cunningham, *Exchange* (1978): Ellen Cornfield hops over Chris Komar in a
screenshot from Charles Atlas, dir., *Exchange*, filmed in 1978, produced in 2013.

Plate 5 (facing)
Merce Cunningham, *Exchange* (1978): screenshot of the "Heroic" solo by Cunningham,
surrounded by half the company seated a in semicircle around him. From Charles Atlas,
dir., *Exchange*, filmed in 1978, produced in 2013.

Plate 6
Merce Cunningham, *Exchange* (1978): screenshot of the "Sorrow" solo by Cunningham.
From Charles Atlas, dir., *Exchange*, filmed in 1978, produced in 2013.

Plate 7 (facing)
Sharon Lockhart, *Goshogaoka Girls Basketball Team: Group I: (a) Kumi Nanjo and Marie
Komuro; (b) Rie Ouchi; (c) Atsuko Shinkai, Eri Kobayashi and Naomi Hasegawa* (1997).
Twelve chromogenic prints in four groups. Group I: 32⅜ × 27⅜ × 1⅝ inches (82.2 × 69.5
× 4.1 cm) framed. © Sharon Lockhart. Courtesy of the artist; Gladstone Gallery, New
York and Brussels; neugerriemschneider, Berlin. Reprinted with permission from
Sharon Lockhart.

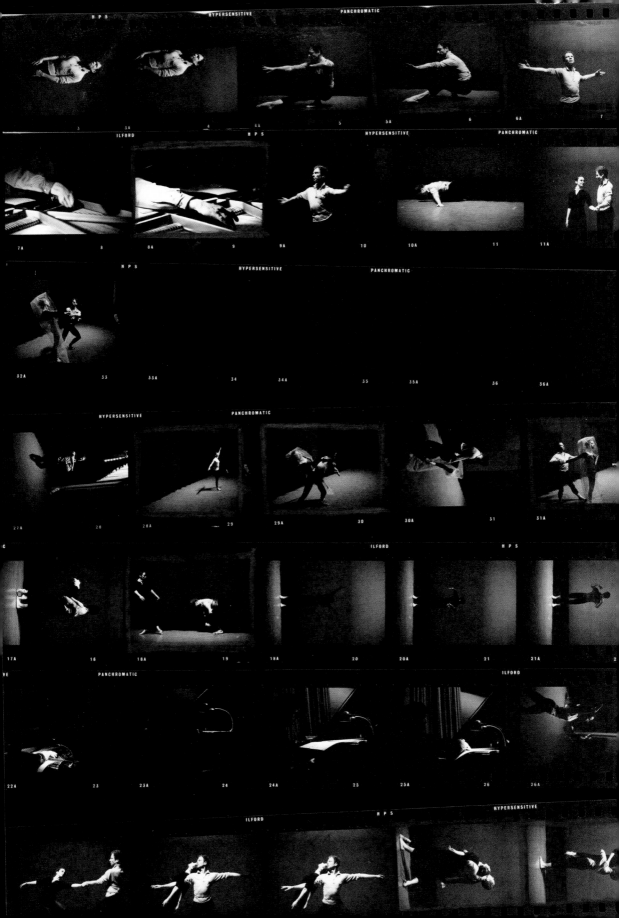

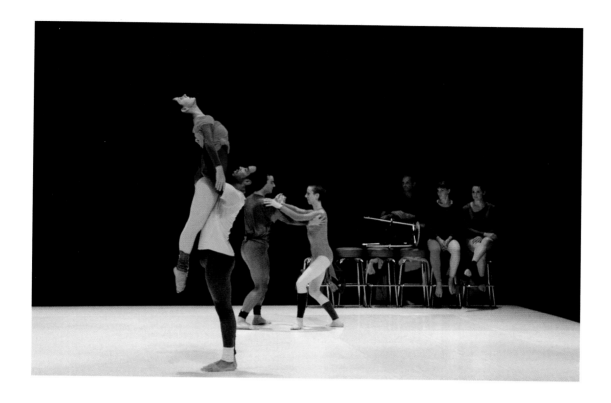

Plate 8 (facing)
Duet from Merce Cunningham, *Suite for Five* (1958): Merce Cunningham and Carolyn Brown.
Photographs by George Moffett (ca. 1958). Contact sheet. Reproduction courtesy Jerome
Robbins Dance Division, The New York Public Library for the Performing Arts.

Plate 9
Merce Cunningham, *Roaratorio* (1983): Jennifer Goggans and Rashaun Mitchell. Photo-
graph by Anna Finke (2010). Reprinted with permission from Anna Finke.

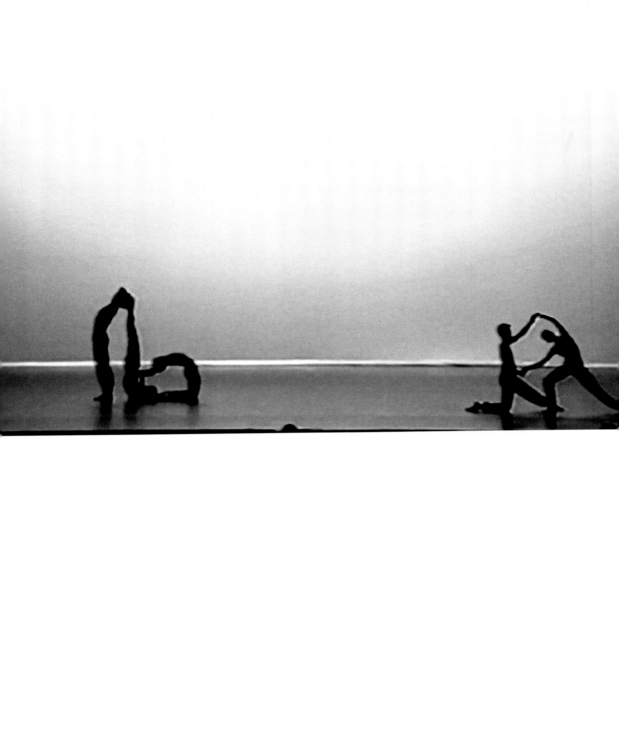

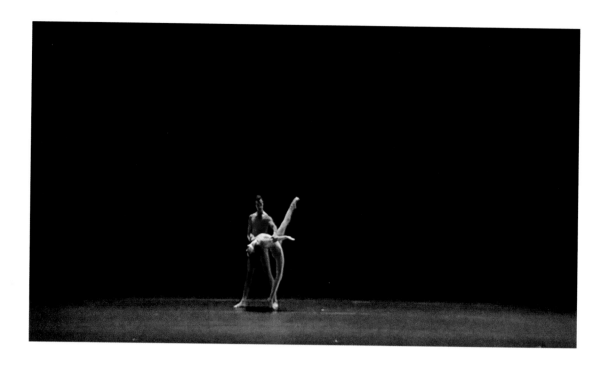

Plate 10 (facing)
Screenshot of Merce Cunningham's *Pictures* (1984) (performance video, 1987; director unknown), lighting by Mark Lancaster.

Plate 11
Screenshot of Merce Cunningham, pose from *Springweather and People* (1955) as performed in *Crises* (1960): Jennifer Goggans and Rashaun Mitchell (performance video, 2016; director unknown).

Plate 12 (facing)
Robert Rauschenberg, *Scanning* (1963). Oil and silkscreen ink on canvas. 55¾ × 73 inches (141.6 × 185.4 cm).
San Francisco Museum of Art. Fractional and promised gift of Helen and Charles Schwab. © Robert Rauschen-
berg Foundation. RRF Registration #63.011.

Plate 13 (facing)
Robert Rauschenberg, *Express* (1963). Oil and silkscreen on canvas. 72 × 120 inches (182.9 × 304.8 cm).
Museo Thysson-Bornemisza, Madrid. © Robert Rauschenberg Foundation. RRF Registration #63.006.

Plate 14
Merce Cunningham, *Crises* (1960): Rashaun Mitchell with Julie Cunningham, and Andrea Weber in the back-
ground. Photograph by Briana Blasko (2006). Reprinted with permission from Briana Blasko.

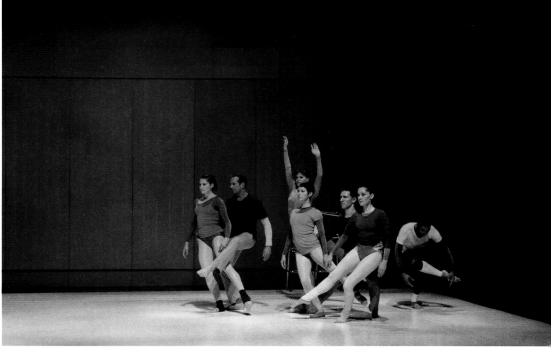

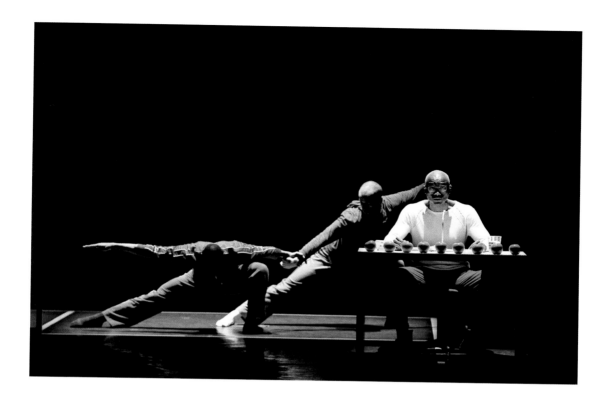

Plate 15 (facing)
Merce Cunningham, *Roaratorio* (1983). Photograph by Anna Finke (2010). Reprinted with permission from Anna Finke.

Plate 16 (facing)
Merce Cunningham, *Roaratorio* (1983): Robert Swinston wrapping his leg around Andrea Weber; with Daniel Madoff, Jamie Scott, Marcie Munnerlyn, Melissa Toogood, and Rashaun Mitchell. Photograph by Anna Finke (2010). Reprinted with permission from Anna Finke.

Plate 17
Bill T. Jones in *Story/Time* (2012). Photograph by Paul B. Goode (2015). Reprinted with permission from Paul B. Goode.

From Vaudeville to *Antic Meet*

Critics consider *Antic Meet* a turning point in Cunningham's career, an advance in his move toward an avant-garde poetics, because it is the first dance bearing no relation to a musical score other than a shared time limit. "This was one of the first times I gave [Cage] only the length of the total dance (twenty-six minutes), but no time points in between," he recalled.[34] In a letter he wrote to his artistic director of the time, Robert Rauschenberg, he described *Antic Meet* as "a series of vaudeville scenes that overlap," indicating that he was conscious of appropriating features of the genre and that he wanted Rauschenberg to design the costumes accordingly.[35] The work is full of ingenious references to vaudeville numbers; Cunningham even titled one of the ten sections "A Single." The first section of the dance is titled "Opener," as in "opening act," and the last section "Exodus." In between are lots of allusions to vaudeville: "Sports + Diversions, 1" is a "meet" between two men, full of farcical acrobatics; Viola Farber's solo in "Sports + Diversions, 3" recalls elements of Loïe Fuller's light shows (Farber's prop, fabricated by Rauschenberg, is an umbrella decorated with Christmas lights); and "A Room for Two" stages a pseudo-romantic duet between Cunningham and Brown. In the program notes, Cunningham identified the tone of the piece with the "absurd," citing Fyodor Dostoevsky's *The Brothers Karamazov*: "Let me tell you that the absurd is only too necessary on earth."[36] This quote signals to the audience that "high" concert dance should not take itself too seriously. The vaudeville elements are there to deflate modernist pretensions, but also to imaginatively exploit a rich set of protomodern theatrical ideas.

"A Single," the next-to-last number of *Antic Meet*, stands in contrast to the other sections. A soft-shoe number, it, too, is reminiscent of vaudeville, of course, but the tone is neither absurd nor parodic; rather, it is nostalgic. Cunningham enters and leaves the stage alone. He is most decidedly the "star act" who arrives, as in a typical vaudeville set, near the end of the "bill" to steal the show.[37] His own comments on his dance in "A Single" indicate that it was based explicitly on the soft shoe he saw Maude Barrett perform: "She showed me . . . I think only once, but when she did I never forgot it, the thing with the foot that I used later in *Antic Meet*. . . . She did two or three steps that way, and she did it very beautifully."[38] David Vaughan recounts another time when Cunningham told him of "the step he remembered from his days with Mrs. Barrett—the foot turning in and out, while she gave a little wave with one hand."[39] The step is clearly identifiable in "A Single," as is the little wave. If we were to rely on Cunningham's words, we might conclude that Barrett's step was of her own invention. But could this have been true, given her apprenticeship in vaudeville? Where, in fact, did Barrett's "step"—"the foot turning in and out"—come from? Was it merely "something [she] did," as Cunningham asserts, or did it belong to another world?[40]

In the letter Cunningham wrote to Rauschenberg, he furnishes a partial

response: he calls "A Single" explicitly a "rubber-leg dance."[41] A rubber-leg dance—otherwise known as an "eccentric dance," "legomania," or "boogie-woogie"—was popularized by an African American hoofer, Henry "Rubberlegs" Williams, in the early 1920s.[42] Initially derived from the cakewalk, which scholars believe to have been invented by African slaves on southern plantations, the rubber-leg dance requires immense flexibility in the hips. The leg turns in and then out in the hip joint either slowly or, more likely in its first "eccentric" versions, at breakneck speed. In the version Cunningham watched and that he performs in "A Single," the dancer's foot is first placed on the ground, the leg turned in; next, the dancer pivots on the ball of that foot such that the entire leg, from the ankle to the top of the thigh, turns out. In an interview with Meredith Monk, Cunningham explains that Barrett, while making this motion, "made a sound on front, side, and heel," thus accentuating the rhythm of the step. While most of "A Single" is soundless, at the end of the number we hear a rhythmic tattoo as Cunningham stamps the floor with his foot in a clearly audible pattern—1, 2, 1-2-3—drawing attention to the noise that tap can make.[43]

We need to recall, then, that the steps Barrett taught to her young students belonged not to white vaudeville performers but rather to African American performers like Henry "Rubberlegs" Williams, who made their name in the Black nightclub circuit of Harlem and on the stages of minstrelsy shows.[44] Whether he was aware of it or not, the movements Cunningham makes in "A Single" are rooted in dances coinvented by African Americans and Irish Americans, the former having done the most to develop the kinds of rhythms we associate with tap today. During the very period when Maude Barrett was beginning her career in vaudeville—that is, in the early teens—vaudeville was the arena in which dancers like Williams were developing their moves, regularly teaching them to performers of many ethnic backgrounds—Irish, Italian, and Jewish. That a white Christian boy in a town in the Northwest should have encountered these dances in an entirely white context should come as no surprise, given their rapid diffusion as a result of the corporate vaudeville tour circuits. What should give us pause, however, is that Cunningham would have been blind to (or at least silent about) the provenance of the steps he attributed to "Mrs. Barrett." Indeed, a closer look at "A Single" suggests that he might not have been as blind as he appears.

One of the most remarkable aspects of "A Single" is that it departs radically from the style and technique that Cunningham had been developing in his classroom and rehearsal studio up to that moment. His signature style involved isolating parts of the body such that the reverse kinematics responsible for the "rubbery," elastic quality of the jazz-dancing body would be blocked. Reverse kinematics, a kind of energetic reverb, allows for smooth articulations between one muscle group and the next. The choreographer was known for attempting to counter that flow and even to suppress the pre-movements required to spring

up into a turn. In "A Single," however, Cunningham allows himself to adopt a markedly different style of dancing. Instead of interrupting and disarticulating his movements, he follows smoothly reverse kinematics, the flow of energy as it traverses his limbs and torso. The rhythms of the steps—the fast triplet at the beginning, the clear 4/4 meter typical of a soft-shoe dance, and the pronounced tattoo at the end—reveal a looser, more "rubbery" Cunningham. The performance theorist Julie Sermon has observed that "A Single" contains several steps fundamental to tap technique: "the alternation toe-heel as well as the rocking from the inner edge to the outer edge of the foot"; the "slide"; the "drag"; the "brush"; and the "scuff."[45]

Further, the costume Cunningham wears in "A Single," a pair of white overalls, is not an indifferent or arbitrary element of the "number." Underneath the overalls, he sports a shirt and tie, and underneath the shirt and tie we can spot a black leotard and tights, the typical uniform of the modern dancer. This uniform, worn by all members of the cast, serves as a kind of skin beneath the various accessories Rauschenberg adds to each dance: the long dresses made of parachute cloth and the neckless sweater for "Bacchus and Cohorts"; the fur coat for "Sports + Diversions, 2"; and, last but not least, the white overalls for "A Single." The black under-layer is especially visible when, near the beginning of the dance, Cunningham deliberately—that is to say, theatrically—rolls back his white sleeves (fig. 6.1).

The pair of overalls was a staple costume of the Black minstrel show. According to Eubie Blake, the ragtime pianist and composer of the 1920s, a very limited number of roles (or really, stereotypes) were available to the African American performer, either in vaudeville or on the Broadway stage. One of those roles was the workman, at once jovial and a bit daft, invariably clothed in workman's garb: "We were supposed to shuffle on stage in blackface, and patched-up overalls," Blake recounts.[46] Cunningham was an adolescent during the period when African

6.1
Screenshot from
Merce Cunningham,
Antic Meet (1958):
Merce Cunningham
in "A Single."
Film by Arne Arn-
bom, dir. (1964).

American performers were slowly making their way into mainstream venues. It is unlikely that he would have missed the reference to blackface minstrelsy embedded in the overalls, although he might simply have associated them with vaudeville in a more generic way. In any case, the white overalls over the black leotard suggest a kind of reverse minstrelsy—the modern dancer playing the role of the white man (complete with white shirt and tie) but underneath it all performing Black rhythms and Black dance.

It is hard to believe that Cunningham was entirely ignorant of the historical resonances of the sartorial choices he—in collaboration with Robert Rauschenberg—made for *Antic Meet*. And yet, all his published references to tap, soft shoe, and other forms of popular dance are invariably references to *white* dance forms: the Irish jigs and reels that are the subject of the next section on *Roaratorio*, and the tap and ballroom dances he associated with Fred Astaire. My point here is not that Cunningham, like so many other white performers, was guilty of exploitative appropriation, conscious or otherwise. Given the history of African Americans in the entertainment field, that should go without saying. My point is simply that there is a complicated relation between Cunningham's rejection of the author function (his own tastes, habits, and training) and the return of the cultural repressed. Speaking in more general terms, Brenda Dixon Gottschild has claimed in *Digging the Africanist Presence in American Performance* that all American modern dance owes a debt to African dance mannerisms as transferred through African American vernacular forms. She offers in support of her claim the modernist mobilization of the hips and the pelvic region; the "articulate" torso; the Graham contraction; dancing in bare feet; and what she calls "weighted gestures," movements that emphasize gravity and contact with the floor. "These particular components of the New Dance," she states, "had no coordinates in European concert or folk traditions. . . . The Africanist presence . . . is a subliminal but driving force."[47] Dixon Gottschild may be overstating the case, for in Germany Mary Wigman and Rudolf von Laban, pioneers of expressionist dance, were certainly interested in weightedness, and it is unclear that they were responding to an "Africanist" influence alone or at all. Still, Dixon Gottschild puts her finger on a central nerve in Cunningham's dancing: he mingled a balletic carriage with an African American and Irish interest in rhythm as a defining feature of style.

Anyone familiar with the Cunningham technique could point out that many of what Dixon Gottschild views as Africanist-inspired elements of modern dance were weeded out as he developed exercises that isolate body parts and stabilize the hips. Nonetheless, it could be argued that his exploration of the back in the geometric tour de force that is *Torse* (1976) paradoxically displays an interest in delving further into what Martha Graham made possible in the first place: the mobile torso. Further, Cunningham's weight-shift method, his way of organizing dance phrases around the number of weight shifts in a phrase (from one to sixty-four, after the sixty-four hexagrams of the *I Ching*), developed for *Torse* and used as another compositional resource thereafter, subtly accentuates gravity as a source of rhythm. It is of course easier to observe the type of "Africanisms" Dixon Gottschild is referring to in a dance like "A Single"; they are inevitably there in the soft-shoe style Cunningham recovers from his past. In a more tacit way, though, the very fact that he establishes rhythm as a center of interest—both as a way of connecting to a past or, alternatively (and more frequently), breaking

from it—places him in a significant and unexplored dialogue with African American performance genres.

The rubber-leg dance of "A Single" maintains at least three degrees of separation from the racist minstrel spectacles of the nineteenth century from which it borrows. Minstrelsy, which mocked not only African American but also "Black" Irish "types," gave way to vaudeville, which in turn participated in the emergence of modern dance.[48] Tap dancing is the thread running through all these forms—minstrelsy, vaudeville, and the soft shoe of "A Single." Insofar as tap privileges the percussive over the narrative, it can be considered seminal to the shift in compositional emphasis that allowed Cunningham to detach his work from a reliance on plot. The influence of the vernacular, in other words, contributed to nourishing his rhythm-based sensibility, allowing him to participate in and appreciate Cage's fascination with percussion instruments when the two were first getting to know each other at the Cornish School. Cage famously privileged rhythmic over melodic instruments; he could avoid his *bête noire*, harmony, by composing for a percussion orchestra or for its offspring, the prepared piano.[49] Cunningham exhibited precocious mastery of complex rhythms (and could participate in Cage's percussion orchestra in 1938) because of his early experience with Barrett, the jig, and the clog.

Vernacular traditions offer the avant-garde a particularly complex dance ancestry, for as scholars like Brian Seibert have observed, it is impossible to determine with historical accuracy to whom the steps and rhythms of tap originally belong. Was the "jiggery" that fathered tap "blacker" or "whiter" in color, more African or Irish in origin? Ultimately, can anyone know whether one set of steps is "Black" and another "white," or whether one percussive riff relies on the Irish fiddle or the African drum? When is it "authentic" for a Black performer to dance a jig, or for a white performer to dance a soft shoe?

In this vein, it is instructive to watch the reconstruction of "A Single" for the Merce Cunningham Dance Company's 2010–11 Legacy Tour. (Given the genealogy of "A Single," the word *legacy* in this context takes on quite another meaning.) The dancer who interprets Cunningham's solo in the 2011 performance filmed at the Brooklyn Academy of Music is Rashaun Mitchell, an African American who became a member of the company in 2004. Mitchell is not the only African American to have danced for Cunningham: Gus Solomons Jr. was a member of the company from 1965 to 1968; Ulysses Dove originated roles from 1970 to 1973; and Foofwa d'Imobilité, the longest-term member of African descent, was a member from 1991 to 1998.[50] During the last years of the company's existence, Mitchell systematically took on Cunningham's roles in dance reconstructions. If we compare a performance video from the 2011 legacy tour to Cunningham's performance in the 1964 version of *Antic Meet* filmed by Arne Arnbom, we see that Mitchell does *not* strive to imitate Cunningham's way of moving.[51] Instead,

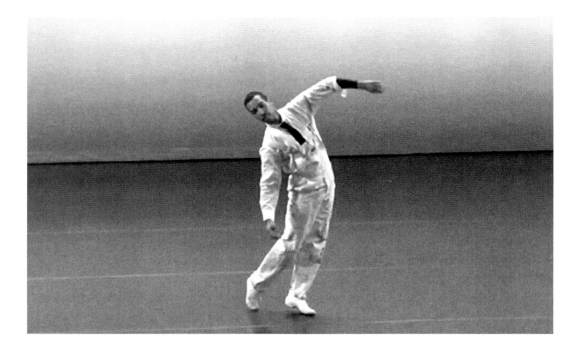

6.2
Merce Cunningham, *Antic Meet* (1958):
"A Single," danced by Rashaun Mitchell;
screenshot from filming of 2011 per-
formance, Merce Cunningham Trust,
director unknown.

he interprets the choreographer's roles with a kind of alert refinement, a studied grace. Interestingly, though, his perfor-mance of "A Single" is full of modern dance mannerisms in a way that Cunningham's is not. Further, his use of space is clearly that of a modern dancer: he makes wide arm movements and full extensions of the leg that differ from Cunningham's less balletic moves. (See figure 6.2.) In short, Mitchell applies his elegant modern technique to the steps of the soft-shoe number that Cunningham learned from Maude Barrett, who learned them from vaudeville performers, who in turn learned them from African American and Irish dancers whose names have for the most part been lost.

The title of the solo, "A Single," can be read in at least two ways. Most explic-itly, it refers to the vaudeville number, a solo act, known as "the soft-shoe single." More subtly, it seems to evoke the existential possibility of being single, of being alone on the stage. But this is precisely what Cunningham's choreographic choices preclude. For the gestures, steps, and, most crucially, the rhythms Cun-ningham embodies are haunted by the gestures, steps, and rhythms of other bodies—bodies both "white" and "Black," that is, bodies racialized in different ways. We might well wonder what it means when Cunningham rolls back his sleeves to reveal the black tunic beneath that covers his "white" skin. In this ges-ture is he revealing the mixed ancestry of his embodiment, or is he emphasizing that embodiment is always a layered creation, that the rhythms we inherit are not our own?

Roaratorio and the "Black" Irish

Roaratorio, Cunningham's 1983 riff on Irish dancing, appears at first to be an entirely different kind of animal from *Antic Meet*. The former is inspired by the music and dance of Ireland, the ambience of the pub, and the rhythms of James Joyce's *Finnegans Wake*; the latter is based on an acquaintance with vaudeville.[52] However, they are both what I would call genre studies, works that approach another dance form as a historical source to be revisited and mined. Given the significance of Irish dances in the development of "jiggery" and other "Black" dances, *Roaratorio* could be regarded as returning to yet another ingredient in the melting pot that created the American vernacular. In the context of James Joyce's *Finnegans Wake*, even the "white Irish" versus "Black African" dichotomy begins to break down, for at the time the *Wake* appeared, the Irish were considered the subalterns of the British Isles, one of the "darker races." According to historians, "The Irish became white in the United States precisely to the extent that both slaves and free blacks were denied full citizenship and even humanity."[53] Or, in Brian Seibert's terms, Irish performers became "white by blacking up."[54]

Roaratorio invites speculation on Cunningham's own ethnic identity to an extent that has rarely been noted by scholars—although it was frequently picked up by reviewers of the time. Klaus Schöning, for instance, observed that Cunningham "is half-Irish," and two French reviewers of a 1983 performance in Paris underscored the appropriateness of Cunningham's return to "le sol irlandais" (Irish soil).[55] More surprising still is that a few years later, in a 1987 BBC interview, Cage himself identified Cunningham as marked by his Irish ethnicity. The composer explains that ever since completing his own hymn to Joyce, *Roaratorio: An Irish Circus on "Finnegans Wake"* in 1979, he had been urging Cunningham to choreograph a companion piece. Why? Because of his ethnic identity: "Since Merce Cunningham is half Irish, I had in mind that it would be a fulfillment of the work if there was a dance component."[56]

Cage's *Roaratorio: An Irish Circus on "Finnegans Wake"* is a work of stunning but chaotic complexity, for his goal in composing it was to re-create the entire soundscape of Joyce's work. Originally conceived as a Hörspiel (sound play) for German radio that had been commissioned by Klaus Schöning in 1979, Cage's *Roaratorio* contains three separate but interrelated "Irish" elements. First, Cage created *Writing for the Second Time through "Finnegans Wake,"* a work composed of 150 mesostics (not all of them complete) drawn from Joyce's novel.[57] Second, he produced a track of 626 different sounds—626 being the number of pages in the Penguin edition of *Finnegans Wake* that he used to make his mesostics. Cage selected sounds from two lists—one that he himself had made of all the sounds mentioned in the *Wake*, and the other a list of all the places enumerated in Louis Mink's *A "Finnegans Wake" Gazetteer*. To assemble the heterogeneous contents

of the sound track, he traveled to Ireland with two assistants and visited as many of the enumerated places as possible to collect the pertinent sounds. He then spent a month in Paris at IRCAM (Institut de Recherche et de Co-ordination Acoustique-Musique) collaging and mixing the collected sounds with others he had discovered in various sound libraries. On top of these two layers Cage added a third: recordings of live performances by the Irish musicians Joe Heaney, a tenor; Seamus Ennis on the uilleann pipes; Paddy Glacking on the fiddle; Matt Malloy on the flute; and Peadher Mercier and his son Mel Mercier on the traditional Irish drum, the bodhrán. During the first live performances, the musicians played onstage in the company of Cage, who read his mesostics. The musicians were directed to interweave traditional Irish jigs, reels, and ballades, entering the soundscape whenever they saw fit. In this way, each live performance of *Roaratorio* would be different from every other one, the only stipulation being that each musician had to play for a minimum of twenty minutes within the sixty-minute time bracket of the piece. The aleatory elements of the piece were overwhelmed, however, by the clear directive of the compositional process—to collect and perform things "Irish." There was absolutely nothing accidental about the contents, which were all ethnically inflected, even if their manner of sequencing and juxtaposition followed no traditional pattern or generic convention.

Cunningham, like Cage, inscribed ethnicity into the fabric of his own *Roaratorio*. He did so, however, not by mentioning *Finnegans Wake* or *Irish* in the title but rather by taking his cue from the rhythms associated with them both. He conversed at length with the Irish musicians on the nature of jigs and reels, and prepared himself further by visiting the New York Public Library to read up on traditional Irish dances, the rhythms of which are integrated into the textual music of the *Wake*.[58] He then choreographed short jigs for individual members of his company—fourteen plus one for himself—which were first performed on the occasion of Events, when Cunningham recycled, juxtaposed, or resequenced excerpts of different dances in new arrangements. The jig is of course the best-known Irish dance; it is usually in 2/4, 3/4, 6/8, or 12/8 meter, although a "slip-jig" is in the more irregular 9/8 meter. In his notes for *Roaratorio*, Cunningham lists these and other Irish dances along with their traditional tempos: "Reels: Fast/Jigs: less/slip-jig: less/Break-Down: less/Hornpipes: slowest," he writes in July of 1983.[59] Of these, only the jig and the reel reappear in the rest of the notes, suggesting that he decided to limit himself to creating variations of just these two dances. Reels traditionally have a 2/4 meter and are the fastest of the Irish dances. Cunningham created four reels for *Roaratorio*, which he interpreted as "partner dances, generally for the full company."[60] (See plate 15.)

Cunningham constructed *Roaratorio* in five sections. The order of the dances within the sections appears to have been determined, at least in part, by a chance procedure. A Procedure page dated June 29, 1983, suggests that he tossed coins to "Find how many phrase lengths to use"; "Find what #s are the phrase lengths";

and "Find where in space" they would be performed.[61] The sheer quantity of pages of carefully worked-out sequences, with numbered dance phrases keyed to a chance-derived number series, indicates that he produced a good deal of paperwork to generate an initial structure. The phrases of the dances themselves were almost entirely of his own invention. The hypercomplex "space games" and "reels in wheels" were the exceptions. Cunningham built the first by sketching a circle, numbering eight points on its circumference, and then using chance to determine the direction in which the dancer would travel—toward which point on the circumference—on each count of the dance. Populating each of *Roaratorio*'s five sections were a variety of dance types in consistent metrical forms.[62]

The first section of the piece begins with members of the company carrying onto the stage the seven stools constituting the décor—vaguely reminiscent of a barroom. They then proceed to place the stools in their starting positions. This first phrase is followed by two duets in what appear to be eight-count phrases, overlapping with four individual jigs in 6/8 time. The 8/8 versus 6/8 meters produce complex 2-against-3 rhythms, exemplifying what Cunningham referred to as "the superimposition of rhythms" he aimed to achieve. After the jigs and jig duets, a male trio shares the stage with a female quartet, both performed at what seems to be a slower 4/4 pace while the stools get rearranged by the remaining dancers. Then there follows a unison sequence with some dramatic female lifts; six wonderfully idiosyncratic individual jigs performed simultaneously; a fast trio at stage left overlapping with a solo at stage right; a reel with almost the full company in 5/4 time; another four individual jigs featuring a male skipping combination repeated in different directions; and finally a "time sequence," an adagio composed of a specific ratio of counts to seconds.

Although immensely rich, this first section contains only a handful of the dance types Cunningham invented or reinvented for *Roaratorio*. In other sections we find waltzes, "space games," "reels in wheels," movement gamuts (constructed from thirty-two predetermined phrases), and the "family portrait," a slow-motion sequence of standing poses involving the full company and found only in the fifth and final section. The "family portrait" reflects Cunningham's wish to emphasize the family as a unit of particular significance to Joyce's book; the *Wake*, he stated in the 1987 BBC interview, "is about the large human family."[63] Accordingly, he wanted to approach his own company as a kind of Irish clan. In fact, the family portrait is one of the few ensemble sequences in *Roaratorio*; Cunningham consciously privileged smaller units, with clusters of dancers spaced at a good distance from one another, perhaps to lend clarity as a counterpoint to what he calls in his notes the "audio diversity" of Cage's score. "[It is] useful to keep the movements separate, + not ensemble work," he tells himself in a note from June of 1983.[64]

With respect to the specific movement varieties used in *Roaratorio*, it is clear that Cunningham often adopted the traditional steps and tempi of the high-

stepping jig. The emphasis on the *passé*, on the feet and hips turning first in, then out, and on the isolation of the lower body from the upper body are all features of the jig that correspond felicitously to the complex, hopping footwork and clear, simple arm positions typical of the Cunningham technique of that era. In the duets, dancers assume the arm positions familiar to Irish dancers, such as the hand-in-hand promenade and the crossed-arm clasp. But what is most strikingly "Irish" about *Roaratorio*, even more than the steps, is the tonicity of the dancing body, the way the dancers maintain an upright carriage and sprightly gait. With one exception—the space games in which emphasis is often placed on stomping the floor—the dancing body of *Roaratorio* is vaporously light. It springs, hops, and leaps, spending as much time off the ground and in the air as possible. At the same time, Cunningham integrates his signature moves from other dances, such as the lift we first encountered in *Suite for Five* (1953–58; see plate 9), the adagio leaning combinations of *Septet* (1953), and the step from the duet in *Second Hand* (1970) in which the male dancer wraps one bent, turned-out leg around the hips of the female dancer in front of him (see plate 16).

In a 1983 interview with Pierre Lartigue, Cunningham provided his own gloss on James Joyce's influence on *Roaratorio*: "A lady said that Joyce used dance to break the flow of the novel. That seems pertinent to me.... I was interested in the different levels of complexity, the superimposition of the simple and the multiple, and the superimposition of rhythms."[65] Cunningham believed (along with Cage) that *Finnegans Wake* was heavily indebted to the "melodies of Irish songs."[66] And indeed, it is easy to discern within Joyce's prose a rhythmic pulse as well as the singsong melodies of lullabies and ballads. However, it is equally easy to discern in the *Wake* rhythms that "*break* the flow," as Cunningham noted—the flow of normal speech or song, but also of narrative momentum. *Roaratorio* is an exploration of all these possibilities offered by rhythm: rhythm as lilting repetition; rhythm as superimposition and syncopation; and rhythm as break, interruption, a resistance to the momentum of the already done, the already known.

Let us consider just one example from the dance: the space games. This category of movement was constructed by taking simple foot movements—*tendus* to the side, front, and back, and *passés*—and sequencing them according to a random number series determining the direction the movement would face or move toward (laterally, up and down, or on the way to a diagonal). Cunningham cued a circle of eight points to eight numbers, then used a chance procedure to produce a sequence of eight numbers and thus the order of the points in the circle toward which the foot would move. The chance procedure ended up generating an unrepeatable series, a string of accented and unaccented movements so long that the word *rhythm*—which implies repeatability—fails to encompass it. Patricia Lent, a member of Cunningham's company, describes the experience of learning the chance-derived patterns of the space games as having to memorize "the longest telephone number in the world," one with no repeating subsections (or

phrases).[67] Watching the space games, she observes, is like "watching an aquarium": one sees constant movement, but the rhythms of that movement are irregular and constantly change.[68]

As a result of Cunningham's randomizing procedure, the jigs and reels are loosened from their Irish moorings. Nonetheless, the dance remains overall under the sign of a Joycean version of "Irishness," a very specific Irishness that suggests its own pixelation. Folk dances (in Cunningham), like traditional sayings (in Joyce), offer an opportunity to play with sequence and flow, for they are made of movable parts and are not subordinate to narrative or emotional expression. The embodiment of "Irishness" in *Roaratorio* is thus complicated by neither the haunting of other populations, as in *Antic Meet*, nor the historical contact among peoples, as in *Finnegans Wake*. The dance takes what are recognizably ethnicized materials (Irish dances) and tries to move them *beyond* any specific cultural identity. It uses chance to disrupt rhythms that characterize an ethnicized cultural practice.

As steeped in "Irishness" as *Roaratorio* may be, then, it also looks forward to a time when Irish ethnicity—when ethnicity itself, for that matter—will become the material for something that escapes ethnic designation altogether.[69] By releasing the steps from their encasement in traditional metrics, Cunningham frees them to form phrases seemingly alien to their source. Using feet as instruments, and chance methods to direct them, he produces awkward sequences that beat out rhythms we do not recognize and cannot repeat. If acculturation relies on repetition, as theorists from André Leroi-Gourhan to Judith Butler have maintained, a choreography of the unrepeatable frustrates acculturation, the acquisition of the repeatable. The application of chance methods to rhythmic sequences takes the body into territory previously unknown. Why would Cunningham have wanted to move Irishness in that direction? Why would he have wanted to disturb identity's flow?

In "The Impermanent Art," he provides a clue. He writes that "toss[ing] pennies"—or using chance—was never an end in itself; it was certainly never meant to create something "inhuman" or "mechanistic": "The feeling I have when I compose in this way is that I am in touch with a natural resource far greater than my own personal inventiveness could ever be, *much more universally human* than the particular habits of my own practice, and organically rising out of common pools of motor impulses."[70] Cunningham's comments could suggest that, as Susan Foster has claimed, his goal was to posit a universal or "neutral" body.[71] But if he aimed for transcendence, it was for a transcendence not of difference but rather of *that which makes us the same*. His effort was directed toward accessing kinetic possibilities before their declension into habits, before their channeling into the bodily hexis of a specific *ethnie*. That is why he breaks the flow: to permit each dancer to discover new possibilities within his or her physical embodiment, to "locat[e] identity in a physicality"[72] that emerges *despite* train-

ing, a physicality that is *not* "Black" or "white," African or Irish, female or male, in any generic way. Cunningham, of course, was not always successful. There are dances (especially when he was first exploring the LifeForms software for generating movement sequences) that do not encourage the dancer's discovery of what makes that dancer a unique human being. But when he does succeed, the dancer has the feeling of having located something all her own. Carolyn Brown: "It was these unpredictable changes of dynamics and the opportunity to play with the phrasing that I loved best. Although the overall rhythmic structure and tempi were Merce's [in other words, he determined a phrase's duration and speed], he wanted me to find my own phrasing within the sections."[73] Neil Greenberg: Cunningham would teach the bare bones of a phrase, "entrusting you with it, then leaving you to figure out its rhythm on your own."[74] Patricia Lent: "Merce would mount the jig, then ask me to take it in a different direction or end up at a different spot. I would say to myself, 'I'm going to stay true to this phrase,' then execute it in my own way. *That way* became part of the dance."[75]

When I asked earlier if there might be another kind of particularity (as opposed to universality) that Cunningham was attempting to affirm, I was thinking of this personal rhythm that his chance-derived sequences could help the dancer unearth. Instead of affirming racial difference—which he had no interest in doing, as Foster trenchantly observes—he sought to affirm *individual* difference on many occasions and in many ways. For instance, he did not attempt, as so many other choreographers do, to get his dancers to perform ensemble sections in perfect unison. One of his last principal dancers, Jennifer Goggans (who reconstructed *Crises* and other works), has spoken of "Cunningham unison," by which she means his looser way of enforcing togetherness.[76] This is not the lockstep identity in timing and posture required by the members of a *corps de ballet*. Instead, it is the paradoxical fruit of a chance-derived continuity *generated by nobody's body* performed by distinctive *individual* bodies. It is the emergence of the unique through an imposition of the arbitrary. Cunningham's compositional devices, such as the weight-shift method or the "telephone number" phrase, ultimately aim to reveal in each dancer a type of embodiment that emerges *after* the arbitrary, a visible and affective dancing self that results from an interdiction, a discipline: to *not* do what was done before.

We might applaud Cunningham's effort to disrupt his own—and his dancers'—acquired rhythms, to encourage alternative solutions to problems of timing and dynamics based on the radical particularity of the individual dancer. In addition, we might be intrigued by the possibilities of deculturation and differentiation that such a disruption allows. At the same time, however, we might want to ask why recourse to a "common" human "pool" might itself be problematic. Might there be cases in which countering one's habits and tastes, disowning one's participation in a shared culture, is *not* liberating? Is the struggle against acquired

patterns an effort to transcend not only culture but also memory—that is, to transcend history itself? Does this effort to transcend history produce an unmarked body, or is the result instead a body marked by a history of *techniques for dehistoricizing embodiment* (such as chance procedures) that themselves belong to a particular ethnicity and class?

The Story of *Story/Time*

Story/Time, by the dancer-choreographer Bill T. Jones, is a dance that raises precisely these questions. Created in 2012, *Story/Time* looks back to Cage and Cunningham to celebrate, historicize, and racialize avant-garde techniques. Self-consciously appropriating the chance procedures identified with their poetics, Jones submits personal stories of his confrontations with racism (among other topics) to time constraints and chance permutations. In *Story/Time*, an aesthetic associated with self-revelation as a *political* strategy (a resistance to the self-erasure occasioned by racism) meets an aesthetic that works toward the erasure of the subject's control over his own expressive material. A desire to expose and thereby affirm the self is countered by a fear of congealing that self into a racialized identity. Jones employs in this work a qualified version of a Cagean chance procedure in a gesture of ambivalence that sometimes arrests but more often accentuates the flow of self-narration and his habitual rhythm of verbal delivery.

In 2014, Jones published a series of lectures on the dance under the title *Story/Time: The Life of an Idea*. Here, he tells of how he was first exposed to Cage, whom he considers an influence even greater than that of Cunningham (although *Story/Time* clearly owes a debt to both). "The first time I heard or saw John Cage," he recalls, "was in 1972 at SUNY Binghamton. How I—a theater/dance major—happened to be present there in the Student Commons . . . is a mystery to me forty years later."[77] Jones's early career would be characterized by daring forays into precisely those areas that Cunningham and Cage had avoided: with Arnie Zane he choreographed explicitly homosexual duets and, after Zane's untimely death in 1988, produced a series of works that took on pressing political and social issues, such as *D-Man in the Waters* (1989), *Last Supper at Uncle Tom's Cabin/The Promised Land* (1990), and *Still/Here* (1994). After an exhausting period during which he gathered and synthesized materials for his 2009 tribute to Abraham Lincoln, *Fondly Do We Hope . . . Fervently Do We Pray*, Jones felt he needed a break. He was inspired to turn away from the monumental subjects he had been treating and take on something more intimate and personal—but with a twist.[78] Having recently retired as a dancer, he was in search of another way to inhabit the stage. Around that time, he began listening to Cage's 1978 recording of *Indeterminacy* "to relax." "It suddenly struck me," he writes, "that I was full of stories of my own and didn't want to organize them with a preconceived structure or arc."[79] He was an "unlikely candidate" to take on the mantle of Cagean aesthet-

ics, having spent his career denouncing racism and homophobia in highly dramatic ways. Yet he needed a technique, something to enable a destabilization of his own familiar narratives about himself and about the place of African American art vis-à-vis the avant-garde.[80] So he decided, although he was "inspired by *Indeterminacy*," that "*Story/Time* would be a system of my making in which I could participate at a remove."[81]

Indeterminacy is actually the name of two works by Cage: one is a lecture on "composition which is indeterminate with respect to its performance," given in Darmstadt, Germany, in 1958,[82] and the other is a collection of short stories, many of which were first read aloud at various performances to David Tudor's musical accompaniment. Both were pertinent to Jones: he wanted to introduce an element of chance into the sequencing of his dance (so that each of its performances would be slightly different, slightly out of his control), and he wanted to use a string of brief anecdotes as the score. Cage's own stories accumulated over many years to add up to 190; when these stories became the accompaniment of Cunningham's *How to Pass, Kick, Fall, and Run* in 1965, he presented only 60 of them, and each had to be read within the time bracket of one minute. Eventually, Cage made a recording of 90 of the stories for Folkways Records; it was while listening to this version that Jones conceived of the plan to create his own variation on Cage's work. He claims in *Story/Time: The Life of an Idea* to have written 170 stories in the spirit of Cage's 190; he then selected 70 of them to be read at each performance of *Story/Time*, a dance for ten dancers, by using the website www.random.org ("as opposed to John Cage's tossing of coins and consulting the *I Ching*").[83]

Already, we can observe a striking difference between Jones's method and that used by Cunningham and Cage for *How to Pass, Kick, Fall, and Run*. As Jones points out in an interview, he is the author of both the stories and the choreography, and thus he is "not in a neutral relationship to what is going on onstage."[84] The stories are explicitly about him; they focus on his parents, who raised him on a farm in Florida where he was born to a family of twelve children; his romantic relationships; and his adventures as an artist. While Cunningham is only tangentially associated with Cage's stories (appearing in a few of them), Jones is the center of attention at every moment, appearing as choreographer, author, and subject. There is another reason why Jones is "not in a neutral relationship to what is going on onstage": some of the autobiographical stories—as well as their movement illustrations—are highly charged, containing accounts of race- and class-based discrimination that contrast sharply with Cage's wry, gnomic tales and Cunningham's athletic but anodyne choreography. Whereas during performances of *How to Pass, Kick, Fall, and Run* Cage sat by the side of the stage, nonchalantly drinking champagne as he read his stories in random order, Jones places himself center stage in front of a table, facing the audience (plate 17).[85] He was intent on "owning" what he refers to as his "loaded persona."[86] Echoing Susan

Foster, he asserts that Cage's and Cunningham's "neutrality," the option they exercised "to disappear" inside their work, was a white privilege not accorded to him as a Black man. He notes that merely occupying the stage as a Black man poses problems for an experimentalism aiming to efface authorship and personality. In *Story/Time*, he didn't want to be "disingenuously self-effacing" or skirt the issue of racial difference; instead, he sought to place that racial difference into productive tension with chance procedures developed by white men for whom self-effacement represented liberation rather than social death.[87]

Further departures from the Cage-Cunningham aesthetic are worth considering. Tonally, some of Jones's stories resemble Cage's—for instance, in one, Jones attends a concert of Lou Harrison's music; in another, he eats a good meal with friends. But other stories tell of harsher experiences: homophobia directed against him and his partner; the molestation of his mother by two white men; eviction and poverty. Another major departure from the classic Cage-Cunningham aesthetic is the fact that the dancing is often cued to the contents of the stories; at times the choreography is obliquely representational and even downright pantomimic. In contrast, the dancing in Cunningham's *How to Pass, Kick, Fall, and Run* does not imitate or reflect anything going on in the stories Cage recounts. It couldn't, for the order of the stories changes every night, whereas the order of the choreography remains fixed. A further difference is that whereas Cage claimed to accept whatever selection and sequence the coin toss devised each night, Jones required that certain episodes and their danced representation be included in every performance.[88] In addition, he allowed himself to "improvise" the timing of the stories instead of sticking to the one-minute limit, thus maintaining what was for him a natural and affectively charged rhythm of delivery.[89] He even allowed himself to change the sequence of the stories and dances if that sequence did not conform to his taste.[90]

Overall, Jones's departures from the Cage aesthetic, his "system of [his] making in which [he] could participate at a remove," reflects his ambivalence vis-à-vis the depersonalization that such experimentalism demands.[91] In story 136, reprinted in *Story/Time: The Life of an Idea*, Jones admits his discomfort with Cage's anti-expressivist aesthetic, even though it allows him to move beyond a racialized experience he both "prize[s]" and fears: "I don't want to be oppressed by my experience," he states; "I realize in trying to return home to some racial/social identification as a Black man that I too rely on a 'gated community' view of certain cultural practices."[92] On the one hand, then, he is attracted to the liberty that experimentalism offers him: "Artists should be the freest in our society," he asserts. On the other, "the artist is a person with a gender, a race, an ethnicity, an economic/educational location—a class, and a history. What does that person who the artist is *need to do*?"[93]

Jones's last question resonates with the questioning I have been tracing through Cunningham's more autobiographical moments in *Antic Meet* and *Roaratorio*,

moments when he looks back at a feature of his embodiment, his past accultura-tion and training, or an element of his ethnic composition. Jones has little to say about Cunningham, considering him to be "too close," "one of the choreogra-phers I have learned the most from," yet with a "form . . . much different from mine."[94] But it is specifically on the level of form that the two choreographers should be compared. By "form" I am not simply referring to their different formal choices with respect to procedure—generating the initial choreography through chance or not; changing the choreography each night or not. I am referring to their choices with respect to dance *technique*, how each choreographer under-stands and mobilizes the dancing body. For Jones, it is the surface (epidural) "Blackness" of his body that lends him a racial identity, not necessarily the way he, or his dancers, move. In contrast, "Irishness" is evoked in *Roaratorio* as a cer-tain rhythmic way of executing a specific type of step. For instance, when Rashaun Mitchell dances *Roaratorio* in the 2011 reconstruction, the rhythmed steps he performs are shared with all the other dancers, and the "Irishness" of the dance applies to his dancing as much as it does to any other member of the clan. In other words, ethnic dancing in Cunningham is a matter of movement style and rhythmic emphasis; thus, it is by manipulating and ultimately interrupt-ing the rhythms of the jigs and reels that dancers ostensibly move beyond the borders of a particular culture, ethnic identity, and history. For Jones, the issue is not performing ethnicity so much as it is revealing the racialization of the sub-ject through the gaze of the observer. There is little identifiably "Black"—either African or African American—in the way he or his dancers move. Although the ten dancers of his company are quite diverse—white, Black, and Asian—they tend to move in a similarly sinuous and flowing way.

It could be that, as Susan Foster has argued, Cunningham is presupposing a kind of "universality" of reception. That is, he is assuming that all bodies danc-ing the jig will have the same capacity to assert the jig's rhythm and thus represent the "Irishness" of the Joycean intertext. But Jones, too, presumes the universal-ity of his *own* dancing style; that is, he presumes that a style as balletic as his should be able to tell any story, should be able to tell *his* story, even though his stylized moves arguably capture little of the actual rhythmic textures of the places and people he represents. His training at SUNY Binghamton was a mixture of Cecchetti ballet, classical modern dance (Doris Humphrey's "catch and release" technique), and classes in West African and Afro-Caribbean dance.[95] The danc-ing in *Story/Time* reflects this heterogeneous training, but it also contains a strong dose of Trisha Brown's "release technique" as well as elements as diverse as Alvin Ailey's flat-back lunges (see plate 17) indebted to Lester Horton's technique, modes of interaction inspired by Steve Paxton's Contact Improvisation, and moves drawn from African American dance culture, from the jitterbug and *American Bandstand* to hip-hop, as well as martial arts and capoeira. For *Story/ Time*, Jones compiled a vocabulary drawn from over thirty years of his own works,

constructing a "menu" from which he then selected the particular movements for each episode. Yet at least to my eyes, the choreography never seems to depart from the flowing, organic, bound/release quality of his signature style.[96] The rhythms of the dance episodes vary according to what is being depicted with the vocabulary chosen to communicate clearly the tone of the action described. The mimetic quality of the dancing—the dancers' pantomime—might be considered the least experimental aspect of Jones's *Story/Time*. So, too, his decision to improvise the length of the stories could arguably be taxed with diluting the challenge of Cage's constraint, allowing him to retain the normal rhythm of his own verbal delivery—his natural vocal inflections, his chosen emphases, and the metric of his respiration.

My comments are not meant as a criticism either of Jones or of *Story/Time*. Jones raises vital questions about the claims of identity—its subversion of, and sometimes its subversion *by*, experimental practices. In addition, he points to persistent inequalities in the reception of Black artists for whom the affirmation of identity may be as important as its escape or deconstruction.[97] "I maintain that there is value in the idea of a true and authentic self," he concludes powerfully in *Story/Time: The Life of an Idea*.[98] Significantly, over time, Jones has found that this self needs to take back a good deal of the control initially yielded to the Cagean experimentalism he initially emulated. Over the years, performances of *Story/Time* have conformed increasingly to his "feeling" that certain stories should be recounted at a particular venue, or that one story should always follow another. In short, he has gradually angled the dance toward his own predilections, toward the ingrained habits that make him a unique performer, one concerned with conveying a specific message and offering a specific experience to his public.

Jones seems to value what Brian Seibert calls "the community-strengthening powers of rhythmic synchronization."[99] In contrast, Cunningham, especially in *Roaratorio*, seeks to disturb that synchronization, even frustrate it. For Jones, the formation of a community based on the affirmation of a common identity constitutes a resistance against the effacement of African American agency. "I am part of a conversation"—a conversation about race—"in a way that Cunningham never was," he observes.[100] In contrast, for Cunningham the directive to be part of a community—and therefore, metaphorically, to keep the same rhythm, to march to the same drum—might easily have seemed coercive, given the ambience of compulsive heterosexuality that characterized the period of the 1940s when he began his career. For him, singularity—not communal identity—constituted a form of resistance. And this singularity would be glimpsed *not* when the choreographer affirms a "true and authentic self"—for that self is also constrained by acquired habits and tastes—but rather when that choreographer abrogates the self's agency to chance.

In sum, Cunningham placed great faith in chance procedures: they would

reveal alternatives he could not have invented on his own, sequences so strange that they would force a rhythmic delivery beyond any rhythms he had encountered before. He valued what emerged when dancers were challenged with something counterintuitive and awkward, for this was the best way he could release them from the clichés embedded in the music and dance rhythms they had acquired. Their solution to the counterintuitive phrase would be based not only on their previous technical training but also on their body type, their mood, and, as he put it, their "person" (understood as something that cannot be consciously divulged). Finally, Cunningham wished to dig deep into the hidden resources of human kinesis, to find possibilities of movement and rhythmic expression that culture had not yet mobilized, that an *ethnie* had not yet identified as its own.

By his own account, Jones was also attracted to the kinds of chance procedures Cage put into play—and for some of the same reasons. Chance procedures provided him with a way to escape the demands of an identitarian work like *Fondly Do We Hope . . . Fervently Do We Pray*. Yet he makes his ambivalence about Cage's experimental procedures quite clear. We could say that Jones "races" (and historicizes) chance procedures; he implies that for some dancers, a limitlessly "open field of possibilities" might offer less the promise of infinite relation than the threat of no relation—to a public, to a history—at all.

Jones admits in *Story/Time: The Life of an Idea* that he has sometimes felt pressure to identify with a community, and that he has wished instead to proclaim that he "is not what the world tells me I am."[101] Yet another instinct has driven him to connect his personal history to a collective one, to assert that he is "a person with a gender, a race . . . an economic/education location."[102] Ultimately, I believe that Cunningham, too, responded to this instinct—the instinct to *locate* the self—when he choreographed "A Single" and nostalgically reprised the steps he had learned in his hometown, Centralia. His careful attention to the rhythms he had adopted as an adolescent suggests that he considered the vernacular dances not only part of his personal history but also a possession he shared with Maude Barrett and, implicitly, with the long line of performers who had preceded her. It could be that in these moments—when Cunningham copies, when he identifies, when he seems the least experimental—he is, in fact, the most experimental insofar as he manages to bring a historically and ethnically specific form of experimentalism into friction with itself.

Buddhism in the Theatre

The year 1952 marks a crucial turning point in the imaginative collaboration between Merce Cunningham and John Cage. "From about 1952 on," Cage told Richard Kostelanetz in 1970, "the music was no longer fitted to the dance."[1] That meant that Cunningham could now approach choreography as an independent medium, one that creates its own rhythm and dynamics without the intervention of a musical score. The change in collaborative method was also crucial for Cage's own intellectual and artistic development: "If you look in my catalogue," he exclaimed, "you'll be amazed at the number of things that happened in 1952."[2] One of the most intriguing things that "happened" was the first performance of *Water Music*, a multimedia sound event that William Fetterman, a meticulous scholar of Cage's "theatre pieces," credits with inaugurating a new genre involving movement as well as sound.[3] Another groundbreaking work of 1952 was *Untitled Event*, otherwise known as the "first Happening," organized by Cage at Black Mountain College in Asheville, North Carolina. Interested in what he called "experimental actions,"[4] by 1952 Cage had taken a definitive turn toward theatre, a territory he shared increasingly with Cunningham and that he would define in 1965 as "something which engages both the eye and the ear."[5] In 1966, to an interviewer's query concerning the theatrical nature of *Untitled Event*, "Why didn't you develop anything in this area yourself?" Cage replied, "I have been doing nothing else since."[6]

Water Music was composed during the spring prior to Cage and Cunningham's seminal summer residency at Black Mountain College, also in 1952, where they inaugurated the genre of the Happening along with M. C. Richards, Charles Olson, and Robert Rauschenberg. In many ways, *Water Music* anticipates the Happening, but the slightly earlier work has received far less critical attention. *Water Music* led to further iterations, including a 1959 spinoff titled *Water Walk*— a solo for Cage—from which the screenshot in figure 7.1 is taken. *Water Music*

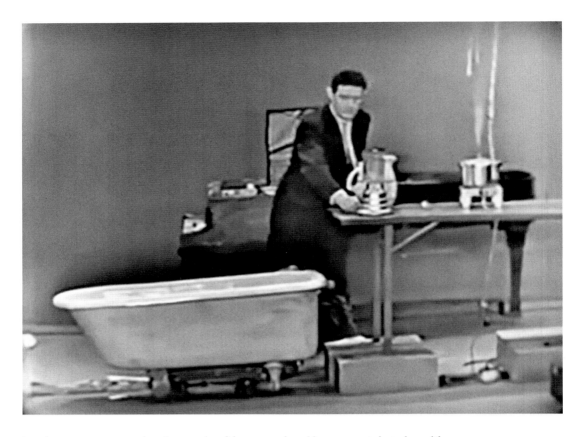

7.1
John Cage, screen-
shot from Water
Walk (1959). TV
episode of I've
Got a Secret.

involves gestures associated not only with conventional instruments but also with nonmusical tools and tasks. To be performed accurately, *Water Music* requires a prepared piano, a radio, whistles, two water containers, a deck of cards, a wooden stick, and a pianist—or, to be more precise, a performer. Not only did the piece introduce a new genre, it also exploded the concert space, expanding it to include new venues (e.g., television) and new sounds.

Cage's increasing reliance on unconventional instruments—from the water containers of *Water Music* to the flapping chicken and piggy bank of *Theatre Piece* (1960)—was motivated by his decision to privilege the everyday, to respect—in Buddhist fashion—each and every thing.[7] Most scholars believe that his interest in Zen Buddhism developed over the early 1950s, even though he had been exposed to a version of its teachings in 1938 when Nancy Wilson Ross lectured at the Cornish School in Seattle. The scholarly consensus seems to be that Cage began attending D. T. Suzuki's lectures with regularity in 1951 (and that Cunningham, too, attended whenever he could). Ironically, Cage's turn toward Buddhism ended up exposing him to unlikely audiences. Further, his promotion of a nonmusical music and a nontheatrical theatre lent him unexpected notoriety among artists of the next generation while challenging his status in the classical music world. The collapse of art into life, or the spectacular into the everyday, opened many doors and inspired many innovations in the world of music, art,

performance, and dance. But as we shall see, it also accentuated important differences between Cage and Cunningham, revealing fault lines in an aesthetic that critics have generally assumed they shared.

For *Water Walk* of 1959, Cage greatly amplified the theatrical possibilities he had discovered while composing *Water Music*; he thereby introduced a form of theatrical everydayness that both drew from and eventually challenged Cunningham's aesthetic of virtuosity and athletic poise. A queer performance work if there ever was one, *Water Walk* is an important intervention that deserves greater consideration, for it throws into relief a set of contradictions internal to Cage's evolving aesthetic, contradictions that would eventually inspire Cunningham to ask questions that were different from Cage's own. The aesthetic *Water Walk* exemplifies was at once ascetic and deeply sensorial, even erotic in its suggestiveness; it was dismissive of fixed relations and yet consistently privileged one relation in particular; it eschewed centers yet craved the camera's attention; it claimed a continuity between life and art yet required for its realization all sorts of theatrical conventions, mechanisms, and props.

Each artist absorbed the lessons of Zen into his practice in ways we shall soon examine, but Cage's devotion was arguably greater and thus the impact on his compositional and performance practices more profound. He never abandoned his interest in Zen Buddhism as both a philosophy and an approach to the creation of art; even during the last year of his life he was still acquiring books on Buddhism, keeping up with the latest commentaries, and deepening his commitment to a nonhierarchical view of life.[8] In contrast, during the early 1990s, Cunningham became preoccupied with refining his use of the software program Life-Forms. (*Trackers*, his first computer-assisted choreographic work, premiered in 1991.) Thus, the respective trajectories of the two artists did not remain strictly parallel, partly because of the respective media in which they worked. When Cage turned toward indeterminacy in 1958, he entered a realm that Cunningham was reluctant to inhabit.[9] For Cage, *indeterminacy* meant "identifying with no matter what eventuality."[10] Until his death in 1992, he was still composing what he called "indeterminate" scores. In contrast, aside from a few forays into indeterminate methods, Cunningham remained wedded to a choreography that was fixed. For him, a commitment to what Cage interpreted as a Buddhist acceptance of "no matter what eventuality" did not include abandoning virtuosic movement in favor of "experimental actions." And yet it is clear that their discovery of Buddhism around 1952 also drew both men closer together on many fronts. Cunningham and Cage discovered the theatrical value of the everyday at roughly the same time: actions such as "washing hands" and "running" appear for the first time in Cunningham's *Collage*, a work originally presented as *Excerpts from Symphonie pour un homme seul* at Brandeis University on June 13, 1952. During that same spring, Cage began to integrate everyday actions into his musical compositions with *Water Music*. Most important—for this chapter, at least—their mutual adop-

tion of a Zen-inspired approach to composition led to the only genre the two developed together, known simply as the Dialogue. When they began to perform Dialogues together in front of college and museum audiences, their two interrelated but distinct approaches to theatricality cohabited the same stage in suggestive ways. Ultimately, the two artists ended up staging not only their professional but also their domestic partnership as a kind of Zen repartee in which they appeared simultaneously as separate and in relation, free to connect—or not.

In contradistinction to so much of Cage and Cunningham's collaborative output, the Dialogue is strictly a twosome, not a threesome, and thus a true partner affair. The generative triangulation that invariably occurred when they added a third member was simply not operative in the case of that genre. They were never joined onstage by David Tudor—so often the third presence while on tour—or by one of their other triangulating collaborators, such as Carolyn Brown, Viola Farber, Marcel Duchamp, Robert Rauschenberg, Morton Feldman, Christian Wolff, or Jasper Johns. Marcel Duchamp once stated that three was the crucial number for him: "For me it is a kind of magic number, but not magic in the ordinary sense. Number 1 is the unity, number 2 is the couple, and 3 is the crowd. In other words," he concluded, "20 million or 3 is the same for me."[11] Ostensibly, then, a threesome could yield an infinite variety of relationships ("20 million"), or what Cage called "openness."[12] In contrast, the Dialogue would eliminate certain permutational possibilities, for it involves merely a "couple." Yet Cage and Cunningham must have found the act of exploring the couple relation on the stage intriguing, for they performed Dialogues together many times over at least two decades. Ultimately, the Dialogue allowed them to examine their divergent ways of interpreting similar directives: to attend to each thing, to eschew centers, to integrate life into art. Against the critical consensus (and accusation) that Cunningham never choreographed a same-sex duet—or, more precisely, a duet for two men—in this chapter I will maintain that in fact the Dialogue *was* that duet. The Dialogue was a *queer duet*, one that implicitly struggles with its own constraints and the constraints of the duet relation in general.

From *Water Music* to *Water Walk*

Predating Black Mountain College's *Untitled Event* by four months, *Water Music* was premiered by the pianist David Tudor on May 2, 1952, at the New School for Social Research in New York City.[13] (It was titled *66 W. 12* after the address of the venue.) On August 12, Tudor again presented *Water Music*, this time at Black Mountain College, just four days before Cage organized the "first Happening," *Untitled Event*.[14] Other iterations followed: *Water Walk* (1959), *Sounds of Venice* (1959), *Music Walk with Dancers* (1960), *Theater Piece* (1960), and *0'00"* (1962). To compose *Water Music*, Cage produced a list of sounds and actions (probably

64 to begin with—the end product uses 49); then, as in his other "chart" pieces of the period, he placed the sounds and actions in the numbered cells of charts and tossed coins to obtain a hexagram (one of the *I Ching*'s 64) that would in turn indicate which would be the next cell (and thus the next sound or action) in the sequence.[15] The sequence thus created became the ten-page score of the piece. In the program notes for Tudor's 1954 version, Cage explains (all in caps) why he considers *Music Walk* a form of theatre: "THE WATER MUSIC IS THEATRE (A PERSON HAS EYES AS WELL AS EARS)."[16] Apparently, the mere addition of visual elements justified, for him, the generic label *theatre*. What he does not state is that these visual elements were also gestural and kinetic. In future years, Cage would come to appreciate and exploit to a greater degree the power of movement to impose his presence on the stage.

Musicians who have interpreted *Water Music*—from David Tudor to Ellsworth Snyder in 1991—have alluded in interviews to the performance qualities they felt they had to cultivate, including at times the creation of a performance persona. Margaret Leng Tan has even stated that when she performs the piece, "I feel I am acting."[17] Yet neither Tan nor Tudor ever performed *Water Walk*, which seems to have required a different type of showmanship. During his lifetime, the work was performed exclusively by Cage. This is probably because its performance requires not the Zen-like austerity exemplified by Tudor but that same Zen-like austerity placed in the service of vaudevillian antics.

To some extent, then, *Water Walk* can be considered not a variant of *Water Music* but rather a new beginning.[18] Cage first performed *Water Walk* on February 5, 1959, on the television stage of *Lascia o Raddopia* (*Double or Nothing*), the live Italian quiz show on which he won six thousand dollars for answering questions about mushrooms over a period of five weeks.[19] He performed the piece two more times for television, once in New York for *The Henry Morgan Show* (June 1959), and once for *I've Got a Secret* (January 1960). The fact that he never performed the piece again suggests that it was designed specifically for TV and not the conventional recital venue. *Water Walk* is certainly more visually captivating, more telegenic, than its earlier iterations. The *I've Got a Secret* version, which can be accessed on YouTube, shows clearly that Cage's manipulation of the props offered many opportunities for the pattern of close-ups and wide-angle shots favored by the two-camera, live-audience format of the period. An odd media event indeed, *Water Walk* is generically unstable, something like a cross between an *I Love Lucy* episode, an *Ed Sullivan Show* episode, and a Henry Cowell percussion piece.[20] All the elements of nascent theatricality in *Water Music* have been expanded: if in *Water Music* Tudor is largely stationary, remaining seated at a prepared piano flanked by tables of radios to turn on and whistles to blow, in *Water Walk*, Cage is constantly in motion. He ambulates from station to station, stopping only to check his stopwatch or lean over the piano to install his "preparations" or perform

arpeggios. Whereas *Water Music* has been cataloged as a piece of "chamber music" and performed in various concert venues,[21] *Water Walk* requires a TV stage filled with props, two cameras, a host, and a live audience.

Yet as casual and entertaining as it might seem, *Water Walk*'s determinate score leaves no room for invention. Indicating a "frontal, proscenium style of performance,"[22] the score reads from left to right, with five-second intervals indicating the time brackets in which the various sounds and gestures are to be made. Among the forty-nine events that make up the piece, we find such actions as placing a toy rubber fish on the strings of the piano (so that the tail fins set off vibrations); putting ice into a glass from an ice bucket; turning a tape machine on and off; manipulating the dials of five different radios placed on either side of a large claw-foot bathtub; slamming a piano lid shut; blowing a whistle; turning a mixer containing ice cubes on and off; opening and closing a pressure cooker; placing a vase holding roses in the bathtub; and squeezing a rubber ducky. Cage: "So I simply put into the chart things that not only would produce sounds but that would produce actions that were interesting to see . . . actions I was willing to involve myself in."[23] In the screenshot reproduced at the start of this chapter, he is making the final gestures of the three-minute-long piece. Having released the steam from a pressure cooker, he moves further along the table to turn off a blender. His last gesture a few seconds later is to replace the cap on the now inactive pressure cooker and look up at the TV show host with an expectant smile, thereby signaling that the piece has concluded.

The actual performance of *Water Walk* is prefaced by a comic routine in which Cage is asked to whisper his "secret"—later revealed to be the names of all the instruments he will play in the piece—in the ear of the bemused host, Garry Moore. Cue cards overlaid on the shot of Moore and Cage display the words Cage is presumably whispering to Moore: "The 'instruments' I will use are"—says the card, with scare quotes added around the word *instruments*—"A Water Pitcher . . . an Iron Pipe . . . a Goose Call . . . a Bottle of Wine . . . an Electric Mixer . . . a Whistle . . . a Sprinkler . . . Ice Cubes . . . Two Cymbals . . . a Mechanical Fish . . . a Quail Call . . . a Rubber Duck . . . A Tape Recorder . . . a Vase of Roses . . . a Seltzer Siphon . . . 5 Radios . . . a Bathtub . . . and . . . a . . . Grand Piano." As the names of the instruments scroll up the screen, Moore repeatedly glances at Cage (whose cheek he cups in his left hand) with an expression of astonishment, causing the audience to giggle. When Cage completes his recital, applause erupts. It is as though the piece had already begun with this brief comedy "number," in which Cage plays Hardy the straight man to Moore's bewildered Laurel.

Although William Fetterman warns us that "one should not be misled into thinking that Cage and Tudor were acting like clowns,"[24] and although during the *I've Got A Secret* episode, Cage insists on his "seriousness" (Moore repeats the word *serious* or *seriously* four times), there is clearly an element of subversive play not only in *Water Walk* but also in Tudor's more muted performances of

Water Music. In fact, viewed from a twenty-first-century perspective, it is hard to miss the comic incongruity and gender-bending elements even in Tudor's studied performance. What kind of pianist, after all, puts a clothespin between the strings of his instrument? What could be sillier than a composer dressed up in a suit playing (with) domestic appliances and children's toys? What might be the "secret"—in *I've Got a Secret*—if not that some grown men like to play (the) house?

"Each Thing-ness"

When Cage inventories his "instruments" on *I've Got a Secret*, he produces a series of important corollary effects. First, he communicates to the viewer that the nature of the instruments employed is indeed unusual and thus deserves notice. These instruments do not belong to the traditional orchestra, nor do they involve the musician in what are traditionally considered musical tasks. In fact, most of the tasks Cage performs in the three-minute piece are associated one way or another with the realm of the domestic worker. He uses appliances that would be found in a kitchen (pressure cooker, blender, water pitcher), a living room (seltzer maker, bottle and glass), a bathroom (bathtub), and a garden (vase of flowers and watering can). Second, the stopwatch Cage manipulates throughout the piece serves to remind the viewer that his actions are timed gestural routines, a detail that resonates with both the discipline of the factory assembly line and the rigor of musical performance as a time-based art. Finally, Cage's inventorying of the instruments highlights what is perhaps the most telling element of his evolving aesthetic, namely the equal importance accorded to each and every sound that the unusual instruments emit. The sounds produced by the household and electronic appliances, the whistles, and the toys are each presented as discrete items in an inventory, or "gamut." Moreover, all the sounds are scored and produced with affectionate attention to the integrity of their singular materiality, their peculiar phonic qualities, just as later, for *Roaratorio: An Irish Circus on Finnegans Wake*, Cage would identify and painstakingly collect each noise, sound, or note mentioned in the *Wake*.

In 1952, Cunningham gave the name "each thing-ness" to the irreducibly singular and independent nature of the kind of objects encountered in the arts of the time. In his essay "The Impermanent Art," he claims that "each thing-ness" has developed into a "growing interest" of several of the artists in his circle, compelling "the use of chance methods" to disentangle "each thing" from its habitual place in a sequence.[25] Among the artists of this circle was Robert Rauschenberg, who at the age of twenty-seven was beginning to experiment with what he called at the time "the collage," later to be dubbed "the combine," an unlikely assemblage of heterogeneous elements, each of which could be appreciated as distinctive once removed from its usual context. A host of influences converged

in 1952 to draw these artists toward an aesthetic of "each thing-ness" and its corollary, an acceptance of all sounds (or movements or images) as equal in aesthetic value. In addition to the Black Mountain College experience, which put Cage and Cunningham in contact with Rauschenberg, Cage's dialogue with Pierre Boulez also contributed to the development of a "thing-in-itself" aesthetic.[26] (Boulez cofounded with Pierre Schaeffer the Paris-based Groupe de Recherches de Musique Concrète, which would eventually spawn IRCAM, where Cage went to make *Roaratorio*.) The concretist composers were determined, like Cage (and Luigi Russolo before them), to integrate a wider variety of sounds into musical composition. Cage's comments in "Experimental Music: Doctrine" of 1955 reflect his adoption of the concretist position: "A sound does not view itself as . . . needing another sound for its elucidation . . . it has no time for any consideration—it is occupied with the performance of its characteristics: before it has died away it must have made perfectly exact its frequency, its loudness, its length, its overtone structure, the precise morphology of these and of itself."[27]

What is striking in this statement is Cage's attribution of agency to a sound ("A sound does not view itself . . ."), as though sound had something to say simply by phenomenalizing its given character. (Consequently, its "meaning" would be nothing more than the exhibition of that character.) Also significant is his refusal to consider a sound in relation to any other sound. This refusal is part of Cage's early rejection of harmony.[28] Already while studying with Arnold Schoenberg in 1935, he realized that he was not interested in establishing fixed relations among notes. Around this time, another composer, Henry Cowell, also became important to him. Cowell's investigations into the alternative sounds that could be wrung from the piano as well as his openness to forms of musical expression outside the Western classical tradition buttressed Cage's conviction that by allowing more sounds into his canon, he could renew and enrich Western sensibilities.

In a sense, Zen Buddhism was for Cage just another way of rephrasing the concretist position. But of course, Zen would come to have a much broader impact on all aspects of his—and Cunningham's—shared existence. Cage's awakening to that philosophy occurred during the early 1950s, when he began attending lectures by D. T. Suzuki. According to Kay Larson, Suzuki's lectures at the Asia Institute and at Columbia focused on the Hua-Yen philosophy of Mahayana Buddhism, a point that is crucial for understanding not only Cage's but also Cunningham's development.[29] The major emphasis in Hua-Yen Buddhism—a Chinese school of Zen—is on two interlocking principles: (1) the complete separateness, or "unimpededness," of each thing; and (2) the "interpenetration" of all things, their limitless relationality.

The impact of Suzuki's teachings with respect to Hua-Yen Buddhism in particular is made evident in a text Cage published in 1958 in the *Village Voice*, "Composition as Process: III. Communication." "In the course of a lecture last winter at Columbia," Cage begins,

Suzuki said that there was a difference between oriental thinking and european [*sic*] thinking, that in european thinking things are seen as causing one another and having effects, whereas in oriental thinking this seeing of cause and effect is not emphasized but instead one makes an identification with what is here and now. He then spoke of two qualities: *unimpededness* and *interpenetration*. Now this *unimpededness* is seeing that in all of space each thing and each human being is at the center and furthermore that each one being at the center is the most honored one of all. *Interpenetration* means that each one of these most honored ones of all is moving out in all directions penetrating and being penetrated by every other one no matter what the time or what the space.[30]

In this passage, Cage is responding to what he calls the "european" emphasis on cause and effect as a type of explanation or rationale for sequencing. He wants to replace this notion of how things are related to one another with a viewpoint that isolates each event from every other event, allowing an event to be neither the cause nor the effect of something else, as though it existed in an absolute here and now. What this would mean in musical terms is that any note could follow any other note, since there would be no harmonic or melodic system and no developmental necessity undergirding the sequence. The isolation of the musical event—or, more broadly, the aural event—speaks to its "unimpededness," its ontology as a "center" (rather than its role as a "leading tone," for instance). Interestingly, in this passage Cage is thinking of music in terms of human beings and human relationships: "each *human being* is at the center," he claims. Here as elsewhere, Cage moves back and forth between a meditation on musical meaning and a meditation on human communication, sounds as centers and human beings as centers—an analogical approach that we will find Cunningham exploring a few years later. Indeed, Cage often approached his artistic practice, his way of handling musical composition, as a model for human comportment. In his view, relationships among sounds are homologous to relationships among human beings: each human being is at once separate and discrete—or "unimpeded"—and each human being is "penetrated by every other one no matter what the time or what the space."

Two decades later, Cage would rephrase the statements he made in "Communication" during his interview with the French composer Daniel Charles. Reminiscing about Oskar Fischinger, with whom he collaborated on an experimental film in 1937, Cage explains that his studies "in the Orient" only confirmed what he had already been sensing a decade earlier while working on Fischinger's film: "The Orient . . . [is] very close to Fischinger. Each sound has its own spirit, its own life. . . . What is true for sounds, applies equally to men."[31] Again, Cage emphasizes the discreteness of each thing (each sound, each man[32]); and again, in order to present this discreteness he returns to the terms of Hua-Yen

Buddhism—"interpenetration" and what he now calls "non-obstruction" (rather than "unimpededness"). The problem for the West, he explains, is that relationships (among men, among sounds) are prescribed, subject to norms, established, and maintained by reducing everything (and everyone) to a common measure: "What Suzuki taught me is that we really never stop establishing a means of measurement *outside the life of things*, and that next we strive to resituate each thing within the framework of that measure."[33] The mistake, he continues, is to "attempt to posit relationships between things by using this framework," this "measure,"[34] which ignores the true "life of things." "So," he concludes, "we lose things, we forget them, or we disfigure them." In contrast, Zen helps us to dissolve the framework, to remove the measuring instrument that forces us to compare one thing to another, to place one thing in relation to another. Not only is each thing its own, incomparable self, but because of that incomparability, each thing can enjoy relations with any other thing. There are no preferences, no tastes: "they are all *interpenetrating* and, as Zen would add, *non-obstructing*."[35]

Of course, several scholars before me have attempted to trace the ways in which Buddhist principles shaped Cage's and Cunningham's practice. Peter Jaeger, for one, has written that Cage "performed" the content of Zen Buddhism "at a formal, material level"; his works function as a "mise-en-scène for the emptiness of the Buddhist void."[36] Presumably, what Jaeger means is that the silences as well as the lack of a traditional harmonic or melodic structure served to separate each sound from every other, recalling what Cage called the "zero," the interval ("void"), we encounter "before reaching the next term."[37] With respect to Cunningham's work, Marilyn Vaughan Drown has argued that the choreographer's decentering of the stage (as in *Summerspace* [1958]), his focus on stillness (as in *Suite for Five* [1953–58]), his stripping down of mannerisms (or, in her terms, "personality"), and his way of layering ensembles all conjure "a dynamic vision of reality" in which relationships are fluid and constantly changing.[38] Cunningham himself has pointed out that his decentered and nonhierarchical use of the stage was a response to "Buddhist thought"; in the 1964 film *Image et technique*, he conjectures that "wherever you are could be a center—well that's a Buddhist thought of course—wherever you are is the center as well as wherever everyone else is."[39]

In his turn, Jonathan Katz has speculated that Cage's—and, by extension, Cunningham's—turn toward Eastern philosophies was motivated by a desire to escape the abstract expressionism of the 1950s, especially the focus on the expressive self defined as heterosexual and male.[40] Katz's argument is that Cage, wishing to free himself from strong emotions during a particularly tumultuous period of his life, transformed his Zen Buddhism into a kind of politicized aesthetics that could accommodate his queerness: "Through Zen, Cage could thus connect his involuntary and highly individuated experience of the closet with a larger social/ethical politics of *monadic non-interference*."[41] The "monadic non-

interference" to which Katz refers is another version of Zen unimpededness, a state in which the individual remains irreducible and unique—independent, as in a state of anarchy—while still capable of entering into an infinite number of relations.

On the one hand, then, Cage and Cunningham were both primed to receive the teachings of Zen Buddhism by a variety of factors both personal and generational: the poetics of impersonality of the early twentieth century; Marcel Duchamp's rejection of measurement and comparison; and the need to mute expression and deny relation during a period of harsh censorship. Zen Buddhism clearly answered a wide variety of needs. On the other hand, though, the ways in which the two artists chose to interpret—or misinterpret—Zen principles were original and daring. Not only did they appropriate unimpededness as an invitation to separate music from dance (and from costumes and décor), making each element independent while simultaneous; they also took Zen Buddhism as a blueprint for living a joint life.

"Is Tragedy Inevitable?"

Cage published many essays and engaged in numerous interviews in which he explicitly relates his compositional practice to Zen Buddhism (as he defined it). Such is not the case with Cunningham, whose writings on the topic remain largely unpublished and unknown to this day. These unpublished writings are important, for they illuminate the connection—as Cunningham understood it—between the development of his choreographic practice and the Zen principles of non-obstruction and interpenetration dear to Cage. Over the course of the 1950s, 1960s, and 1970s, Cunningham performed with his company in various university gymnasiums and other nonconcert venues. As part of these engagements, he was often asked to give lectures and/or multiday workshops on choreography. His notes to these lectures and workshops provide valuable clues to his preoccupations of the period. For instance, in a 1957 Lecture-Demonstration at the Roslyn Arts Center on Long Island, he presents his aesthetic in the following terms: "The question [up to now] has been how you feel or think one movement should follow another. (what movement means in relation one to the other). . . . My composing is from the view that life is constantly shifting & changing, and that we live in a democratic society, that people & things in nature are *mutually independent of, and related to* each other."[42] Cunningham implies here that his interest in "what movement means in relation one to the other" has developed into an interest in how things are "constantly shifting & changing," and thus how relations between "people & things in nature" are unstable, unfixed. (Interestingly, he associates these principles with democracy, thereby politicizing his process, making it an analog—as Cage consistently did—for social and economic formations.) In the 1957 Lecture-Demonstration, Cunningham associates his own

experiments with continuity—how one movement follows another—not with Cage or Zen Buddhism alone but also with Gertrude Stein. It is Stein, he states, who focuses on "what comes after what"—on "grammar" (not content)—as the basis of meaning.[43] More interesting still, he alludes to a figure who does not appear in Cage's writings at all: Hanya Holm, one of his teachers at the Bennington College Summer Program he attended in 1938. Holm, he recounts, first introduced him to the notion that "the most interesting choreography could be observed by looking at people in the streets," a statement one might have attributed to Cage, given his emphasis during the 1950s on the aesthetic value of everyday phenomena, but that Cunningham identifies here as emerging from within the world of dance itself.[44]

What we can glean from these writings is that during the 1950s, Cunningham was preoccupied with three fundamental questions, all of which were suggested to him by a felicitous confluence of influences from philosophy, literature, art, and dance: (1) how "people & things in nature" might serve as a model for choreographed movement; (2) how individual movements relate, "one to the other"; and (3) how principles of interpenetration and non-obstruction can be transported into dance composition. With respect to the last question, the appeal of Zen Buddhism was arguably that it provided him with a justification for continuing to explore precisely what he already wished to explore in the domain of movement: how one movement is at once itself and something in relation to another movement. From the 1950s onward, Cunningham never stopped asking how movement is changed by "grammar" and how it is changed by cohabitation. Can things, in fact, interpenetrate while remaining themselves? Can choreography preserve the independence of each movement while accepting that each movement will enter into a relation with what comes next?

These are the questions he addresses repeatedly in his Lecture-Demonstrations and workshops of the period. With respect to the integration of everyday movements (those of "people in the street"), Cunningham was able to test the effectiveness of these movements during his 1952 residency at Brandeis, where he choreographed *Excerpts from Symphonie pour un homme seul* for a group of students with less than optimal professional skills. (He included "the gestures they did ordinarily," such as "shaking hands," "washing clothes," "eating," and so on.)[45] After the Brandeis experience, he ended up using everyday movements only sporadically—and in a manner substantially different from the choreographers associated with the Judson Dance Theater; yet he nonetheless continued to use such movement in his workshops for pragmatic reasons. Given his students' limitations and the fact that he was teaching choreographic technique, he tended to emphasize how formal decisions affect how we *perceive* the content rather than the content itself. Unable to indulge his enduring interest in virtuosity, the workshops were given over to the study of sequencing and its dramatic results. The issue of how discrete movements form relations thus became a more

persistent focus of his teaching and—one suspects—his own choreographic practice. Cunningham's emphasis on the forging of relations (as opposed to the "each thing-ness" of that which is being related) constitutes a departure from a strictly Cagean aesthetics and marks a significant difference between the two artists. If for Cage enlarging music's "gamut" to include any and all sounds was a fundamental element of his aesthetic project, integrating everyday movement into dance was for Cunningham mostly a pragmatic move, not an end in itself.[46]

Unfortunately, there do not appear to be any available records of workshops before 1972, but a folder of unpublished notes housed at the New York Public Library does at least provide a glimpse into what Cunningham was thinking about during the 1970s.[47] I will focus on two workshops in particular, one given in Pittsburgh in July of 1972—known as the "Pittsburgh Workshop"—and the other titled "Workshop in Flexibility," given over the period of a week in July of 1974. During those years, flexibility seems to have been the theme not only of Cunningham's workshops but also of his choreographic output. For *Signals* (1970), he allowed the unique conditions of performance to determine specific actions in such a way that dancers had to be flexible, ready to change the order of what they were doing at a moment's notice.[48] Similarly, for *TV Rerun* (1972) he asked dancers to choose from a set of previously learned materials what they would perform and in which order. For *Changing Steps* (1973), he changed the order of the sections for each performance. Flexibility could thus be considered Cunningham's version of indeterminacy, a kind of indeterminacy "lite." As in Cage's version of indeterminacy, Cunningham's "flexibility" also involves the use of chance procedures, but he sticks to coin tossing (to determine the use of "time," "space," and "movement [any form]," as he puts it in the Pittsburgh Workshop), whereas Cage was turning to more baroque procedures involving transparencies and grids.[49] The purpose for both Cage and Cunningham was "to bring about an unforseen [*sic*] situation."[50] However, in Cunningham's case, once that situation emerged, it would remain a fixed piece of choreography; the dancers were not usually given time brackets in which they might perform any action whatsoever except in the context of a workshop exercise. Further, there is something specific to Cunningham's flexibility that does not find its correlate in Cage's indeterminacy: his main purpose, we read in his notes (fig. 7.2), is to learn how movement events "are *altered* by immediate circumstances," or how one "independent phrase" is "*affected*" by another."[51] Cunningham is clearly interested in how the integration of non-intentional variables transforms a sequence—an overlap of "independent phrases"—into a relation, or what he explicitly calls drama in the Pittsburgh Workshop. "Drama: heightening of tension," he writes in the top margin.

It is hard to imagine Cage showing equal interest in how the results of an indeterminate score might engender "drama," or how one phrase might be "affected" by another. Yet these are major themes of the "Workshop in

Pittsburgh Workshop

Chance (July 1972)

Drama:
heightening of
tension

① Use time – chance composition
② " Space – " "
③ " Movement " (any form)]

composed
+
performed

combine ②
" ③

Indeterminacy :

| the movements as Events can be prepared. They are altered by the immediate circumstances |

① Single indeterminate exercise, phrase, event

② Several together, each person making an independent phrase or series of phrases, events which can be affected by another.

③ Group Event, with cues done by 1 or several to cue change of events

Individuals may enter events or not; leave them at any point to enter another, or a solo event.

Flexibility" of 1974. As Cunningham writes in his shorthand manner, "The aim of class 'Workshop in Flexibility' is 'open-mindedness'; this should be understood as referring not only to continuity of dance-movements, but of actions, + life, if that's possible. Everyday actions are usable, at this point in society . . . that is, there are multiple possibilities in mvt. as to what follows what." Then he adds in the margins: "How does this relate to 'relationships' as seem inherent in a 'plot'?"[52]

What is striking here is not that Cunningham is still entertaining the use of everyday actions in dance; this is part of his general strategy to loosen up the students so that they start to think in terms of continuity rather than contents.[53] What *is* striking is that he associates this continuity—the "multiple possibilities in mvt as to what follows what"—with the question of relationships and plot. Some of his punctuation choices—the scare quotes and the brackets—suggest his discomfort with the terms. Yet use them he does—and repeatedly. Here, Cunningham seems to be linking the multiple possibilities of sequencing and juxtaposition in the realm of movement to a similar multiplicity of possibilities in the realm of human relationships, exploring the forms they can take. His lesson asks students to discover how the "independent" movement event is "altered" by coming into contact with another movement event. The unspoken question is, How independent are human movements once placed in a sequence or juxtaposed on a stage? What if the two dancers touch? Is it inevitable that the sequencing and juxtaposition of movements, no matter how mutually independent, will generate a plot?

In short, Cunningham seems to be drawn toward questions that fall outside Cage's explicit concerns. He is interested in observing and exploiting moments of relation, how each thing, each center, while non-obstructed, enters into a kind of "constellation," and how it is affected and altered by its place in that constellation. The term *constellation*, of course, is Cage's own. In his interview with Daniel Charles, he evokes the metaphor of the constellation to describe the emergence of relations among separate "stars," or discrete phenomena. If what fascinates Cunningham is how things are affected or changed by their arrangements in time and space, Cage is convinced of the impermanence of all arrangements and thus the immutability of the thing-in-itself despite its "interpenetration." Again, Cage's emphasis is on discontinuity and openness, while Cunningham's is on the generation of "plots."

"I know perfectly well that things interpenetrate," Cage responds, as if irritated by his interviewer's objection. "But I think they interpenetrate more richly and with more complexity when I do not establish any connection."[54] So far, so good: Cunningham, too, is convinced that non-intentional connections promise greater richness and complexity. But then Cage continues: "I can accept the relationship between a diversity of elements, as we do when we look at the stars, discover a group of stars and baptize it 'The Big Bear' . . . but what makes the

constellation into an object"—as opposed to something non-obstructed, unfixed—"is the relationship I *impose* on its components. But I can refrain from positing that relationship, I can consider the stars as separate . . . then I simply have a group of stars."[55]

Cunningham, for his part, is not so sure that one can "refrain from positing that relationship." Perhaps one can leave it up to the spectator to posit it, but the mere presence of human beings on a stage, even if their actions are determined by chance procedures, poses the inevitable question of their relationship to one another. As a choreographer, Cunningham is always working with "the human situation on stage."[56] In contrast, Cage is working with the concatenation of sounds. Here, an important gulf opens between a sound-centered and a movement-centered aesthetic: a person on a stage, no matter what he or she is doing, no matter in what order, poses the question of meaning—"what does it mean rears its ugly head," as Cunningham puts it in a Lecture-Demonstration of 1954.[57] Ugly or no, the question cannot be avoided. In his notes to his "Workshop in Flexibility," Cunningham asks if in fact certain plots (like "constellations") tend to reappear. If one starts with human beings in movement on a stage (the fundamental a priori of his craft), then "is tragedy inevitable?" he asks.[58] Once encounters occur, are their "routes" firmly established? Do these routes always lead in the same direction? Or can non-intentional composition, as suggested by Cage, offer more complexity, more unseen choices?

Cunningham invents exercises for the "Workshop in Flexibility" that allow him to explore precisely these questions. He challenges students to begin with the simplest movements available: "simple or elementary movements have the most freedom in terms of flexibility; they are less encumbered with particular 'routes.'" Then he directs the students to choose one "*a priori*"—his examples are a pantomime, an arm gesture, a daily task. They must decide how many of these to use. If a given student chooses four pantomimes (Cunningham's example), that individual should "change order" in order to practice "flexibility."[59] But developing flexibility is not enough; the student must also be able to ascertain how the integrity of the original dance unit is "affected" by the relation into which it enters, whether that relation is sequential ("change order") or simultaneous. The student must learn to detect how drama emerges even from processes of permutation, how incipient investments accrue, that is, after the arbitrary. Again, it is hard to imagine Cage teaching a composition class in which students would be asked to analyze how drama arises from a random sequencing of sounds.

Consider, for instance, "Lesson #2" of the "Workshop in Flexibility" that was presented on July 9. Here, Cunningham calls for students to find out what happens when "someone [is] hanging on performer [relationships] [either completely off ground, or partially off.] What is changed?"[60] In another exercise, he asks students to see whether "holding poses touching or not" makes a difference.

When musing on his recent experience setting *Un Jour ou Deux* (1973) on the dancers of the Paris Opera Ballet, he concludes that "some more flexible ways of dealing with positions seem essential," given "all this change"—the relativity of space, but also "t.v., radio, movies, jets."[61] Cunningham is pointing to the acceleration and multiplication of contacts among things, the fact that in modernity distances have been reduced, enabling a greater variety and number of encounters. The aim of the workshop is precisely to confront choreographically this multiplication of encounters, to make students flexible, able to cope with a richer and more complex world. Yet at the same time, Cunningham implies, a multiplication of encounters does not, as a corollary, imply that they no longer have any significant impact. He still asks his students to gauge how their movement has been affected as a result of the new contact. "Homework" for Lesson #4, for instance, "will be flexibility in directions, + relationships."[62] In short, the overall objective is not simply to witness changes in directions but to *live* them, to find out how they affect the body, how they inspire relationships, how they suggest—or "impose" (Cage's word)—"plots."

"I don't feel just going fast or slow is an answer," Cunningham muses in his notes to the "Workshop in Flexibility." To reflect the modern world, its velocities, technologies, and diverse media, more is required of the choreographer. Accordingly, he suggests another route: "a possibility that exists in human relationships [not fast or slow—but few or many]."[63] As before, he closets the pertinent points within the safety of brackets—"[few or many]"—implicitly establishing an analogy between possibilities that exist within artistic practice and those that exist within human relationships. (Similarly, Cage treats "sounds" as "men" in the passages quoted earlier.) What Cunningham seems to be suggesting is that there is a parallel between what goes on in the theater—any dance phrase (and thus any dancer) can encounter any other—and what goes on in life. One could have many relationships at the same time, or pass from one relationship to another, without prioritizing any given person or any given tendency. In this manner, Cunningham speculates, new plots might be devised. Everything doesn't have to end in "tragedy." The end of the drama (the "route") is not necessarily culturally overdetermined in advance. But of course, such a scenario fails to take into account how movements (and people) who enter into relations—whether "few or many"—are nonetheless affected altered, even obstructed, by the human situation they must inevitably confront.

The Dialogue as Queer Duet

Many people . . . were chatting with their neighbors and generally looking around when a man slid a table to the middle of the floor, turned around and pushed it back again.

The man pushing the table wore a blue shirt out at the waist, blue jeans and moccasins. The people who didn't know he was John Cage assumed he was a stagehand working

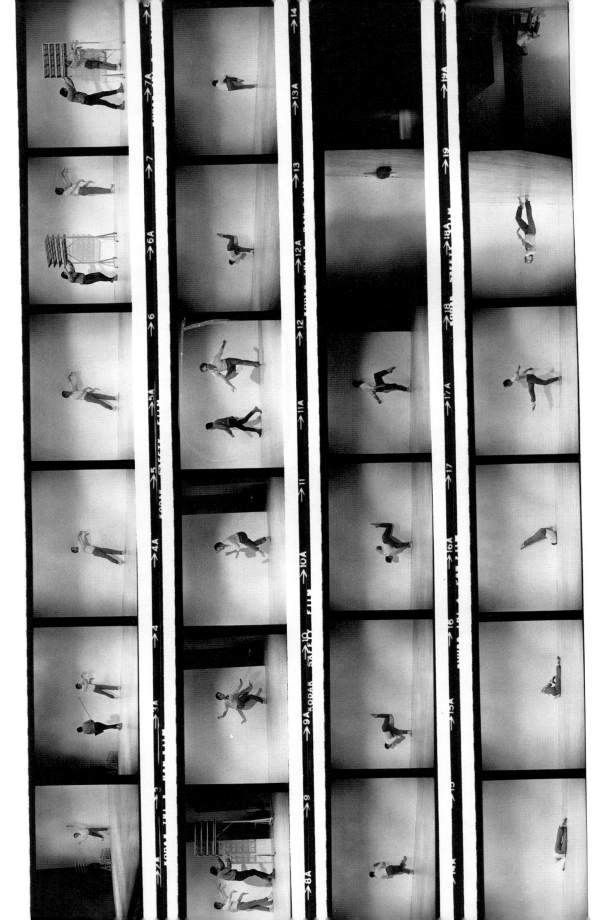

on the set *and kept on talking but others began listening because the noise the table made was the opening salvo in the performance. . . .*

Suddenly, Merce Cunningham squirted in from the side and lay with his forehead pressed against the tile floor and his long arms spread. *Nothing happened. There was no motion for a few moments, and there was complete silence.*

Cage walked to a counter and set an electric pot of water boiling and put a microphone to his throat.

Then while Cunningham danced, Cage slurped down a soft drink. The microphone amplified his swallowing so that each glug and slurp filled the room with loud noise.[64]

7.3 (facing) John Cage and Merce Cunningham, *Dialogue* (1972). Photograph by James Klosty at the Walker Arts Center, Minneapolis. Reprinted with permission from James Klosty.

So reads the most complete account of a Dialogue we have, an account provided by Larry Caldwell of an October 30, 1978, performance at the Denver Art Museum. As far as I have been able to ascertain, no video recordings or films of a Dialogue performance exist. And no one who has seen a performance has left a fuller description than the one quoted above. Neither Cage nor Cunningham wrote anything about the Dialogue genre, although they each—thankfully—left at least one score behind.[65] The Dialogue is thus—other than James Klosty's photographic documentation (fig. 7.3)—truly a lost event. It is the most ephemeral of Cunningham and Cage's co-creations, a type of performance that remains only in the form of documents. No one person (or couple) has tried to reconstruct a Dialogue, perhaps because of its "highly personal" and "non-theatrical" nature, as one sympathetic viewer reported.[66] The Dialogue is a curious genre, a "non-theatrical" theatre coterminous with the life span of its original cast. It is reliant not only on the personalities of the individuals involved but also on the personality of the relation between them. It is the personality of this relation that will occupy me in this concluding section of the book.

In a sense, Cage and Cunningham began performing Dialogues the moment they appeared together on the same stage. The genre was a logical outgrowth of the collaborative method they had used throughout their working lives, one involving a detachment with respect to the objectives and results of the other's contribution. *Non-obstruction* and *interpenetration* are terms that could easily describe what both artists were attempting to realize when they collaborated on their first joint concert at the Humphrey-Weidman Studio in New York City on April 5, 1944. At this concert, Cunningham danced three solos (accompanied by Cage), then Cage played three pieces of his music independently, then Cunningham danced another three solos (accompanied by Cage). The only connection between Cunningham's dance and Cage's music was the coincidence of sectional breaks. Yet if the dance seemed "non-obstructed" by the music—and vice versa—the very fact that they occurred simultaneously placed them in relation to each other. The perception of one inevitably affected the way the other was perceived.

A few years later, the two artists produced their first joint Lecture-Demonstration. Hoping to avoid the pedantry of the genre—"the conventional

talking and demonstrating"—they decided that each of them, separately, would compose a short piece right under the public's eye.[67] The audience could thus witness at close range the products of a non-obstructional creative practice: Cage and Cunningham occupied the same space and time, seemingly without responding to what the other was doing. In Cage's terms, they were cohabiting without being in "conversation." This refusal to converse (in Cage's sense) would prove to be the single most important feature of the Dialogue genre. In his interview with Daniel Charles, Cage states quite bluntly that the reason he does not appreciate jazz is that it remains too much like a "conversation." "In most jazz compositions," he says, "I hear an improvisation that resembles a conversation. One musician answers another. So, rather than each one doing what he wants, he listens with all his might to what the other one is doing."[68] Whatever the merits of Cage's understanding of jazz might—or might not—be, his comments reveal something important about his aspirations for the Dialogue. As opposed to a conversation, the Dialogue is not meant to establish social communication. It is entirely conceivable that Cage misunderstood the type of social communication jazz is attempting to forge, and that he was stubbornly blind to the (racist) context in which it might be necessary to forge such a conversation. Paradoxically, however, and unbeknownst to him, he actually shared with (at least some) jazz musicians their desire to *rethink social communication*, that is, to rethink the models of normative relationality that a white, heterosexual space offers. The Dialogue provided a format in which to test what happens, not when two separate people improvise, but rather when they each randomize—then juxtapose—a set of actions typical of their own practice. The Dialogue should in theory permit the emergence of refreshing juxtapositions, a flexibility in relations, while allowing each participant to perform actions that are personally relevant, "the gestures they did ordinarily."[69] However, these gestures are (1) resequenced according to an arbitrary order; and (2) performed in the company of someone else. In this way, both individuals gain a certain freedom with respect to their habits, *including their habits of social interchange*. Theoretically, they meet in ways that cannot be predicted in advance, interacting while remaining within their own orbits (like stars).

Cage's description of the procedure during his interview with Daniel Charles (apropos of his piece *Musicircus* [1967]) is illuminating in this regard:

JC But the principle of the *Musicircus* . . . is a principle of a flexible relationship, of a flexibility of relationships.

DC What do you mean by that?

JC Interpenetration must appear through non-obstruction.[70]

For Cage, then, if interpenetration occurs, it must do so "through non-obstruction." This means that two (or more) entities operating within the same

spatial and temporal frame should interpenetrate without regard either for the norms and rules of an art form or the oppressive conventions of social exchange. Daniel Charles then attempts to tease out the analogy between musical performance (*Musicircus*) and human behavior: "So, in your ideal society, people would be near each other but not communicating." Cage responds, "They would not communicate, but they would talk, they would carry on *dialogues*." "Communicating," he insists, "is always *imposing* something: a discourse on objects, a truth, a feeling."[71] Seemingly puzzled, his interlocutor perseveres: "But if nothing imposes itself, we could say anything at all." Cage: "It is that 'anything at all' which allows access to what I call the *openness*."[72]

Most of the Dialogues were performed between 1972 and 1978 during residencies at various colleges, universities, and art institutions—Detroit Institute of the Arts in 1972; SUNY Brockport, SUNY Geneseo, Kent State University, and Dartmouth College in 1973; the Walker Arts Center in Minneapolis in 1972, 1974, and 1978; the University of Washington in 1977; the Denver Art Museum in 1978; and the American Center in Paris in 1978.[73] Upon examining the dates, we might surmise that the couple's interest in the Dialogue format initially had something to do with Carolyn Brown's departure from Cunningham's dance company in the fall of 1972. When she left, Cunningham was deprived of one of his most valued female leads. To avoid having to recast her roles, he filled his tour schedule with new works, Lecture-Demonstrations, Events, and Dialogues. The Dialogue thus appears to have filled a very significant gap in his dance card. It clearly provided an excuse for Cage to accompany Cunningham to the various venues where he was asked to teach and perform. In addition, it served the function of allowing the company dancers to take time off from a demanding schedule. Finally, and perhaps most important, it offered Cage an opportunity to become Cunningham's dance partner; as he put it in an interview with David Sears, "As I move [during a Dialogue], that has to be thought of in relation to dance. I am aware that I'm moving where angels fear to tread."[74]

David Vaughan dates the first Dialogue as occurring on August 12, 1967, while Cage and Cunningham were visiting the Skowhegan School of Painting and Sculpture in Maine. According to a review in the local *Somerset Reporter*, Cage read sections from his "Diary: How to Improve the World (You Will Only Make Matters Worse)" while also producing an array of sounds from tape recorders, amplifiers, and a grand piano. Near him, Cunningham went through his ritualistic warm-up exercises, then performed several excerpts from the solos in his repertory.[75] If this account is accurate, then the first foray into the Dialogue genre closely resembled the joint concerts of the 1940s: the composer would play his composition and the dancer would dance his choreography. The Dialogues of the 1970s, however, were theatre pieces—like *Water Walk*—rather than concerts or recitals. They provided Cage with the option to *move*, to do more than read

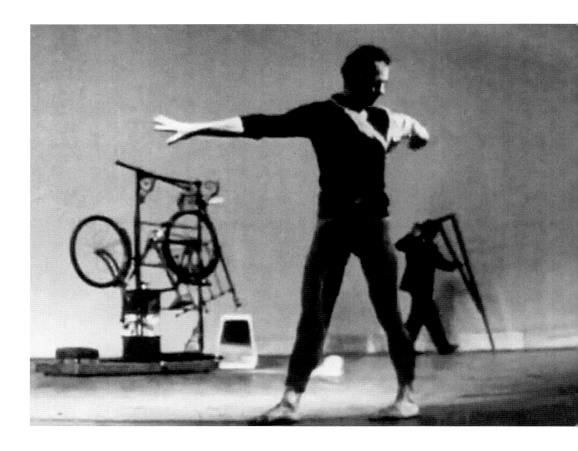

aloud or play an instrument. As William Fetterman confirms, Cage "was at his most physical" when participating in a Dialogue.[76] In short, through the Dialogue genre, Cage could become a dancer too.

We know more or less what Cage did during the Dialogue at the Denver Art Museum in 1978: he "walked to a counter and set an electric pot of water boiling and put a microphone to his throat." Meanwhile, Cunningham was lying "with his forehead pressed against the tile floor and his long arms spread." The difference between the two sets of gestures is striking: Cage's gestures are methodical, pragmatic, whereas Cunningham's prone posture seems almost abject in comparison. And yet the disconnect between their actions suggests something more structural, namely, the division of labor that characterized not only their mode of collaboration but also their daily lives. Performing simultaneously on the same stage, they would have had a hard time *not* evoking their mode of coupling (that particular plot). But again, as in Cage's famous 1989 description of their home life—"I do the cooking and Merce does the dishes"[77]—there is nothing directly sexual about the interaction, no touching—and certainly no lifts, as in a traditional duet. To this extent, both members of the couple do manage to exit the closet—*but only to enter the kitchen.* Even though the Dialogue allows them to

expose their moving bodies on the same stage, it casts their coupledom—and their bodies—in domestic terms, that is, as divided labor, as a set of mutually non-obstructing gestural scores unfolding at the same time. While Cage gurgles and mixes, moves furniture, or puts on masks, Cunningham lies flat and hugs a wall.

Most of the reviews of Dialogue performances stress the dramatic nature of Cunningham's movements and the more workmanlike, task-oriented gestures of Cage. ("The people who didn't know he was John Cage assumed he was a stagehand working on the set," Caldwell tells us.) In one review, Cage is described as "assembling and dissembling piles of junk";[78] in another, we find him "scraping, dragging or thumping the various objects" he found "stashed" in the wings.[79] According to Fetterman, Cage first began cultivating this onstage "stagehand" presence during a 1964 filming of *Story* (1963) while the Merce Cunningham Dance Company was in Finland. In the film, Cage can be seen pushing an inverted music stand—like a vacuum cleaner—from one side of the stage to the other. Again, the gesture is a domestic one: Cage is cleaning up in a kind of assisted pantomime, advancing and then retreating a few steps in a clearly choreographed routine.[80] (See figure 7.4.)

As we saw earlier, Cage consistently filled his theatre pieces with task-like gestures; however, in the Dialogues he added larger movements, taking full advantage of the dimensions of the stage. By displacing the more cumbersome objects he found on the set—an entire table instead of a teapot, for instance—he managed to mobilize his body in a way that the earlier gestures programmed for *Water Walk* did not. Amplifying his gestures and the sounds his body made (e.g., putting the mike against his throat) allowed him to participate if not as a dancer, then at least as a body exposing itself theatrically, making itself seen (and heard) as theatre. The photographs reproduced above from James Klosty's contact sheet of a 1972 Dialogue (fig. 7.3) show the composer moving a large object from upstage right to upstage left, the same trajectory he takes with the instrument stand in *Story*. One of Cage's surviving scores for a Dialogue contains directions for no less than ten acts of heavy lifting: for example, "Move object 3 to Post 6 (without mask)"; "Move object 7 to Post 8 (without mask)"; "Move object 4 to Post 4 (wearing mask)"; and so on.[81] The score is indeterminate in that "object 3" changes according to what Cage finds at hand, while "Post 6" shifts depending on the spatial organization of the venue. What remains determinate are the gestures we have come to recognize, like insistent operatic motifs, from his theatre pieces: "drinking with throat mike"; "start coffee pot"; "make cup of tea"; "drink some tea"; "flush the pot"; "drink beer"; and so on. As in *Theater Piece* of 1960, Cunningham adds a set of masks—a penguin mask and a dog mask in the 1978 version. The chance-derived sequence requires that Cage wear (or not wear) the mask while completing another action: for example, "Go downstairs wearing

7.4 (facing) Screenshot from Merce Cunningham, *Story* (1963); performance film (Finland, 1964, director unknown). Cage is in the background pushing a music stand, Cunningham is in the foreground, with a Robert Rauschenberg sculpture to his left.

Dog mask, flush pot, and start."[82] Reviews of the period as well as Cunningham's own score suggest that masking, or disguise in general, was also central to his performance.

Consider, for instance, Cunningham's score dated May 15, 1974. This previously unpublished version of a Dialogue was prepared for one of the performances at the Walker Art Center. The numbering on the right-hand side of the page refers to the multiple costume changes: for instance, "23" = "change [to blue leo + tights]." What was the purpose of these changes of clothing? And why the masks? Unfortunately, it is impossible to know whether Cage and Cunningham discussed the theme of self-disguise beforehand, but it is indeed notable that they both consistently included self-disguising means in their scores. Cage, apparently, did not always don a mask, and sometimes Cunningham added a section where he batted around in a plastic bag (as in *Place* [1966]) or moved under a carpet (as in *Winterbranch* [1964]). A chance procedure might have determined at which points in the performance the mask or costume would be donned, but the initial decision to include them in the Dialogue "gamut" registers an awareness of their signifying power. The mask, of course, is emblematic of the theatrical, signaling self-reflexivity, theatre to the second power. It is as though Cage and Cunningham were saying, "we are *playing* at playing roles," practicing a kind of self-exposure hidden in plain view.

Ultimately, in the Dialogue Cunningham and Cage cohabit the stage not simply as dancer and composer but also as members of a couple, mixing autobiography with chance operations to theatricalize their division of labor, both professional and domestic. The Dialogue stages their relationship as a set of gestures, displaying what each is "willing" to do.[83] ("I do the cooking and Merce does the dishes.") Here, in the Dialogue, it is not the nature of the aesthetic or compositional procedure that distinguishes the two—for they have both followed roughly the same chance operation—but rather the nature of their physical performances (and the nature of their *wills*). As a gifted dancer, Cunningham is the more visually salient of the two performers. Clothed in a set of tights or rehearsal pants, he is more vulnerable to the spectator's gaze and, to that extent, feminized.[84] The poses of the Dialogue that have been captured by photographers reveal at once the power of the heightened visibility Cunningham enjoyed and the vulnerability and abjection that subtend it. (See figure 7.3.) We might recall that Cage's career was for many years the more successful one, both financially and in terms of renown. But in the Dialogue it is Cunningham who is in the limelight and Cage who drifts in and out of the shadows. Cunningham's body is marked, his movements recognizably those of a trained dancer. Cage, in contrast, represents the Everyman, the stagehand. But it is that very contrast that makes the piece a Dialogue and not two solos. Here, the virtuosic appears next to the everyday, the feminized (yet masterly) dancer appears next to the masculinized worker (who appears, *by contrast*, aesthetically weak). My point here is that the

presence of one person inevitably affects how we experience the presence of the other. The cohabitation of the two performers installs them in a relation, lends each of them roles, sets them—willy-nilly—en route toward a (queerly hetero-sexual) plot.

Although Cage and Cunningham have always been thought of as practicing identical methods and holding identical views, I would like to conclude by suggesting that this is in fact not the case. Not only did they integrate chance in very different ways into the creation of their works; they also maintained two not-completely-coincident visions of theatre and life. For Cage, "not only is each thing its own incomparable self, but because of that incomparability, each thing can enjoy relations with any other thing."[85] But for Cunningham, the realization of one of the "multiple possibilities" means that "each thing" cannot then "enjoy relations with any other thing"—not because relation is "imposed" from without but because relation is "inherent," it emerges from within. It is our "nature," as he writes in "The Impermanent Art."[86] Subsequently, even a few moments later, the relation might be undone, the bonds loosened. Nevertheless, certain relations keep reemerging, certain couples keep reforming, despite the masks. The dialogue between Cage and Cunningham thus turns out to be more like a persistent question: Can a generative (but arbitrary) multiplicity still be maintained within the couple relation? Can one *relate* and at the same time *not*?

As the two artists moved from the ear to the eye, from the concert to the dance venue, such questions became more urgent. For in the realm of the visible and the kinetic that Cunningham inhabited, "multiple possibilities" had to give way to the exigencies of *theatre*—such as the frontal orientation of the proscenium stage (which privileges one position over another); the pull of narrative and drama on the temporal unfolding of no matter "what follows what"; the human situations that inevitably emerge when human beings come into contact; and, last but not least, the constellating force of movement itself, the way in which movement (as opposed to sound) contains incipient culturally and anatomically conditioned vectors of energy that form the patterns Cunningham saw, the symmetries, reversals, variations, and repetitions we still see, the very relations we call choreography and that make choreography, like life, an art.

Coda

Three years before Cage died, he finally changed his mind about the peculiar form of relation that, he believed, shuts down possibilities and obstructs freedom, namely, harmony. His gripe with harmony had always been the way it prescribes intervals (and chord progressions), how it *fixes* relations among what he thought should be free and independent sounds. In a late performance sound piece of 1989, *How to Get Started*, Cage shares with his audience an account of how

his approach to harmony had recently changed.[87] *How to Get Started* is an "improvisation"—Cage's word—insofar as it involves organizing by chance, at the moment of performance, the order of ten separate story ideas, each one written on a card. As Cage elaborates on his story idea, his improvisation is recorded by sound engineers, who immediately superimpose the first story on the next until all ten stories are being read—one live, the others recorded—at the same time. Each story possesses its own coherence, like the stories of *Indeterminacy* (1959). But in *How to Get Started*, Cage as he reads also pauses to hear—and to share with the audience—the unexpected juxtapositions that occur *among* the stories. That is, he creates an interval during which relations (among stories) can emerge.

At one point, Cage refers to his *Sculptures Musicales* (1989), a work inspired by Marcel Duchamp's idea for a composition of the same name, and notes how the simultaneous performance of two sounds necessarily installs a relation between them. Once there are two sounds, he observes, a kind of volume is created, a musical sculpture engendering a three-dimensional sonic space. He then recalls his experience way back in 1950 in the anechoic chamber of Harvard University, the original scene, if you will, from which his successive experiments with silence and ambient sound would flow. Even in this womb-like chamber, Cage finds that he cannot hear one sound alone. Not only is there always sound—and thus never complete silence—but there are always *two* sounds: the beating of the heart and the hum of the nervous system. These superimposed sounds reflect the volume of his own body. They signify his embodiment, the innate "harmony" of his being.

"Harmony," he concludes in what turns out (unintentionally?) to be the last story he recounts, has always been "a long-standing problem for me." Now, though, he is "having a changed feeling about harmony." Despite what Arnold Schoenberg said so many years ago—that Cage would never be a composer because he had no ear for harmony—the composer insists, "I *have* a feeling for it." In fact, he goes on, "I love it just as much as all my life I've loved no harmony at all. What [harmony] is is an attitude toward togetherness of sound that is not legal, not theoretical . . . the thing I don't like and have never liked about harmony is its theory of telling us what's right and what's wrong, . . . Each piece," he concludes, "has, so to speak, its own harmony."[88]

Here, in what might well be his last statement on the matter, Cage distinguishes a conventional theory of harmony from a more circumstantial one. Harmony as conventionally understood is a system that enforces rules: certain fixed relations among notes are "legal" and others are not. Yet there also exists an alternative vision of harmony, a "togetherness of sound" that is not "legal" or "theoretical" (and thus neither generalizable nor prescriptive) but rather embodied, unique to "each piece," unique to each space in which it is performed. If there is a harmony for each constellation of sounds, then, by extension, there is a har-

mony for each constellation of individuals too. Explicitly, of course, Cage is talking about his (new) approach to harmony in music. Implicitly, he is offering an alternative view of sociality, a vision of the arrangements and thus the relations that human beings, once brought together, inevitably form. Each piece establishes its own tonal, visual, and kinetic universe in which we feel the pull of certain arrangements and lend them the quality of necessity in the context they shape. Here, we find a vision *not* of an entirely open musical (or social) universe, one in which all encounters and all connections remain within reach. (There is no limitless non-obstruction, just as there is no limitless interpenetration, once the die is cast.) Instead, Cage suggests something much closer to what Cunningham proposes in the workshops we have been studying: that an unpredictable situation will *imply* rather than impose a relation, and that relation itself is inevitable—even if "tragedy" is not.[89] The question he raises repeatedly in his workshops is *what plots* the dance movements, sequential or combined, will "indicate": "What is 'physical' human relationship," he asks himself in 1974, "and what does it indicate beyond the [pleasurable or painful] fact of physical contact?"[90] Time and again he requires his students to spin plots out of chance encounters, to reach "beyond" an accidental physical contact for a drama they can unfold.

Yet if Cage waited until the end of his career to conclude that merely combining sounds will generate a relation among them (and thus the physical sound cannot remain "in itself"), in contrast, Cunningham was always aware that dancers together on a stage are likely to suggest a relation, the bare bones of a plot. Further, he knew that even a solo dancer may convey the drama that such relations evoke. As stripped down as a dancer's vocabulary might be, each movement is still capable of resonating with a *gestural* quality, a contingent momentum that carries that dancer forward in space and time—not toward anyone or anywhere, but rather in the direction that an individual impulse outlines in its course. "Gesture *is* evocative,"[91] Cunningham reminds us: "It is gesture that brings the space into focus, that brings the spectator there," he writes in "A Method of Making Dances."[92]

Thus, while each movement takes place within an arbitrary framework, the relation born of *that* movement in *that* framework definitively alters and affects the dance, lending it a meaning we can detect. It is true that Cunningham was relentless in his attempt to disrupt preconceived meanings and trajectories, to increase the flexibility of the dancer while augmenting what an audience would accept as (meaningful) dance. The technique he developed over the course of his career aimed specifically to extend a dancer's way of enchaining movements, making it possible for him to break the rules established by the release techniques so essential to the modern dance training of his time.[93] In seeking to break these connections, however, Cunningham was not rejecting relation per se, just as Cage was not rejecting harmony per se. Instead, both artists were choosing to define

relations and harmonies as contingent and fluid, not based on rigid laws. What Cunningham in particular demonstrated is that relation, and even drama, could depend on the specific persons and places involved. Focusing on the individual performers (rather than the individual sounds) he had before him, Cunningham recognized that this evocative, gestural quality of movement, while limiting in one sense, is also a powerful tool he could exploit. He thus contradicted his own stated goals by *accentuating* the gestural qualities in the movements randomly combined—to bring "space into focus," to bring "the spectator there."

A final anecdote: While reconstructing *Summerspace* on the dancers of the New York City Ballet in 1966, Cunningham realized how dependent the piece was on the ability of the dancers to establish relations among themselves. In one of those rare moments when he speaks candidly about his actual dramaturgical practice, he recalls, "I asked them to look *at people*, not 'stage right.'"[94] Without telling the dancers *what* to emote, he provided a concrete physical direction that would *make* them emote. In effect, he prevented the dancers from executing the movements mechanically by substituting a human being for a written coordinate on an impersonal map. Ultimately, he wanted them to use the gaze not simply to orient themselves in space *but also to make a connection*. He thereby invited the dancers to remotivate a sequence that had been produced by arbitrary means: "4 to 2, fast air, three persons, together."[95] Faithful to a deeper impulse, Cunningham chose to engage in a dramaturgical process that encouraged the development of the very connections his choreographic process aimed to break. After the arbitrary, he remade a world.

Acknowledgments

I grew up in a building known as the Westbeth Artist Housing, which also happens to be the place where the Merce Cunningham Dance Studio was located from 1970 to 2012. My mother and I lived on the third floor; Merce Cunningham worked on the eleventh, occupying a space that had formerly been a sound studio for Bell Laboratories. The first person I have to thank, then, is my mother, Dorothy Noland, who moved us into the Westbeth Artist Housing in the fall of 1969. The impetus for writing this book came, in part, from my need to be near her during a period when she was unwell. She not only gave me a home in New York but was also instrumental in facilitating my research. However, on October 31, 2013, she passed away. I had just begun to plow through the large archive of materials housed first on the second floor of Westbeth, then at the Performing Arts Division of the New York Public Library. I still needed to spend a good deal more time in the city, but suddenly I had no place to stay.

This book could not have been written without the extraordinary generosity of my mother's friends. Dody Epstein, Donna Kelsh, and Jackie Lee all stepped in to provide me with bed and board. Friends from Westbeth also offered to put me up: Stephanie Wales, Sandra Kingsbury—I am so grateful to you both. And I don't think I can ever thank Lisa and Mark Shufro enough. Their home in Brooklyn became my second home.

During this difficult time, I also received encouragement and affection from friends in Vermont, Michèle Ratté, Eric Shenholm, and Irene Kacandes; from colleagues in the dance world, Sally Ann Ness and Mark Franko; from my cousin, Joel Saxe; and from my pals back at home, Kathy Ragsdale, Michael Fuller, Joe McKenna, Susan Klein, and Victoria Bernal. But friends and neighbors were not the only people to offer generous support. Administrators and former dancers from the Merce Cunningham Dance Company were remarkably forthcoming and helpful from the start. The first time I knocked on the door of the Cunning-

ham archive at Westbeth, David Vaughan welcomed me in. Up until a few weeks before his death on October 17, 2017, he was still briskly replying to my emails, sharing as much as he possibly could. Patricia Lent, the company's Director of Licensing, accorded me a crucial interview in 2011; Nancy Dalva, its Resident Scholar, met with me multiple times, extending her trust and friendship; Carolyn Brown, Marianne Simon, Yvonne Rainer, Bill T. Jones, Robert Swinston, Jeff Slayton, Timothy Ward, Neil Greenberg, Kristy Santimyer-Melita, Meg Harper, Victoria Finlayson, Ellen Cornfield, and Alastair Macaulay all agreed to be interviewed and gave me their valuable time. Executive Directors Lynn Wichern and Ken Tabachnik always said yes, and Kevin Carr and Keary Champi, their assistants, responded rapidly and with good humor to the mountain of requests I made over the course of seven years.

There were several moments during those years when I thought that some kind of divinity of chance was at work. For instance, when phoning the Merce Cunningham Trust for a routine query, I happened upon Jennifer Goggans, one of Cunningham's most spectacular dancers and now Education and Curriculum Development Director for the Trust. After just a brief conversation, Jennifer allowed me to observe two reconstructions: one for the Merce Cunningham Trust Fellowship Workshops production of *Crises* in 2014, and one with the repertory company of the Opéra de Lyon, its production of *Winterbranch* in 2015. I am grateful to all the dancers in those two productions who replied thoughtfully to my questions. As a result of attending the full schedule of rehearsals, I became more familiar with these dances and grew to understand better what the Cunningham technique is and does. I had taken several classes at the Westbeth studio while in high school, an experience that gave me a certain understanding from within; but watching Jennifer teach the dances allowed me to observe Cunningham's attention to detail and made me recognize the great extent to which the look and tone of a dance can be affected by the addition of music, costumes, and lighting.

The second person to whom I owe boundless gratitude is Alla Kovgan, the director of a forthcoming 3-D film on Merce Cunningham. I simply could not have finished my research on this book without Alla's help. She—and Kate Markoski, whose secret contribution was invaluable—gave me the keys to the kingdom. Every conversation I had with Alla was generative and invigorating. Jennifer and Alla taught me that joyful sharing among professionals is indeed possible. Doubtless, I will never know Cunningham's choreography as intimately as they do, and so I apologize to them (and to all former members of the company) in advance for any inaccuracies my book may contain.

Many others helped me complete my research. At the New York Public Library, I was assisted by Tanisha Jones and Thomas Lisanti; at the John Cage Archives in Red Hook, New York, Laura Kuhn was welcoming and informative; at Jacob's Pillow in Becket, Massachusetts, Norton Owen shared hot cocoa with

me on cold days and saw to it that every video, every program, and every last bit of Cunningham lore was made available to me. A host of other librarians at too many institutions to name responded to my requests and went the extra mile to unearth rare documents for my perusal. I thank them all for their time.

In 2014, I was fortunate to receive a Clark-Oakley Humanities Fellowship and spent a wonderful year in Williamstown, Massachusetts, writing first drafts. I am grateful for assistance, advice, and camaraderie from Parul Mukerji, Prita Meier, Thomas Crow, Darby English, David Breslin, Jacobé Huet, Michael Ann Holly, and Karen Bucky at the Clark Institute; Leyla Rouhi and Krista Birch at the Oakley Center; and Kathryn Kent, Erica Dankmeyer, Kashia Pieprzak, and Amy Holpzapfel at Williams College. (A special shout-out to Amy, who read and commented helpfully on one chapter—thank you!) All these vital contacts would have been impossible without the generous support of the Clark-Oakley Humanities Fellowship and a fellowship from the John Simon Guggenheim Foundation, which I also received in the spring of 2014.

Many other friends and colleagues contributed to the development of my ideas. An independent study with Olivia Gunn was a delightful way to begin my research; also rewarding was an invitation from my colleague Simon Penny to present in his seminar. A weeklong residency as a guest faculty member at Stanford University brought me into fruitful contact with dance scholars from all over the country. I am grateful to Janice Ross, Susan Manning, and Rebecca Schneider for inviting me, and to Lucille Toth and Rebecca Chaleff for continuing the conversation. In France, where I spent two years directing the University of California Education Abroad Program, I was lucky to find myself surrounded by excellent colleagues in dance and performance studies. Paule Gioffredi, Julie Sermon, and Clauda Palazzolo at the University of Lyon 2, Gretchen Schiller at the University of Grenoble, Isabelle Launay at the University of Paris, St. Denis, and Barbara Formis at the Panthéon Sorbonne all invited me to participate in colloquia and share my work. I learned a tremendous amount from their scholarship and will always treasure their friendship.

In addition, I would like to express my gratitude to Gail Hart and David Pan, my former and current chairs in the Department of European Languages and Studies at the University of California, Irvine, and to the former Dean of Humanities Georges Van Den Abbeele. These colleagues created an intellectual environment in which I could transition smoothly from being a scholar of literature to a scholar of dance. Few universities, I suspect, would reward such an unexpected evolution. The UC Irvine Humanities Commons awarded me a publication grant that subsidized the beautiful reproductions found in this book. Suzanne Bolding and Dante Masci worked as research assistants on the ground, locating articles for me in UCI's library when I was in France. In short, individuals and institutions alike were unfailingly helpful. Moreover, my editor at the University of Chicago Press, Susan Bielstein, and her assistant, James Toftness, couldn't

have been more professional, accommodating, and enthusiastic. I am grateful, too, for Sandra Hazel's careful copyediting and sound advice.

Finally, I would like to acknowledge my debt to the many insightful critics and scholars who have written on Cunningham's work over the years. Edwin Denby, Alexander Bland (Nigel Gosling and Amanda Lloyd), Arlene Croce, Deborah Jowitt, Jill Johnstone, Roger Copeland, Alastair Macaulay, Nancy Dalva, Susan Leigh Foster, Dee Reynolds, Gay Morris, Suzanne Huschka, Julie Perrin, and Isabelle Launay have immeasurably enriched our experience and our understanding of his choreography. Further, I am mindful that a host of dynamic young scholars are currently conducting research on Cunningham that will provide new insights—Daniel Callahan, Abigail Sebaly, Noémie Solomon, Rebecca Chaleff, and Hannah Yohalem, to name just a few. There are many ways to approach Cunningham's repertory; I could cover only a few subjects, and so I am glad that other scholars are entering the field. One reviewer of my manuscript asked me to include a chapter on the Event, which was impossible given the length of the book. I direct interested readers to Douglas Crimp's nuanced reviews of recent Events and look forward to reading Claire Bishop's forthcoming article on the same topic. We are a community—not exactly touring together in a VW van, but inspired by those who once did.

In closing, I dedicate this book to my family—my husband, Christopher Beach, and my children, Julian and Francesca, as well as my new daughter-in-law, Courtney. We all remember my mother with affection, sorrow, gratitude, and love.

An earlier, and shorter, version of chapter 3 appeared as "Merce Cunningham: Corps à corps avec l'écrit, or, The Body in/and Writing," *Revue française d'études américaines* 153, no. 4 (2017): 79–97. Reproduced by permission of Association Française d'Études Américaines. An earlier version of chapter 5 appeared as "*Bound and Unbound*: Reconstructing Merce Cunningham's *Crises* (1960)," in *The Oxford Handbook of Dance and Reenactment*, edited by Mark Franko (London: Oxford University Press, 2018), 101–42. Reproduced by permission of Oxford University Press, https://global.oup.com/academic/product/the-oxford-handbook -of-dance-and-reenactment-9780199314201?cc=gb&lang=en&.

Notes

Introduction

(1) Merce Cunningham, "Notes for a Lecture-Demonstration at the Henry Street Play-house, Manhattan, April 27, 1957" (typescript; *MGZMD 351, folder 1957, Lecture Notes 1952–1972, Jerome Robbins Collection, Performing Arts Division, New York Public Library). A partial version of this text is cited in Vaughan, *Merce Cunningham: Fifty Years*, 97. All subsequent references to this volume will appear as Vaughan.

(2) On Cunningham's "posthumanism," see Portanova, *Moving without a Body*; on his aesthetics of indifference, see Roth and Katz, *Difference/Indifference*; on his abstraction and disarticulation of the human body, see Foster, *Reading Dancing*.

(3) On "relationality," see Bourriaud in *Esthétique relationnelle*. Here, the term refers to works of art that model alternative (noncapitalist) social relations. My use of the term resonates in important ways with Bourriaud's, but I am not suggesting that Cunningham consistently sets up works (or Events) that model social relations in a literal man-ner. Bourriaud focuses on works that engage the audience (or spectator) via encoun-ters—or in Marcel Duchamp's vocabulary, "rendez-vous"—that amplify the role of spectatorship. The "rencontre aléatoire" of interest to Bourriaud (22) is largely between audience and artwork, whereas I am referring for the most part to encounters that occur among dancers on the stage. Another way of thinking about "relations" in choreography would be through Erin Manning's writings inspired by Gilles Deleuze and Albert North Whitehead; see Manning, *Relationscapes*. My interest in this book is in Merce Cunningham's own way of conceiving and describing how movement implies relation, even when subjected to a chance procedure.

(4) Cunningham, *MGZMD 295, box 14, Choreographic Records, Jerome Robbins Collec-tion, Performing Arts Division, New York Public Library.

(5) Other variables were determined by what Cunningham called "the necessary relation-ships" that emerged as a result of "throws" (of dice or coins). "The timing," he wrote, "cannot help but be influenced by the necessary relationships which occur through-out!!!" (Cunningham, box 14, Choreographic Records.)

(6) According to Victoria Finlayson, who danced in the original production, he neither

encouraged nor discouraged the tensions but was "certainly not averse" to using them to "add to the drama" of the dance. Telephone interview with the author, March 2, 2019.

(7) There are some recent exceptions to this rule; see, for instance, Perrin, *Figures de l'attention*; and Sebaly, "Between Performance and the Present." See also later reviews by Marcia Siegel, Arlene Croce, and Deborah Jowitt, as well as Callahan, "The Dancer from the Music." Alastair Macaulay, the dance reviewer for the *New York Times*, is particularly sensitive to Cunningham's theatricality. Valda Setterfield, who danced for Cunningham in 1961 and from 1965 through 1975, has stated that he gave her "the most extraordinary understanding of stagecraft." See Vaughan, "Cunningham and His Dancers," 31.

(8) Alla Kovgan, a New York–based filmmaker, has scoured the archives of television stations in Europe in an attempt to recover footage. Recently she has discovered a recording made by a Hamburg TV station of *Changeling* (1957) and excerpts from *Springweather and People* (1955): see Sheets, "Long-Lost Merce Cunningham Work Is Reconstructed in Boston."

(9) The term *continuity* is one of two terms central to Cunningham's practice; the other is *gamut*. Cage introduces both in "Experimental Music: Doctrine" of 1955. See his *Silence*, 17 and 16.

(10) On the "unconnected" nature of his choreography, see Cunningham, *Changes*.

(11) Agamben, "Notes on Gesture," 57.

(12) Cunningham, "The Impermanent Art (1952)," 86; original emphasis. The term *arbitrary* in my subtitle, "After the Arbitrary," is meant as a synonym for *random*; both words refer to that which is unintentional, not governed by a method or a conscious decision (or by "my will," as Cunningham puts it). My use of the term *arbitrary* is also meant to highlight the opposition, well established in semiotics, between the "motivated" sign and the "arbitrary" sign. A motivated sign is one that bears some relation to what it signifies; an arbitrary sign is one that functions by convention alone. I am interested in this book in the moments of selection during the choreographic process when Cunningham *re-motivated* his materials, that is, when he took the results of the chance operation and changed them slightly in order to accommodate an emotive or aesthetic intention. Few commentators have been attentive to these acts of selection that occurred *after* the chance process. I take to heart, then, the observations of his dancers, for they have proved to be most alert to these moments of intentional craftsmanship. See, for instance, Valda Setterfield's comments in Vaughan, "Cunningham and His Dancers": "It is my impression that if for one reason or another he didn't like what was there, he used his savvy, as Steve [Paxton] said, to make something conform more to what he wanted to have happen" (24).

(13) Cage, "45′ for a Speaker" (1954), 174; "Theater is all the various things going on at the same time" (149).

(14) Cunningham, "A Method of Making Dances," Lecture-Demonstration at the Roslyn Arts Center, Long Island, April 17, 1957 (unpublished manuscript, typescript; *MGZMD 351, Lecture Notes 1952–1972, Jerome Robbins Collection, Performing Arts Division, New York Public Library); added emphasis.

(15) See Duchamp, "The Bride's Veil," 32.

(16) Vaughan, 107. My interpretation is based on viewing the 1964 version of *Antic Meet* filmed for Swedish television by Arne Arnbom; *Concert for Piano and Orchestra*, by John Cage; set by Robert Rauschenberg; dancers: Merce Cunningham (not in "Social"), Carolyn Brown, Viola Farber, Barbara Lloyd, Sandra Neels, and Steve Paxton. The film can be found at https://dancecapsules.mercecunningham.org (accessed January 29, 2019).

(17) Vaughan, 105. The cocktail party atmosphere of "Social" is also satirical, a send-up of the aesthetics of indifference. The impersonality of the cocktail party is not the impersonality Cunningham is seeking to evoke. Normally, when people encounter each other in his choreography they interact, whereas in "Social" they merely bump into each other, maintaining an implacable indifference that becomes comical.

(18) See Copeland, *Merce Cunningham*.

(19) Lesschaeve and Cunningham, *The Dancer and the Dance*: "More than dancing . . . it was the idea of being on stage, in a theater, that fascinated me" (33). All subsequent references to this volume will be indicated as Lesschaeve.

(20) On Rauschenberg, see Crow, *The Long March of Pop*: "no condition of true randomness can ever be sustained, regularities begin to appear" (72); "it is a persistent tendency of art composed from inventories of fragmentary elements to organize itself into larger chains or networks of allegorical meaning" (233).

(21) Cunningham, quoted in Vaughan, 128; added emphasis.

(22) Rainer, "No Manifesto."

(23) Jill Johnston famously claimed in a *Village Voice* article of 1963 that "his dances are all about movement, and what you see in them that relates to your common experience is your own business and not his" (Johnston, "Cunningham and Limón," 33).

(24) Maude Barrett herself spent many years on the vaudeville stage, and Cunningham accompanied her and her daughter on a vaudeville tour. See Vaughan, 12–15. Don McDonagh is one of the few critics to have remarked on the impact of Cunningham's early theatre experience on his later work: "In other ways, he retained the conventions of the theatrical world in which he was brought up" (McDonagh, "New Concerns and New Forms," 37).

(25) See "Tracing Creativity," Gretchen Schiller's essay on the flamenco foot in the dance of Germana Civera; and Taylor, *The Archive and the Repertoire*.

(26) Johnston, "Two Reviews," 35. In 1989, Anna Kisselgoff also found that "one movement is equivalent to another. If we think we discern meaning in Mr. Cunningham's choreography, that is because we have attached interpretations to what we see" ("Dissociation in Merce Cunningham's Premiere," 17). On the Clement Greenberg generation that produced such views (it's all about the material), see C. Jones, *Eyesight Alone*.

(27) Barnes, "A Dance Is a Journey but . . ." In a similar vein, see Banes, "Nouvelle danse New Yorkaise"; and Carroll, "The Return of the Repressed."

(28) Foster, *Choreographing Empathy*, 64.

(29) Febvre, *Danse contemporaine et théâtralité*, 21. "The return of theatricality to contemporary dance," she concludes, "is the return of what Cunningham repressed" (28); my translation.

(30) Louppe, *Poétique de la danse contemporaine*, 32, 142, 117; added emphasis, and my translation.

(31) Puchner, *Stage Fright*, 3. Cage and, more ambivalently, Cunningham were part of the generation of modernist dramatists—from Mallarmé to T. S. Eliot and Stein—who defined themselves as "against theatre," "theatre" understood here as a cult of personality, the mimesis of realist plots and stereotypes.

(32) Cunningham, "Excerpts from Lecture-Demonstration Given at Ann Halprin's Dance Deck (July 13, 1957)," 100; added emphasis.

(33) Cunningham, "The Impermanent Art (1952)," 86; my emphasis.

(34) In "45′ for a Speaker," Cage writes, "Harmony, so-called, / is a forced abstract vertical relation which blots out the spontaneous / transmitting nature of each of the sounds forced into it" (152).

(35) Cage and Charles, *For the Birds*, 92.

(36) Cunningham, "The Impermanent Art (1952)," 87.

(37) There is a political or antiestablishment aspect to Cunningham's critique of conventional relations. His target was not only conventional relations between movements but also traditional relations between people, as is made manifest in the script of his 1944 play titled *Four Walls*. Here, the parents of a nuclear family struggle with the rebelliousness of a daughter, "Girl," who refuses to enter a loveless marriage. Against the coaxing of her suitor—"Now darling, we have problems to arrange, and even dates to forecast"—Girl responds simply, "But not relationship to question?" See Cunningham, unpublished manuscript of *Four Walls* (1944). I thank David Vaughan for sharing his copy of this manuscript with me.

(38) Cunningham, "The Impermanent Art (1952)," 86.

(39) I will return to the question of what it means to be affected in chapter 7.

(40) Cunningham, notes for a "Workshop in Flexibility," July 5, 1974 (typescript; *MGZMD 95, box 30, Lecture Notes 1972–1986, Jerome Robbins Collection, Performing Arts Division, New York Public Library).

(41) For a longer meditation on the relation of gesture to meaning in Cunningham's works, especially *Winterbranch* of 1964, see Noland, "Ethics, Staged."

(42) On Duchamp's negative attitude toward "taste," see Cabanne, *Dialogues with Marcel Duchamp*, 48: "Cabanne: What is taste for you? Duchamp: A habit. The repetition of something already accepted."

(43) See the interview with Cage in Raynal (dir.) and Becker and O'Wyers (cinematography), *Image et technique: Merce Cunningham* (documentary video, 27 min.; sound, black and white, filmed June 1964; *MGZIDF4441, Merce Cunningham Dance Foundation Collection, Performing Arts Division, New York Public Library).

(44) Moten, *In the Break*. I explore the concept of "inter(in)animation" in chapter 2.

(45) See Cunningham, notes for a "Workshop in Flexibility."

(46) Kirby and Schechner, "An Interview with John Cage," 60.

Chapter One

(1) On Cunningham and recycling, see Launay, *Poétiques et politiques des répertoires*.

(2) On Cage's misunderstanding of improvisation, and particularly jazz improvisation, see Lewis, *A Power Stronger Than Itself*, 129–31. For an alternative version, see Cage and Charles, *For the Birds*, 171–72; and Kostelanetz, *Conversing with Cage*, 225.

(3) Cage, "Composition as Process: II. Indeterminacy," 35.

(4) Cunningham did create a few more works containing indeterminate elements, such as *Story* (1963), *TV Rerun* (1972); *Changing Steps* (1973), and *Rondo* (1996).

(5) Dee Reynolds notes, "It's very remarkable and many people have commented on this—that although . . . the sequence is random and although it is chance, when you see it, you get a tremendous sense of inevitability, in fact more than with something that's more conventionally structured, because there it looks contrived" (Reynolds, "The Possibility of Variety," 38–43).

(6) See Cabanne, *Dialogues with Marcel Duchamp*, 48.

(7) On the category of the *work* in dance, see Pouillaude, *Le désoeuvrement chorégraphique*.

(8) One important exception is Franko, "The Readymade as Movement." See also Tomkins, "An Appetite for Motion," 239–96; and Basualdo and Battle, *Dancing around the Bride*. See also Rosenberg, "The Bride Is Dance," in *Screendance*, 93–109.

(9) For instance, when teaching *Summerspace* (1958), he taught the phrases separately to each dancer in order to underscore their separateness, their autonomy with respect to each other. See chapter 2.

(10) See Duchamp, "The Bride's Veil," 31. Duchamp speaks of "canning chance" [*du hasard en conserve*] in reference to *3 Standard Stoppages* (1914).

(11) See Bonk, *Marcel Duchamp: The Box in a Valise*, 9. See also Naumann, "Marcel Duchamp: A Reconciliation of Opposites," 42.

(12) For an analysis of the difference between the two versions, see Troche, *Le hasard comme méthode*, 301–2.

(13) Duchamp, "The Bride's Veil," 33.

(14) Duchamp, 33. *The Green Box* appeared in English in 1957.

(15) *Unhappy Readymade* was made by the artist's sister, Suzanne Duchamp, after instructions Duchamp supplied in a letter. Duchamp might have been inspired by Stéphane Mallarmé's suggestion that a book be left out in the breeze to have its pages flipped open by chance; see "Le livre, instrument spirituel," 378. Duchamp made portions of the *Large Glass* by subjecting the placement and shape of figures to chance: the three panes of the Bride's halo copy the shape of a curtain hung in an open window as the air blows it about; the nine holes on the upper right-hand panel mark the spot where thrown matches soaked in paint hit the glass. For a discussion of these procedures, see Moldering, *Duchamp and the Aesthetics of Chance*.

(16) Janis and Janis, "Marcel Duchamp, Anti-Artist," 38.

(17) See Vaughan, "'Then I Thought about Marcel . . .'"; Franko, "The Readymade as Movement"; Carroll and Banes, "Cunningham and Duchamp"; and Copeland, *Merce Cunningham*.

(18) On Cunningham's "clothes race," see Basualdo, "Blossoming of the Bride," 153. As Basualdo points out, many commentators have found "further narrative content" in *Walkaround Time*; see, for instance, Mueller, "Merce Cunningham's *Walkaround Time*"; Vaughan, "Then I Thought about Marcel . . .'"; Franklin, "Merce on Marcel"; and Noland, "Inheriting the Avant-Garde."

(19) See Vaughan, "'Then I Thought about Marcel . . . ,'" 66–70.

(20) See Jasper Johns's account as related to Macaulay's in "Cunningham and Johns."

(21) Duchamp, *Notes and Projects for the "Large Glass,"* 18.

(22) Macaulay, "Cunningham and Johns."

(23) On Duchamp's recycling of motifs, see Schwarz, *Marcel Duchamp*, n.p. The first appearance of the *Chocolate Grinder* was in 1911; Duchamp's "first mechanomorphic painting," *Coffee Mill*, was also completed in 1911. See also Moldering, *Duchamp and the Aesthetics of Chance*. It could be that Cunningham, too, was working from the line drawings Johns saw; Paul B. Franklin claims that Cunningham "only saw the *Large Glass* in person after choreographing *Walkaround Time*." Franklin, "*Walkaround Time*," 37.

(24) A caveat: We cannot know the role that chance procedures played in the composition of *Walkaround Time*. Apparently, Cunningham kept notes, but they have not been found. Last report from Laura Kuhn: "David Vaughan, archivist for the Cunningham Dance Foundation, kindly searched Cunningham's choreographic archive for notes related to *Walkaround Time* but did not locate any" (Kuhn, interviewed along with Merce Cunningham by Paul B. Franklin in "Merce on Marcel," in Basualdo and Battle, *Dancing around the Bride*, 284). The New York Public Library collection has notebook pages on the filming of *Walkaround Time* but not the original notes.

(25) For Duchamp's fascination with the fourth dimension, see Henderson, *Duchamp in Context*; and Adcock, "Conventionalism in Henri Poincaré and Marcel Duchamp."

(26) In an interview with the author December 14, 2018, Meg Harper, who danced in the original production of *Walkaround Time* (and in Charles Atlas's 1973 film version), claimed that the second half of the dance mirrors in reverse the first half (December 14, 2018; New York City). George Baker's description of *Relâche* indicates that the ballet also reversed the order of the first act in the second act; see Baker, *The Artwork Caught by the Tail*, 300.

(27) In his notes, Duchamp often represents *The Large Glass* as the depiction of "her intense desire for the orgasm," in other words, the moment before the Bride's "fall" at the "apotheosis of virginity" (see Schwarz, *Marcel Duchamp*, 28, 32, 22).

(28) See Vaughan, "'Then I Thought about Marcel . . .'" Duchamp's first name for the readymade was "le tout fait, en série" (see Schwarz, *Marcel Duchamp*, 2).

(29) Duchamp, *The Salt Seller*, 32. It is unlikely, however, that Duchamp himself selected his readymades in this manner. See, for instance, his description of *Bicycle Wheel* (1913) in Cabanne, *Dialogues with Marcel Duchamp*: "The word 'readymade' did not appear until 1915, when I went to the United States. It was an interesting word, but when I put a bicycle wheel on a stool, the fork down, there was no idea of a 'readymade,' or anything else. It was just a distraction. I didn't have any special reason to do it, or any intention of showing it, or describing anything. . . . In 1914, I did the 'Bottle Rack.' I just bought it, at the bazaar of the town hall. The idea of an inscription came as I was doing it. There was an inscription on the bottle rack which I forget" (Duchamp, 47). Dalia Judovitz writes that the "only readymade with an explicit mention of time is *Comb* (*Peigne*, 1916). It is a gray steel dog comb that bears a French punning inscription on its edge, '*3 or 4 drops of height have nothing to do with savagery*' and a time indicator, 'FEB 17, 1916 11 A.M.' (lower left) and 'M.D.' (lower right)" (Judovitz, "Duchamp's Engineering of Time").

(30) Duchamp, "Apropos of 'Readymades'" (1961): "A point which I want very much to establish is that the choice of these 'readymades' was never dictated by esthetic delec-

tations. This choice was based on a reaction of visual indifference" (141). The categories of the "readymade aided" and the "reciprocal readymade" enlarged the scope, allowing him to include works of art, such as the *Mona Lisa* (in *L.H.O.O.Q.*), which possess obvious visual interest.

(31) Franklin, "Merce on Marcel," in Basualdo and Battle, *Dancing around the Bride*, 263. Cunningham refers to *Relâche* and the "entr'acte with a movie in it" in Lesschaeve, 114. In *Chance and Circumstance*, Carolyn Brown recounts that "John and Merce" sent her off "to see René Clair's extraordinary film, *Entr'acte*" (233).

(32) See Baker, *The Artwork Caught by the Tail*.

(33) Franklin, "Merce on Marcel," in Basualdo and Battle, *Dancing around the Bride*, 263. Cunningham refers to *Relâche* and the "entr'acte with a movie in it" in Lesschaeve, 114.

(34) After the slow-motion sequence, the hearse enters the countryside, at which point the coffin falls off and lands in an open field. The coffin opens to reveal the hunter, miraculously returned to life. In *Drawing on Art*, Dalia Judovitz argues that in the burial and resuscitation scene of *Entr'acte*, the filmmakers are explicitly alluding to the battles that were taking place between two wings of the interwar avant-garde. See also Peterson, "Paris Dada."

(35) On Duchamp and Étienne-Jules Marey, see Rowell, "Kupka, Duchamp, and Marey." For the difference between Duchamp's approach to movement and that of the futurists, see de Duve, *Pictorial Nominalism*.

(36) I use the term *ghosting* here to indicate a relation of what I will call "inter(in)animation" in chapter 2. The term designates a scene of mimesis in which something from the past comes to inhabit something in the present that is thereby transformed into a ghost.

(37) *Walkaround Time*, which had long been out of the repertory, was reconstructed in April of 2017 at the Opéra National de Paris. Charles Atlas's film version of *Walkaround Time* from 1973 (40 min.) can be accessed at mercecunningham.org.

(38) Meg Harper has called the staccato movements of her duet with Douglas Dunn "a little bit robotic." She notes that the phrase in which they appear is repeated three times. According to Harper, Cunningham frequently repeated phrases three times, believing that it took that many repetitions for the eye of the spectator to register clearly the movements involved. The duet was the first that Cunningham made for Harper; she joined the company in 1968 when he was choreographing the dance. Harper, interview with the author, December 14, 2018.

(39) Étienne-Jules Marey's chronophotographic series also contained sequences based on the galloping of a horse. Since Douglas Dunn executes some foot movements that resemble a horse's pawing of the ground, it is entirely possible that Cunningham was taking some of his inspiration from Duchamp's inspiration.

(40) This is not true, we should note, of the "assisted readymade," such as *L.H.O.O.Q.* (1919), or the "reciprocal readymade"—"Use a Rembrandt as an ironing board" (Duchamp, "The Bride's Veil," 13–101).

(41) This view has, of course, been contested. See Perloff, "Marcel Duchamp's Conceptual Poetics."

(42) Duchamp: "You have to approach something with an indifference, as if you had no aesthetic emotion. The choice of readymades is always based on visual indifference

and, at the same time, on the total absence of good or bad taste" (Cabanne, *Dialogues with Marcel Duchamp*, 48).

(43) We should note that the runners are all male and white and thus not neutral in some absolute sense.

(44) Johnston, "Modern Dance," 82. In *Changes*, Cunningham claims to have chosen dance movements for *Suite by Chance* (1953) as "unadorned" as possible (n.p.).

(45) The term "intentional arc" is Maurice Merleau-Ponty's, meaning the entire length of a series of intentional gestures leading to a goal (*The Phenomenology of Perception*, 157).

(46) The meaning of the artwork, according to a Duchampian perspective, would be accorded by the spectator: "Posterity is a form of the spectator" (Cabanne, *Dialogues with Marcel Duchamp*, 76).

(47) See Franko, "The Readymade as Movement," 218; and Franklin, "*Walkaround Time*," 48.

(48) See Troche, *Le hasard comme méthode*, on Breton versus Duchamp. See also Duchamp's interview with Tomkins, *Marcel Duchamp: The Afternoon Interviews*, in which he sounds surprisingly like Breton: with reference to *Erratum musical*, Duchamp states that it was a "real expression of the subconscious through chance. . . . And so an action like throwing dice to find the notes on a piece of music was nevertheless a subconscious expression of myself" (51).

(49) See A. Jones, *Postmodernism and the Engendering of Marcel Duchamp*; Krauss, *The Optical Unconscious*; and Adcock, "Duchamp's Eroticism."

(50) Cunningham, "The Impermanent Art (1952)," 86.

(51) Cédric Andrieux, in Bel, *Cédric Andrieux* (2000). Andrieux danced with the Merce Cunningham Dance Company from 1999 to 2007.

(52) See Scherer, *Le "Livre" de Mallarmé*.

(53) Mallarmé, "Le livre, instrument spirituel," 378.

(54) See Schneider on the interval in "In Our Hands."

(55) Cunningham, box 9, Choreographic Records.

Chapter Two

(1) Moten, *In the Break*, 71.

(2) Schneider, *Performing Remains*. The pertinent lines from Donne's "The Extasie" (1633): "When love with one another so / Interinanimates two souls / That abler soul, which thence doth flow / Defects of loneliness controls." The poem treats the body as a book in which God writes.

(3) Schneider, *Performing Remains*, 189.

(4) Troche, *Le hasard comme méthode*, 298; my translation. Troche observes that *erratum* is a term of trade in printing, a "faute d'impression" that presupposes a norm, a correct imprint. She speculates that Duchamp used *erratum* instead of the expected plural, *errata*, to underscore the link to the Latin verb, *errare*, to wonder or err (300, 306).

(5) Cage states this most succinctly during an interview recorded in a film by Jackie Raynal (dir.) and Etienne Becker and Patrice O'Wyers (cinematography) titled *Image et technique: Merce Cunningham* (documentary video, 27 min.; sound, black and white, filmed June 1964; *MGZIDF4441, Merce Cunningham Dance Foundation Collection, Performing Arts Division, New York Public Library).

(6) Louppe, "Imperfections on Paper," 6; Huschka, *Merce Cunningham und der moderne Tanz*, 381.

(7) See Silverman, *Begin Again*, 97.

(8) On the status of the work as a set of variants, see Pouillaude, *Le désœuvrement chorégraphique*. His observations illuminate Cage's practice, perhaps more than Cunningham's.

(9) Kotz, *Words to Be Looked At*, 48. See also Louppe, "On Notation." I am aware that *writing, inscription*, and *mark-making* are not fully synonymous; I use them here to denote the practice of leaving marks on paper that are legible, interpretable, within a conventional semiotic system.

(10) Johnston, "Merce Cunningham," 21.

(11) Simone Forti's *Dance Constructions* of the 1960s are being collected by the Museum of Modern Art in New York. Amanda Jane Graham's recent article on Trisha Brown suggests a turn in dance criticism toward a greater interest in documenting the paperwork informing the dance; see Graham, "Space Travel."

(12) Neither "The Function of a Technique for Dance" (1951) nor "Space, Time, and Dance" (1952) mention that at the time of their composition, Cunningham was beginning to employ chance procedures involving the *I Ching*.

(13) Hering, "Merce Cunningham and Dance Company," 69.

(14) Charlip, describing Cunningham's procedure, famously writes that "it is possible for anything to follow anything else" ("Composing by Chance,"19).

(15) A residue of this bias against inscription remains in the contemporary dissatisfaction with the term "choreo*graphy*" and the efforts to "free" dance from "the tyranny" of the grapheme. See Lepecki, *Exhausting Dance*; and Charmatz, "Manifesto for a Dancing Museum."

(16) Merce Cunningham in Vaughan, 240.

(17) My thanks to Laura Kuhn for allowing me to consult Cage's copy of *Finnegan's Wake*.

(18) See Johnston, "Cunningham and Limón" (quoting Cunningham): "I don't look in a book, I make a step."

(19) On the difference between Cage and Duchamp regarding conceptual art, see Troche, *Le hasard comme méthode*, and Noland, "(After) Conceptualism."

(20) See Cage, "Part of a Letter from Jackson Mac Low."

(21) See Rotman, *Becoming beside Ourselves*; Christin, *L'image écrite*; and Harris, *The Origin of Writing*.

(22) Goody, *The Domestication of the Savage Mind*, 81; original emphasis. Goody has been criticized by contemporary anthropologists for distinguishing too sharply between societies "with writing" and those "without" ("savage"). In *Lines: A Brief History*, Tim Ingold points out that the conception underlying inscriptive practices—that of making lines on a surface—extends beyond the act of inscription itself to inform how a wide spectrum of societies create paths or measure distances.

(23) Goody, *The Domestication of the Savage Mind*, 78.

(24) Goody, 84; added emphasis.

(25) Cage developed the idea of the "gamut" in the early 1950s. He compares the gamut to a "collection" (e.g., "as one chooses shells while walking") in "Composition as Process: I. Changes" (1958), 19.

(26) Cunningham: "In making a dance continuity, the procedure has been to discover how you feel or think one movement should follow another. What movement means in relation one to another. But now there's a different way of looking at continuity. In contemporary art and music, one of the major interests has been the separation of each element, one left distinct from the other and having no connection, other than that they exist in the same time and space" ("Excerpts from Lecture-Demonstration Given at Ann Halprin's Dance Deck [July 13, 1957]," 101).

(27) Cage, "Composition" (1952), 59.

(28) See Lesschaeve, 18: "One of the points that distinguishes my work from traditional choreographies, classical and modern, is certainly this enlargement of possibilities."

(29) For a seminal reflection on dance notation and movement, see Franko, *Dance as Text*. In a more contemporary context, Trisha Brown has investigated the possibilities of generating dances from inscriptive systems. Trained in part by Robert Dunn, one of Cage's students, Brown began in the early 1960s to generate dances from diagrams; see Graham, "Space Travel."

(30) Bernard, "Danse et Hasard," pp. 75-79; quotations are from p. 77; my translation.

(31) Nancy Dalva thinks that the positions taken in the photograph are from *Aeon* (1961); email communication with the author, May 7, 2018.

(32) Vaughan, 110.

(33) Vaughan, 112.

(34) Humphrey, *The Art of Making Dances*, 82.

(35) Humphrey, 80.

(36) Cunningham, "*Summerspace* Story," 52.

(37) The folders on *Summerspace* held at the New York Public Library (*MGZMD 295) contain at least four distinct sets of notes: undated notes; Margaret Jenkins's 1965 notation of the dance under Cunningham's supervision; notes dated 1987; and notes dated 1998. (The latter three are for reconstructions by various ballet companies or reprises by the Merce Cunningham Dance Company.) The notes I consider original to the composition of the dance appear in a folder marked "SS 1958" (box 14) and are fragile, chipping and browning at the edges. However, these notes do not bear a date, which is why they are cataloged as "undated."

(38) Cunningham, "*Summerspace* Story," 52.

(39) Cunningham, 54.

(40) Carolyn Brown stresses in her article on reconstructing *Summerspace* for ballet companies in 1998, 1999, and 2000 that the hardest thing for the ballet dancers to master was the rapid changes in pace; see Brown, "*Summerspace*."

(41) For a systematic examination of the score as used in composition, see Sermon, *Partition*.

(42) Darby English in conversation with the author at the Clark Art Institute, Williamstown, MA, March 4, 2015.

(43) The boxes around the numbers mean that those phrases are to be performed "alone," with no other dancers moving at the same time. When an oblong circle is drawn around two numbers, that means that the two phrases overlap or are performed at the same time.

(44) Lesschaeve, 72; added emphasis. The set of interviews were begun in 1977.

(45) This is the reason John Cage gives in his interview with Richard Kostelanetz for why chance operations couldn't be followed as strictly in dance as in music; see Kostelanetz, *Conversing with Cage*.

(46) The Charles Atlas film of a 2001 performance (21 min., 40 sec.) can be viewed at https://dancecapsules.mercecunningham.org (accessed January 29, 2019).

(47) Deborah Jowitt writes beautifully about Cunningham's treatment of human relationships in *Summerspace*. In *Time and the Dancing Image*, she notes that "the performers seem isolated from each other, bent on private errands. When they do come together, the encounters look almost accidental. Brown, leaping, with Cunningham running along in back of her, is repeatedly caught by him in midair, and eventually carried off-stage, but this is no climax of desire; it is a witty converging of two paths" (277–78); "Relationships between dancers may occur fugitively, but, although they may seem tender or playful or contentious, they are not fraught with evolving drama" (287).

(48) On the role of divination in the development of writing as a reading of space, see Christin, *L'image écrite*.

(49) By observing the development of dancers such as Andrea Weber, who joined the company in 2004, danced in ensemble works, then emerged as a principal soloist in reconstructions, we can see how the demands of Cunningham's technique actually change the way a dancer moves. We could claim that the dancer's body is "inter(in)animated" by the script it actualizes, just as the technologies that create the script must respond to the complexities of actualization, in a process that is as recursive as it is teleological.

(50) Cunningham, "Four Events That Have Led to Large Discoveries," 276.

(51) See Vaughan, 208. *Roadrunners* is a complex piece, involving the *I Ching* but also a series of sixty-four "figures" Cunningham viewed on the Greek vases he saw at "the antique Greek museum in West Berlin" (Lesschaeve, 154).

(52) See Schiphorst, "Making Dances with a Computer," 82. She notes that "computer technology is as much affected by the articulation of dance knowledge as dance and choreography is affected by the articulation of technological knowledge" (83) and provides a thorough account of how different versions of LifeForms responded to new challenges in motion capture, playback, and editing.

(53) Roger Copeland provides a chronology and analysis of Cunningham's progression from early to late methods of composition in "Cunningham, Collage and the Computer."

(54) See interview with Merce Cunningham included in the DVD of *Biped/Pond Way*, a recording by Charles Atlas of a 2005 performance released in 2006 by mk2 Films (DVD; 1 hr. 38 min.). See also Schiphorst, "Four Key Discoveries."

(55) Schiphorst, "LifeForms," 49. Schiphorst explains that for the early experiments with LifeForms, the motions of the avatar were pre-segmented into "keyframes, each [one] containing a body shape" (50).

(56) Dixon, *Digital Performance*, 188.

(57) Bernard, "Danse et Hasard," 77.

(58) Dixon, *Digital Performance*, 184.

(59) Copeland, "Cunningham, Collage, and the Computer," 52.

(60) Portanova, *Moving without a Body*, 116.

(61) Schiphorst, *Thecla Schiphorst and Merce Cunningham Talking about LifeForms*, film recorded at Simon Frasier University, 1992 (70 min.; *MGZIDVD 5-1377, Performing Arts Division, New York Public Library). See also Vaughan, "A Way of Looking."

(62) Laban identified four factors of effort and eight variations on those factors: space (direct or indirect); weight (strong or light); time (sudden or sustained); and flow (bound or free). Theoretically, all types of effort could be described through a combination of these variants, e.g., a lightly weighted, sustained, indirect free-flowing movement. For a full account, see Laban and Lawrence, *Effort*.

(63) Cunningham, *MGZMD 295, box 14, Choreographic Records.

(64) Portanova, *Moving without a Body*, 116; original emphasis.

(65) See interview with Merce Cunningham in Atlas, dir., *Biped/Pond Way* DVD. He also states here that LifeForms allowed him to "see what one is doing from a different angle": "If you can see yourself outside of yourself you can make additions."

(66) Cunningham, interview.

(67) Cunningham, "Four Key Discoveries," 111, 110.

(68) Copeland, *Merce Cunningham*, 35.

(69) Cunningham insisted that a dance cannot be discussed without considering the individual dancer: "You can give them the same movement and then see how each does it in relationship to himself, to his being, not as a dancer but as a person" (Lesschaeve, 65).

(70) Copeland, "Cunningham, Collage and the Computer," 42.

(71) Portanova, *Moving without a Body*, 115.

(72) Cunningham, "The Impermanent Art (1952)," 86.

(73) Cunningham, "Two Questions and Five Dances," 59.

(74) My analysis of *Biped* is based on Charles Atlas's film version of 2005 and my own viewing of the reconstruction at the Brooklyn Academy of Music on December 8, 2011.

(75) There is far more to say about *Biped*. At approximately twenty minutes into the dance, Cunningham introduces drama in a clearly intentional manner, choreographing the emergence of a duet seemingly out of nowhere. (The black curtain at the rear of the stage allows dancers to emerge suddenly, making visually striking formations under focused beams.) This duet begins with Caley lifting Ogan high in front of him so that the two merge into one elongated, more-than-human body. The periodic striping of the stage with light creates the impression of an undersea universe lit up by the rays of the sun. (The lighting is by Adam Copp.) The large dimensions of the avatar at times dwarf the dancers, making them seem like sea animals—an effect amplified by the iridescent costumes crafted by Suzanne Gallo. The musical score by Gavin Bryers, which is continuous, even melodic, sometimes breaks off for no reason, leaving the dancers in a loud silence until the music resumes. Interestingly, there is only one instance of floor work: during the last sequence, with all fourteen dancers on stage, Caley stretches out on the floor. Since LifeForms is essentially concerned with locomotion (the basic options, from the beginning, were walk, run, and hop), the prone figure executing floor work suggests an endpoint—a kind of human outside—to the avatar-assisted aesthetic.

Chapter Three

(1) Denby, "Merce Cunningham," 407.

(2) See Puchner, *Stage Fright*; and Barish, *The Antitheatrical Prejudice*. Like many in his generation, Cunningham rejected bourgeois theatre, but not theatre in general.

(3) On Cunningham as dramatic, see Siegel, who refers to his "latent dramatic qualities" in "Prince of Lightness"; Tomkins, who claims he had an "innate and nearly infallible sense of theater" (*The Bride and the Bachelors*, 265); and Johnston, "Cunningham in Connecticut."

(4) Vaughan, 15. Koiransky's name sometimes appears as Koriansky (in Vaughan). He was born in 1884 and died in 1968. He left Russia in 1919 and arrived in the United States in 1922 to teach décor and costume design at the American Laboratory Theater founded by Richard Boleslavsky and Maria Ouspenskaya in 1923, then moved to Seattle and eventually Hollywood in the 1940s. See Benedetti, "Les éditions occidentales des oeuvres de Stanislavski."

(5) On Koiransky's involvement in the writing of *My Life in Art*, see Senelick, "New Information on *My Life in Art*."

(6) See Gordon, *Stanislavsky in America*, 21–27. On Boleslavsky, who fled Russia in 1920, see Carnicke, *Stanislavsky in Focus*, 41–44.

(7) See Gordon, *Stanislavsky in America*, 91–92.

(8) An exception: Cage returned throughout his life to the notion of art as "imitating nature in its mode of operation," although he interpreted it in his own way. See Coomaraswamy, *The Transformation of Nature in Art*, 11.

(9) Coomaraswamy's rendering of Bharata-muni's *Natya Sastra* does not correspond exactly to the text, which is itself a compendium of different sources; for instance, it was Abhinavagupta in the tenth century who added the ninth *rasa, shanta* ("bliss," "tranquility").

(10) Cage learned of Coomaraswamy from his teacher (and student), Gita Sarabhi; see Patterson, "Cage and Asia," 49–72. See also Patterson, "The Picture That Is Not in the Colors," 177–215.

(11) See Cage, "The East in the West." Cage's and Cunningham's engagement with Asia is not a superficial appropriation but a deep commitment that had behavioral, political, dietary (and thus environmental), and aesthetic consequences. It is reductive to deride the interest they took in Zen Buddhism or Indian *rasa* theory as a simple case of orientalism. See Srinivasan, *Sweating Saris*, 113; and Wong, *Choreographing Asian America*, 38.

(12) See Copeland, *Merce Cunningham*, 71.

(13) Cunningham's Choreographic Records for *Neighbors* (1991) indicate that yet another dance was influenced by *rasa* theory; here he also mentions "the odious" (*MGZMD 295, box 9).

(14) Patterson, "The Picture That Is Not in the Colors," 185.

(15) This is true, of course, of Martha Graham as well. Her notebooks contain a plethora of allusions to myths as recorded by Joseph Campbell, and quotations from *King Lear*, Virginia Woolf, Euripides, etc. See Graham, *The Notebooks of Martha Graham*.

(16) See Johnston, "Cunningham and Limón" (quoting Cunningham): "I don't look in a book, I make a step."

(17) See Vaughan, 33–34.

(18) Cunningham, unpublished manuscript of *Four Walls*, 3. I thank David Vaughan for sharing his copy of this manuscript with me.

(19) Cunningham, *Four Walls*, 1.

(20) Alastair Macaulay found this letter in a scrapbook maintained by Cunningham's family; he shared these quotations with me in an email message dated June 1, 2015. I am grateful to Macaulay for allowing me to quote from the letter and point readers to his forthcoming biography.

(21) See also Bonnie Bird's account in *Frontiers* and Bonnie Bird, interview with David Vaughan, October 13, 1987 (video, 33 min.; camera: Elliot Caplan; *MGZIDF 5046, Performing Arts Division, New York Public Library).

(22) Vaughan, 15.

(23) See Gordon, *Stanislavsky in America*, 9.

(24) Stanislavsky, *My Life in Art*, 347.

(25) Stanislavsky, *An Actor Prepares*, 159.

(26) Stanislavsky, *My Life in Art*, 343.

(27) Stanislavsky, 348.

(28) Gordon, *Stanislavsky in America*, 78.

(29) The 1938-39 course catalog of the Cornish School describes the orientation of its Theatre Department in the following terms: "The creative training includes exercises in concentration and imagination including the study of relations to outer contacts and to inner processes. It includes also the development of intelligent observation with the object of gathering material for characterization, together with a study of dramatic literature and current theatre productions." The first-year curriculum stressed "Phonetics," "Eurythmics," and "Dance" as well as more classical theatrical practices, such as "Playreading" (Cornish School of the Allied Arts course catalog, 1938–39; accession number 2564-001, box 14, Special Collections, Cornish School of the Arts, Seattle). Arlene Croce even finds traces of classical Stanislavsky acting in *Solo* (1973): "He comes as close to Stanislavskian realism as the structure of his work can ever have allowed him to come. . . . Cunningham devotees are not surprised that he has taken his dance from nature or that he isolates, tenses, and relaxes his muscles with animal-like control, but we are startled to find the animals really there" (Croce, "Notes on a Natural Man," 11). Theories of acting (as well as oratory) have always been concerned with the relation between felt emotion and external physiognomy. For an in-depth study, see Roach's *The Player's Passion*; on Stanislavsky in particular, see 157, 162, 199, and 217. See also Franko's excellent "Expressivism and Chance Procedure."

(30) Cunningham, box 13, Choreographic Records.

(31) See Vaughan, 39.

(32) Vaughan, 58.

(33) See January 21, 1951, program for the Hunter College Playhouse performance in New York City (https://dancecapsules.mercecunningham.org [accessed February 6, 2019]).

(34) Vaughan, 62.

(35) See Coomaraswamy, *The Dance of Siva*, 31; and Schechner, "Rasaesthetics," 340.

(36) Coomaraswamy, *The Transformation of Nature in Art*, 52.

(37) For his composition to accompany *Sixteen Dances*, *Concerto for Prepared Piano and*

Chamber Orchestra, Cage also juxtaposed intentional compositional practices and chance procedures; see Pritchett, *The Music of John Cage*.

(38) Cunningham, box 13, Choreographic Records.

(39) Cunningham, box 13, Choreographic Records.

(40) Cunningham, box 13, Choreographic Records. There is evidence that Cunningham was thinking about the "permanent emotions" as early as 1943. Cage writes in a letter to Cunningham postmarked June 28, "I don't know: this gravity elastic feeling to let go and fall together with you is one thing, but it is better to live exactly where you are with as many permanent emotions in you as you can muster. Talking to myself" (*The Selected Letters of John Cage*, 60).

(41) Coomaraswamy, *The Transformation of Nature in Art*, 52.

(42) Coomaraswamy, 52; added emphasis.

(43) Coomaraswamy, 52.

(44) Coomaraswamy, 52.

(45) Coomaraswamy, *The Mirror of Gesture*, 5; added emphasis.

(46) Coomaraswamy, 4, 3.

(47) Cunningham did share this information with his readers in 1968, in an essay titled "Two Questions and Five Dances" that appeared in *Dance Perspectives*.

(48) While rehearsing *Pool of Darkness*, for instance, Cunningham refused to answer Annaliese Widman's repeated questions. "Widman kept asking questions about the psychological motivation of the movements that he was unable or unwilling to answer" (Dorothea Berea, quoted in Vaughan, 57). Widman left the company shortly afterward.

(49) See Cunningham, "The Impermanent Art (1952)," 86–87.

(50) Cunningham, 87.

(51) Johnston, "Cunningham and Limón," 33.

(52) Brown, *Chance and Circumstance*, 119.

(53) Gretchen Schiller, email correspondence with the author, March 3, 2017.

(54) Brown, *Chance and Circumstance*: "In order for Cunningham dancers to be 'musical,' they must discover, *in the movement*, out of their own inner resources and innate musicality, what I call, for want of a better word, the 'song'" (195–96; original emphasis). Kristy Santimyer Melita, who danced with the Merce Cunningham Dance Company from 1985 to 1989, notes that she did not make up songs to anchor the dance phrases that were difficult to learn; she relied more on memorizing the rhythm (interview with the author, November 3, 2017). Victoria Finlayson, who danced with the company from 1984 to 1992, provides an account of how she learned Cunningham's rhythmically difficult phrases. Referring to *Fielding Sixes* (1980), based on permuting patterns of a six-beat measure, she states that the rhythms never inspired to her create a "story line." Instead, through devoted practice, the rhythm "become more and more somatic." Finlayson would discover within the phrase a "texture": "plush or pointy," "dark or light." By repeating material alone after rehearsal was over, she could identify what she called "the rhythmic drama." She also remembered Kimberly Bartosik (a company member from 1987 to 1996) telling her that she *did* make up a story, perhaps as a mnemonic device or motivating factor. Testimony from dancers indicates that they attacked the problem of memorizing and developing the difficult material in different ways. According to Finlayson, if Cunningham felt that a dancer could take a

simple phrase and inject it with dramatic dynamic qualities, he would give that dancer a simple phrase. If he felt that a dancer needed more complex material to work with to make the dance interesting, he would give that dancer "more to do." Finlayson, interview with the author, March 2, 2019.

(55) About *Roadrunners* (1979), for instance, Cunningham writes in his notes, "This is a narrative"; he tells us that *Place* (1966) involves "plots"; *Rebus* (1975) is about "Bacchus and the Bacchae"; and *Story* (1963) is a bunch of stories, "because everything is" (Cunningham, boxes 11, 10, 13, Choreographic Records).

(56) Cunningham, "The Impermanent Art (1952)," 87.

(57) Cunningham, box 13, Choreographic Records; original emphasis.

(58) See also Noland, "The Human Situation on Stage."

(59) John Cage to Merce Cunningham, postmarked July 22, 1944, in *The Selected Letters of John Cage*, 71. According to Jean Erdman, Cage was encouraging Cunningham to "get out from under Martha's thumb" (quoted in Vaughan, 26–27). See also Brown, *Chance and Circumstance*, 54.

(60) Cunningham, *Changes*, n.p.

(61) See Franko, "Expressivism and Chance Procedure," 147.

(62) See Katz, "John Cage's Queer Silence."

(63) Folland, "Robert Rauschenberg's 'Red Show.'"

(64) Lesschaeve, 106.

(65) Cunningham, *Changes*, n.p.; see section on *Suite for Five* (1953–58).

(66) Joseph Campbell, who was a friend of Cage and Cunningham's as well as the husband of Jean Erdman, a frequent dance partner of Cunningham's, also critiqued the reliance of modern dance choreographers on texts. However, he saw Graham's approach to textual and mythic sources as an exception, a model to be emulated rather than scorned. He writes in the March 1944 issue of *Dance Observer*, "I attended my first [modern dance] concert . . . I should have thought myself wandered into the Modern Library" (Campbell, "Betwixt the Lip and the Cup," 30).

(67) Lincoln Kirstein commissioned the program, which also included a "Dramatic ballet in one act" called *Blackface*, by Lew Christensen. Tally Beatty and Betty Nichols played a "Colored Couple."

(68) Johnston, "Cunningham and Limón": "It is as difficult to conceive of Cunningham without Cage's music (and direction) as it is to imagine Limón without his literature."

(69) Program notes, Connecticut College, August 4, 1950. This program may be found in the archive of the American Dance Festival. At this concert, where Cunningham was featured as a guest artist, he performed four solos: "Two Step" (1949), "Root of an Unfocus" (1944), "The Monkey Dances" (1948), and "Before Dawn" (?).

(70) See Rossen, *Jewish Identity in American Modern and Postmodern Dance*.

(71) Litz, quoted in Morris, *A Game for Dancers*, 27.

(72) Graham began teaching modern dance for actors at the Neighborhood Playhouse in 1921; her written comments suggest that she was interested in removing inhibitions so that performers could come into closer contact with their most profound emotions. The Neighborhood Playhouse is identified with the acting technique of Sanford Meisner; the Meisnerian Method emphasizes the actor's authentic, personal responses.

(73) Franko, *Martha Graham in Love and War*, 103. Cunningham's comments on Martha

Graham in his interview with Calvin Tomkins indicate that he, too, believed that the issue of expressivity in her work is more complex than it has been portrayed to be: "It's always seemed to me that Martha's followers make her ideas much more rigid and specific than they really are with her, and that Martha herself has a basic respect for the ambiguity in all dance movement" (*The Bride and the Bachelors*, 246–47).

(74) Franko, 102; my emphasis.

(75) Cunningham, box 17, Choreographic Records; also quoted in Vaughan, 40; added emphasis.

(76) Cage confirms that *The Seasons*—both his score and Cunningham's choreography—was conceived under the sign of Hindu mythology. Speaking of his own score, he states, "*The Seasons* is an attempt to express the traditional Indian view of the seasons as quiescence (winter), creation (spring), preservation (summer), and destruction (fall)" (Vaughan, 40).

(77) Vaughan, 62.

(78) Program notes quoted in Brown, *Chance and Circumstance*, 119.

(79) Vaughan, 88; see also Cunningham, box 8, Choreographic Records.

(80) Cunningham, letter to Robert Rauschenberg, July 12, 1958 (Cunningham, box 1, Choreographic Records). The letter is reprinted in Vaughan, 105.

(81) Cunningham, box 13, Choreographic Records.

(82) Vaughan, 103.

(83) Cunningham, box 1, Choreographic Records.

(84) Cunningham, box 1, Choreographic Records.

(85) Rebecca Chaleff has pointed to the homosexual overtones of this section (conversation with the author, April 26, 2015); Nancy Dalva, in contrast, claims that it reflects Cunningham's playful relation with his brother (conversation with the author, October 2012).

(86) See also Cunningham, Choreographic Records, for *Travelogue* (1977) (box 15) and *Rebus* (1975) (box 11), which reference explicitly the drunken fall of Joyce's hero; it is easy to identify Cunningham's pantomime of this scene at the beginning of *Travelogue*. For a meditation on how a different culture might interpret Cunningham's gestures, see Nagura, "Cross-Cultural Differences in the Interpretation of Merce Cunningham's Choreography."

(87) Lesschaeve, 106.

(88) Vaughan, 62; Cunningham, "Two Questions and Five Dances."

(89) Johnston, "Merce Cunningham & Co.," 6.

(90) See Launay, *Poétiques et politiques des répertoires*, 285–325.

(91) Cunningham in Lesschaeve, 106.

(92) Lesschaeve, 107; original emphasis.

(93) Hardy, "Between the River and the Ocean," 57.

(94) Mueller, "He Breaks All Rules."

(95) Lesschaeve, 155.

(96) Lesschaeve, 155.

(97) Lesschaeve, 84.

(98) Cunningham, box 5, Choreographic Records.

(99) Cunningham is known to have frequently changed the order of sections in a dance

when he revived it. For a 1991 revival, he created yet another order (see notes from 1990, box 5): I. heroic (solo); fear (group); odious (solo); II. humour (duet); sorrow (solo) (female); erotic (duet); III. anger (solo); wondrous (group).

(100) Cunningham, box 5, Choreographic Records.

(101) For a longer meditation on gesture in Cunningham's work, especially *Winterbranch* (1964), see Noland, "Ethics, Staged."

(102) Lesschaeve, 65.

(103) Lesschaeve, 72.

(104) "She [Martha Graham] could give you some sort of emotional explanation, and I would notice that the dancers had some feeling about it very often, but I couldn't do it" (Lesschaeve, 67).

(105) Lesschaeve, 68.

(106) Vaughan, 59.

(107) Lesschaeve, 81.

(108) Lesschaeve, 68.

(109) Cunningham, "The Impermanent Art (1952)," 86.

(110) See Darwin, *The Expression of Emotions in Animals and Man*. See also Noland, "The Human Situation on Stage."

(111) Denby, "Merce Cunningham," 407.

(112) We should recall that in his notes, Cunningham suggested that part 3 of *Exchange* should involve "discs." Box 5, Choreographic Records.

(113) Puchner, *Stage Fright*, 3. "Even the most adamant forms of modernist anti-theatricalism," writes Puchner, "feed off the theater and keep it close at hand" (2).

(114) Folland, "Robert Rauschenberg's 'Red Show,'" 88.

Chapter Four

(1) See the online visual presentation by Gilles Amalvi, "Boris Charmatz" (http://www.borischarmatz.org/en/savoir/piece/50-ans-de-danse-50-years-dance-flip-book-roman-photo; accessed February 20, 2019).

(2) Macaulay, "Using a Familiar Device to Dance out of the Past, Page by Page."

(3) See Greskovic, "Merce Cunningham as Sculptor"; and Solomon, "*STILL LIFE*."

(4) See Vaughan, "Merce Cunningham's *The Seasons*"; and Bellow, "A May-December Romance?"

(5) See Tomkins, *The Bride and the Bachelors*, 239–96. In a telephone interview with the author, Carolyn Brown insisted that Cunningham dancers never "pose," his dance is never static (February 2014); yet *pose* is a word Cunningham uses frequently in his notes.

(6) Nancy Dalva, the director of a series of minidocumentaries titled "Mondays with Merce," stated that she felt ambivalent about the efforts on behalf of the Merce Cunningham Trust to license his works for reconstruction, maintaining, understandably, that only the original productions under Cunningham's supervision are authentic and true to his aesthetic. Interview with the author, October 2012. Carolyn Brown expressed similar reservations during an interview with the author July 14, 2011.

(7) Robert Swinston, interview with the author, July 2011, Hanover, NH.

(8) Franko, "The Readymade as Movement."

(9) Schneider, *Performing Remains*, 148. "A pose can be said to be reenactive, citational. Even if the precise original of a pose is unclear, or nonexistent, there is still a citational quality to posing due to the fact that a pose is arrested, even if momentarily, in what is otherwise experienced as a flow in time. The pose articulates an interval, and so, in Henri Bergson's sense, is given to multiple and simultaneous time(s). The freeze or lag in time that is the moment of arrested stillness defines a pose as a pose and might grant the pose a kind of staginess, or theatricality, as if (paradoxically perhaps) theatricality were the very stuff of an inanimate stillness" (90). See also Owens, "Posing"; and Campany, "Posing, Acting, Photography."

(10) Philip Auslander, quoted in Schneider, *Performing Remains*, 132; added emphasis.

(11) Vaughan, 89. The recent reconstructions (2003, 2005) have contained only two solos for a male dancer.

(12) See Pritchett, *The Music of John Cage*, 94.

(13) Cunningham, *MGZMD 295, box 14, Choreographic Records; added emphasis. Interestingly, in the reprint of this section of his notes in *Merce Cunningham: Fifty Years*, Cunningham replaces "stopped position" with "held poses" (Vaughan, 89).

(14) The second movement of Erik Satie's *Socrate* is titled "On the Banks of the Ilissus." For the composition of *Second Hand* in 1969-70, Cunningham recopied all the lyrics in the original French written by Victor Cousin, which recount a conversation between Socrates and Phaedrus. Carolyn Brown commented in an interview that given the platonic intertext, the *Second Hand* duet "should be a duet with two males" and not a duet between a "male and female" (see Vaughan, 28).

(15) I thank Carolyn Brown for this clarification during a phone conversation in February 2014. Brown mentions Louis A. Stevenson twice in her autobiography, *Chance and Circumstance*. He and his wife were friends of Carolyn and Earle Brown's. That photographs—or, more precisely, the photographic—inspired Cunningham is confirmed by a comment he made about *Duets* (1980): "The ending is comprised of three short phrases, each followed by a brief stop, as though a still photograph were being taken" (Lesschaeve, 156).

(16) In Cunningham's note, the stick figure representing shape number 6 is partially obscured by the one above, number 4, "holding on shoulder of M"; nonetheless, it is possible to discern a line representing the lifted leg as well as Cunningham's two legs, the right one more bent than the left.

(17) In his notes, Cunningham often placed inside single quotation marks descriptive titles for sections of a dance (or even individual phrases) that he seldom shared with his dancers.

(18) Direct allusions to Sergei Eisenstein, an early practitioner of dramatic montage, appear in the notes to *Antic Meet* (1958). For instance, Cunningham refers to *Potemkin* (the mother and child episode on the steps)—as well as Dostoevsky (*MGZMD 295, box 1, Choreographic Records). According to David Vaughan in a conversation with the author (May 2011), Cunningham was intrigued by all things Russian. He even taught himself the Russian language while in his twenties.

(19) Both these films are available on the website of the Merce Cunningham Trust. See https://dancecapsules.mercecunningham.org/overview.cfm?capid1=46107 (accessed March 4, 2019).

(20) Barthes, "The Third Meaning," 68.

(21) Krauss, "Reinventing the Medium," 297–98.

(22) Cunningham, "The Function of a Technique for Dance," 60; original emphasis.

(23) We should recall that Robert Rauschenberg invented the name "combines" with Alexander Calder's mobiles in mind. He, too, was playing with the contrast between movement and stillness during the same period. Notes for *Aeon* indicate that he was interested in "stances + actions" (*MGZMD 295, box 1, Choreographic Records).

(24) See Cunningham, *MGZMD 295, box 14, Choreographic Records, for *Suite for Five*.

(25) See Lepecki, *Exhausting Dance*.

(26) *Suite for Five* program note, University of Notre Dame, May 18, 1956; reprinted in Vaughan, 89. Vaughan tells us that the word *ballet* was "amended" to *dance* (281).

(27) Moten, *In the Break*, 200. Moten is interested in the sound in the photograph, the listening in the looking. Listening, like seeing movement, is another time-based phenomenon.

(28) Immediately after finishing *Pictures* (and perhaps while composing it), Cunningham turned to a dance called *Phrases* (1984), in which the traversal of the stage space—or the transition movement—was paramount. He habitually alternated between works that focus on quick and athletic movement and works that focus on the more sculptural, pictorial, and photographic qualities of dance. For instance, while continuing to explore stillness in *Suite for Five*, he also began taking notes for *Changeling* (1957), *Picnic Polka* (1957), and *Antic Meet* (1958), all extremely kinetic dances. What is interesting is that when he worked with photographs or filmic stills, the opposition between "pictures" and "phrases" tended to deconstruct.

(29) The arch-walk is reiterated in *Aeon* (1961) and yet again in *Fabrications* (1987). As an aside, I learned while watching rehearsals for the reconstruction of *Crises* in 2014 that the arch-walk is one of the most difficult passages for the dancers reprising Brown's role to learn. It requires transforming a pose that would normally involve a release—the woman falls into the man's arms—into a pose that can support shifts of weight from one foot to the other.

(30) Barbara Morgan's photographs of Martha Graham appeared in popular magazines and are anthologized in *Martha Graham: Sixteen Dances in Photographs*, first published in 1941.

(31) See Franco, "Ausdruckstanz." Laban did embrace film as a medium for capturing dance.

(32) Noverre, *Letters on Dancing and Ballets*, 35.

(33) Noverre, 9.

(34) Homans, *Apollo's Angels*, 75.

(35) Lesschaeve, 125.

(36) Schneider, *Performing Remains*, 162.

(37) Barthes, "Camera Lucida," 24.

(38) Lesschaeve, 125.

(39) Krauss, "Perpetual Inventory," 107: "The media saturation of daily life had made the ubiquity of the photographic a subject of some urgency, whether for theory or for making art."

(40) Vaughan, 128.

(41) Krauss, "Perpetual Inventory," 113.

(42) Eisenstein, "A Dialectic Approach to Film Form," 52.

(43) See Warburg, "A Lecture on Serpent Ritual"; and Brandstetter, *Poetics of Dance*, 79. Brandstetter's account emphasizes Warburg's theory that the energy of movement finds itself crystalized in the symbol, a gestural image he calls a "dynamogram." On the *pathosformel* and the dynamogram, see also Didi-Huberman, *The Surviving Image*. The degree to which Warburg actually understood Hopi dance culture has recently been contested by Karen Ann Lang in *Chaos and Cosmos* (100–105).

(44) Eisenstein, "Word and Image," 17.

(45) "What comprises the dynamic effect of a painting"? asks Eisenstein. "The eye follows the direction of an element in the painting. It retains a visual impression, which then collides with the impression derived from "following the direction of a second element. The conflict of these directions"—evolving in time—"forms the dynamic effect in apprehending the whole" ("A Dialectic Approach to Film Form," 51).

(46) Schneider, *Performing Remains*, 148.

Chapter Five

(1) *Crises* was reconstructed by Jennifer Goggans in a Merce Cunningham Trust Fellowship Workshop from October 21 to November 7, 2014, in New York City. There were two performances (one of each cast) at City Center on November 7, 2014. Quotations from Goggans's speech and her directions to dancers during the rehearsals are all recorded in my personal notes. The dancers in the two casts were Benny Olk/Ernesto Breton (Merce Cunningham); Pareena Lim/Erin Dowd (Carolyn Brown); Tess Montoya/Lindsey Jones (Viola Farber); Jenna Lee Hay/Vanessa Knouse (Marilyn Wood); and Amy Blumberg/Rebecca Hadly (Judith Dunn).

(2) Jennifer Goggans reconstructed *Winterbranch* (1964) for Benjamin Millepied's L.A. Dance Project in 2013 and for the Opéra Ballet of Lyon in March–April 2016. See Noland, "Ethics, Staged."

(3) See Franko, "Introduction: The Power of Recall in a Post-Ephemeral Era."

(4) On the closure of the Merce Cunningham Dance Company, see Noland, "Inheriting the Avant-Garde."

(5) The conceit of *Trio A* (1966) is that each gesture should be executed only once and always in the same monotone way. The "No Manifesto" contained the directives "No to virtuosity," "No to spectacle," and "No to involvement of performer or spectator." See Rainer, "No Manifesto," 51.

(6) See Charmatz, "Manifesto for a Dancing Museum."

(7) Vaughan, 124. Cunningham makes it clear that Rauschenberg matched the costumes to the dance; as in a traditional collaboration, he was "responding" to the "disquieting quality of the dance movement" (124).

(8) According to Carolyn Brown, the dancers did not hear Nancarrow's score until the first performance. See *Chance and Circumstance*, 276.

(9) Daniel Callahan demonstrates in his two chapters on Merce Cunningham that cueing movement to the music was not as much of a deviation as previous scholars have assumed it to be; see "The Dancer from the Music," 141–207.

(10) It is for this reason that I find misleading many of the accounts of Cunningham's

practice that rely on Gilles Deleuze's notion of a "Body w/o Organs." See, for instance, Damkjaer, "The Aesthetics of Movement"; Gil, "The Dancer's Body"; and Huschka, *Merce Cunningham und der moderne Tanz*.

(11) Cunningham, *Changes*. "So from the beginning I tried to look at the people I had, and see what they did and could do. . . . Because it isn't only training, although that has a great deal to do with it. It has to do with temperament and the way they see movement, the way they are as persons and how they act in any situation; all that affects the dancing. It's all part of it" (Lesschaeve, 65). On Cunningham's special way of mobilizing dancers as "persons," see Coates, "Beyond the Visible," 1–7.

(12) Cunningham, *MGZMD 295, box 3, Choreographic Records.

(13) Cunningham, *Changes*, n.p.; quoted in Vaughan,122.

(14) Cunningham may have been referencing the title of one of Martha Graham's early solos, *Moment of Crisis*, from 1944.

(15) Cunningham, "Space, Time and Dance," 39.

(16) See Mellers, review of *Crises* for the *New Statesman*, 160.

(17) See Brown, *Chance and Circumstance*: "The general audience response was outright laughter plus much ill-suppressed giggling" (276).

(18) Hering, "Silences and Sounds," 22.

(19) Hering, 24.

(20) On dance as "just movement," see Franko, "The Readymade as Movement": "There is, I suspect, an institutional investment in keeping North American dance, even in its most 'avant-garde' manifestations, non-discursive" (214).

(21) Cunningham, "The Impermanent Art (1952)," 86. See also Lesschaeve: "Movement comes from something, not from something expressive but from some momentum or energy" (68); and Cunningham, "Space, Time and Dance": "What is seen, is what it is" (39).

(22) Foster, *Reading Dancing*, xiv, 168. Foster adds nuance to her reading in "Closets Full of Dances: Modern Dance's Performance of Masculinity and Sexuality," an essay I return to in chapter 6.

(23) Nancy Dalva, who has been particularly alert to the presence of passion in Cunningham's work, nonetheless subscribes to the dictum that, as she puts it, "He made the viewer the *auteur*" (see Dalva, "The Way of Merce").

(24) Callahan, "The Dancer from the Music," 205.

(25) Cunningham, box 3, Choreographic Records.

(26) See Acocella, "Cunningham's Recent Work." Writing about *Trackers* (1991), Acocella observes, "Whatever his grief about the end of his dancing career, in this piece it had been reabsorbed into comedy, reobjectified" (13–14).

(27) Cunningham, "Space, Time, and Dance," 39: "There is a tendency to imply a crisis to which one goes and then in some way retreats from."

(28) Cunningham, 39.

(29) The idea for the elastic may have come from Maude Barrett, Cunningham's first dance teacher in Centralia, Washington. Apparently, for some performances she would put a big rubber band over her skirt and then walk on her hands.

(30) John Cage's comments are relayed in Vaughan, 123.

(31) Mark Franko argues persuasively that the seeming neutrality, coolness, and deperson-

alization of movement that critics have noted in Cunningham's work is not a necessary aspect of his aesthetic but began to creep into performances during the late 1970s; see Franko, *Dancing Modernism, Performing Politics*.

(32) These are Carolyn Brown's words from a telephone interview with the author, November 20, 2014.

(33) Brown, *Chance and Circumstance*, 272. The letter is dated August 1, 1960.

(34) Brown, 272. The letter is dated July 27, 1960.

(35) Cunningham, box 3, Choreographic Records. See also Vaughan, 122–24.

(36) Cunningham, box 3, Choreographic Records.

(37) Cunningham, box 3, Choreographic Records.

(38) *Sensuous* is the term Jennifer Goggans used to describe Viola's movements when teaching the duet to Merce Cunningham Trust Fellowship Workshop dancers Lindsey Jones and Tess Montoya.

(39) A photo of Farber and Cunningham in these positions may be found in Cunningham, *Changes*.

(40) Cunningham, box 3, Choreographic Records.

(41) According to Farber's husband of nine years, Jeff Slayton, Cunningham and Farber carried on a particularly intense relationship, what he called a "love-hate relationship" that continued throughout her life until she died in 1998. "Their dancing on stage was their love affair," Slayton claimed in an interview with the author May 20, 2015.

(42) Callahan, "The Dancer from the Music," 147.

(43) Cunningham, box 3, Choreographic Records.

(44) Cunningham, box 3, Choreographic Records.

(45) See Johnston, "Jigs, Japes, and Joyce"; and Burt, *The Male Dancer*.

(46) At least one critic saw the influence flowing the other way: Clive Barnes wrote after seeing *Crises* that Farber's body was like "pliable putty"; "Merce Cunningham's greatness as a dancer is projected with a penetrating intensity particular to himself, although his characteristic quick, intense style has been captured most closely by Viola Farber" (quoted by Slayton in *The Prickly Rose*, 50).

(47) See also Lepecki, "Choreography as Apparatus of Capture."

(48) Lepecki, *Exhausting Dance*, 46.

(49) Franko, "Given Time," 119.

(50) Cunningham, *Changes*, n.p.; and Vaughan, 122.

(51) Cunningham, box 3, Choreographic Records; original emphasis.

(52) Cunningham, box 3, Choreographic Records.

(53) Cunningham, box 3, Choreographic Records.

(54) Cunningham, box 3, Choreographic Records; added emphasis.

(55) Vaughan, 69; added emphasis.

(56) Cunningham, "The Impermanent Art (1952)," 86; added emphasis.

(57) Vaughan, 105.

(58) Author's interview with Patricia Lent, March 10, 2011. The Choreographic Records for *Roaratorio* (box 11) contain a passage that reads as follows: "stools—beasts of burden/ packs on backs/wagons/goods + chattels."

(59) See Martha Graham, *Lamentation*, at https://youtube.com/watch?v=xgf3xgbKYko (accessed February 13, 2019). We might think also of Cunningham's parody of *Lamen-*

tation in *Antic Meet* (1958), the scene in which he struggles to put on a many-limbed sweater.

(60) Gell, *Art and Agency*.

(61) Adrian Heathfield in conversation with the author, April 26, 2015. On interpellation by objects, see Bernstein, "Dances with Things." Bernstein speaks about how things "hail" us, providing a script that we then act out. See also B. Brown, "Thing Theory"; and Coole and Fox, *New Materialisms*.

(62) On human and nonhuman assemblages, see Bennett, *Vibrant Matter*; on the "actant" and the theory of distributed agency, see Latour, *Reassembling the Social*.

(63) See Viola Farber's account in Slayton, *The Prickly Rose*, 30-35.

(64) For details concerning Viola Farber's departure from the Merce Cunningham Dance Company, see the transcript of her taped interview with Rose Anne Thom in 1991.

(65) Slayton, *The Prickly Rose*, 34.

(66) Franko, "Expressivism and Chance Procedure," 150.

(67) Timothy Ward, interview with the author, June 14, 2015.

(68) Deborah Jowitt reviewed the 2006 performance at the Joyce Theater, New York, for the *Village Voice*; she writes of Mitchell's last entrance, "Crawling on his hands and feet, belly up, imagine a stallion sniffing out a bunch of mares."

(69) Brown, "*Summerspace*," 76.

(70) Douglas Dunn, quoted by Jowitt in *Time and the Dancing Image*, 281-82.

(71) Lesschaeve, 106.

(72) Lesschaeve, 107. At this stage of his career (1980), Cunningham still called his female dancers "girls" and his male dancers "men," an artifact of an earlier era that doesn't seem to have been reflected in the level of respect he showed his female dancers, though it betokens a latent conventionality.

(73) Lesschaeve, 107.

(74) The Choreographic Records for *Variations V* (box 16) state that the variables he was working with—"separate + dependent"—contain "seeds of bondage." Later dances also work on a similar principle: for *Trails* (1982), Cunningham choreographed separate phrases for the two dancers in a duet, allowing them to encounter each other as their paths crossed without planning it. Such examples could be multiplied.

(75) Vaughan, 93.

Chapter Six

(1) Clive Barnes calls Cunningham's dances "faceless, placeless" while reviewing *Place* (1966) in "Dance: Cunningham Back; After Triumphs Abroad." Jill Johnston claimed in 1963 that "his dances are all about movement." ("Cunningham and Limón," 33).

(2) See Manning, *Modern Dance/Negro Dance*.

(3) Foster, "Closets Full of Dances," 175.

(4) Cunningham, "The Impermanent Art (1952)," 87; Cunningham, "Choreography and the Dance," 59.

(5) Vaughan, "Cunningham and His Dancers," 26, 27.

(6) Leroi-Gourhan, *Le geste et la parole II*, 135.

(7) See Golston, *Rhythm and Race in Modernist Poetry and Science*. For an exposition on the difference between *ethnic* and *racial*, see Cornell and Hartmann, *Ethnicity and Race*:

"We shall call 'ethnic groups' those human groups that entertain a subjective belief in their common descent because of similarities of physical type or of customs, or both, or because of memories of colonization and migration" (17); "ethnicity," they write, "is family write very large" (20). I will use *ethnic* and *ethnicized* to refer to groups allied by a common history (Leroi-Gourhan's usage [*Le geste et la parole II*]), whereas when I use *race* or *racialized* I refer to how these groups have been (pejoratively) classified.

(8) Cunningham recalls in "The Impermanent Art (1952)" that Maude Barrett insisted "there was not such a thing as just 'tap'; instead, there was 'the waltz clog,' 'the southern soft shoe,' 'the buck and wing,' and all were different, and she would proceed to show us how they were different. The rhythm in each case was the inflecting force that gave each particular dance its style and color" (quoted in Vaughan, 87).

(9) Neil Greenberg, telephone interview with the author, October 23, 2017.

(10) Jennifer Goggans, interview with the author, March 2016; and Neil Greenberg, telephone interview with the author, October 23, 2017.

(11) Daniels, "Cunningham in Time (1985)," 164 and 163; Denby, "Elegance in Isolation (1944)," 27.

(12) Seibert, *What the Eye Hears*, 30.

(13) Cunningham, "The Function of a Technique for Dance," 61. For examples of dances in which Cunningham more closely follows a musical (rhythmic) score, see Callahan, "The Dancer from the Music."

(14) John Cage, "In This Day," 94.

(15) Author's interview with Rebecca Chaleff, December 2017.

(16) Brown, *Chance and Circumstance*, 373. According to many dancers who worked with him, Cunningham sang his choreography. When teaching phrases, he could clap out the rhythms as if following the ebb and flow of a memorized rhythmic refrain. Cunningham even choreographed a dance, *Fast Blues*, performed to the accompaniment of jazz drumming by Baby Dodds for a recital at Columbia University on May 19, 1946, the last recital he would give before leaving Martha Graham's company.

(17) Brown, 373.

(18) Cage, "Goal: New Music, New Dance," 87.

(19) See Foulkes, *Modern Bodies*; Albright, *Traces of Light*; Jarvinen, *Dancing Genius*; McDonagh, Martha Graham interview with Merle Armitage.

(20) See Daly, *Done into Dance*; and Manning, *Modern Dance/Negro Dance*, xx.

(21) See Snyder, *The Voice of the City*, 26–41; Seibert, 117.

(22) On whites "borrowing" from Blacks and the evolution of minstrelsy into tap, see Seibert, 74. "Vaudeville might just have been the most integrated profession in America, though it was usually assumed that one black act on any white bill was enough" (Seibert, 127). On the history of African American dance, see Dixon Gottschild, *Waltzing in the Dark*, 8, 32, 58–59.

(23) Hill, *Tap Dancing America*, 6.

(24) Cunningham and Monk, interview with Merce Cunningham, July 4, 1997 (audiocassette, 54 min.; Jerome Robbins Collection, Performing Arts Division, New York Public Library).

(25) Cunningham, *MGZMD 295, boxes 7 and 18, Choreographic Records.

(26) Hill, *Tap Dancing America*, 11.

(27) Lesschaeve, 34.

(28) See Seibert, 117.

(29) See Dixon Gottschild, *Waltzing in the Dark*, 83.

(30) *Dime a Dance*, *Banjo*, and *Picnic Polka*, like Sophie Maslow's *Folksay* (1942), Doris Humphrey's *The Shakers* (1930), Ted Shawn's *Ponca Indian Dance* (1934), and Martha Graham's *American Document* (1938) and *Appalachian Spring* (1944), reflect the infatuation with Americana typical of the period. On *Banjo*, see Feldman, "*Banjo*: Cunningham's Lost American Piece."

(31) Jean Erdman, "Interview with Jean Erdman by Don McDonagh, Dated October 4, 1993," part 1 (audiotape, 47 min.; *MGZTL 4-2567, Performing Arts Division, New York Public Library).

(32) Snyder, *The Voice of the City*, xviii.

(33) See also Cunningham's *Split Sides* (2003) and *eyeSpace* (2006).

(34) Vaughan, 106.

(35) Vaughan, 105.

(36) Vaughan, 103.

(37) See Seibert on the "penultimate slot" reserved for the star, 118; and Hill, *Tap Dancing America*, on "the walkaround finale" (as well as "competitive sections"), 9.

(38) Vaughan, 12, 108.

(39) Vaughan, 105. See also Cunningham's archived comments on Barrett: "She taught us in her kitchen at some point, on the linoleum. And I can still hear her, see it actually, making taps with her foot. She hit the front, the side, and the back. And then we would get out these little clips and plod away. And she'd say, "No, that's not it." And then she'd get up and do it. And I can still hear the difference. The rhythm was so wonderful." Cunningham, "A Life in Dance," interview, *PBS NewsHour*, July 24, 1999 (videodisc, 14 min.; *MGZIDVO 5-328, Performing Arts Division, New York Public Library).

(40) Vaughan, 12, 108.

(41) Vaughan, 105.

(42) See Stearns and Stearns, *Jazz Dance*, 83. On "eccentric" dance, see Seibert, 122.

(43) Cunningham and Monk, interview with Merce Cunningham, July 4, 1997 (audiocassette, 54 min.; Jerome Robbins Collection, Performing Arts Division, New York Public Library). See also Cunningham on *Two Step* (1949) in Vaughan, 53.

(44) "Rubberlegs" Williams acquired his name because of the elasticity of his legs. He was particularly renowned for his performance of the cakewalk and the Charleston, and was active in blackface minstrelsy. He can be seen in the short film *Smash Your Luggage* of 1933 at https://www.youtube.com/watch?v=_L5J3044W6s (accessed February 15, 2019). On Black minstrelsy, see Sampson, *Blacks in Blackface*; and Lott, *Love and Theft*.

(45) Email communication with Julie Sermon, September 12, 2016.

(46) Eubie Blake, quoted in Snyder, *The Voice of the City*, 122.

(47) Dixon Gottschild, *Digging the Africanist Presence in American Performance*, 49–50.

(48) On the Irish as "Black," see O'Neill and Lloyd, "The Black and Green Atlantic." See also Nowatzki, "Paddy Jumps Jim Crow."

(49) Is it merely a coincidence that Cage invented the prepared piano to compose a piece to accompany a dance choreographed by the Cornish School's only African American pupil, Syvilla Fort? The piece was titled *Bacchanale* and was composed in 1938–40.

According to Kay Larson, Syvilla Fort's mother cleaned floors at the Cornish School "so her daughter could afford tuition" (see *Where the Heart Beats*, 67). On Fort's subsequent career, see Ayoka Chenzira, dir., *Syvilla* (16mm film, 22½ min.; Performing Arts Division, New York Public Library). On the invention of the prepared piano, an instrument Cage invented by placing rubber bands, screws, and bolts on the strings of a grand piano, see Silverman, *Begin Again*, 30-32.

(50) Marianne Preger-Simon recounts that Foofwa d'Imobilité was the stage name of Frédéric Gafner. See Simon, *Dancing with Merce Cunningham*, 147-48. Simon's account of how dancers learned Cunningham's difficult rhythms confirms that he gave a good deal of latitude to dancers; they were not allowed to change the rhythm, but they could interpret it as full persons with individual life histories and physical skills.

(51) *Antic Meet* (1958), filmed in 1964 for Swedish television. Arne Arnbom, director; music for piano by John Cage; set by Robert Rauschenberg; dancers Merce Cunningham (not in "Social,"), Carolyn Brown, Viola Farber, Barbara Lloyd, Sandra Neels, and Steve Paxton (available at https://dancecapsules.mercecunningham.org [accessed January 29, 2019]). The 2011 performance videos of *Antic Meet* may be found at the same site.

(52) Cunningham's interest in Joyce's writings probably began in the early 1940s, for Joycean titles start to crop up in his repertory around that time, such as *In the Name of the Holocaust* (1943) and *Tossed as It Is Untroubled* (1944). See Vaughan, "Cunningham, Cage and Joyce." The figure of H. C. Earwicker reappears with surprising frequency in Cunningham's notes for *Travelogue* (1977), *Rebus* (1975), and *Sounddance* (1975). Some critics have even identified Cunningham's role in *Roaratorio* as a personification of Joyce's Everyman.

(53) O'Neill and Lloyd, "The Black and Green Atlantic," xvi.

(54) Seibert, 73.

(55) See Cage, *Roaratorio: Ein irischer Circus über "Finnegans Wake,"* 15, quoted in Vaughan, "Cunningham, Cage and Joyce," 79; Lartigue, "Merce Cunningham"; and Sirvan, "Ballade irlandaise."

(56) Dickinson, "John Cage: Irish Circus; BBC 3 Interview with John Cage and Merce Cunningham, 19 July 1987" (audiocassette, 30 min.; Jerome Robbins Collection, Performing Arts Division, New York Public Library).

(57) A mesostic is a verse created by picking out the letters of a name—in the case of *Roaratorio*, the name JAMES JOYCE—from the source text and placing one letter of that name in each line of the stanza.

(58) Cunningham may have been familiar with Henry Cowell's writings on traditional Irish music. Cowell's liner notes to *Irish Jigs, Reels & Hornpipes*, published by Folkways Records in 1956, contain diagrams of traditional dance steps. Cunningham may also have consulted J. G. O'Keeffe, *A Handbook of Irish Dances, with an Essay on Their Origin and History* (1902), available at the New York Public Library. He told Alastair Macaulay that he read "two whole books" about the jig meter; see Macaulay, "Hard to Grasp, but Harder to Say Goodbye."

(59) Cunningham, box 11, Choreographic Records, dated July 10, 1983.

(60) Lent, "Introduction to *Roaratorio*."

(61) Cunningham, box 11, Choreographic Records.

(62) "Reels in wheels" involved short phrases repeated in different directions. Patricia Lent divides the movement material of *Roaratorio* into eight "categories of movement." "Everybody talks about the chance," she told me. "Nobody talks about the invention" (interview with the author, March 24, 2011).

(63) Dickinson, "John Cage: Irish Circus; BBC 3 Interview with John Cage and Merce Cunningham, 19 July 1987" (audiocassette, 30 min.; Jerome Robbins Collection, Performing Arts Division, New York Public Library).

(64) Cunningham, box 11, Choreographic Records, dated July 29, 1983.

(65) Lartigue, "Merce Cunningham," quoted in Vaughan, "Cunningham, Cage and Joyce," 88.

(66) See Cage, "On Having Received the Karl Sczuka Prize for *Roaratorio*," speech delivered in Donaueschingen, Sternensaal, Germany, October 20, 1979.

(67) Patricia Lent, interview with the author, March 24, 2011.

(68) Lent interview. A second example of how Cunningham departs from traditional Irish rhythms can be found in the sections of the dance called "movement gamuts." Here, he follows a compositional method, the weight-shift method, initially developed for *Torse* in 1976. Instead of taking time counts as the basic metric, Cunningham counts weight shifts, building phrases shift by shift from a gamut of preselected steps. For the movement gamuts of *Roaratorio*, he developed thirty-two phrases, each of which contains a number of weight shifts ranging from one to thirty-two.

(69) Joyce himself strives in *Finnegans Wake* to destabilize the very definition of Irish identity. The novel is by no means "Irish" in some straightforward and unalloyed way. As he wrote, the Irish are not a "pure . . . race"; "it is useless to look for a thread that may have remained pure and virgin without having undergone the influence of a neighbouring thread" (Joyce, "Ireland, Island of Saints and Sages," 165–66).

(70) Cunningham, "The Impermanent Art (1952)," 86; added emphasis.

(71) Foster, "Closets Full of Dances": "the universality presumed" by Cunningham (175).

(72) Foster, 175.

(73) Brown, *Chance and Circumstance*, 195.

(74) Neil Greenberg, telephone interview with the author, October 23, 2017.

(75) Lent, interview with the author, March 24, 2011.

(76) Goggans referred several times to "Cunningham unison" during rehearsals I attended for the Lyon Opera Ballet production of *Winterbranch* (1964) in March of 2016. For a fuller account of this production, see Noland, "Ethics, Staged."

(77) B. Jones, *Story/Time*, 1.

(78) B. Jones, telephone interview with the author, September 22, 2017. B. Jones, *Story/Time*, 15: "I must admit that my struggles to craft a work like *Fondly* . . . left me desiring a means to create past my limitations of memory and taste."

(79) B. Jones, *Story/Time*, 14. Earlier, Jones published *Last Night on Earth*, an autobiography with a more typical chronological structure, with Peggy Gillespie.

(80) B. Jones, telephone interview with the author.

(81) B. Jones, *Story/Time*, 14. Jones had already used Cage's *Empty Words* (1979) to accompany a section of his 1999 dance, *We Set Out Early . . . Visibility Was Poor*.

(82) Cage, "Composition as Process: II. Indeterminacy," 35.

(83) B. Jones, *Story/Time*, 15.

(84) B. Jones, telephone interview with the author, September 22, 2017.

(85) The table is host to a collection of green apples; they relate to one of the stories Jones wrote in which he meets an older white man doing menial work like people of color; the man takes an apple out of his pocket and wipes it with a handkerchief. The green apple might also reference *Proxy*, a dance that Steve Paxton performed in 1961 in which a performer eats a pear.

(86) B. Jones, telephone interview with the author. For an analysis of Jones's confrontational style—and his unique positioning within the avant-garde—see Morris, "What He Called Himself." See also Martin, *Critical Moves*.

(87) In a phone interview with the author, Jones stated that he placed himself center stage in performances of *Story/Time* because he didn't want to be "disingenuously self-effacing" (September 22, 2017).

(88) B. Jones, *Story/Time*: "My stories are not consistently arranged by random procedure. Some stories and sequences were so important to me that they were given pride of place nightly, complete with crafted lighting and even sound. Why? Because there was a 'feeling' I had that I insisted on preserving and sharing with an audience" (16). "You're not John Cage," Jones says about himself in his interview "Conversation with Philip Bither."

(89) B. Jones, *Story/Time*, 16.

(90) Jones confided that he thought Cage, too, would "spin again" if he didn't like the results of his chance procedure (telephone interview with the author, September 22, 2017).

(91) Bill T. Jones has shown himself to be consistently resistant to the depersonalization of not only his person but also his body. For instance, when he began working with the computer software artists Paul Kaiser and Shelley Eshkar to produce *Ghostcatching* in 1997, he insisted on finding ways to capture his own body and its singular way of moving, thus working against the schematization that inevitably attends motion-capture technologies. Jones even had a motion sensor affixed to his genitals so that there could be no confusion concerning his gender. Paul Kaiser recounts that his experience of collaborating with Merce Cunningham earlier that same year was markedly different. While creating *Hand-Drawn Spaces* (1998) with Cunningham (along with Eshkar), Kaiser was not called on to make the kind of distinctions that Jones required. "The differences between the two [Cunningham dancers Jeannie Steele and Jared Phillips] in size and sex and style were annulled as Merce combined their captured phrases freely," Kaiser recalls. "Psychology and intention were absent from this choreographic process. . . . [Cunningham] had no qualms about motion-capture or computer composition or hand-drawn rendering, all seen as different means to the same end he'd been pursuing for the past fifty years. Not so Bill T. Jones. 'I do not want to be a disembodied, denatured, de-gendered series of lines moving in a void,' [Jones] said. Whereas *Hand-Drawn Spaces* reveled in the freedom of abstracted motion, [Jones's] *Ghostcatching* would question it" (Kaiser, "Steps," 37–39).

(92) B. Jones, *Story/Time*, 101, 99.

(93) B. Jones, 98; added emphasis.

(94) B. Jones, 4.

(95) In *Last Night on Earth*, Jones recounts learning the "Cechetti [*sic*]" method of ballet

and the Humphrey-Weidman technique as well as African and Caribbean dance with Percival Borde at SUNY Binghamton (85, 107–9). At the State University of New York, Brockport, he was introduced to Richard Bull's improvisation class (114) and Steve Paxton's improvisational method through Lois Welk (116). In the afterword he describes learning Trisha Brown's style (271).

(96) Paul Kaiser describes this signature style well: to capture Jones's way of moving for the creation of *Ghostcatching* (1997), "[it was] not a matter solely of [Jones's] skeleton and of the angles it took, but also of the undulation and quivering of liquid muscle" ("Steps," 41).On Jones's training, see Roy, "Step by Step Guide to Dance."

(97) See Dixon Gottschild, *The Black Dancing Body*.

(98) B. Jones, *Story/Time*, 11.

(99) Seibert, 50.

(100) B. Jones, telephone interview with the author, September 22, 2017.

(101) B. Jones, *Story/Time*, 101.

(102) B. Jones, 98.

Chapter Seven

(1) Cage interviewed by Kostelanetz, *The Theatre of Mixed Means*, 62.

(2) Cage interviewed by Kostelanetz.

(3) See Fetterman, *John Cage's Theatre Pieces*, 25 (hereafter referred to as Fetterman). See also Kirby and Schechner, "An Interview with John Cage."

(4) Cage, "Experimental Music: Doctrine," 13.

(5) Kirby and Schechner, "An Interview with John Cage," 50. Compare this to his 1954 definition: "Theatre is all the various things going on at the same time"; "Theatre takes place all the time wherever one is and art simply facilitates persuading one this is the case" ("45′ For a Speaker," 149; 174).

(6) Cage interviewed by Kostelanetz, *The Theatre of Mixed Means*, 57.

(7) "This testing of art against life was the result of my attending the lectures of [D. T.] Suzuki for three years. I think it was from 1949 to 1951" (Kostelanetz, 52).

(8) I thank Laura Kuhn for sharing a list of books in Cage's library. In what might be his last interview, conducted by Max Blechman, Cage stated, "I think that all of creation is at the center and that there are no better points than others. It is a Buddhist idea. . . . Everything is the world honored one, in other words everything is the Buddha" (Blechman, "Last Words on Anarchy," 274–75).

(9) This turn was initiated during the process of composing *Concert for Piano and Orchestra* in 1950; see Pritchett, *The Music of John Cage*; and Nichols, *John Cage*.

(10) Cage, "Composition as Process: II. Indeterminacy," 35.

(11) Marcel Duchamp, quoted in Schwarz, *The Complete Works of Marcel Duchamp*, 31.

(12) Cage and Charles, *For the Birds*, 148.

(13) According to Fetterman, David Tudor performed *Water Music* "at least nine times from 1952 through 1960" (25).

(14) See Fetterman, 25; Diaz, *The Experimenters*; Dubin, *Black Mountain College*.

(15) On Cage's "chart technique," see Pritchett, *The Music of John Cage*, 78.

(16) I have not located the program, very likely from the London performance of 1954, but David Tudor copied this sentence in his own hand and placed it in the file with the

score of that performance; the slip of paper on which his note is written can be found in the David Tudor Papers, Getty Research Institute.

(17) Quoted in Fetterman, 27. Tan refers to *Water Music* as "highly choreographed," as though Cage had entered Cunningham's orbit.

(18) The score for *Water Walk* was generated by using the procedure developed for *Fontana Mix*, also composed in Milan (in 1958); see Pritchett, *The Music of John Cage*, 130; and Fetterman, 43–45.

(19) See Cage, *The Selected Letters of John Cage*, 130.

(20) The year 1952 is also the year that Lucille Ball's famous "Vitameatavegamin" episode of *I Love Lucy* was first aired (on May 5). The "zany" aesthetics of *I Love Lucy*—which resemble those of *Water Walk*—are discussed by Sianne Ngai in *Our Aesthetic Categories*. Ngai never mentions Cage, although he would fit well into any of her three categories. Instead, Kay Larson makes the link between Cage and the entertainment industry: see *Where the Heart Beats*, 61–62. Calvin Tomkins reports that when Federico Fellini saw Cage on *Lascia o Raddoppia*, he offered the composer a part in *La Dolce Vita*, which unfortunately Cage did not accept (see Tomkins, *The Bride and the Bachelors*, 133). See also Silverman, *Begin Again*, 169–70.

(21) Fetterman, 29.

(22) Fetterman, 32.

(23) Kirby and Schechner, "An Interview with John Cage," 60.

(24) Fetterman, 66.

(25) Cunningham, "The Impermanent Art (1952)," 87.

(26) Nattiez and Davoine, *Pierre Boulez, John Cage*.

(27) Cage, "Experimental Music," 14.

(28) On Cage's struggle with the Western harmonic system, see Pritchett, *The Music of John Cage*; and Nichols, *John Cage*; and Cage and Charles, *For the Birds*, 72.

(29) Larson, *Where the Heart Beats*, 174. See also Anderson and Cage, "Taking Chances": "Suzuki's first class . . . concerned itself with the Buddha's final teachings, emphasizing the interpenetration of all things in a world of phenomenal abundance" (53).

(30) Cage, "Composition as Process: III. Communication," 46–47; added emphasis.

(31) Cage and Charles, *For the Birds*, 90. The Fischinger film is *Optical Poem*. See Silverman, *Begin Again*, 25 and 39: "Oskar Fischinger's advice to liberate the sounds dwelling within objects"; and Kostelanetz, *John Cage, Writer*, 31.

(32) It is unfortunate, but Cage systematically uses the generic universal *men*.

(33) Cage and Charles, *For the Birds*, 91; added emphasis.

(34) Cage and Charles, 91.

(35) Cage and Charles, 91; added emphasis. See Perloff, "Unimpededness and Interpenetration."

(36) Jaeger, *John Cage and Buddhist Ecopoetics*, 3. Alexandra Monroe calls this "*mediated* Zen" (*The Third Mind*, 199–271; quotation is from p. 199).

(37) Cage and Charles, *For the Birds*.

(38) Drown, "Merce Cunningham and Meaning," 24.

(39) Raynal (dir.) and Becker and O'Wyers (cinematography), *Image et technique: Merce Cunningham* (video documentary, 27 min.; sound, black and white, filmed June 1964). See mercecunningham.org/media.

(40) See Katz, "John Cage's Queer Silence"; and C. Jones, "Finishing School." It is worth recalling that Cage's teacher, Henry Cowell, spent four years in prison for what were deemed homosexual acts.

(41) Katz, "John Cage's Queer Silence."

(42) Cunningham, "A Method of Making Dances," Lecture-Demonstration at the Roslyn Arts Center, Long Island, April 17, 1957 (unpublished manuscript, typescript; *MGZMD 351, box 29, Lecture Notes 1952–1972, Jerome Robbins Collection, Performing Arts Division, New York Public Library), 2, 3. See also "Excerpts from Lecture-Demonstration Given at Ann Halprin's Dance Deck (July 13, 1957)," 100–101.

(43) See the draft of a Lecture-Demonstration at Vassar College dated November 9, 1954 (unpublished manuscript; *MGZMD 351, box 29, Lecture Notes 1952–1972), 4.

(44) Cunningham, "A Method of Making Dances."

(45) Vaughan, 63.

(46) One important exception is *Variations V* (1965), which includes some of the everyday actions of *Excerpts from Symphonie pour un homme seul* (1952).

(47) See Brown's description of a three-week summer residency at the University of California, Los Angeles, in July 1963: *Chance and Circumstance*, 357.

(48) Vaughan, 178. See also Cage on flexibility in Cage and Charles, *For the Birds*, 52.

(49) Cunningham, notes for "Pittsburgh Workshop" (unpublished manuscript; *MGZMD 351, box 30, Lecture Notes 1952–1972, Jerome Robbins Collection, Performing Arts Division, New York Public Library), 1.

(50) Cage, "Composition as Process: II. Indeterminacy," 36.

(51) Cunningham, notes for "Pittsburgh Workshop"; added emphasis.

(52) Cunningham, notes for a "Workshop in Flexibility," July 5, 1974 (unpublished manuscript, typescript; *MGZMD 295, box 22, Lecture Notes 1972–1986, Jerome Robbins Collection, Performing Arts Division, New York Public Library), 6. It is not clear whether these page numbers were part of the original manuscript or added later. Some of the pages lack page numbers.

(53) The first exercise he assigns on July 8 requires students to make phrases of specific lengths involving any kind of motion whatsoever—walking, gesturing with the arms, performing a daily task, or executing "dance" movements—for the purpose of developing their ability to change the order of the movements, to increase their "flexibility." See Cunningham, notes for a "Workshop in Flexibility," 3.

(54) Cage and Charles, *For the Birds*, 78.

(55) Cage and Charles, 78–79; added emphasis.

(56) See recording of Cage and Cunningham, "Rehearsing the Human Situation on Stage," Zellerbach Hall, University of California, Berkeley, September 29, 1989 (Videodisc, 93 min.; *MGZIDVD-5-1422, Performing Arts Division, New York Public Library).

(57) Cunningham, draft of a Lecture-Demonstration at Vassar College, November 9, 1954 (unpublished manuscript; *MGZMD 351, box 29, Lecture Notes 1952–1972).

(58) Cunningham, notes for a "Workshop in Flexibility," 3.

(59) Cunningham, 3.

(60) Cunningham, 3; Cunningham's brackets.

(61) Cunningham, 2.

(62) Cunningham, 4.

(63) Cunningham, 2; Cunningham's brackets.

(64) Caldwell, "Show Features Common Sounds," in Fetterman, 248; added emphasis.

(65) There are six scores for Cage's part, one in the John Cage Archive at Northwestern University and five in Cage's own manuscript collection, now held in the John Cage Trust at Bard College, Red Hook, New York. One score for Cunningham's part is in the Merce Cunningham Collection at the New York Public Library.

(66) See O'Connell on the April 28, 1973, performance of a Dialogue at Dartmouth College, "Evaluation Form for Local Sponsors," dated May 5, 1973, Dartmouth College Archives, Hanover, NH: "The Cunningham/Cage Dialogue, perhaps because of the highly personal and non-theatrical nature of the communication," was the "least successful" of all the performances, classes, and workshops given during the residency.

(67) Cunningham, quoted in Vaughan, 44. The 1948 Lecture-Demonstration was held at Virginia State Teachers College in Farmville.

(68) Cage and Charles, *For the Birds*, 171.

(69) Vaughan, 63.

(70) Cage and Charles, *For the Birds*, 52.

(71) Cage and Charles, 148; added emphasis.

(72) Cage and Charles, 148; original emphasis.

(73) Fetterman claims that the Dialogue was performed approximately twenty-one times between 1970 and 1985 (121).

(74) Interview with John Cage by David Sears at Cage's home, New York City, February 1, 1981 (audiocassette, 75 min.; Performing Arts Division, New York Public Library).

(75) See Vaughan, 161–62.

(76) Fetterman, 121.

(77) Panel discussion led by David Vaughan at the University of California, Berkeley. See Callahan for full transcript ("The Dancer from the Music," 186).

(78) Robertson, "The Merce Cunningham Dance Company," 8AE.

(79) Close, "Cunningham-Cage 'Event' Well Planned."

(80) Fetterman, 121.

(81) Fetterman notes that the score is undated, but the sequence of actions closely resembles that of the 1978 Denver Art Museum performance; see pp. 248, 249.

(82) See Fetterman, 250–52.

(83) Kirby and Schechner, "An Interview with John Cage," 60.

(84) On the male dancer as feminized, see Morris, "What He Called Himself."

(85) Cage and Charles, *For the Birds*, 91.

(86) Cunningham, "The Impermanent Art (1952)," 86.

(87) Cage, *How to Get Started*, recorded August 31, 1989 (compact disc; Microcinema, 2011). See also Kuhn, "A Few Words about John Cage and Improvisation."

(88) Cage, *How to Get Started*. See also Johnson, "Intentionalité et non-intentionalité dans l'interprétation de la musique de John Cage." Johnson observes that Cage actually resurrected an earlier meaning of harmony that focuses on perception of sound rather than its strict organization according to rules. (See pp. 477–78.)

(89) "Is tragedy inevitable?" Cunningham wonders in his "Workshop in Flexibility" (notes

for a "Workshop in Flexibility," July 5, 1974; unpublished manuscript, typescript; *MGZMD 295, box 22, Lecture Notes 1972–1986, Jerome Robbins Collection, Performing Arts Division, New York Public Library), 3.

(90) Cunningham, notes for "Workshop for Teachers," April 1974 (*MGZMD 295, box 22); Cunningham's brackets.

(91) Lesschaeve, 107.

(92) Cunningham, "A Method of Making Dances," Lecture-Demonstration at the Roslyn Arts Center, Long Island, April 17, 1957 (unpublished manuscript, typescript; *MGZMD 351, box 29, Lecture Notes 1952–1972, Jerome Robbins Collection, Performing Arts Division, New York Public Library).

(93) Robert Swinston has stated that even contemporary modern dance training hinders dancers who want to learn the Cunningham technique: "The problem with modern dancers trained in other techniques is they understand shift of weight as an invitation to create momentum, throwing the weight further in the direction (reverb), thereby making it impossible to go in a counterintuitive direction." Interview with the author, July 7, 2011, at Dartmouth College, Hanover, New Hampshire.

(94) Cunningham, "Music, Dance, and Chance Operations: A Forum Discussion with Merce Cunningham," interview with Cunningham and Marianne Simon led by Robert Stern at the University of Massachusetts, Amherst, February 16, 1970; added emphasis (available on audio disc, 59 min.; *MGZTL 4-122, Performing Arts Division, New York Public Library).

(95) See figure 2.8, note from *Summerspace* (1958).

Bibliography

Archived Sources

Armitage, Merle. Interview with Don McDonagh, 1972. Sound recording, 32 min. *MGZTL 4-2524, part 1, Jerome Robbins Dance Division, New York Public Library for the Performing Arts.

Berea (Silver), Dorothy. Interview with David Vaughan, Greensboro, North Carolina, November 3, 1978. Audiocassette, 44 min. *LTC-A-1194, Performing Arts Division, New York Public Library.

Bird, Bonnie. Interview with David Vaughan, October 13, 1987. Video, 33 min. Camera: Elliot Caplan. *MGZIDF 5046, Performing Arts Division, New York Public Library.

Cage, John. Interview with David Sears at Cage's home, New York City, February 1, 1981. Audiocassette, 75 min. Performing Arts Division, New York Public Library.

Cage, John, and Merce Cunningham. "Rehearsing the Human Situation on Stage: Interview with David Vaughan." Zellerbach Hall, University of California, Berkeley, September 29, 1989. Videodisc, 93 min. *MGZIDVD-5-1422, Performing Arts Division, New York Public Library.

Chenzira, Ayoka, dir. *Syvilla: They Dance to Her Drum*. 16mm film, 22½ min. Performing Arts Division, New York Public Library.

Cornish School of the Allied Arts. Course catalog, 1938–39. Accession number 2564-001, box 14, Special Collections, Cornish School of the Arts, Seattle.

Cunningham, Merce. Choreographic Records. *MGZMD 295, boxes 1–3, 5, 9–11, 13–18, 22; and *MGZMD 351, boxes 29 and 30, Jerome Robbins Collection, Performing Arts Division, New York Public Library.

Cunningham, Merce. Draft of a Lecture-Demonstration at Vassar College, November 9, 1954. *MGZMD 351, box 29, Lecture Notes 1952–1972, Jerome Robbins Collection, Performing Arts Division, New York Public Library.

Cunningham, Merce. "Four Walls." Unpublished manuscript, typescript, 1944.

Cunningham, Merce. "A Method of Making Dances." Roslyn Arts Center, Long Island, April 17, 1957. Unpublished manuscript, typescript. *MGZMD 351, Lecture Notes 1952–

1972, box 29, Jerome Robbins Collection, Performing Arts Division, New York Public Library.

Cunningham, Merce. "Music, Dance, and Chance Operations: A Forum Discussion with Merce Cunningham." Interview with Cunningham and Marianne Simon led by Robert Stern at the University of Massachusetts, Amherst, February 16, 1970. Audio disc, 59 min. *MGZTL 4-122, Performing Arts Division, New York Public Library.

Cunningham, Merce. "Notes for a Lecture-Demonstration at the Henry Street Playhouse, Manhattan, April 27, 1957." Unpublished manuscript, typescript. *MGZMD 351, folder 1957, box 29, Lecture Notes 1952–1972, Jerome Robbins Collection, Performing Arts Division, New York Public Library. A partial version of this text is cited in Vaughan, *Merce Cunningham*, 97.

Cunningham, Merce. Notes for a "Workshop in Flexibility," July 5, 1974. Unpublished manuscript. *MGZMD 95, box 30, Lecture Notes 1972–1986, Jerome Robbins Collection, Performing Arts Division, New York Public Library.

Cunningham, Merce. Notes for a "Workshop for Teachers," April 1974. Unpublished manuscript. *MGZMD 295, box 22, Lecture Notes 1972–1986, Jerome Robbins Collection, Performing Arts Division, New York Public Library.

Cunningham, Merce. "Pittsburgh Workshop." Unpublished manuscript. *MGZMD 351, box 30, Lecture Notes 1952–1972, Jerome Robbins Collection, Performing Arts Division, New York Public Library.

Cunningham, Merce. *Sixteen Dances*. Program with notes for the January 21, 1951, performance at the Hunter College Playhouse, New York City. Dancecapsule.www.merce cunningham.org. Accessed February 6, 2019.

Cunningham, Merce, and Meredith Monk. Interview with Merce Cunningham, July 4, 1997. Audiocassette, 54 min. Jerome Robbins Collection, Performing Arts Division, New York Public Library.

Dickinson, Peter. "John Cage: Irish Circus; BBC 3 Interview with John Cage and Merce Cunningham, 19 July 1987." Audiocassette, 30 min. Jerome Robbins Collection, Performing Arts Division, New York Public Library.

Erdman, Jean. "Interview with Jean Erdman by Don McDonagh, Dated October 4, 1993," part 1. Audiotape, 47 min. *MGZTL 4-2567, Performing Arts Division, New York Public Library.

Farber, Viola. "Interview with Rose Anne Thom, 1991." Handwritten transcript, May 29, November 18 and 25, 1991; March 18, 20, and 24, 1992, 208 pp. Oral History Project, Performing Arts Division, New York Public Library.

O'Connell, James S., Jr. "Evaluation Form for Local Sponsors." National Endowment of the Arts: Coordinated Residency-Touring Program 1972–1973, dated May 5, 1973. Dartmouth College Archives.

Schiphorst, Thecla. *Thecla Schiphorst and Merce Cunningham Talking about "LifeForms."* Film recorded at Simon Frasier University, 1992. 70 min. *MGZIDVD 5-1377, Performing Arts Division, New York Public Library.

Sears, David. Telephone interview with Merce Cunningham, May 19, 1983. 66 min. *MGZTL 4-1529, Oral History Project, Performing Arts Division, New York Public Library.

Interviews and Conversations

Brown, Carolyn. Interview by the author, Rhinebeck, NY, July 2011; telephone conversation February 2014; and telephone interview November 20, 2014.

Chaleff, Rebecca. Conversation with the author, April 26, 2015; interview December 2017.

Cunningham, Merce. "A Life in Dance." Interview, *PBS NewsHour*, July 24, 1999. Videodisc, 14 min. *MGZIDVO 5-328, Performing Arts Division, New York Public Library.

Dalva, Nancy. Interview by the author, October 2012.

English, Darby. Conversation with the author, Sterling and Francine Clark Art Institute, Williamstown, MA, March 4, 2015.

Finlayson, Victoria. Telephone interview by the author, March 2, 2019.

Franklin, Paul B. "Merce on Marcel: An Interview with Merce Cunningham." In *Étant donné, no. 6: Marcel Duchamp and John Cage*, edited by Paul B. Franklin. Paris: L'Association pour l'Étude de Marcel Duchamp, 2005. Reprinted in Basualdo and Battle, *Dancing around the Bride*, 257–69.

Goggans, Jennifer. Interview by the author, March 2016.

Greenberg, Neil. Telephone interview by the author, October 23, 2017.

Harper, Meg. Interview by the author, December 14, 2018.

Heathfield, Adrian. Conversation with the author, April 26, 2015.

Jones, Bill T. Telephone interview by the author, September 22, 2017.

Kirby, Michael, and Richard Schechner. "An Interview with John Cage." *Tulane Drama Review* 10, no. 2 (Winter 1965): 50–72.

Lent, Patricia. Interview by the author, March 10 and 24, 2011.

Melita, Kristi Santimyer. Interview by the author, November 3, 2017.

Slayton, Jeff. Interview by the author, May 20, 2015.

Swinston, Robert. Interview by the author, January 2010; July 2011, Dartmouth College, Hanover, NH.

Ward, Timothy. Interview by the author, June 14, 2015.

Films and Recordings

Amalvi, Gilles. "Boris Charmatz: 50 ans de danse (50 Years of Dance)/Flip Book/Roman-Photo." http://www.borischarmatz.org/en/savoir/piece/50-ans-de-danse-50-years-dance-flip-book-roman-photo. Accessed February 20, 2019.

Arnbom, Arne, dir. Version of Merce Cunningham's *Antic Meet* (1958) filmed for Swedish television, 1964. Music for piano by John Cage; set by Robert Rauschenberg; dancers: Merce Cunningham, Carolyn Brown, Viola Farber, Barbara Lloyd, Sandra Neels, and Steve Paxton. The film can be found at dancecapsules.mercecunningham.org. Accessed February 20, 2019.

Atlas, Charles, dir. Film version of Merce Cunningham's *Exchange* (1978).

Atlas, Charles, dir. 1973. Film version of Merce Cunningham's *Walkaround Time*. 40 min. www.mercecunningham.org.

Atlas, Charles, dir. Film version of a 2001 performance of Merce Cunningham's *Summerspace*. 21 min., 40 sec. www.mercecunningham.org.

Atlas, Charles, dir. Film version of a 2005 performance of Merce Cunningham's *Biped/Pond Way*. DVD, 1 hr. 38 min. mk2 Films, 2006.

Atlas, Charles, dir. *Locale*. Choreography by Merce Cunningham.

Bel, Jérôme, choreographer. Cédric Andrieux. Filmed 2009. First performed by Cédric Andrieux at the Théâtre de la Ville, Paris, for the Festival d'Automne. Vimeo video excerpts available on Youtube.com: https://www.youtube.com/watch?v=crEg8JpS0Fg. Accessed March 5, 2009.

Cage, John. *How to Get Started*. Recorded August 31, 1989. Compact disc. Microcinema, 2011.

Jones, Bill T. Conversation with Philip Bither. Walker Art Center, walkerart.org/channel /2011/bill-t-jones-in-conversation-with-philip-bith. Accessed February 20, 2019.

Raynal, Jackie, dir.; Etienne Becker and Patrice O'Wyers, cinematography. *Image et technique: Merce Cunningham, 1964*. Documentary video, 27 min.; sound, black and white. Rehearsal and performance fragments, filmed June 1964. *MGZIDF4441, Merce Cunningham Dance Foundation Collection, Performing Arts Division, New York Public Library.

Williams, Henry "Rubberlegs." Performance in excerpt from *Smash Your Luggage* (1933). YouTube video, 7:07, published October 2, 2008. https://www.youtube.com/watch?v= _L5J3044W6s.

Published Sources

Acocella, Joan. "Cunningham's Recent Work: Does It Tell a Story?" *Choreography and Dance: An International Journal*, vol. 4, pt. 3 (1997): 3–16.

Adcock, Craig. "Conventionalism in Henri Poincaré and Marcel Duchamp." *Art Journal/ College Art Association of America* 44 (1984): 249–58.

Adcock, Craig. "Duchamp's Eroticism: A Mathematical Analysis." In *Marcel Duchamp: Artist of the Century*, edited by Rudolf Kuenzli and Francis Naumann, 149–67. Cambridge, MA: MIT Press, 1996.

Agamben, Giorgio. "Notes on Gesture." In *Means without End: Notes on Politics*, translated by Vincenzo Binetti and Cesare Casarino. Minneapolis: University of Minnesota Press, 2000.

Albright, Ann Cooper. *Traces of Light: Absence and Presence in the Work of Loïe Fuller*. Middletown, CT: Wesleyan University Press, 2007.

Anderson, Laurie, and John Cage. "Taking Chances: Laurie Anderson and John Cage." *Tricycle: The Buddhist Review* (Summer 1992).

Baker, Georges. *The Artwork Caught by the Tail: Francis Picabia and Dada in Paris*. Cambridge, MA: MIT Press, 2007.

Banes, Sally. "Nouvelle danse New Yorkaise." *Festival Internationale de Danse* (1985).

Barish, Jones. *The Antitheatrical Prejudice*. Berkeley: University of California Press, 1981.

Barnes, Clive. "Dance: Cunningham Back; After Triumphs Abroad, 2 New York Premieres at the Hunter Playhouse." *New York Times*, December 11, 1966.

Barnes, Clive. "A Dance Is a Journey but . . ." *New York Times*, November 20, 1970.

Barthes, Roland. "Extracts from Camera Lucida." In *The Photography Reader*, edited by Liz Wells, 19–30. London: Routledge, 2003.

Barthes, Roland. "The Third Meaning." In *Image, Music, Text*, translated by Stephen Heath, 52–68. London: Fontana Press, 1977.

Basualdo, Carlos. "Blossoming of the Bride: On *Walkaround Time*." In *Merce Cunningham:*

CO:MM:ON TI:ME, edited by Fionn Meade and Joan Rothfuss, 145–54. Minneapolis: Walker Art Center, 2017.

Basualdo, Carlos, and Erica F. Battle, eds. *Dancing around the Bride: Cage, Cunningham, Johns, Rauschenberg, and Duchamp*. Philadelphia: Philadelphia Museum of Art, 2012.

Bellow, Juliet. "A May-December Romance? Time and Collaboration in *The Seasons*." In *Merce Cunningham: CO:MM:ON TI:ME*, edited by Fionn Meade and Joan Rothfuss, 49–58. Minneapolis: Walker Art Center, 2017.

Benedetti, Jean. "Les éditions occidentales des oeuvres de Stanislavski." In *Le théâtre d'art de Moscou: Ramifications, voyages*, edited by Marie-Christine Autant-Mathieu, 79–95. Paris: CNRS, 2005.

Bennett, Jane. *Vibrant Matter: A Political Ecology of Things*. Durham, NC: Duke University Press, 2010.

Bernard, Michel. "Danse et Hasard ou les paradoxes de la composition chorégraphique aléatoire." *La revue d'esthétique* 29, no. 92 (1992): 75–79.

Bernstein, Robin. "Dances with Things: Material Culture and the Performance of Race." *Social Text* 27, no. 4 (Winter 2009): 67–94.

Bird, Bonnie. *Frontiers: The Life and Times of Bonnie Bird*. With Karen Bell-Kanner. New York: Routledge, 2012.

Blechman, Max. "Last Words on Anarchy." In *Conversing with Cage*, 2nd edition. Edited by Richard Kostelanetz, 209–10, 274–75, 278–80. 2nd ed. New York: Routledge, 2003.

Bonk, Ecce. *Marcel Duchamp: The Box in a Valise*. Translated by David Britt. New York: Rizzoli, 1989.

Bourriaud, Nicolas. *Esthétique relationnelle*. Paris: Les Presses du Réel, 2001.

Brandstetter, Gabriele. *Poetics of Dance: Body, Image, and Space in the Historical Avant-Gardes*. Translated by Elena Polzer with Mark Franko. Oxford: Oxford University Press, 2015.

Brown, Bill. "Thing Theory." *Critical Inquiry* 28, no. 1 (Autumn 2001): 1–22.

Brown, Carolyn. *Chance and Circumstance: Twenty Years with Cage and Cunningham*. New York: Knopf, 2009.

Brown, Carolyn. "*Summerspace*: Three Revivals." *Dance Research Journal* 34, no. 1 (Summer 2002); 74–82.

Burt, Ramsey. *The Male Dancer: Bodies, Spectacle, Sexualities*. New York: Routledge, 2007.

Cabanne, Pierre. *Dialogues with Marcel Duchamp*. Translated by Rob Padgett. London: Thames and Hudson, 1971.

Cage, John. "Composition." In *Silence*, 57–60.

Cage, John. "Composition as Process: I. Change." In *Silence*, 18–34.

Cage, John. "Composition as Process: II. Indeterminacy." In *Silence*, 35–40.

Cage, John. "Composition as Process: III. Communication." In *Silence*, 41–56.

Cage, John. "The East in the West." In *John Cage, Writer: Selected Texts*, edited by Richard Kostelanetz, 21–26. New York: Cooper Square Press, 2005.

Cage, John. "Experimental Music: Doctrine." In *Silence*, 13–17.

Cage, John. "45′ for a Speaker." In *Silence*, 146–94.

Cage, John. "Goal: New Music, New Dance." In *Silence*, 87–88.

Cage, John. "In This Day." In *Silence*, 94–95.

Cage, John. "On Having Received the Karl Sczuka Prize for *Roaratorio*," speech delivered in Donaueschingen, Sternensaal, Germany, October 20, 1979. Published as "On Having

Received the Karl-Sczuka-Prize in Donaueschingen: A Speech by John Cage," in Cage, *Roaratorio: Ein irischer Circus über "Finnegans Wake,"* edited by Klaus Schöning, 155–66. Königstein im Taunus, Germany: Athenäum, 1985.

Cage, John. "Part of a Letter from Jackson Mac Low and an Answer to His Old Letters." *Vort* 8 (1975).

Cage, John. *Roaratorio: Ein irischer Circus über "Finnegans Wake."* Edited by Klaus Schöning. Königstein im Taunus, Germany: Athenäum, 1985.

Cage, John. *The Selected Letters of John Cage.* Edited by Laura Kuhn. Middletown, CT: Wesleyan University Press, 2016.

Cage, John. *Silence: Lectures and Writings.* Middletown, CT: Wesleyan University Press, 1961.

Cage, John. *Writing through "Finnegans Wake."* Tulsa: University of Tulsa, 1978.

Cage, John, and Daniel Charles. *For the Birds.* New York: Marion Boyars, 2000.

Cage, John, and Daniel Charles. *Pour les Oiseaux: Entretiens avec Daniel Charles.* Paris: L'Herne, 2002.

Caldwell, Larry. "Show Features Common Sounds." *Daily* (Boulder, CO), October 31, 1978. In Fetterman, 248.

Callahan, Daniel. "The Dancer from the Music: Choreomusicalities in Twentieth-Century American Modern Dance." PhD diss., Columbia University, 2012.

Campany, David. "Posing, Acting, Photography." In *Stillness and Time: Photography and the Moving Image,* edited by David Green and Joanna Lowry, 101–3. Brighton, UK: Photoworks/Photoforum, 2006.

Campbell, Joseph. "Betwixt the Lip and the Cup." *Dance Observer* (March 1944).

Campbell, Joseph, and Henry Morton Robinson. *A Skeleton Key to "Finnegans Wake": Unlocking James Joyce's Masterwork.* Edited and with a foreword by Edmund L. Epstein. Novato, CA: New World Library, 2005.

Carnicke, Sharon Marie. *Stanislavsky in Focus.* 2nd ed. New York: Routledge, 1998.

Carroll, Noël. "The Return of the Repressed." *Dance Theatre Journal* 12, no. 1 (1984): 16–18, 27.

Carroll, Noël, and Sally Banes. "Cunningham and Duchamp." *Ballet Review* (Summer 1983): 73–79.

Chang, Garma C. C. *The Buddhist Teaching of Totality: The Philosophy of Hwa Yen Buddhism.* University Park: Pennsylvania State University Press, 1971.

Charlip, Remy. "Composing by Chance." *Dance Magazine,* January 1954, 17–19.

Charmatz, Boris. "Manifesto for a Dancing Museum." In Solomon, *Danse: An Anthology,* 233–40.

Christin, Anne-Marie. *L'image écrite, ou la déraison graphique.* Paris: Flammarion, 2001.

Close, Roy M. "Cunningham-Cage 'Event' Well Planned." *Minneapolis Star,* October 17, 1978.

Coates, Emily. "Beyond the Visible: The Legacies of Merce Cunningham and Pina Bausch." *PAJ: A Journal of Performance and Art* 32, no. 2 (May 2010): 1–7.

Coole, Diana H., and Samantha Fox. *New Materialisms: Ontology, Agency, and Politics.* Durham, NC: Duke University Press, 2010.

Coomaraswamy, Ananda K. *The Dance of Siva: Fourteen Indian Essays.* Introduction by Romain Rolland. New York: Sunwise Turn, 1924.

Coomaraswamy, Ananda K. *The Mirror of Gesture: Being the "Abhinaya Darpana" of Nandikesvara*. Translated by Ananda Coomaraswamy and Gopala Kristnayya Duggirala. Cambridge, MA: Harvard University Press, 1917.

Coomaraswamy, Ananda K. *The Transformation of Nature in Art*. New Delhi: Munshiram Manoharlal, 1972.

Copeland, Roger. "Cunningham, Collage and the Computer." *PAJ: A Journal of Performance and Art* 21, no. 3 (September 1999): 42–54.

Copeland, Roger. *Merce Cunningham: The Modernizing of Modern Dance*. New York: Routledge, 2004.

Cornell, Stephen, and Douglas Hartmann. *Ethnicity and Race*. 2nd ed. London: Pine Forge Press, 2007.

Croce, Arlene. "Notes on a Natural Man." *New Yorker*, February 7, 1977, 92.

Crow, Thomas. *The Long March of Pop: Art, Music, and Design 1930–1995*. New Haven, CT: Yale University Press, 2015.

Cunningham, Merce. *Changes: Notes on Choreography*. New York: Something Else Press, 1968.

Cunningham, Merce. "Choreography and the Dance." In *The Creative Experience*, edited by Stanley Rosner and Lawrence E. Abt, 175–86. New York: Grossman, 1970.

Cunningham, Merce. "Excerpts from Lecture-Demonstration Given at Anna Halprin's Dance Deck (July 13, 1957)." In Vaughan, *Merce Cunningham*, 100–101.

Cunningham, Merce. "Four Events That Have Led to Large Discoveries (19 September 1994)." In Vaughan, *Merce Cunningham*, 276.

Cunningham, Merce. "The Function of a Technique for Dance (1951)." In Vaughan, *Merce Cunningham*, 60–61.

Cunningham, Merce. "The Impermanent Art (1952)." In Vaughan, *Merce Cunningham*, 86–87.

Cunningham, Merce. "Space, Time, and Dance (1952)." In Vaughan, *Merce Cunningham*, 66–67.

Cunningham, Merce. "*Summerspace* Story: How a Dance Came to Be." *Dance Magazine*, January 1966, 52–54.

Cunningham, Merce. "Two Questions and Five Dances." *Dance Perspectives* 34 (Summer 1968).

Cunningham, Merce, and Carolyn Brown, Laura Diane Kuhn, Thecla Schiphorst, and Joseph V. Melillo. "Four Key Discoveries: Merce Cunningham Dance Company at Fifty." *Theater* 34, no. 2 (Summer 2004): 104–11.

Dalva, Nancy. "The Way of Merce." © *Nancy Dalva* (blog), 1992, 2012, and 2014, https://cunninghamcentennial.blog/?p=258. Accessed February 20, 2019.

Daly, Ann. *Done into Dance: Isadora Duncan in America*. Middletown, CT: Wesleyan University Press, 1995.

Damkjaer, Camilla. "The Aesthetics of Movement: Variations on Gilles Deleuze and Merce Cunningham." PhD diss., Stockholm University in cotutelle with Université de Paris VIII, 2005.

Daniels, Don. "Cunningham in Time (1985)." In Kostelanetz, *Merce Cunningham: Dancing in Space and Time*, 160–72.

Darwin, Charles. *The Expression of Emotions in Animals and Man*. New York: Appleton, 1896.

DeFrantz, Thomas. "Unchecked Popularity: Neoliberal Circulations of Black Social Dance." In *Neoliberalism and Global Theatres: Performance Permutations*, edited by Lara Nielson and Patricia Ybarra, 128–42. New York: Palgrave Macmillan, 2012.

Deleuze, Gilles. *Cinema 2: The Time-Image*. Translated by Hugh Tomlinson and Robert Galeta. London: Athlone, 1989.

Denby, Edwin. "Elegance in Isolation (1944)." In Kostelanetz, *Merce Cunningham: Dancing in Space and Time*, 28–29.

Denby, Edwin. "Merce Cunningham." *Dance Perspectives* (Summer 1968).

Desmond, Jane C., ed. *Dancing Desires: Choreographing Sexualities on and off the Stage*. Madison: University of Wisconsin Press, 2001.

Diaz, Eva. *The Experimenters: Chance and Design at Black Mountain College*. Chicago: University of Chicago Press, 2015.

Didi-Huberman, Georges. *The Surviving Image: Phantoms of Time and Time of Phantoms; Aby Warburg's History of Art*. Translated by Harvey Mendelsohn. University Park: Penn State University Press, 2016.

Dixon, Steve. *Digital Performance: A History of New Media in Theater, Dance, Performance Art, and Installation*. Cambridge, MA: MIT Press, 2007.

Dixon Gottschild, Brenda. *The Black Dancing Body: A Geography from Coon to Cool*. London: Palgrave Macmillan, 2005.

Dixon Gottschild, Brenda. *Digging the Africanist Presence in American Performance: Dance and Other Contexts*. Westport, CT: Greenwood Press, 1998.

Dixon Gottschild, Brenda. *Waltzing in the Dark: African American Vaudeville and Race Politics in the Swing Era*. New York: Palgrave, 2000.

Drown, Marilyn Vaughan. "Merce Cunningham and Meaning: The Zen Connection." *Choreography and Dance: An International Journal*, vol. 4, pt. 3 (1997): 17–28.

Dubin, Martin. *Black Mountain College: An Experiment in Community*. Evanston, IL: Northwestern University Press, 2009.

Duchamp, Marcel. "Apropos of 'Readymades' (1961)." In *The Salt Seller: The Writings of Marcel Duchamp*, edited by Michel Sanouillet and Elmer Peterson, 141–42. Oxford: Oxford University Press, 1973.

Duchamp, Marcel. "The Bride's Veil." In *The Writings of Marcel Duchamp*, edited by Michel Sanouillet and Elmer Peterson, 15–101. New York: Da Capo Press, 1973.

Duchamp, Marcel. *Notes and Projects for the "Large Glass."* Edited by Arturo Schwarz. New York: Henry Abrams, 1970.

Duchamp, Marcel. *The Salt Seller: The Writings of Marcel Duchamp*. Edited by Michel Sanouillet and Elmer Peterson. Oxford: Oxford University Press, 1973.

Duve, Thierry de. *Pictorial Nominalism*. Minneapolis: University of Minnesota Press, 2005.

Eisenstein, Sergei. "A Dialectic Approach to Film Form." In *Works: Selections*, vol. 1. Edited by Richard Taylor. London: I. B. Tauris, 2010.

Eisenstein, Sergei. "Word and Image." In *Works: Selections*, vol. 1.

Febvre, Michèle. *Danse contemporaine et théâtralité*. Paris: Éditions Chirion, 1995.

Feldman, Elyn. "*Banjo*: Cunningham's Lost American Piece." In *Dance: Current Selected Research*, edited by Lynette Y. Overby and James H. Humphrey, 89–96. New York: AMS Press, 1989.

Fetterman, William. *John Cage's Theatre Pieces: Notations and Performances*. Edinburgh: Harwood, 1996.

Folland, Thomas. "Robert Rauschenberg's 'Red Show': Theater, Painting, and Queerness in 1950s Modernism." *Modernism/Modernity* 24, no. 1 (January 2017): 87–115.

Foster, Susan Leigh. *Choreographing Empathy: Kinesthesia in Performance*. New York: Routledge, 2011.

Foster, Susan Leigh. "Closets Full of Dances: Modern Dance's Performance of Masculinity and Sexuality." In Desmond, *Dancing Desires*, 147–208.

Foster, Susan Leigh. *Reading Dancing: Bodies and Subjects in Contemporary American Dance*. Berkeley: University of California Press, 1986.

Foulkes, Julia L. *Modern Bodies: Dance and American Modernism from Martha Graham to Alvin Ailey*. Chapel Hill: University of North Carolina Press, 2002.

Franco, Susanne. "Ausdruckstanz: Traditions, Translations, Transmissions." In *Dance Discourses: Keywords in Dance Research*, edited by Susanne Franco and Marina Nordera, 80–98. Abingdon, UK: Routledge, 2007.

Franklin, Paul B. "*Walkaround Time*: Merce Cunningham's Terpsichorean Tribute to Duchamp." In *Étant donné: Not Wanting to Say Anything about Marcel*, 37–59. Paris: Association pour l'Étude de Marcel Duchamp, 2005.

Franko, Mark. *Dance as Text: Ideologies of the Baroque Body*. Rev. ed. Oxford: Oxford University Press, 2015.

Franko, Mark. *Dancing Modernism, Performing Politics*. Bloomington: Indiana University Press, 1995.

Franko, Mark. "Expressivism and Chance Procedure: The Future of an Emotion." *Res: Anthropology and Aesthetics* 21 (Spring 1992): 142–60.

Franko, Mark. "Given Time: Dance and the Event." In *Of the Presence of the Body: Essays on Dance and Performance Theory*, edited by André Lepecki. Middletown, CT: Wesleyan University Press, 2004.

Franko, Mark. "Introduction: The Power of Recall in a Post-Ephemeral Era." In *The Oxford Handbook of Dance and Reenactment*, edited by Mark Franko, 1–15. Oxford: Oxford University Press, 2017.

Franko, Mark. *Martha Graham in Love and War: The Life in the Work and the Work in the Life*. Oxford: Oxford University Press, 2014.

Franko, Mark. "The Readymade as Movement: Cunningham, Duchamp, and Nam June Paik's Two Merces." *Res: Anthropology and Aesthetics* 38 (2001): 211–19.

Gell, Alfred. *Art and Agency: An Anthropological Theory*. Oxford: Oxford University Press, 1998.

Gil, José. "The Dancer's Body." In *A Shock to Thought: Expression after Deleuze and Guattari*, edited by Brian Massumi, 117–28. New York: Routledge, 2002.

Golston, Michael. *Rhythm and Race in Modernist Poetry and Science: Pound, Yeats, Williams, and Modern Sciences of Rhythm*. New York: Columbia University Press, 2008.

Goody, Jack. *The Domestication of the Savage Mind*. Cambridge: Cambridge University Press, 1977.

Gordon, Mel. *Stanislavsky in America: An Actor's Workbook*. New York: Routledge, 2010.

Graham, Amanda Jane. "Space Travel: Trisha Brown's *Locus*." *Art Journal* 75 (2016): 26–45.

Graham, Martha. *The Notebooks of Martha Graham*. Introduction by Nancy Wilson Ross. New York: Harcourt Brace Jovanovich, 1973.

Greskovic, Robert. "Merce Cunningham as Sculptor." *Ballet Review* 11, no. 4 (Winter 1984): 88–95.

Hardy, Camille. "Between the River and the Ocean." *Dance Magazine*, July 1992, 57.

Harris, Roy. *The Origin of Writing*. London: Bloomsbury, 1986.

Henderson, Linda Dalrymple. *Duchamp in Context: Science and Technology in the "Large Glass" and Related Works*. Princeton, NJ: Princeton University Press, 1998.

Hering, Doris. "Merce Cunningham and Dance Company, December 29–January 3, 1954, Theatre De Lys." *Dance Magazine*, February 1954, 69–70.

Hering, Doris. "Silences and Sounds: Thirteenth American Dance Festival, August 18–21; Connecticut College, New London." *Dance Magazine*, October 1960, 22.

Hill, Constance Valis. *Tap Dancing America: A Cultural History*. Oxford: Oxford University Press, 2010.

Homans, Jennifer. *Apollo's Angels*: *A History of Ballet*. New York: Random House, 2010.

Humphrey, Doris. *The Art of Making Dances*. Edited by Barbara Pollack. New York: Grove Press, 1959.

Huschka, Sabine. *Merce Cunningham und der moderne Tanz*. Würzburg: König Shausen and Neumann, 2000.

Ingold, Tim. *Lines: A Brief History*. London: Routledge, 2015.

Jaeger, Peter. *John Cage and Buddhist Ecopoetics*. London: Bloomsbury, 2013.

Janis, Harriet, and Sidney Janis. "Marcel Duchamp, Anti-Artist." In *Marcel Duchamp in Perspective*, edited by Joseph Masheck, 30–40. Englewood Cliffs, NJ: Prentice-Hall, 1975.

Jarvinen, Hanna. *Dancing Genius: The Stardom of Vaslov Nijinsky*. New York: Palgrave, 2014.

Johnson, Tom. "Intentionalité et non-intentionalité dans l'interprétation de la musique de John Cage." In *John Cage*, special issue, *Revue d'esthétique*, nos. 13–15 (1987–88): 451–85.

Johnston, Jill. "Cunningham and Limón." *Village Voice*, September 5, 1963.

Johnston, Jill. "Cunningham in Connecticut." *Village Voice*, September 7, 1961.

Johnston, Jill. "Jigs, Japes, and Joyce." *Art in America* (January 1987): 103–5.

Johnston, Jill. "Merce Cunningham." In "Time to Walk in Space," special issue, *Dance Perspectives*, no. 34 (Summer 1968): 47–53.

Johnston, Jill. "Merce Cunningham & Co." *Village Voice*, February 24, 1960.

Johnston, Jill. "Modern Dance." In Basualdo and Battle, *Dancing around the Bride*, 75–86.

Johnston, Jill. "Two Reviews." In Kostelanetz, *Merce Cunningham: Dancing in Space and Time*, 32–36.

Jones, Amelia. *Postmodernism and the Engendering of Marcel Duchamp*. Cambridge: Cambridge University Press, 1994.

Jones, Bill T. *Last Night on Earth*. With Peggy Gillespie. New York: Pantheon Books, 1995.

Jones, Bill T. *Story/Time: The Life of an Idea*. Princeton, NJ: Princeton University Press, 2014.

Jones, Caroline A. *Eyesight Alone: Clement Greenberg and the Bureaucratization of the Senses*. Chicago: University of Chicago Press, 2015.

Jones, Caroline A. "Finishing School: John Cage and the Abstract Expressionist Ego." *Critical Inquiry* 19, no. 4 (Summer 1993): 628–65.

Jowitt, Deborah. "Merce Cunningham." *Village Voice*, October 10, 2006.

Jowitt, Deborah. *Time and the Dancing Image*. New York: William Morrow, 1988.

Joyce, James. "Ireland, Island of Saints and Sages" (1907). In *The Critical Writings of James Joyce*, edited by Ellsworth Mason and Richard Ellmann, 153–74. New York: Viking, 1959.

Judovitz, Dalia. *Drawing on Art: Duchamp and Company*. Minneapolis: University of Minnesota Press, 2010.

Judovitz, Dalia. "Duchamp's Engineering of Time." Paper delivered at the Modernist Studies Association Conference, Pasadena, California, November 2015.

Kaiser, Paul. "Steps." In *Ghostcatching*, 21–48. New York: Cooper Union School of Art, 1999.

Kappenberg, Claudia. "An Inter-disciplinary Reading of the Film *Entr'acte*." In *The Oxford Handbook of Screendance Studies*, edited by Douglas Rosenberg, 187–204. Oxford: Oxford University Press, 2016.

Katz, Jonathan. "John Cage's Queer Silence; or, How to Avoid Making Matters Worse." http://www.queerculturalcenter.org/Pages/KatzPages/KatzWorse.html. Accessed February 21, 2019.

Kisselgoff, Anna. "Dissociation in Merce Cunningham's Premiere." *New York Times*, March 2, 1989.

Kostelanetz, Richard. *Conversing with Cage*. New York: Routledge, 1987.

Kostelanetz, Richard, ed. *John Cage, Writer: Selected Texts*. New York: Cooper Square Press, 2005.

Kostelanetz, Richard, ed. *Merce Cunningham: Dancing in Space and Time*. New York: A Cappella Books, 1992.

Kostelanetz, Richard. *The Theatre of Mixed Means*. London: Pitman, 1970.

Kotz, Liz. *Words to Be Looked At: Language in 1960s Art*. Cambridge, MA: MIT Press, 2007.

Krauss, Rosalind E. *The Optical Unconscious*. Cambridge, MA: MIT Press, 1994.

Krauss, Rosalind E. "Perpetual Inventory." In *Robert Rauschenberg*, edited by Branden W. Joseph, 93–132. October Files, 4. Cambridge, MA: MIT Press, 2002.

Krauss, Rosalind E. "Reinventing the Medium." *Critical Inquiry* 25 (Winter 1999): 289–305.

Kraut, Anthea. "Reenactment as Racialized Scandal." In *The Oxford Handbook of Dance and Reenactment*, edited by Mark Franko, 355–74. Oxford: Oxford University Press, 2017.

Kuhn, Laura. "A Few Words about John Cage and Improvisation." Program liner notes to John Cage, *How to Get Started*, recorded August 31, 1989. Compact disc. Microcinema, 2011.

Kuhn, Laura. "A Few Words about John Cage and Improvisation." Published in conjunction with an interactive installation August 14, 2009, at Slought Foundation, University of Pennsylvania, Philadelphia. https://slought.org/media/files/how_to_get_started.pdf, pp. 2–8.

Laban, Rudolf von, and F. C. Lawrence. *Effort*. London: MacDonald and Evans, 1947.

Lang, Karen Ann. *Chaos and Cosmos: On the Image in Aesthetics and Art History*. Ithaca, NY: Cornell University Press, 2006.

Larson, Kay. *Where the Heart Beats: John Cage, Zen Buddhism, and the Inner Life of Artists*. New York: Penguin, 2012.

Lartigue, Pierre. "Merce Cunningham: Superpositions sur le sol irlandais." *L'Humanité* (Paris), November 1983.

Latour, Bruno. *Reassembling the Social: An Introduction to Actor-Network-Theory*. Oxford: Oxford University Press, 2007.

Launay, Isabelle. *Poétiques et politiques des répertoires: Les danses d'après I*. Pantin: Centre national de la danse, 2017.

Lent, Patricia. "Introduction to *Roaratorio*." Unpublished speech delivered on the occasion of the June 2010 performance of the Legacy Tour at Walt Disney Hall, Los Angeles.

Lepecki, André. "Choreography as Apparatus of Capture" *TDR* 51, no. 2 (2007): 119–23.

Lepecki, André. *Exhausting Dance Performance and the Politics of Movement*. New York: Routledge, 2006.

Leroi-Gourhan, André. *Le geste et la parole II: La mémoire et les rythmes*. Paris: Albin Michel, 1964.

Lesschaeve, Jacqueline, and Merce Cunningham. *The Dancer and the Dance: Merce Cunningham in Conversation with Jacqueline Lesschaeve*. New York: Marion Boyers, 1985.

Lewis, George E. *A Power Stronger Than Itself*. Chicago: University of Chicago Press, 2008.

Lott, Eric. *Love and Theft: Blackface Minstrelsy and the American Working Class*. New York: Oxford University Press, 1993.

Louppe, Laurence. "Imperfections on Paper." In *Traces of Dance*, edited by Laurence Louppe, 9–34. Paris: Éditions Dis Voir, 1994.

Louppe, Laurence. "On Notation." In Solomon, *Danse: An Anthology*, 89–102.

Louppe, Laurence. *Poétique de la danse contemporaine*. 3rd ed. Brussels: Contredanse, 2004.

Macaulay, Alastair. "Cunningham and Johns: Rare Glimpses into a Collaboration." *New York Times*, January 8, 2013.

Macaulay, Alastair. "Hard to Grasp, but Harder to Say Farewell." *New York Times*, December 25, 2011.

Macaulay, Alastair. "Using a Familiar Device to Dance out of the Past, Page by Page." *New York Times*, November 5, 2013. https://www.nytimes.com/2013/11/05/arts/dance/flip-book-by-boris-charmatz-is-inspired-by-old-photos.html.

Mallarmé, Stéphane. "Le livre, instrument spirituel." In *Oeuvres complètes*, edited by Henri Mondor and G. Jean-Aubry, 224–28. Paris: Gallimard, 1945.

Manning, Susan. *Modern Dance/Negro Dance: Race in Motion*. Minneapolis: University of Minnesota Press, 2004.

Manning, Susan. *Relationscapes: Movement, Art, Philosophy*. Cambridge, MA: Harvard University Press, 2009.

Martin, Randy. *Critical Moves: Dance Studies in Theory and Politics*. Durham, NC: Duke University Press, 1998.

McDonagh, Don. "New Concerns and New Forms." In *The Rise and Fall of Modern Dance*. New York: A Cappella Books, 1990. Orig. pub. 1970.

Mellers, Wilfred. "*Crises*." *New Statesman*, July 31, 1964; 160.

Merleau-Ponty, Maurice. *The Phenomenology of Perception*. Translated by Colin Smith. London: Routledge, 2003.

Moldering, Herbert. *Duchamp and the Aesthetics of Chance: Art as Experiment*. Translated by John Brogden. New York: Columbia University Press, 2010.

Morgan, Barbara. *Martha Graham: Sixteen Dances in Photographs*. New York: Morgan and Morgan, 1980.

Morris, Gay. *A Game for Dancers: Performing Modernism in the Postwar Years 1945–1960*. Middletown, CT: Wesleyan University Press, 2006.

Morris, Gay. "What He Called Himself: Issues of Identity in Early Dances by Bill T. Jones." In Desmond, *Dancing Desires*, 243–66.

Moten, Fred. *In the Break: The Aesthetics of the Black Radical Tradition*. Minneapolis: University of Minnesota Press, 2007.

Mueller, John. "He Breaks All Rules." *Rochester (NY) Democrat and Chronicle*, October 12, 1978.

Mueller, John. "Merce Cunningham's *Walkaround Time*." *Dance Magazine*, June 1977, 94–95.

Munroe, Alexandra. *The Third Mind: American Artists Contemplate Asia 1869–1989*. New York: Guggenheim, 2009.

Nagura, Miwa. "Cross-Cultural Differences in the Interpretation of Merce Cunningham's Choreography." In *Moving Words/Re-Writing Dance*, edited by Gay Morris, 270–87. London: Routledge, 1996.

Nattiez, Jean-Jacques, and Françoise Davoine. *Pierre Boulez, John Cage: Correspondance et documents*. Winterthur, Switzerland: Amadeux, 1990.

Naumann, Francis M. "Marcel Duchamp: A Reconciliation of Opposites." In *The Definitively Unfinished Marcel Duchamp*, edited by Thierry de Duve, 69–84. Halifax, Nova Scotia: Nova Scotia College of Art and Design; Cambridge, MA: MIT Press, 1991.

Ngai, Sianne. *Our Aesthetic Categories*. Cambridge, MA: Harvard University Press, 2015.

Nichols, David. *John Cage*. Urbana: University of Illinois Press, 2007.

Noland, Carrie. "(After) Conceptualism: Contemporaneity in Choreography." In *Being Contemporary: French Literature, Culture, and Politics Today*, 43–66. Liverpool: Liverpool University Press, 2016.

Noland, Carrie. "Ethics, Staged." *Performance Philosophy* 3, no. 1 (2017): 67–91.

Noland, Carrie. "The Human Situation on Stage: Merce Cunningham, Theodor Adorno, and the Category of Expression." *Dance Research Journal* 42, no. 1 (Summer 2010): 46–60.

Noland, Carrie. "Inheriting the Avant-Garde: Marcel Duchamp, Merce Cunningham, and the Legacy Plan." *Dance Research Journal* 45, no. 2 (August 2013): 85–123.

Noverre, Jean Georges. *Letters on Dancing and Ballets*. Translated by Cyril W. Beaumont. New York: Dance Horizons, 1975.

Nowatzki, Robert. "Paddy Jumps Jim Crow: Irish-Americans and Blackface Minstrelsy." *Éire-Ireland* 41, nos. 3–4 (Fall/Winter 2006); 162–84.

O'Neill, Peter D., and David Lloyd. "The Black and Green Atlantic: An Introduction." In *The Black and Green Atlantic: Cross-Currents of the African and Irish Diasporas*, edited by Peter D. O'Neill and David Lloyd, xv–xx. London: Palgrave, 2009.

Owens, Craig. "Posing." In *Beyond Recognition: Representation, Power, and Culture*, 201–17. Berkeley: University of California Press, 1994.

Patterson, David W. "Cage and Asia: History and Sources." In *John Cage*, edited by Julia Robinson, 49–72. October Files, 12. Cambridge, MA: MIT Press, 2011.

Patterson, David W. "The Picture That Is Not in the Colors: Cage, Coomaraswamy, and the Impact of India." In *John Cage: Music, Philosophy, and Intention 1933–1950*, edited by David W. Patterson, 177–216. New York: Routledge, 2002.

Perloff, Marjorie. "Marcel Duchamp's Conceptual Poetics." In *20th Century Modernism: The "New Poetics,"* 77–120. London: Blackwell, 2002.

Perloff, Marjorie. "Unimpededness and Interpenetration." In *A John Cage Reader*, 4–16. New York: Peters, 1982.

Perrin, Julie. *Figures de l'attention: Cinq essais sur la spatialité en danse*. Dijon: Presses du Réel, 2012.

Peterson, Elmer. "Paris Dada: Publications and Provocations." In *Paris Dada: The Barbarians Storm the Gates*, edited by Elmer Peterson and Stephen C. Foster, 1–32. Farmington, MI: Gale Press, 2001.

Portanova, Stamata. *Moving without a Body: Digital Philosophy and Choreographic Thought*. Cambridge, MA: MIT Press, 2013.

Pouillaude, Fréderic. *Le désoeuvrement chorégraphique: Étude sur la notion d'oeuvre en dance*. Paris: Vrin, 2009.

Preger-Simon, Marianne. *Dancing with Merce Cunningham*. With a foreword by Stuart Hodes and an afterword by Alastair Macaulay. Gainesville: University Press of Florida, 2019.

Pritchett, James. *The Music of John Cage*. Cambridge: Cambridge University Press, 1996.

Puchner, Martin. *Stage Fright: Modernism, Anti-Theatricality, and Drama*. Baltimore: Johns Hopkins University Press, 2002.

Rainer, Yvonne. "No Manifesto." In *Works 1961–1973*, 51. Halifax: Press of the Nova Scotia College of Art and Design, 1974. Also: http://www.1000manifestos.com/yvonne-rainer -no-manifesto/, accessed February 28, 2019.

Reynolds, Dee. "The Possibility of Variety: Dee Reynolds Phones Merce Cunningham." *Dance Theatre Journal* 2, no. 2 (2004): 38–43.

Roach, Joseph. *The Player's Passion: Studies in the Science of Acting*. Ann Arbor: University of Michigan Press, 1993.

Robertson, Allen. "The Merce Cunningham Dance Company." *Minnesota Daily* (University of Minnesota–Twin Cities), October 27, 1978, Arts and Entertainment, 8AE–9AE.

Rosenberg, Douglas. *Screendance: Inscribing the Ephemeral Image*. Oxford: Oxford University Press, 2012.

Rossen, Rebecca. *Jewish Identity in American Modern and Postmodern Dance*. Oxford: Oxford University Press, 2014.

Roth, Moira, and Jonathan D. Katz. *Difference/Indifference: Musings on Postmodernism, Marcel Duchamp and John Cage*. Amsterdam: GB Arts International, 1998.

Rotman, Brian. *Becoming beside Ourselves: The Alphabet, Ghosts, and Distributed Human Being*. Durham, NC: Duke University Press, 2008.

Rowell, Margit. "Kupka, Duchamp, and Marey." *Studio International* 198, no. 1 (1973).

Roy, Sanjoy. "Step-by-Step Guide to Dance: Bill T. Jones." *Guardian* US edition, November 9, 2010. https://www.theguardian.com/stage/2010/nov/09/bill-t-jones-fela -choreographer.

Sampson, Henry T. *Blacks in Blackface: A Sourcebook on Early Black Musical Shows*. Toronto: Scarecrow Press, 2014.

Schechner, Richard. "Rasaesthetics." In *Performance Theory*, 333–67. London: Routledge, 2004.

Scherer, Jacques. *Le "Livre" de Mallarmé: Premières recherches sur des documents inédits*. Paris: Gallimard, 1957.

Schiller, Gretchen. "Tracing Creativity: A Performative Portrait." Unpublished manuscript, 2016. University of Grenoble, France.

Schiphorst, Thecla. "Four Key Discoveries: Merce Cunningham Dance Company at Fifty." *Theater* 34, no. 2 (Summer 2004): 104–11.

Schiphorst, Thecla. "LifeForms: Design Tools for Choreography." In *Dance and Technology I: Moving toward the Future; Proceedings of the First Annual Conference*, edited by A. William Smith, 46–52. Westerville, OH: Fullhouse, 1992.

Schiphorst, Thecla. "Merce Cunningham: Making Dances with the Computer." *Choreography and Dance* 4, no. 3 (1997): 79–97.

Schneider, Rebecca. "In Our Hands: An Ethics of Gestural Response-Ability." *Performance Philosophy* 3, no. 1 (2017): 108–25.

Schneider, Rebecca. *Performing Remains: Art and War in Times of Theatrical Reenactment.* New York: Routledge, 2011.

Schwarz, Arturo. *The Complete Works of Marcel Duchamp.* New York: Harry Abrams, 1970.

Schwarz, Arturo. *Marcel Duchamp.* New York: Harry N. Abrams, 1975.

Sebaly, Abigail. "Between Performance and the Present: Robert Rauschenberg's Belt for Merce Cunningham's *Aeon.*" http://www.walkerart.org/collections/publications/art-expanded/between-performance-and-the-present/. Accessed February 20, 2019.

Seibert, Brian. *What the Eye Hears: A History of Tap Dancing.* New York: Farrar, Straus and Giroux, 2015.

Senelick, Laurence. "New Information on *My Life in Art.*" *Theatre Survey* 24, nos. 1–2 (May and November 1983): 127–30.

Sermon, Julie. *Partition: Objet et concept des pratiques scéniques (20ᵉ et 21ᵉ siècles).* Paris: Presses du Réel, 2016.

Sheets, Hilarie M. "Long-Lost Merce Cunningham Work Is Reconstructed in Boston." *New York Times*, June 18, 2015. http://www.nytimes.com/2015/06/19/arts/design/long-lost-merce-cunningham-work-is-reconstructed-in-boston.html?_r=2.

Siegel, Marcia B. "Prince of Lightness: Merce Cunningham (1919–2009)." *Hudson Review* 62, no. 3 (Autumn 2009): 471–78.

Silverman, Kenneth. *Begin Again: John Cage, a Biography.* New York: Knopf, 2010.

Sirvan, René. "Ballade irlandaise." *Le Figaro*, October 28, 1983.

Slayton, Jeff. *The Prickly Rose: A Biography of Viola Farber.* Bloomington, IN: Author House Press, 2006.

Snyder, Robert W. *The Voice of the City: Vaudeville and Popular Culture in New York.* 2nd ed. Chicago: Ivan R. Dee, 2000.

Solomon, Noémie, ed. *Danse: An Anthology.* Monts, France: Les Presses du réel, 2014.

Solomon, Noémie. "*STILL LIFE*: Le dispositif chorégraphique de Merce Cunningham comme réarticulation de l'histoire en danse." In *Recréer, scripter: Mémoires et transmissions des ouvrages performatives et chorégraphiques*, edited by Anne Bénichou, 351–72. Paris: Les Presses du Réel, 2015.

Srinivasan, Priya. *Sweating Saris: Indian Dance as Transnational Labor.* Philadelphia: Temple University Press, 2012.

Stanislavsky, Constantin. *An Actor Prepares.* Translated by Elizabeth Reynolds Hapgood with an introduction by John Gielgud. New York: Theatre Arts Books, 1980.

Stanislavsky, Constantin. *My Life in Art*. Translated by Jean Benedetti. New York: Routledge, 2008.

Stearns, Marshall, and Jean Stearns. *Jazz Dance: The Story of American Vernacular Dance*. New York: Da Capo Press, 1994.

Taylor, Diana. *The Archive and the Repertoire: Performing Cultural Memory in the Americas*. Chapel Hill, NC: Duke University Press, 2003.

Tomkins, Calvin. "An Appetite for Motion." In *The Bride and the Bachelors*, 239–96.

Tomkins, Calvin. *The Bride and the Bachelors*. New York: Viking Press, 1965.

Tomkins, Calvin. *Marcel Duchamp: The Afternoon Interviews*. New York: Badlands, 2013.

Troche, Sarah. *Le hasard comme méthode: Figures de l'aléa dans l'art du XXᵉ siècle*. Rennes: Presses Universitaires de Rennes, 2015.

Vaughan, David. "Cunningham and His Dancers: An Interview with Marianne Preger-Simon, Viola Farber, Carolyn Brown, Douglas Dunn, Steve Paxton, Valda Setterfield, Gus Solomons, and Roger Copeland. *Ballet Review* 15, no. 3 (Fall 1987): 19–40.

Vaughan, David. "Cunningham, Cage and Joyce: 'This longawaited messiagh of roaratorios.'" *Choreography and Dance: An International Journal*, vol. 1, pt. 4 (1992): 79–88.

Vaughan, David. *Merce Cunningham: Fifty Years*. Chronicle and commentary by David Vaughan. Edited by Melissa Harris. New York: Aperture, 1997.

Vaughan, David. "Merce Cunningham's *The Seasons*." *Dance Chronicle* 18 (2): 311–18.

Vaughan, David. "'Then I Thought about Marcel . . .': Merce Cunningham's Walkaround Time." In *Merce Cunningham: Dancing in Space and Time*, edited by Richard Kostelanetz, 66–70. Pennington, NJ: A Cappella Books, 1982.

Vaughan, David. "A Way of Looking: Merce Cunningham and *Biped*." *Dancing Times*, October 2000, 61–63.

Warburg, Aby. "A Lecture on Serpent Ritual." *Journal of the Warburg Institute* 2, no 4 (April 1939): 277–92.

Wong, Yutian. *Choreographing Asian America*. Middletown, CT: Wesleyan University Press, 2010.

Index

Names and Terms

Dances and Films by Merce Cunningham

Writings by Merce Cunningham